Your paintings reminded me
of Gauguin. I hope this
gives you joy and
inspiration.
 Love
 Linda

Christmas in Metico 1989

GAUGUIN
Life • Art • Inspiration

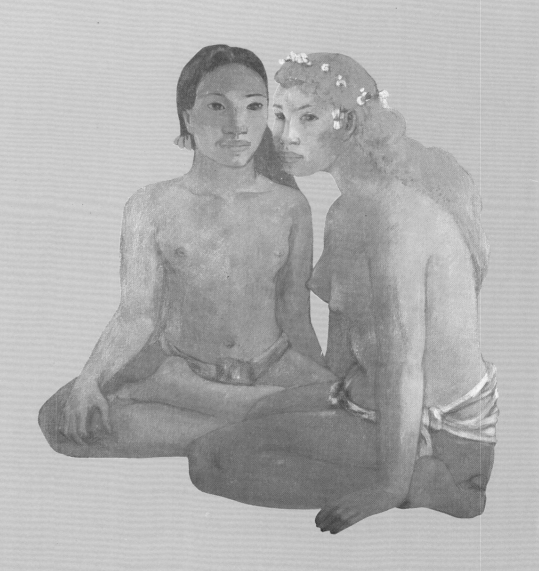

Editor, English-language edition: Nora Beeson
assisted by Heidi Colsman-Freyberger
Jacket design: Darilyn Lowe

Library of Congress Cataloging-in-Publication Data

Le Pichon, Yann.
 Gauguin: life, art, inspiration.

 Translation of: Sur les traces de Gauguin.
 Bibliography: p. 256.
 Includes index.
 1. Gauguin, Paul, 1848-1903. 2. Painters–France–.
Biography. I. Title.
ND553.G27L32 1987 759.4 [B] 86-26446
ISBN 0-8109-0993-6

Times Mirror Books

Printed and bound in France
by Maury Imprimeur S.A. and Reliure Brun S.A.

Yann le Pichon

GAUGUIN
Life · Art · Inspiration

Translated from the French by I. Mark Paris

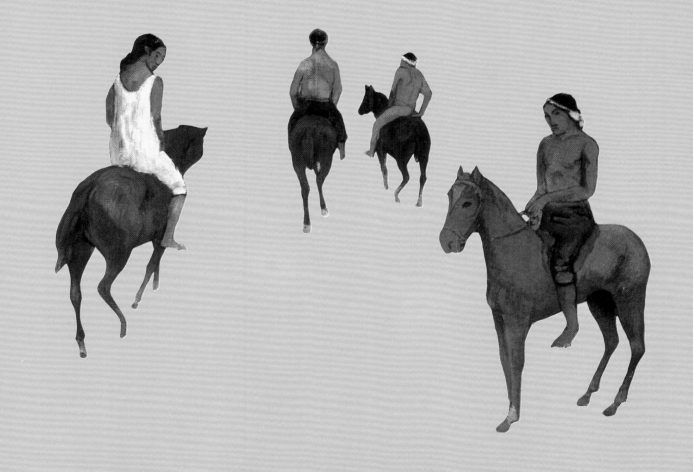

Harry N. Abrams, Inc., Publishers, New York

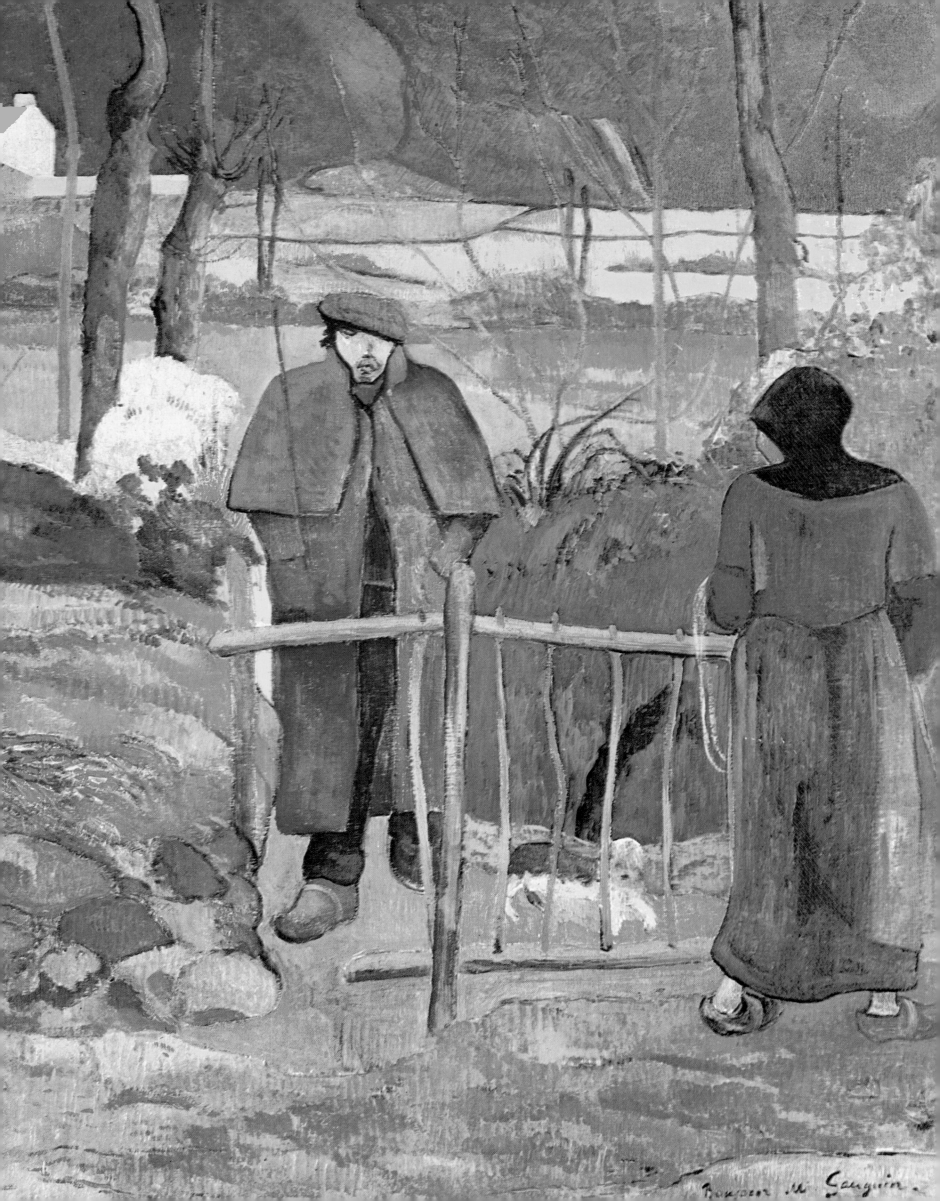

Bonjour M. Gauguin

Contents

1. Gauguin. *Bonjour, Monsieur Gauguin.* 1889 (reproduced in part, see also 246)

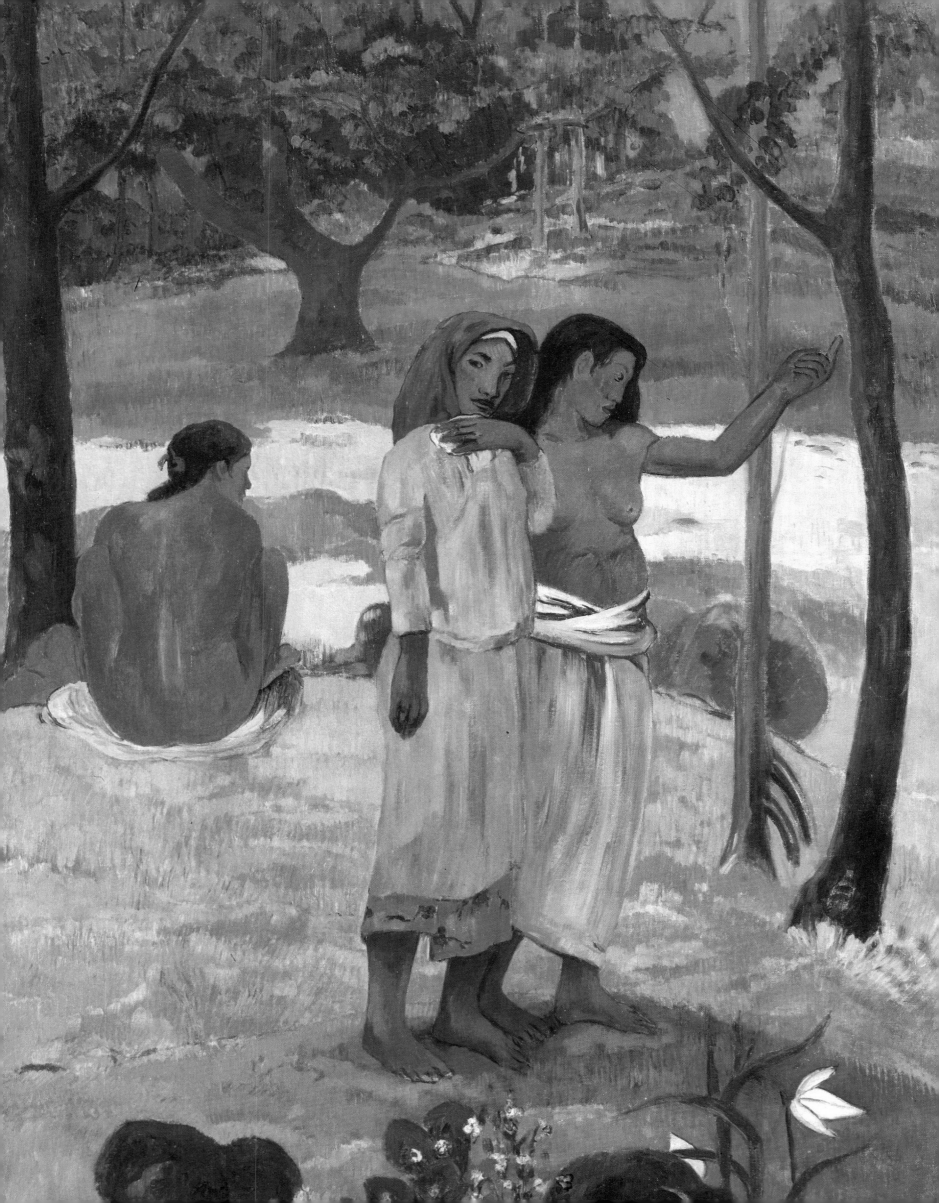

Preface

Gauguin has inspired many a biography and monograph, but Yann le Pichon has written something especially original and stimulating. To be sure, he retraces the life of an artist of genius; but he also draws on a wealth of pictorial sources in order to shed light on an unknown Gauguin driven by insatiable curiosity.

Moving though the life of Gauguin may be, he was not the only member of his generation to belong to the world of the "cursed artists." The problem of the *artiste maudit* was a societal and cultural one. Except for a few anomalies (Da Vinci, Rubens, Velázquez, and Ingres), landscape and portrait painters in previous centuries accepted their station and were satisfied with their lot in life. But with the French Revolution and the demise of guilds, frustration became their stock-in-trade. They felt unappreciated and unloved. From Diderot on, artists were on a par with writers and philosophers. But now that the middle class had replaced the nobility as the status quo, people who preached modernity were regarded as revolutionaries. The fact that Baudelaire, the author of *Les Fleurs du Mal,* spoke up loud and clear on behalf of Delacroix was enough to arouse the suspicion of the art establishment. In *L'Œuvre* and *Manette Salomon,* Zola and Goncourt, respectively, laid bare the physical and psychological wretchedness of these outcasts for all to see.

At no time was the spiritual distress of the *indépendants* and the *refusés* greater than during the reign of Napoleon III, when the clientele of France's official exhibitions showered government-approved "stars" with encomium and gold.

Granted, society was to blame; but so was Gauguin. With his passing whims and inability to lead a conventional life, he sowed the seeds of his own misfortune. But we must look beyond circumstances to heredity. Born in June 1848, at the height of a revolution, Gauguin was a scion of the middle class. His father, an obscure journalist with liberal leanings, had to go into exile after the coup d'état of 1851. On his mother's side, the lineage is stranger still. She was the respectable daughter of Flora Tristan, the quixotic, militant Saint-Simonian who threw in her lot with her comrades-in-arms. Gauguin spent his early childhood with Uncle Tristan y Moscoso in Lima.

Once he was back in Orléans, the lad dreamt of nothing but adventure. In 1865 he signed up as an apprentice with the Merchant Marine and sailed the seas from South America to Scandinavia. By 1871, however, he was keeping the accounts in Paris for a stockbroker by the name of Bertin; he had "settled down" or so it seemed. In fact, he did so well for himself that he could afford to indulge a penchant for Impressionist paintings.

Before long, he had left the Stock Exchange for artists' studios and was studying with Bouillot, a sculptor's assistant and admirer of Bonvin and Lépine. That is how Gauguin came to enlist in the legions of Art; there he remained to his dying day.

This brilliantly written book, with its outstanding illustrations and scholarship, does not stop at biography, superb though it may be. The insightful historian and critic Yann le Pichon has refined the approach he used in his book on Henri Rousseau and now bids us enter another inner sanctum. Many an unexpected apparition awaits us there! When we see Gauguin's paintings and sculpture, we picture him working alone in his studio. Actually, the giants of the past were all around him—in spirit. There was Courbet, for example, the master of naturalism, whose *The Source* lives on in the pose of *Hina Te Fatou*. Le Pichon comes across many such borrowings. Who but the author would have found, much less managed to substantiate, a link between Jongkind, the painter of riverfront Paris, and the Master of the Marquesas? The same Jongkind who himself followed in the footsteps of Dutch counterparts in the seventeenth century? Who would have thought that a road led from Gouda all the way to Papeete?

But that is just the starting point of Yann le Pichon's quest. Gauguin, we learn, may have derived a particular gesture in *Nave Nave Mahana* from Prud'hon's *Le Bain*. From Raphael to Ingres, from Tintoretto to Michelangelo, there were very few luminaries Gauguin did not turn to for inspiration, perhaps unconsciously. Some of the borrowings can be traced to the other side of the world: Hokusai, for one, whose work became the rage of Paris, thanks to Braquemond. The author ties in others with certain figures the Le Nain brothers depicted in the seventeenth century. From Botticelli to the fresco painters of ancient Egypt, from Phidias in Greece to Borobudur in Java, the sources Paul Gauguin drew upon are as countless as they are varied. Some will say that Picasso, too, studied and to some extent quoted Cranach, primitive art, Athenian women at the well, and Goya. But the Catalan master did it as a joke. He readily owned up to it.

With Gauguin, however, everything takes place in a dream world—a little-known world until now—along the tangled byways of an unconscious steeped in beauty. Perhaps in the empyrean that is now his resting place, Paul Gauguin will enjoy rediscovering in this book a good many of his own recollections . . . unless the artist holds it against Mr. Le Pichon for knowing more nowadays than even he does about the telltale images that sustained his genius.

Maurice Rheims
of the Académie Française

8

*"Color, like music [a form of] vibration,
has the power to attain what is most pervasive,
yet most elusive, about nature:
its inner strength."*

*"All things considered, in painting one must search
for suggestion rather than for description."*

*"There is nothing surprising or baffling in my work except
for that 'savage-in-spite-of-myself' quality.
That is why it is inimitable."*

*"The only way to break new ground is to go back to nature,
to the dawn of humanity."*

*"I am good [at what I do]
because I never allow myself to be sidetracked by others,
because I always do what is within me."*

*"I tried to make everything in this painting breathe:
faith, passive suffering, a sacred, primitive tone,
and the cry of nature at its most majestic."*

*"When you come right down to it, painting is like man:
mortal, but locked in a never-ending struggle with matter."*

"Fame! What a hollow word! What a hollow reward!"

To all of Paul Gauguin's progeny,
legitimate or otherwise,
and to those who, knowingly or not,
look to this prophet of modern art
as their spiritual father,
I dedicate this labor of love.
I thank my family and friends
for their encouragement.

Yann le Pichon

Introduction

Where Did He Come From?
Who Was He?
Where Was He Going?

Thiis book will attempt to answer as unambiguously as possible these three fundamental questions about Paul Gauguin, assuming that we can indeed fathom geniuses who transcend themselves in their work, but who also leave telltale clues about the inner workings of their hearts and minds. As Gauguin himself stressed time and again to his friends, "It's the inside you've got to see."

What makes exploring the life story and lifework of Gauguin so captivating is that few artists have so completely lost, and regained, their bearings during so unbridled a quest for absolute happiness. Fate thwarted him every step of the way and withheld recognition until after he died, but then how glorious it was after so much misery! Since then, he has been duly acknowledged as one of the most influential fathers or prophets of modern art. His direct descendants were the prolific school of Pont-Aven, the Nabis or the French Symbolists, and the Fauves; subsequent offshoots include the Cubists and the Surrealists. As recently as 1984, a major exhibition at the Museum of Modern Art in New York, "Primitivism in Twentieth-Century Art," made it abundantly clear that Gauguin was really the one who opened people's eyes to the depth and evocative power of the primitive art of "savages." By pitting himself against the positivistic, hyperdescriptive naturalism of Realism and Impressionism, he paved the way for the outbursts of Fauvism, the idealizing bent of Symbolism, and the Cubist reversion to structure. Like his contemporary Henri Rousseau, he showed the Surrealists how liberating the unconscious could be. "Pure color! Everything must be sacrificed for it!" With this as his "Eureka!" Paul Gauguin guided those painters inclined to abstraction and chromatic frenzy to the very limits of color, toward the light of the intellect. In short, he was instrumental in transforming what had been an exercise in trompe-l'œil back into painting aimed not at the senses but at the mind and the unconscious. The art of Gauguin involved "the whole man" and to achieve it he assumed the role of exorcist. In Brittany, he played the bard; in Polynesia, the natives looked upon him as a kind of sorcerer and nicknamed him "man who creates men." How apt their characterization was, because he did more than refashion them in clay and wood or create them anew on his canvases. By treasuring them against their will and putting them on the path of self-transcendence, he made new men of them.

Spurning all coteries, rejecting all dogmatism, risking his own skin in his fierce pursuit of happiness, he succeeded above all else in "establishing the right to dare everything." That was how the painter put it in a letter (October, 1902) to his friend, Georges-Daniel de Monfreid, as his life drew to a close. It was a life Gauguin bravely proffered to his art and his admirers even though (perhaps also because) most of his contemporaries repudiated him. "They study color solely in terms of decorative effect, but lack freedom," he said of his detractors. "They probe all around the eye, but not the mysterious center of thought."

"Gauguin laid the groundwork for the accomplishments of those who followed," René Huyghe points out, and rightly so. "But he did more. He taught them ahead of time how to violate the precepts to which they were so willing to subject themselves. He showed them that an artist could explore the structural possibilities of a painting as freely and as boldly as he wished and still not deprive it of content, meaning, soul . . . the spiritual intensity that is just as vital to art as form." Certainly Gauguin can be credited with getting his fellow Europeans, blasé and effete though they had become, to notice the sacred beauty of the primitive art of Pre-Columbian America, Brittany, India, Indonesia, Cambodia, and Oceania. The fascination of the Fauves and Cubists with African sculpture can be traced back to him. Moreover, by exposing the misdeeds of a colonial conquest often carried out in defiance of natives, their beliefs, and their urge to express themselves symbolically through their art, by turning that art into an unprecedented source of inspiration, Gauguin rescued Western culture from a self-centeredness that had grown not only sterile, but, for him at least, tiresome and revolting.

Where did he come from? Who was he? Where was he going? These three essential questions are the very ones Paul Gauguin himself tried to answer in Tahiti. Ailing, isolated, his despondency deepened by the news that his beloved daughter, Aline, had died, he resolved in December, 1897, to take arsenic and do away with himself. First, however, he painted his great testamentary work, the frescolike *Where Do We Come From? What Are We? Where Are We Going?*

As we ponder not only this masterly evocation of the one enigma that has always obsessed mankind but most of the paintings that bear the stamp of Gauguin's protean, syncretic, mythicizing genius, these three questions come down to the following: How did the things he created take shape? He put the question to de Monfreid in March, 1891: "When does the execution of a painting begin and end? At the very moment when the most intense emotions fuse in the depths of one's being, when they burst forth, when the whole concept wells up like lava from a volcano, is there not something like a breakthrough? The work of art is created suddenly, brutally, if you wish, but is it not great and superhuman in appearance? The cold calculations of reason have not presided over this birth, but who can say when, in the depths of one's being, a work of art was begun—unconsciously perhaps?"

Some will point out that the unconscious is elusive. How, then, are we to detect it in paintings, pottery, sculpture, and wood reliefs that have outlived their models, their creator, the sensual and intellectual relations between them in a particular setting? But because the unconscious does, so to speak, spring leaks—sometimes with explosive force, as Gauguin suggests—it lays itself open to detection and even analysis, however incomplete. Haphazard or recurring childhood memories, telltale admissions, slips of the pen or tongue, inadvertent omissions, corrections, even misspellings or other careless mistakes in his autobiographical writings, literary works, or letters (Victor Merlhès has just compiled a new edition of Gauguin's correspondence for the Singer-Polignac Foundation) will yield revealing glimpses into the workings of his unconscious. "To overcome all diffidence," he himself once stated, "I stepped way back, farther back than the horses of the Parthenon," back to the hobbyhorse of his childhood days in Peru, to the pieces he whittled with a penknife when he was a schoolboy in the Petit Séminaire in Orléans.

However, there was more to Gauguin than what he said or wrote. We have come too late to hear his Breton wooden shoes producing against the rocks of Pont-Aven the "dull, muffled, powerful tone" he sought in his painting; or to hear him singing now spirited, now

plaintive tunes amid the dunes of Le Pouldu; or to listen as he strummed his inseparable mandolin inside Polynesian huts; or to watch him running across the scorching beaches of Martinique, Tahiti, and Dominique as the painter-satyr chased exotic Eves in their inaccessible, primordial Gardens of Eden. Just the same, his re-creations, so realistic and yet so fanciful, so worldly and yet so visionary, live on at the four corners of the earth like so many professions of faith. Or are they confessions of metaphysical doubt, declarations of love, admissions of horror, invitations to join him on his great voyage toward jubilation, compassion, and prayer—in short, appeals to become his accomplice?

I myself became an accomplice of Gauguin early on, destined to love, understand, and want to know more about him through his art: those spellbinding, unsettling paintings; those pieces of sculpture, so puzzling yet so expressive; those drawings and engravings, so straightforward and at the same time able to conjure up the supernatural and the transcendent. The stage was set on the Pacific coast of Indochina; here, near Polynesia, I spent my enthralling childhood years. My first vacation in France, after the war, took me to Le Pouldu and Pont-Aven. I stayed with a Breton uncle whose father, a Quimperlé pastry cook who had become an innkeeper at Le Pouldu, had met some of Gauguin's pupils. A great-uncle of mine, a former naval officer, told me about the time he made an expedition to Tahiti back when Gauguin had lived there. The next thing to put me on his trail was my research into the world of Henri Rousseau. Gauguin and he were more than just neighbors in the Plaisance section of Montparnasse; their roles in the history of art are inextricably linked. (After seeing some of Rousseau's work at the Salon des Indépendants, Gauguin is said to have declared, "No one else's painting passes muster here but his! His blacks are wonderful.") I discovered that, like Rousseau *Le Naïf,* he often relied on photographs, copies of old masters, and snapshots of ancient relief carvings to help him crystallize his ideas for a painting. I found myself making a methodical search in books, dissertations, catalogues, and articles for all of Gauguin's sources of inspiration, whether surmised, verifiable, or self-evident. My objective, however, was to go beyond mere compilation, to give an accurate account of a life and work—in the case of Gauguin, they are one and the same. Here, too, was an opportunity to shed light on a number of previously unpublished influences and allusions which may seem surprising, but only at first.

Fortunately, help was lavished upon me along the way, and at the end of the book I have given credit to all the men and women who were so generous with their confidence and support. However, I should like to single out here those Gauguin experts and devotees without whom I could not have delved into the artist's creative imagination, nor probed the springs that drove him from deep within, nor followed his life story so closely: Gilles Artur, the learned curator of the Musée Gauguin, Tahiti, focal point of so much information about the lonely man who founded the "Studio of the Tropics;" Maurice Malingue, who gave me such ready access to the photographs and biographical material it has taken him more than forty years to compile; Father Patrick O'Reilly, who was kind enough to share with me his collection of old photographs of Polynesia; the people in charge of the museum in Pont-Aven and my cousins in Le Pouldu, the Pouzoullics, who helped me locate the places Gauguin painted as well as a few individuals whose Breton forbears modeled for him; Maïotte Dauphite, the West Indian curator of the Musée Gauguin in Martinique, who made his stay in Le Carbet come alive again; Elizabeth Altarriba (Emile Bernard's daughter), her husband, and their friend Serge Clin, who is better acquainted than anyone else with the life of the man who pioneered Synthetism and with those who trace their roots to Gauguin's closest associates, greatest admirers, or those who extended their hospitality to him; Daniel

Wildenstein and David Cooper, who were putting together an updated catalogue raisonné of Gauguin's paintings based on the one compiled by the late Georges Wildenstein, who had discussed my project with me; all those affiliated with the departmental museum at the Prieuré de Saint-Germain-en-Laye and its curator, Marie-Amélie Anquetil, who gave me the run of its library. It was my pleasure to persuade her to plan an exhibition on the influence of Gauguin and then to assist her in getting it ready for the fall, 1985. She was kind enough to introduce me to a number of collectors, including the preeminent Gauguin enthusiast Samuel Josefowitz. Thanks also to the curators and research assistants of French museums (in particular, the Musée d'Orsay and the Musée des Arts Africains et Océaniens) as well as to foreign museums and galleries which preserve and exhibit his works, writings, and memorabilia; last but not least, all of the authors whose books and full-scale studies I have consulted and included in the bibliography. Many of them—especially René Huyghe, Bernard Dorival, John Rewald, Bengt Danielsson, and Françoise Cachin—have re-created the cultural context in which Gauguin emerged and, in so doing, bear out Taine's conviction that "a work of art is determined by an aggregate, to wit, the general state of the ambient mood and mores." Truly, Gauguin burst on the scene in the nick of time. The world had grown too old not to feel a visceral need to revitalize art by returning to its wellspring: aspiration to the divine by investing that which is human with sacredness. Over the years, Gauguin learned to let the supernatural take hold of him and hold out the hope of happiness; he sensed it in Peru, Brittany, and Martinique, and the Tahitians and Marquesans taught it to him firsthand.

The chapters correspond to the principal stages of Gauguin's career. I have done my utmost to trace those events, however trivial they may seem, which punctuated and fueled his roving, headstrong life, with its alternating phases of enthusiasm and depression. My purpose is to determine precisely why he backtracked away from our civilization and toward a realm beyond the real world. Furthermore, whenever I include excerpts from Gauguin's writings and letters, or from eyewitness accounts, I have been careful to do so verbatim, mistakes and all, lest indirect quotations mislead or misinform. While in Polynesia, Gauguin became the first artist whose work straddles art and anthropology, if not ethnography. Therefore, I decided to juxtapose preliminary sketches (however crude), pictorial sources such as paintings, sculpture, and photographs (however improbable), and colorplates of key works, all on a series of pages that follow his career by period and by subject. Gauguin often drew analogies between music and painting, and he composed many a variation on unchanging themes. By studying the scores of his multicolored partitas, the reader will be able to puzzle them out, step by step, and trace a path of creativity that moved back in time in order to blaze new trails.

Now that this demanding inquiry into Paul Gauguin has reached its conclusion—and I owe a debt of gratitude to my publisher for encouraging me to overcome obstacles I encountered along the way—I feel closer to the artist than ever before. I should like to venture an answer, oversimplified though it may be, to our three pivotal questions. I would readily say that Gauguin was the product of a childhood under the spell of sublimation and that he was what he became: an insatiable man advancing toward God with an eagerness that grew more desperate the more happiness gave way beneath his feet. We see it in all of his paintings, those testaments to his courage and power to beguile.

Yann le Pichon

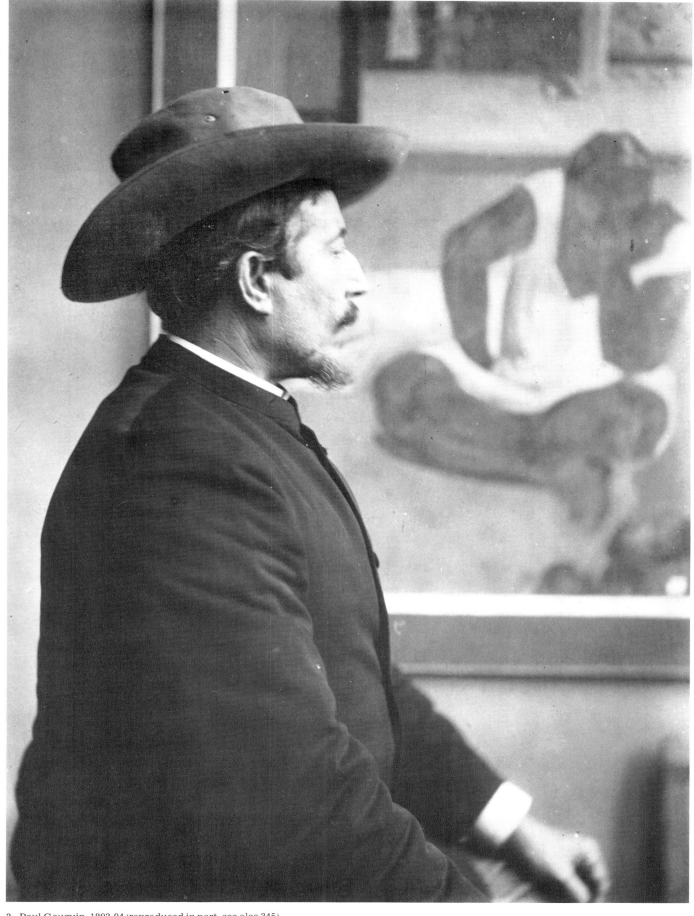

3. Paul Gauguin, 1893-94 (reproduced in part, see also 345)

1
The Call of the High Sea and of Art

June 1848–June 1886

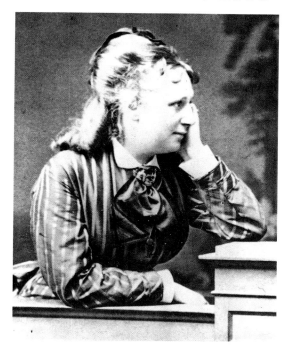

5. Mette Gauguin leaning on a railing

"To understand men you must look beyond their deeds," noted Flora Tristan, author of *Peregrinations of a Pariah* and the somewhat legendary grandmother of Paul Gauguin. The wishes, sorrows, and dreams of Gauguin himself are as vital to fathoming him as his exploits. He claimed to be descended on his grandmother's side from a "Borgia of Aragon, Viceroy of Peru." In his memoirs, *Avant et Après (The Intimate Journals),* he described this fiery, moody, militant Saint-Simonian as a "socialist bluestocking," an anarchist, and an indefatigable traveler who sacrificed her entire fortune to further the cause of the working class. However, he also confessed to knowing nothing specific about her and that he found it impossible to "sift truth from fiction." The same can be said of Gauguin: in everything he did, he, too, took to living out what he fancied himself to be so that his life's work might be brought to fruition. He answered the call of the high sea by joining the Navy, then answered the call of art by studying with the Impressionists. However, it was not until his first trip to Brittany in 1886 that he finally carved out a creative niche all his own. Only then did Gauguin begin to realize that, if he was to become what he longed to be, he would have to merge his two great ambitions and proceed as a whole man. By bridging the gap between reality and imagination, he could offer up his life to his lifework. "My wish was to will," he declared when his wanderings had at long last come to an end. Anyone intent on retracing the artist's advances and reversals along the path to glory—posthumous only, we might add—would do well to keep this in mind.

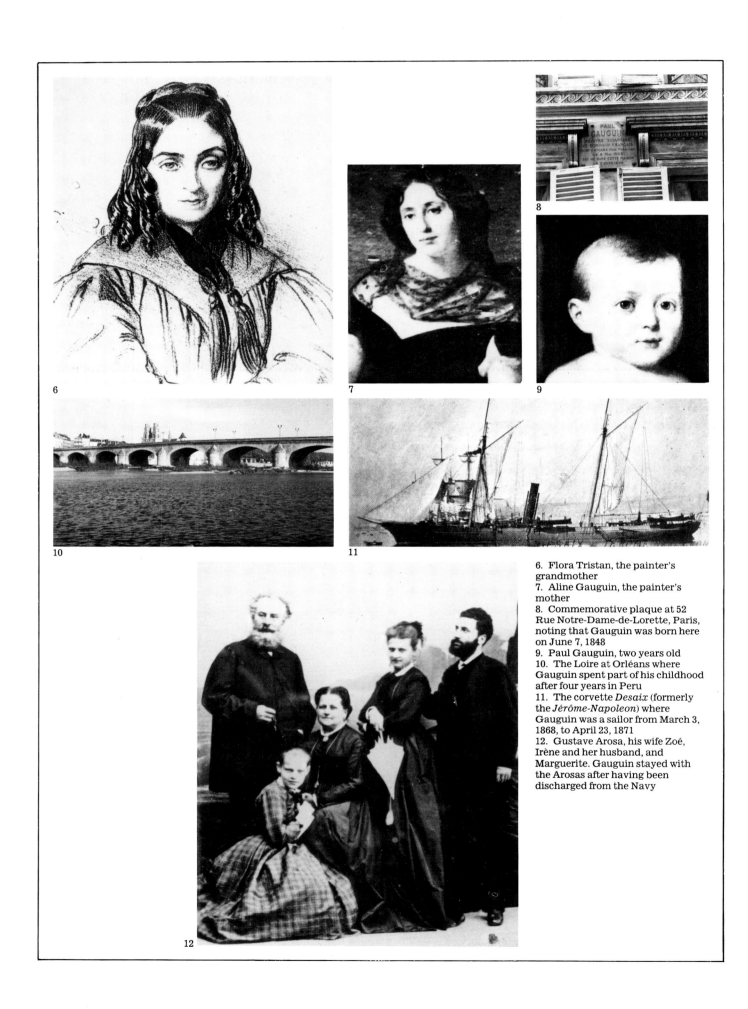

6. Flora Tristan, the painter's grandmother
7. Aline Gauguin, the painter's mother
8. Commemorative plaque at 52 Rue Notre-Dame-de-Lorette, Paris, noting that Gauguin was born here on June 7, 1848
9. Paul Gauguin, two years old
10. The Loire at Orléans where Gauguin spent part of his childhood after four years in Peru
11. The corvette *Desaix* (formerly the *Jérôme-Napoleon*) where Gauguin was a sailor from March 3, 1868, to April 23, 1871
12. Gustave Arosa, his wife Zoé, Irène and her husband, and Marguerite. Gauguin stayed with the Arosas after having been discharged from the Navy

Everything about the life of Paul Gauguin falls into place, even when things did not work out in his favor. If there were setbacks and miscalculations, he had no one to blame but himself; the only party he held accountable was himself. "Nothing occurs by chance," he observed. Everything about him—ancestry, background, adolescence—pointed to a calling whose sheer intensity more than made up for a late start. Like the umbilical cord that bound him tightly to his grandmother, then to his mother Aline, then to his daughter Aline, the same thread brought his life round full circle. This thread would be spun out more and more: from Lima to Orléans, Paris, Rouen, and Copenhagen; from Pont-Aven to Panama and Martinique, then back to Arles and Le Pouldu; finally, from Tahiti to Hiva Oa. There, blinded by some unknown radiance—"Is it day or night, morning or evening?" he asked Pastor Vernier before dying of a ruptured blood vessel—he snapped the guiding thread.

"Ideas, like dreams, are more or less crystallized assemblages of related things or thoughts," Gauguin had written a few months earlier. "Do we really know where they come from?" More than any other time, they take shape during infancy and throughout childhood. He never stopped believing that through Don Mariano de Tristan Moscoso—whose illegitimate daughter was Gauguin's maternal grandmother—he was a half-breed, part Spanish grandèe, part pure Aztec savage. He was forever trying to reconcile his lofty, lordly ambitions and his irresistible fascination with the instinctive life of "primitives." For him, art was either "essentially instinctive" and "purebred," or it was not. Poses had to have a distinctly animal quality; he admired "savages" who "love unwittingly." He emphasized his hooked nose in self-portraits to demonstrate that there really was something of the Indian about him. A work of art, he noted, should not be thought of as a finished product but as something taking shape. He gave this example: "A mother never considers her child really ugly." "My dear son shall have to carve out a career on his own," Gauguin's own mother wrote in her will. "He has made himself so little liked by all of his friends that he shall find himself quite forsaken."

Aline Chazal was born in 1825, after her mother, Flora Tristan, had walked out on her husband. Her childhood was tragic. Her father, a first-rate painter and lithographer by the name of André-François Chazal, kidnapped little Aline from boarding school. Flora accused him of indecent assault on his daughter and had him incarcerated. As soon as he was released, he inflicted a gunshot wound on his estranged wife and found himself sentenced to twenty years at hard labor.

Ancestry and Atavism

In 1844 Flora Tristan was in Bordeaux and about to embark on a campaign for the emancipation of the working class when she suffered a cerebral hemorrhage and died. Two years later, on June 15, 1846, Aline Chazal married Clovis Gauguin, a journalist eleven years her senior. Descended from a long line of gardeners from the Loiret, but whose father had become a well-to-do grocer in Orléans, Clovis wrote for *Le National,* a republican periodical. (Paul delighted as much in growing flowers as in painting them, and in Tahiti he reverted to his father's profession when he founded his own periodical, *Le Sourire.*)

Their first child, Marie, was one year old when "Petit Paul" came into the world, about ten in the morning on June 7, 1848, at 52 Rue Notre-Dame-de-Lorette. He was baptized thirteen months later in the church for which their street was named. In the meantime, Louis-Napoléon Bonaparte had been elected president of France. An opposition paper, *Le*

National, flew into a panic and foundered. "Did my father see the coup d'état of 1852 coming? I don't know, but the fact remains that he felt the sudden urge to head for Lima and intended to start a newspaper there." ("The sudden urge," mind you, stated Paul Gauguin, whose own travel plans were so lacking in foresight.)

With his wife and their children, Marie and Paul, Clovis Gauguin boarded the *Albert* bound for Peru. He was counting on Flora Tristan's well-heeled paternal uncle to help out; surely Don Pio de Tristan Moscoso would welcome them in Lima just as he had once welcomed Flora Tristan. An anxious and decidedly irascible sort, Clovis "had the misfortune," the painter tells us, "to fall in with an appalling captain, which did him terrible harm as he had an advanced case of heart disease. When he attempted to go ashore at Port-Famine, in the Strait of Magellan, he collapsed in the whaleboat. He had died of a ruptured blood vessel." The date was October 30, 1849; they buried him on the spot. (Paul Gauguin, his father, and his maternal grandmother all died of similar causes.)

The person Gauguin later called his "venerable uncle" welcomed Aline Gauguin and her two fatherless children with open arms. "His pretty niece, who bore so striking a resemblance to his beloved brother, Don Mariano, became the apple of his eye." The artist looked back on the five years he spent under Don Pio's roof, in the "delectable" atmosphere of Lima, as pleasant and happy ones. Some of his memories proved decisive. "I have remarkable visual recall, and I remember . . . the church with the dome entirely of carved wood added later on. I can still see our little Negress, . . . the Chinaman who found me in a grocery sucking on some sugar cane . . . while my mother, all in tears, had people looking high and low for me." He had memories of Peruvian mummies, of seeing a terrifying madman in his room one night when there was a full moon. He distinctly recalls his mother—her prankishness, her "eyes, so gentle and affectionate," her pride, her extravagance. (Sculpture, Negresses, madmen, the impish and spendthrift Aline—premonitions of a life caught up in memory, emotion, and fantasy.)

Aline's father-in-law, Guillaume Gauguin, died in Orléans on April 9, 1855. Since he had already made arrangements for the disposition of his sizable estate, she thought it best to return to France. At first she lived near Isidore Gauguin—"Uncle Zizi," her unmarried brother-in-law who had been appointed guardian of the children—and put her son Paul in the Petit Séminaire, a boarding school in Orléans. In 1860, after selling off her holdings, she decided to set herself up as a dressmaker in Paris. The artist's memories of this period are few but significant, such as the time a little old woman predicted that he would become a great sculptor. Or the time he ran away from home, though not for very long. "I always had the urge to run away like that. . . . I took it into my head to fill a handkerchief with sand, tie it to the end of a stick, sling it over my shoulder, and steal into the forest of Bondy. . . ." Then he adds the warning, "Beware of pictures," since it was a folk woodcut of the Wandering Jew that had given him the idea in the first place. As far as he was concerned, all the Petit Séminaire taught him was to "hate hypocrisy, phony virtues, informing on others, and to watch out for anything that went against my instincts, my heart, and my mind."

In 1862, Aline Gauguin sent for Paul and put him in a boarding school for teen-age boys in Paris run by a Monsieur Loriol. There, at 49 Rue d'Enfer, he took fencing lessons and dreamed of becoming a naval officer. Three years later, his mother away in the country due to ill health, Paul Gauguin enlisted in Le Havre as an apprentice in the Merchant Marine. (He was unable to report for the entrance examination for Naval College.) He was assigned to the *Luzzitano,* a 654-ton three-master bound for Rio de Janeiro. The crossing was a smooth one, and en route a first mate told him of his travels to French Polynesia as a cabin boy and

of his captivating stay on a South Sea island. Once in Rio, our happy-go-lucky apprentice of seventeen looked up a certain Mme. Aimée, an opera singer from Bordeaux, who "overthrew my virtue." The ground was propitious, he hastens to add, "for I became quite the rake."

Acting as second lieutenant on the *Chili*, a 1,277-ton three-master, Gauguin set sail for Valparaiso on October 29, 1866. His voyage of rediscovery along the coast of South America included a stopover on the island of Taboga, off Panama. On December 14, 1867, he landed at Toulon and there the ship was laid up. By then the news reached him that his mother had died July 7 at home (2 Rue de l'Hospice, Saint-Cloud). "It is my belief," she wrote in her will, "that I shall die before my children come of age, and I wish to provide them with a guardian of my own choosing. That is why I hereby name Monsieur Gustave Arosa as their guardian. I ask him to be so good as to consent, and that both he and his beloved wife show them the affection they always have shown them." She left Paul all of her portraits and other paintings.

A close friend of Aline Gauguin and a weekend neighbor in Saint-Cloud, Gustave Arosa was a wealthy stockbroker on the Paris Exchange who had already claimed part of the fortune his Spanish father had amassed in Peru. He was an avid art enthusiast and took the trust Aline had placed in him very much to heart. For his part, Paul made up his mind to fulfill his military service obligations, enlisted in the Navy, and, on March 3, 1868, boarded the imperial yacht *Jérôme Napoléon* in Cherbourg as Ordinary Seaman Gauguin. The following particulars were noted at the time: "Height, 1.63 meters; hair, brown; eyes, brown; nose, average; forehead, high; mouth, average; chin, rounded; face, oval." Actually, he had somewhat reddish hair, green eyes tinged with gray, a low forehead, and a decidedly aquiline nose, not to mention an attribute the official who filled out his registration card could not foresee: rather cantankerous. For thirty-seven months and twenty-seven days he sailed the seas aboard this 450-horsepower corvette set aside for the personal use of Prince Jérôme, first cousin of Napoléon III. (The ship was re-christened the *Desaix* in September, 1870.) Gauguin cruised the Mediterranean: Malta, the Cyclades, Salonika, Constantinople; Varna on the Black Sea; London; Corsica, Naples, and Corfu; Trieste and Venice. The writer Ernest Renan was on board as the guest of Prince Jérôme during a North Sea expedition that took Gauguin to Scotland and the Arctic Circle. France's declaration of war on Prussia shifted his tours of duty to Boulogne, Cherbourg, the Baltic, Danzig, and Copenhagen; there also were patrols in the North Sea and just off French ports along the Atlantic. On April 23, 1871, Gauguin was discharged after a final swing to Algiers and Toulon. He came away from his years at sea seasoned, but disappointed. He practically never spoke of the experience again, except to declare to his sister that it was "a bitter episode in my life."

The Influence of Gustave Arosa

Gauguin returned to Saint-Cloud only to discover that his mother's house had burned down on January 25. Much to his dismay, his cherished mementos—"some Peruvian vases and, most of all, quite a few solid silver figurines"—were nowhere to be found. Gustave Arosa maintained a Paris residence at 5 Place Bréda, and the time had come to put all the odds in his charge's favor. His influence on Paul Gauguin's life was threefold. He found him a job as an intermediate broker with his partner Bertin; his splendid collection of paintings and his ongoing work with photography opened Paul's eyes to the world of art; and it was under his roof (and auspices) that he fell in love with Mette Gad and decided to make her his wife. It was also here that he met his future teacher, Camille

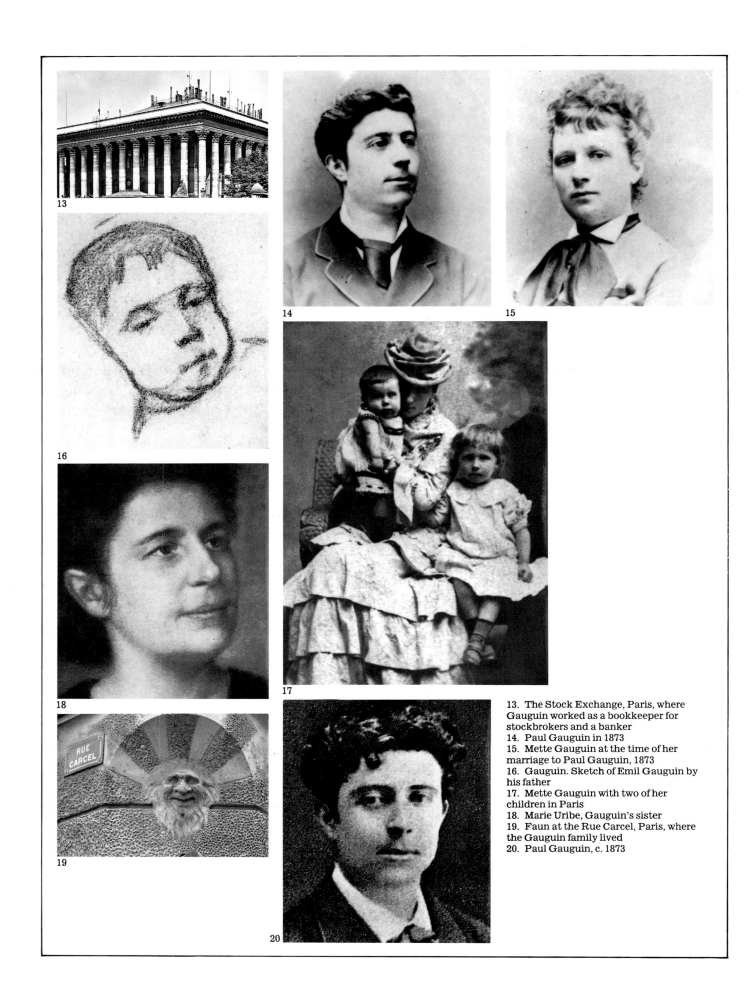

13. The Stock Exchange, Paris, where Gauguin worked as a bookkeeper for stockbrokers and a banker
14. Paul Gauguin in 1873
15. Mette Gauguin at the time of her marriage to Paul Gauguin, 1873
16. Gauguin. Sketch of Emil Gauguin by his father
17. Mette Gauguin with two of her children in Paris
18. Marie Uribe, Gauguin's sister
19. Faun at the Rue Carcel, Paris, where the Gauguin family lived
20. Paul Gauguin, c. 1873

Pissarro, and that Gustave's brother, Achille Arosa, told Gauguin of his visit to Polynesia. Now Paul hoped that he might go there himself one day.

After finding accommodations with his sister Marie, near both the Arosa residence and Bertin et Cie. (corner of Boulevard des Italiens and Rue Laffitte), Gauguin literally got down to business. As go-between for stockbroker and client, he found the job of soliciting orders from speculators playing the Stock Exchange very much to his liking. "All of his notes were terse and to the point," his son Pola later recalled, "and he wrote in a small, neat, easy-to-read hand. He was as punctual as clockwork . . . and never sat around idle." Come evening, he would sequester himself at 15 Rue La Bruyère, reading Baudelaire, Balzac, Barbey d'Aurevilly, and Edgar Allan Poe; he also took to sketching and drawing. On Sundays, the Arosas enjoyed having him over to their Paris or Saint-Cloud residence; the fact that their daughter, Marguerite, was an artist piqued his interest in painting. He could marvel at leisure at Arosa's collection: the many Delacroix, the Corots ("He was given to dreaming, and in front of his pictures so am I"), the Courbets, Daumiers, Jongkinds, Boudins. His discriminating mentor also boasted some choice specimens from the Barbizon school, which Gauguin found equally appealing. A friend of the photographer Nadar, Arosa used a collotype process to illustrate a book on the painter Prud'hon and another on Trajan's Column in Rome. His project at the time was to photograph paintings in his collection and antique relief carvings; Gauguin would have occasion to refer to these pictures in years to come.

Marriage to Mette Gad

Gauguin's future wife was one of five children to survive the death of their father, a cantonal judge in rural Denmark. After serving as governess for the children of Prime Minister Estrup, Mette Sophie Gad, then twenty-two, came to Paris in October, 1872, to improve her French. (A Mr. Heegaard had chosen Mette as a traveling companion for his daughter, Marie.) The two of them found accommodations on Rue des Martyrs in a boarding house run by the Fouignet de Pellegrue family, who happened to know the Arosas. Before long, Mette and Marie were asked over to 5 Place Bréda. Just before Christmas, Marie Heegaard wrote to her family of the wonderful time she was having at the Arosas and of "a young Monsieur Gauguain [sic], who secretly pines for Mette who plays the Beauty with the Heart of Stone," a part she would not find easy to give up thereafter! Granted, she was, according to Marie Gauguin, "short on tenderness"; Pola Gauguin recalls that her voice was "almost like a man's"; even Marie Heegaard had to admit that she was "a bit on the blunt side." Just the same, Mette Gad had endearing qualities that Gauguin found irresistible: intelligence, openmindedness, "individuality," and "forthrightness of feeling." A few parties and fancy-dress balls at the Arosas (she went as a man the first time around), a few meals in a working-class restaurant near the Stock Exchange, and his mind was made up. "Madly in love," he proposed to her in January, 1873. After spending some time with her family, Mette Gad became Mme. Paul Gauguin on November 22 with ceremonies at the Lutheran Church of the Redeemer and the Town Hall of the ninth *arrondissement*. He was twenty-five; she, twenty-three.

The newlyweds set up housekeeping at 28 Place Saint-Georges. Even then, Gauguin was painting and practicing portraiture every chance he got, including Sundays and holidays. Their first son, Emil, was born on August 31, 1874. "White as a swan," was how Gauguin described him to Marie Heegaard, "strong as a Hercules, but mind you, I don't know how

likeable he is; with such a grouch for a father, the odds are he's not." Strangely enough, he ended this letter with "Women! We always love you far too much." It seems clear that he had failed to cheer Mette sexually and that she had not realized just how much her husband's artistic calling had already begun to overshadow everything else in his life.

In January, 1875, the Gauguins moved into a more spacious apartment at 54 Rue de Chaillot. Their neighborhood in the sixteenth *arrondissement* was also home to both Marie Gauguin (her husband, Juan Uribe, was a native of Colombia) and Mette's younger sister, who was married to the Norwegian painter Fritz Thaulow. At night, Gauguin would excuse himself to work at his painting, and on Sundays he would go off to paint along the embankments of the Seine or in the western confines of the city. One of his landscapes, *Forest Interior at Viroflay,* was exhibited at the Salon of 1876; Charles Yriarte mentioned that it showed "considerable promise." Gauguin's desire to devote more time to art seemed to be taking a toll on his career and Mette was starting to get concerned. Without giving up the brokerage business altogether, he resigned from Bertin et Cie.

With a second child now on the way, the Gauguins moved to the left bank of Paris: 74 Rue des Fourneaux, in the Vaugirard district. Here were born their daughter Aline (December 24, 1877) and their son Clovis (May 10, 1879). Their landlord, Jules-Ernest Bouillot, gave Paul his first lessons in sculpture. In the spring of 1880, they rented a cozy townhouse with a studio and garden from Félix Jobbé-Duval, a Breton painter living in the same district. Gauguin found the blissful intimacy of their family life at 8 Rue Carcel inspiring. Two more sons came into the world: Jean on April 12, 1881, and "Petit-Paul" (or Pola) on December 6, 1883, a month before the family moved away from Paris. Hard hit by the Stock Market crash, Gauguin had his heart set on going off somewhere "to devote myself entirely to painting" and to command "the notice of art lovers." He convinced himself that a clientele was just waiting to be built up in Rouen, where, he declared to Pissarro, "there are well-heeled merchants." Gauguin had made his conversion known to Pissarro as early as 1881. "Little by little, I am letting business fall by the wayside, rather, I'm forgetting how to conduct it. But give up painting—never!" Just the same, Pissarro put him on his guard: "After thirty years of painting . . . I am still hard up. Let the younger generation bear this in mind. There are winners, but no jackpots!"

Before he reached the point of severing all ties with his business career—and, as a result, with his family—Gauguin enjoyed a few years of prosperity, first as a bookkeeper with Bourdon, a banker and outside broker on Rue Le Peletier, then with Thomereau, an insurance agency on Rue de Richelieu. Following the example of the Arosa brothers, he channeled much of his savings into paintings, watercolors, and drawings, building up a private collection that he was to resell, or let his wife sell for him, as future disappointments dictated. It included over forty works by the likes of Manet, Boudin, Jongkind, and Daumier, not to mention Impressionists such as Degas, Monet, Renoir, Guillaumin, and Cézanne. By 1879 he had acquired three paintings by Camille Pissarro, whom he met at Gustave Arosa's; that same year Pissarro became Gauguin's friend, advisor, instructor, and guide. But Pissarro did more than school him in the technique of Impressionist painting. He invited him to paint by his side, first at Pontoise, then in the neighboring village of Osny, and he took him to the Café de la Nouvelle Athènes, where Impressionist painters congregated. Through him Gauguin met Cézanne, Degas, and Guillaumin, who later became a close friend. He also worked with Emile Schuffenecker, a student from the Académie Colarossi whom Gauguin had met at the Stock Exchange, but he much preferred the company of the Impressionists, even though his peremptory manner aroused suspicion and distrust in Renoir and Monet.

At the invitation of Pissarro and Degas, Gauguin took part in the fourth Impressionist exhibition in April, 1879. Was it on this occasion that Manet made his encouraging remarks? As long as he lived, Gauguin would remember what the Master said when Gauguin apologized for being a mere amateur. "Nonsense!" Manet retorted, "the only amateurs are the ones who paint badly!" To the fifth Impressionist exhibition (1880) Gauguin sent views of Vaugirard and Pontoise, as well as a marble bust. The following year his contributions to the sixth exhibition in Nadar's studio included a nude study of his maidservant. It was acclaimed by J.-K. Huysmans in *L'Art moderne*. Increasingly sure of himself, Gauguin tried to take control of the seventh Impressionist exhibition (1882), then being planned. However, he locked horns with Degas over the latter's insistence that Raffaelli be included. Although Manet and Renoir looked askance—"Gauguin is playing the dictator," Manet wrote to Berthe Morisot—Gauguin sent a dozen paintings and a bust of his son Clovis.

With France in the throes of economic crisis, sales of his pictures in a slump, the Impressionists going their separate ways (this came as a severe blow), and their principal dealer, Durand-Ruel, showing no interest in his work, Gauguin looked for ways of saving his skin. He approached Pissarro, whom he now saw more regularly, about making Impressionist tapestries. He let his imagination run away with him: a group of radical Spanish republicans, led in Paris by one Ruiz Zorilla, had him carry out a secret mission. In August, Gauguin stole into Roussillon on the Spanish border, the painter in him hoping to take advantage of the change of scenery; but all he brought back from Cerbère was a small watercolor. In late October, he traveled to Rouen—Pissarro was painting there at the time—and decided to make it his home. So, on January 4, 1884, off to Rouen went the whole family, settling as best they could in lodgings not far from the Eglise Saint-Ouen on Impasse Malherne.

The Decision to Paint

An impasse in more ways than one! By and by Pissarro began receiving letters from Gauguin: "Here my wife is insufferable, finds fault with everything, paints everything black. I must confess, things really are as black as they seem. . . ." Gauguin quickly realized that he could not make ends meet as a painter in Rouen and gave in to Mette's wish to return to Denmark. Once she was home, she would enlist the help of her relatives to get him back on his feet. In July, she boarded a ship bound for Copenhagen, where she planned to give French lessons. Meanwhile, Gauguin sent some paintings to Christiania (Oslo), Norway, for a show his wife's brother-in-law, Fritz Thaulow, had invited him to take part in. He tried to sell a Manet and, after searching high and low for work, landed a job as Scandinavian representative for Dillies et Cie., of Roubaix, makers of water-repellent canvas. (His contact was his childhood friend Antoine Favre, who also represented the firm.) In November, he was reunited with his family in Copenhagen (Mette had taken refuge with her mother) and shortly thereafter decided to move to a spacious apartment in the new Gamle Kongevej district. The Friends of Art Society arranged a show of his work early in May, 1885, but it was given a frigid reception. Gauguin was no more successful at selling Dillies' rotproof tarpaulins than he was at finding a market for his paintings. He came to loathe Denmark, its bone-numbing climate and hypocritical attitudes. Most of all, he hated his in-laws, who were soon looking down their noses at him and making it abundantly clear that he was as good as useless, what with Mette the family's

sole means of support. Although the sale of a Manet brought in 1,300 francs, they were forced to tighten their belts and moved into a cramped apartment at 51 Norregade. Bristling with resentment, Mette became openly petulant; her husband took refuge in the attic to paint. Judging by his letters to Pissarro and Schuffenecker, he became less and less sure of where to turn next. "My wife, my family, everyone, in fact, is on my back about this confounded painting of mine," he wrote in late May. "But one man's faculties can't cope with two things at once, and I for one can do *one thing only:* paint. Everything else leaves me stupefied."

Now Mette resigned herself—not without relief—to the prospect of separation. In June, Gauguin returned to Paris, moved in with his friend Emile Schuffenecker, and tried to sell some paintings from his collection to Durand-Ruel. He asked Mette to send him his paintbox, hoped that the sculptor Bouillot might have something for him to do, and started looking up his old fellow-workers at the Stock Exchange. Already he was contemplating going off to "some out of the way place in Brittany," once he found buyers for his paintings.

He spent July and August at a friend's in Dieppe, where a whole colony of painters, including Degas, congregated every summer. Jacques-Emile Blanche, who, like most of them, steered clear of Gauguin, later recalled seeing him, "haggard-looking," painting by himself amidst the rocks. Gauguin then traveled to London to contact Spanish republicans in hopes of abetting their subversive activities. While he was there, he discovered English painting.

In the middle of October, his sister, Marie Uribe, brought Clovis back to him. Father and son moved into a small apartment at 10 Rue Cail, near the Faubourg Saint-Denis, where his friend, "Marsouin" Favre, lived. He roamed the city for a means of support. Expecting to secure a position as an "advertising inspector," only to end up pasting posters in railway stations for five francs a day, he found himself utterly destitute. Even though his little boy had taken sick and lacked proper care, he reacted to Mette's concern with one belligerent letter after another, harboring resentment for having been so misjudged and treated so contemptuously in Denmark. "As my prospects brighten," he wrote to her, "I fully intend to take back other children." Meanwhile, he had become wrapped up in the eighth Impressionist exhibition. This time, however, his sister refused to take her nephew in and accused Paul of turning his back on his career, wife, and children for "that ghastly painting." Clovis was placed in a boarding school in Antony, on the outskirts of Paris.

Gauguin managed to get his friend Schuffenecker into the exhibition, which was shown at 1 Rue Laffitte from May 15 to June 15, 1886. It was a disaster for Gauguin, whose wood relief and nineteen paintings of Rouen, Denmark, and Dieppe left most of the critics cold. Degas and Berthe Morisot stole the show; Pointillist works by Seurat, Signac, and the one responsible for rallying them around the Neo-Impressionist banner, Pissarro, raised a few eyebrows. As for Gauguin's paintings, Félix Fénéon, writing for *La Vogue,* spoke in terms of "dull color schemes" and "ominous-looking" skies. Fortunately, Félix Bracquemond, a painter who paid Gauguin 250 francs for one of his pictures, advised him to shift his sights to ceramics and introduced him to a protégé of his, Ernest Chaplet. Painter and ceramist hit it off right away; everything boded exceedingly well. Gauguin, who by now had made up his mind to spend the summer in Brittany, was already wondering how being removed from his element would affect him, already mulling over the ideas he would come back with, ready for firing in Chaplet's kiln. He felt a visceral need to set out on a pilgrimage to the wellsprings of his inspiration so that he might become the hero of his lifework. If Gauguin withdrew to Pont-Aven in Brittany, it was to get his true bearings and transcend himself.

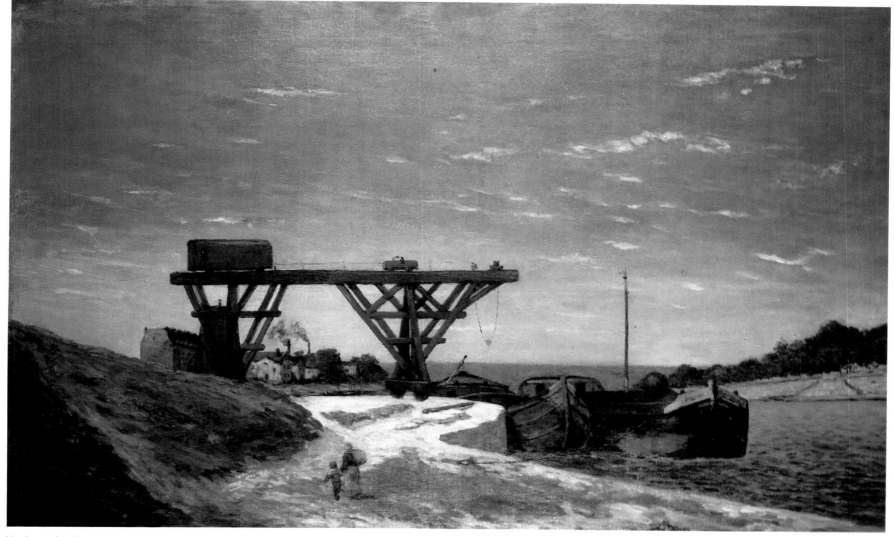

21. Gauguin. *The Seine between the Pont d'Iéna and the Pont de Grenelle*. 1875

22. Bridge over the Seine, Paris

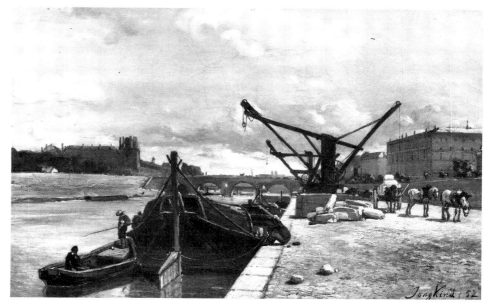

23. Johan Barthold Jongkind. *View of the Pont-Royal in Paris*. 1852

G auguin's guardian, Gustave Arosa, owned several paintings of berthed boats by Jongkind, whose work helped put French painters on the path toward Impressionism. Following in the Dutchman's footsteps, our budding artist made for the banks of the Seine (as did Armand Guillaumin). As he studied the barges moored alongside the quays like horses at rest— were they recalling adventures of long ago or dreaming of glories to come?—the call of the high seas gave way to the call of art. Paul Gauguin was getting ready to become what he already sensed he would be: a creator with a gift for reconciling the real and imaginary, life and longing, time and space. The in-depth view shown here hints at the future course of the man who ultimately fused gracefulness and mystery. With these early, but already masterly, efforts, Paul Gauguin took stock of his protean genius for the very first time. "Who can say when, in the depths of one's being, a work [of art] was begun?" he once asked. Perhaps it was on the banks of the Loire, in Orléans, where he spent part of his childhood.

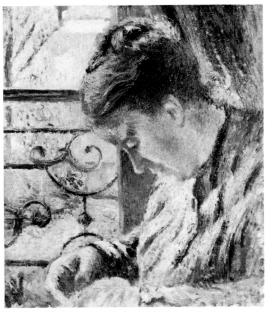

24. Camille Pissarro. *Madame Pissarro Sewing near a Window*. 1878–79

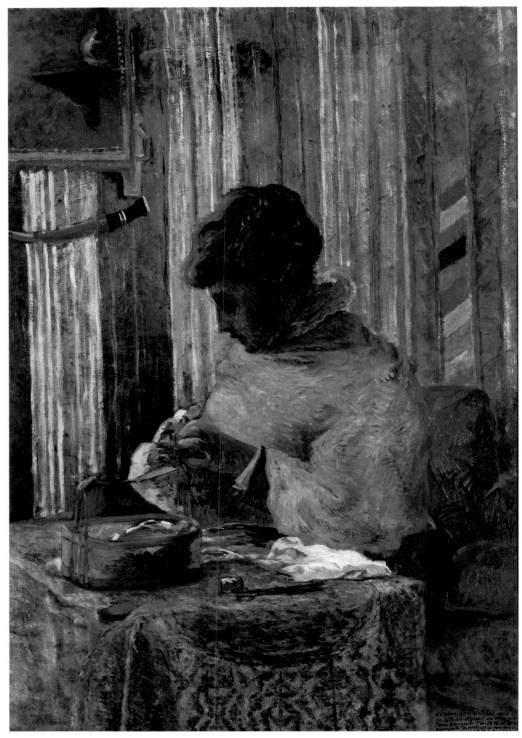

25. Gauguin. *Mette Gauguin Sewing near a Window*. 1878

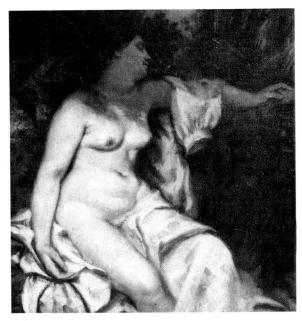

26. Gustave Courbet. *Bather Sleeping near a Brook*. 1845

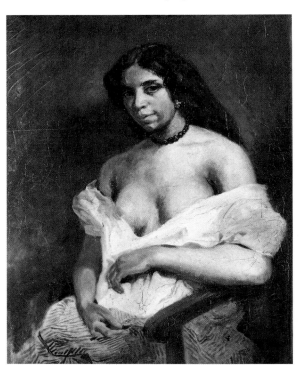

27. Eugène Delacroix. *Aline the Mulatto*. 1824–26

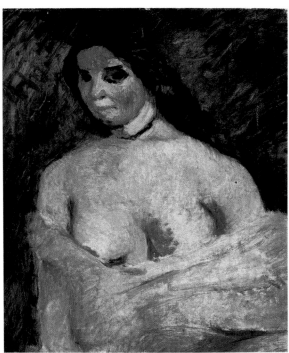

28. Gauguin. *The Mulatto after Delacroix*. 1878

28

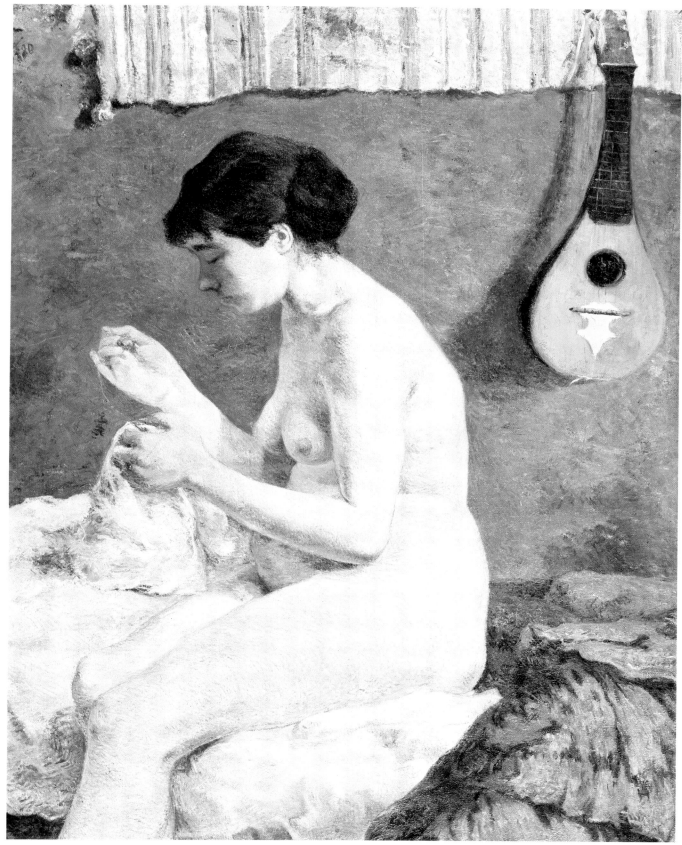

29. Gauguin. *Study of a Nude: Suzanne Sewing.* 1880

I n Paul Gauguin mon père, *Pola Gauguin recounts an incident his mother recalled and told him about. The artist had asked their maidservant to pose nude for him. When Mette made her misgivings known, Justine pointed out that "there was nothing unusual about it. Why, she had sat for Delacroix himself, so there was nothing for Madame to worry about." Exhibited at the sixth Impressionist show of April, 1881, this nude study won high praise from J.-K. Huysmans. "I do not hesitate to state," he wrote in L'Art moderne, "that among contemporary painters who have done nudes, none has struck so violent a note of reality, and I do not exclude Courbet...."* Then, drawing a parallel between Gauguin and Rembrandt, he underscored the unerring realism of his painting. "It is an unqualified success," Huysmans concluded. "He has created an intrepid and forthright picture." *Although the critic contrasts Gauguin and Courbet, one cannot help detecting the verist influence of the master of Ornans, not to mention an intimist mood reminiscent of Corot and the vaguely Oriental surroundings à la Delacroix. In fact, Gauguin thought so highly of the latter's* Aline the Mulatto *during a visit to the Musée Fabre in Montpellier that he copied it—a harbinger of his fascination with women of color in years to come. Be that as it may, the portrait of his wife sewing reveals a decidedly Impressionist approach that no one but Pissarro could have inspired.*

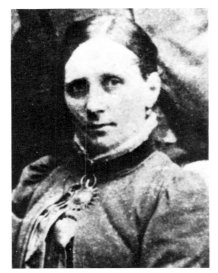

30. Mette Gauguin, c. 1873

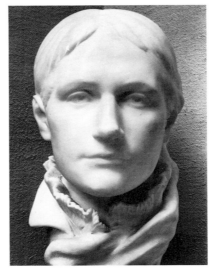

31. Gauguin. *Bust of Mette Gauguin.* c. 1879

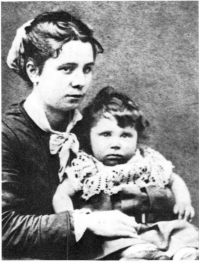

32. Emil Gauguin and his nanny Justine. 1875

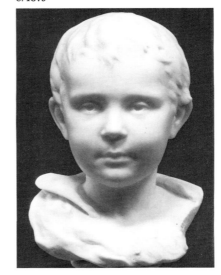

33. Gauguin. *Bust of Emil Gauguin.* c. 1878

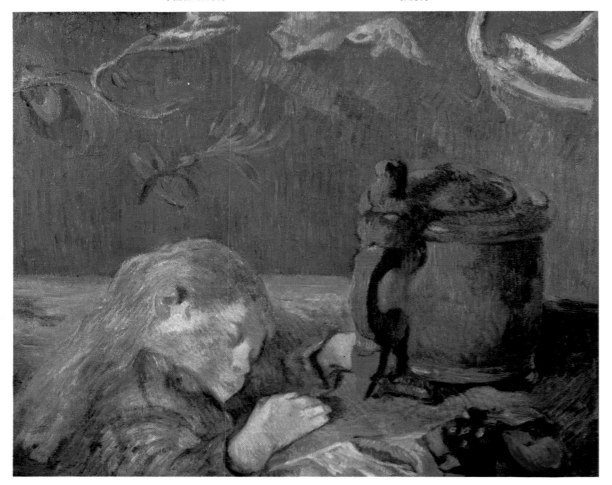

34. Gauguin. *Clovis Sleeping.* c. 1883

35. Gauguin. *The Painter's Family in the Garden of Rue Carcel in Paris.* c. 1882

auguin groped for bearings, made friends with Pissarro, picked up some words of encouragement from Manet, and sought the company of young Impressionists. As Françoise Cachin sees it, the fact that he tried his hand at sculpture reveals "a lack of fulfillment, a need for solidity, a need, possibly even this early on, for something dark and mysterious that Impressionism's fluttering play of light failed to provide." In the spring of 1877, he and his family moved to the Vaugirard district of Paris. There he was introduced to sculpture by Jules-Ernest Bouillot, who helped him with his busts of Emil and Mette. From 1880 to 1883 he rented a place facing the Eglise Saint-Lambert from Félix Jobbé-Duval, a painter. This thoroughly Impressionist painting reflects the domestic calm the Gauguins enjoyed during those years at 8 Rue Carcel. The blue wall of the room where his son is sleeping is an early indication of the painter's penchant for mystery.

36. Gauguin. *Snow, Rue Carcel*. 1882

37. The garden of Rue Carcel today

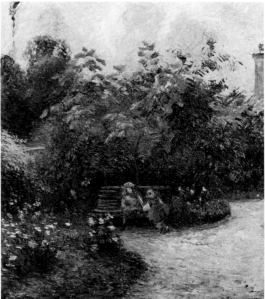

38. Camille Pissarro. *A Corner of the Garden,
Hermitage District*. 1877

39. Camille Pissarro. *Portrait of Gauguin.* — Paul
Gauguin. *Portrait of Pissarro*. 1883

The Bois d'Amour is the setting of this glistening
scene which Paul Gauguin painted in the summer
of 1886, during his first visit to Pont-Aven.
Consciously or not, this was to be one of his last exercises in
the purely naturalistic approach he had picked up from
Camille Pissarro as the two of them roamed the countryside
of the Oise and Rouen in search of landscapes. Meanwhile,
Seurat and Signac in Paris had officially introduced their
Divisionist and Pointillist techniques at the eighth
Impressionist exhibition; the fact that Gauguin's mentor
was receptive to their concept of pulverized, quasi-
"chemical" painting made him all the more determined to
reject it. Yet, here is proof that he could have been
instrumental in helping the Neo-Impressionists work out
their theories. Instead, he headed for Brittany in search of
something new. Together with Emile Bernard, a young
painter already won over by Louis Anquetin, Gauguin
spent the next two years gradually developing a more
synthetic, more symbolic approach that could tap the
unseen forces of the imagination. Adopted son rebelling
against spiritual father? Perhaps. With the intention of
outstripping him? Most assuredly!

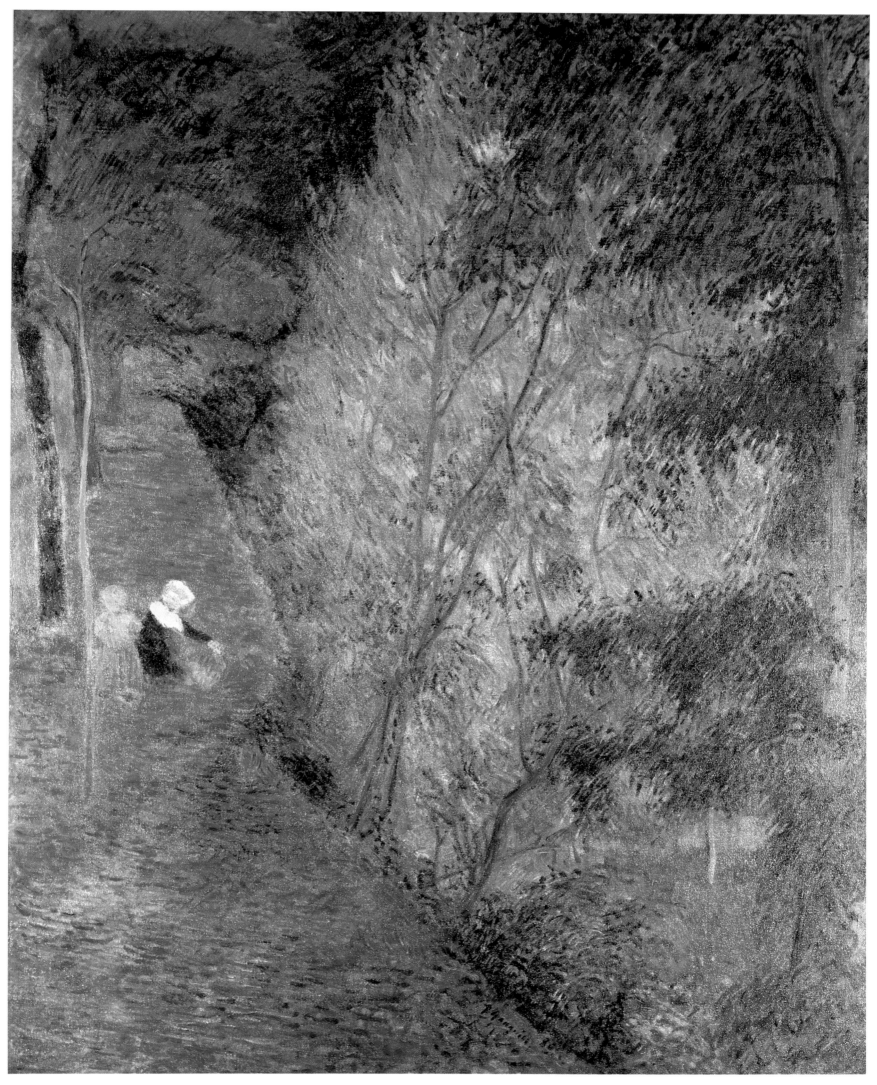

40. Gauguin. *Mother and Child under the Trees*. 1886

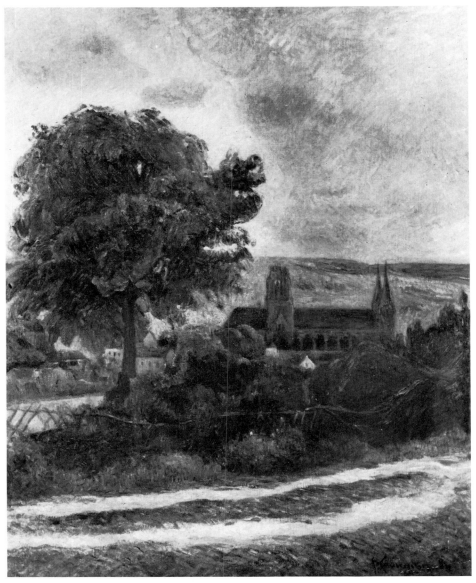

41. Gauguin. *Rouen, Church of Saint-Ouen*. 1884

45. Mill at Osny

"I am glad to know that Gauguin the Terrible is with you," Guillaumin wrote Pissarro on June 30, 1883. "It would have distressed him no end had he not been able to spend his vacation working under your guidance. He may be gruff, but he's a decent enough companion. You'll find him out and about in stormy weather." The master of Pontoise had recently relocated to the neighboring village of Osny, and it was there that Camille Pissarro introduced him first to Impressionist technique, then to the "constructive manner" of Cézanne. Some of the views they painted side by side of the approach to the village, water mills, the surrounding countryside, are not unlike The Sluice Gate at Osny. Gauguin's style took on the characteristics of his teacher's. After Gauguin moved his family to the port city of Rouen, he succumbed to the charms of the light there, gleaming fitfully through cloudy Norman skies. From a vantage point atop Mont Saint-Aignan (below), the painter has overlapped the church of Saint-Ouen and its famous High Gothic predecessor, Rouen Cathedral; the pastoral setting is worthy of Pissarro.

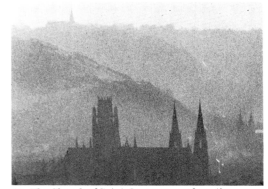

42. The Church of Saint-Ouen as seen from the outskirts of Rouen

43. The spires of Rouen Cathedral and the Church of Saint-Ouen as seen from the outskirts of the city

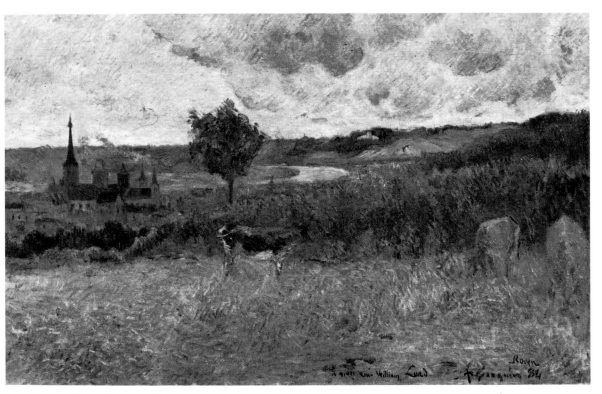

44. Gauguin. *View of Rouen, with the Spires of the Cathedral and the Church of Saint-Ouen*. 1884

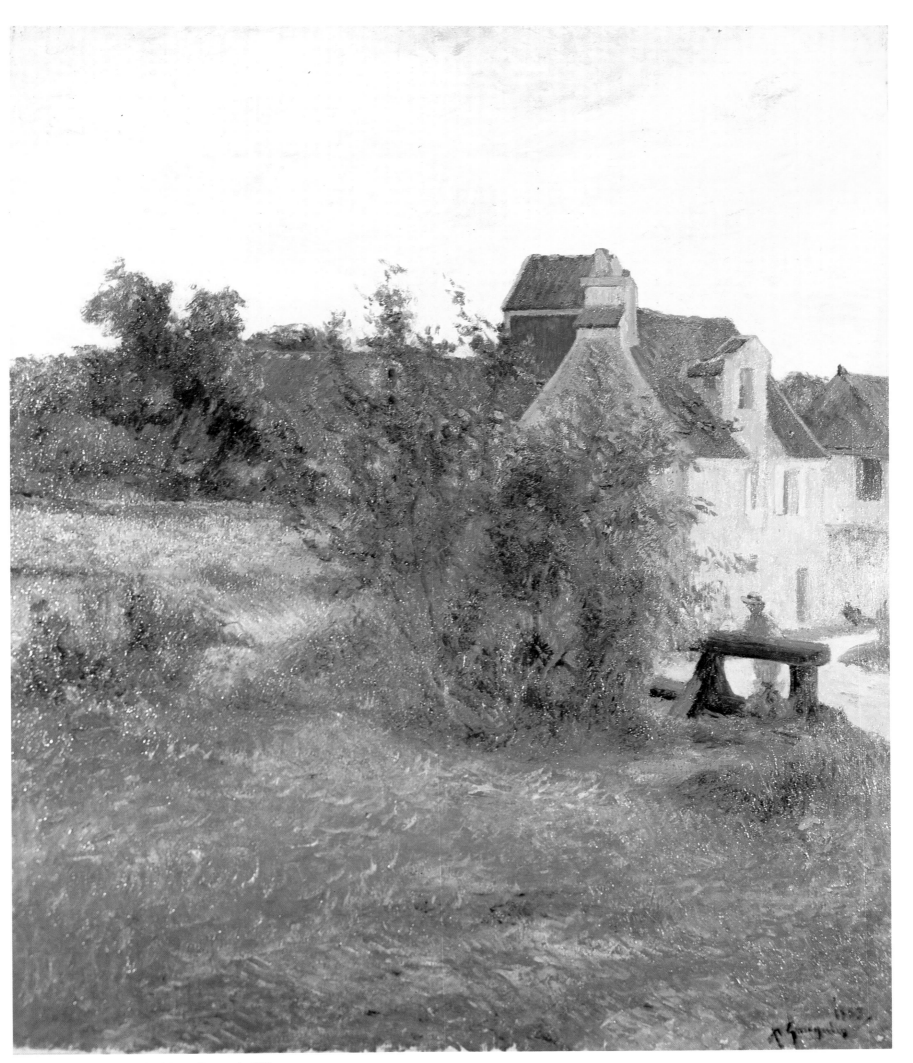

46. Gauguin. *The Sluice Gate at Osny, Normandy.* 1883

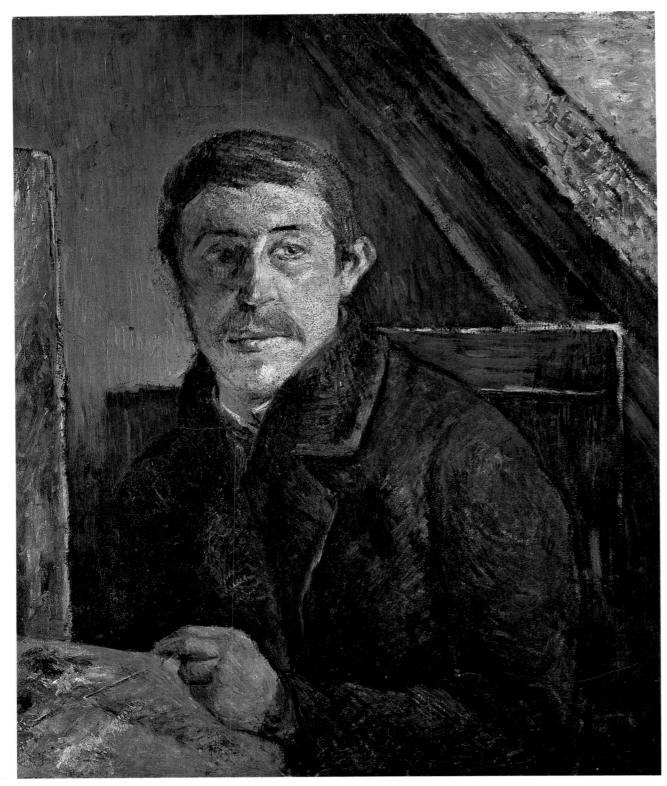

47. Gauguin. *Self-Portrait before an Easel.* 1885

48. Paul Gauguin, c. 1885 in Copenhagen

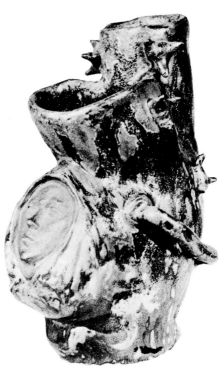

49. Gauguin. *Glazed Stoneware Vase with Mask*

N o sooner had Gauguin been reunited with his family in Copenhagen than disappointment set in over the icy reception his in-laws and their Danish friends gave him. "He was pushed farther and farther into the background," Pola Gauguin recalls. "He had to take refuge in a small inner room because the parlor was set aside for his wife and her pupils. . . . The light filtering through a little transom was all he had to work by, which made it impossible for him to paint from models. The only model he had was himself, and there he kept his lonely vigil during the long winter months, painting his own portrait. His rugged, energetic face is transfixed in deep thought. His heavy-lidded gaze is introspective, and his full lips are pursed. . . . A violent revolt was brewing inside him," a revolt that culminated in his return to France, with "I hate the Danes" as his parting words. Upsetting though this episode may have been, it did not stifle his interest in subjects such as this bouquet of flowers in one of his ceramic pots, together with his trusty mandolin and a light faience plate. Could the picture in the upper part of this still life—possibly a Pissarro—tell of his yearning for more cheering surroundings and the beginnings of a life-long passion for flowers?

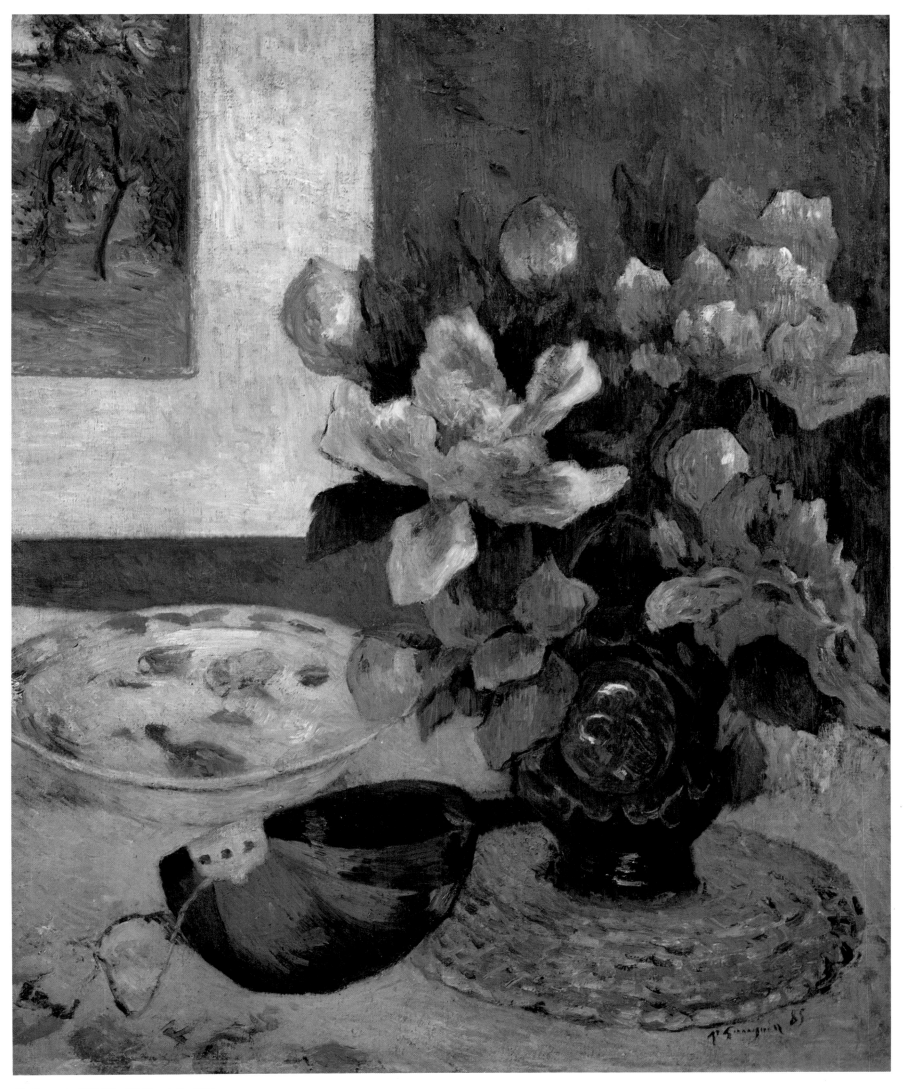

50. Gauguin. *Still Life with Mandolin.* 1885

51. Odilon Redon. *Madame Odilon Redon*. 1885

53. Clovis Gauguin as a child in Copenhagen

54. Paul Cézanne. *The Artist's Son*. 1880–85

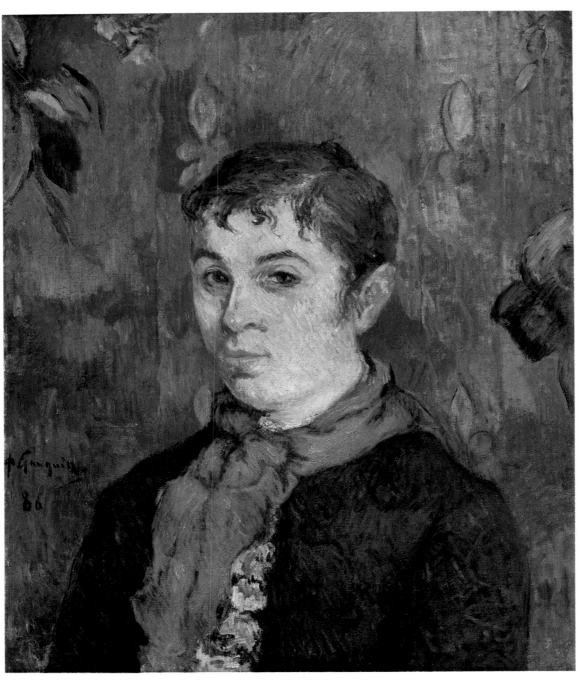

G auguin was unstinting in his praise for Cézanne when he wrote to Schuffenecker from Copenhagen in January, 1885. "Look at Cézanne the misunderstood, the essentially mystic nature of the East (he looks like an old man from the Levant). His work exudes the mystery and drowsy tranquility of a recumbent man deep in thought. His somber colors are in keeping with the Oriental character; his reds are astonishingly resonant . . . and his backgrounds are both imaginative and realistic." Despite this enthusiasm, a mutual distrust sprang up between the two painters. According to Pola Gauguin, his father's aversion to Cézanne was so intense that "he forbade his six-year-old son Emil to play with Cézanne's son Paul. But his admiration for Cézanne the painter was such that he copied one of his pictures." After Gauguin left Denmark in June, he later did a portrait of his son Clovis that bears comparison with the one Cézanne did of his son Paul. X-ray photography reveals that Gauguin painted the androgynous-looking subject of La Fille du Patron over the portrait of a young man: here, too, we are reminded of Cézanne. Nowhere is his brand of "resonance" more patent than in the red silk scarf. There is also a kinship with work by Odilon Redon.

Opposite
55. Gauguin. *Portrait of Clovis*. 1886

52. Gauguin. *La Fille du Patron*. 1886

2
Withdrawal to Brittany

July–October 1886

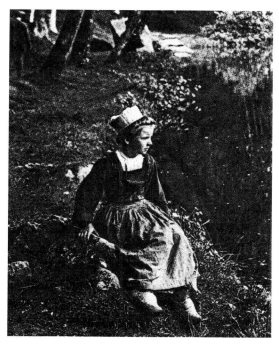

57. Breton girl sitting on a rock in the Bois d'Amour

Unexpectedly or not, a new season can work visceral changes in the lives of those creative giants predisposed to the sense of renewal it brings. So it was with the first summer Gauguin spent in Brittany, on the captivating banks of the Aven River. It was the middle of July, 1886, and he was about to cross his Rubicon. The die was cast! He was sick at heart over the fact that relations between him and his wife had taken an obvious turn for the worse and that a separation, not only from Mette and her hated Danish family but from his beloved children, was all but inevitable. In addition, the year of privation he and his son Clovis had just endured in Paris had taken a heavy toll on him. He went off to Pont-Aven the way a person in need of spiritual renewal goes on retreat: by withdrawing from the world and its illusions. From now on, he would devote his entire being to his art.

"I am leaving Paris this Friday for some out-of-the-way spot to produce some art," he wrote to Félix Bracquemond a few days before his departure. The enchanting "spot" which Jobbé-Duval, a Breton painter, had recommended enticed Gauguin all the more in those lean times because, to quote the artist, "you can live there for next to nothing." (The French equivalent of this expression, *la vie y est pour rien,* points up the self-contradictory nature of the choices he had to face: on the one hand, constantly on the lookout for money-making ventures, on the other, insinuating that life is nothing next to art.)

Stripped of everything except his faith in his "prospects"—his perpetual excuse for

sudden changes of heart, the word runs through his letters like a leitmotif—our pilgrim-painter acquired that summer of 1886 the only form of wealth that poverty bestows: freedom to move about, to meditate, to commune with oneself. "Come what may," he wrote his wife in late July, "perhaps one day when my art makes everyone stand up and take notice, some enthusiastic soul will retrieve me from the gutter."

Already weary of the naturalistic excesses of Impressionism, thoroughly dissatisfied with the way it fragmented pictorial space—just then, Pointillism was bursting on the scene with pulverized compositions like Seurat's *The Island of La Grande Jatte*—and with his feud with Pissarro, Seurat, and Signac coming to a head, Gauguin went off to live among a people that kept in touch with the world beyond by clinging to the heritage of a civilization steeped in mysticism and myth. There, among the Bretons of Finistère, he discovered that "it's the inside you've got to see," much as they see their inner selves in sacred springs and ageless wells. From the openwork spires of the church in Pont-Aven to the Trémalo Chapel in the Bois d'Amour to the neighboring parish of Nizon, the call rang out. The time had come to sequester himself, to withdraw to this "land of quaint folkways" so that he might become what he had been all along: an artist enamored of the Absolute. Gauguin yearned to have "in a single glance, memories welling up from deep inside to flood my soul."

The Inn of Marie-Jeanne Gloanec

As Gauguin and Achille Granchi-Taylor, a painter he had met at the Stock Exchange, boarded the train for Lorient and Quimperlé, he felt free as air and already under the spell of Brittany, that inscrutable Celtic region whose "barbaric" spirit Ernest Renan had recently extolled in his *Souvenirs d'enfance et de jeunesse*. They arrived late in the day, when the last rays of the setting sun bring out the furze blossoms. During the fifteen-kilometer stage-cart ride to Pont-Aven, Gauguin had time to marvel at the undulating countryside, checkered with wheat fields that converge on the cheerful town of water mills already so popular among painters, French and foreign alike. He alighted on the square in front of the town hall. Instead of staying at the Hôtel des Voyageurs (Julia Guillou, proprietress), the Hôtel de Bretagne, or the Lion d'Or—all of which were beyond his means—he took the advice of the Jobbé-Duvals and headed toward the Maison Gloanec, an unassuming boarding house just off the bridge over the Aven. He was given a hearty welcome by the ingenuous and prim Marie Lepape, one of three "domestics" in the employ of Marie-Jeanne Gloanec, a widow. His room on the third floor had a sloping ceiling. Gauguin later tried to lead the maidservant astray by insisting she pose nude for him. She was glad to be of service, but not at the expense of propriety.

Among the small but garrulous horde of painters sitting at wooden tables on the sidewalk, chatting and puffing on their pipes, were Gauguin and the Swedish painter Otto Hagborg, who was the brother of one of Mette's friends. "I managed to scrape together the money for my trip to Brittany," he wrote to his wife shortly thereafter, "and I live on credit. There's hardly a Frenchman, all foreigners, a man and two women from Denmark, the brother Hagborg, and lots of Americans. . . . We pay 75 francs a month at the hotel for room and board. The food fattens you up as you eat it."

So there he was, taking strolls around the immediate vicinity of the Maison Gloanec, sizing up this dank place where huge granite boulders litter the bed of the Aven as it rushes down from Rosporden and winds between age-old water mills. He made his way toward the

uplands of Lezaven and Bel-Air, lingered in hayfields or on the Lollichon farm, paused to watch local kids going for a dip around the rocks of Le Poche-Menu, and proceeded toward the Bois d'Amour. Taking out the little notebook he had bought in a bookstore back in Rouen, he made some hurried sketches of washerwomen on their knees, thatched cottages nestled in trees, geese, pigs, goats, sheep, Breton women carrying bread, and painters loitering on the low wall of the bridge.

"No one who ever saw Gauguin in his prime is likely to forget him," recalls the Scottish painter A. S. Hartrick in *A Painter's Pilgrimage Through Fifty Years*. "Tall, dark-haired and swarthy of skin, heavy of eyelid, . . . he dressed like a Breton fisherman in a blue jersey, and wore a beret jauntily on the side of his head. . . . In a manner he was self-contained and confident, silent and almost dour, though he could unbend and be quite charming when he liked. . . . Perhaps the most vivid memory I have of him is of a blazing hot day when I was painting . . . and I saw a boat rowed by two Bretons coming slowly up the river; . . . and just astern, Gauguin, naked save for a pair of slips, holding on to a rope, . . . evidently enjoying himself hugely."

Establishment painters reigned supreme in Pont-Aven at the time, and Gauguin had to brave the ill will of most of them. Hubert Vos, among others, did his best to hold him up to ridicule. Some of the younger ones, however, soon came under the spell of his baffling personality, his distinctive Japanese approach to composition, the way his paintings managed to be both Impressionistic and solid, frothy and profound, cheerful and nostalgic. One of them, Ferdinand Loyen de Puigaudeau, suggested they work together in a studio he was renting from Marie-Perrine Bergé, a member of the Lollichon family. Before long, other painters were gravitating to the Lollichons' delapidated country house in Lezaven: Achille Granchi-Taylor, sporting frock coat and wooden shoes; Charles Laval, a sickly architect's son who boasted Bonnat and Cormon as teachers; Emile Jourdan, always ready to hoist a few with Gauguin. Then there was Henri Delavallée, a source of detailed information about their hero's work and technique. (A schoolmate of his from the Académie des Beaux-Arts, the painter Hersart du Bouron, brought him to Pont-Aven and put him up in the Château du Plessis just above the village.)

First Steps toward Synthetism

"I was in front of the terrace of the [Maison] Gloanec when I saw Gauguin for the first time," wrote Delavallée. "He had a beret on his head and was carrying one of those easels you can work at standing up. I went toward him, and I recall that we talked about Degas and Pissarro, for whom he professed great admiration. In those days, his painting was very streaked and he was far more concerned about questions of technique than matters of doctrine. . . . 'I only paint with sable brushes,' he pointed out to me. 'The paint stays thicker that way. When you use ordinary brushes, two adjoining colors mingle; with sable brushes, you get juxtaposed colors.' Time and again you'd hear him talking about 'synthesis,' because this was a concept that intrigued him even then. Gauguin used to paint with tiny brushstrokes. . . . He laid on his colors as boldly as he could, but more than anything else he streaked them. He would prepare his canvases in the studio before going off to paint outdoors. First he put in the background, then roughed out the subject."

Delavallée found him exceedingly haughty, "a bit naive and quite mystifying, very much the dauber, very dry-witted." Was Gauguin pulling his leg, he wondered, when he assured them that his eyes had become frostbitten from all the sailing he had done in cold

weather? Well, one thing he did not suffer from was cold feet. As he took in the village, trying to find himself in its inhabitants, their children, and their animals, he simplified what he saw with increasing boldness.

Gauguin was proud and he let Mette know it. "I am working a great deal here and with favorable results. People respect me as the best painter in Pont-Aven. I am making a name for myself, and everyone here (Americans, Englishmen, Swedes, Frenchmen) is clamoring for my advice, which I am rather foolish to give." His most ardent admirer, Emile Schuffenecker, simply passed through Pont-Aven on his way to Concarneau. There he met young Emile Bernard, who shared his fascination with the medieval flavor of Breton garb and had set out on a walking tour of the region. Schuffenecker strongly recommended that he look up Gauguin. "The next day I was in Pont-Aven," Bernard later wrote. "I introduced myself to Monsieur Gauguin, who was surly toward me and seemed not to think as highly of his friend as his friend did of him."

A School of Art in the Making

The fifteenth of August was a holiday at Marie-Jeanne Gloanec's, and Gauguin presented her with a beautiful still life on a white tablecloth. That day he boasted to Mette that he "ruled the roost" in Pont-Aven. A month later, however, as summer wound down and the daubers packed up, the evenings, he found, began to drag on a bit. In early October, he notified his wife that he would be returning to Paris on the thirteenth to take up residence in "a little hovel" (rented by Schuffenecker) at 257 Rue Lecourbe, a stone's throw from Ernest Chaplet's ceramics studio on Rue Blomet. Having fetched his son Clovis, put him in a boarding school, and sold a small Jongkind for 350 francs, he rushed headlong into designing fifty-odd pieces of pottery for firing in Chaplet's kiln. "You shall protest vociferously when you see these monstrosities," he wrote to Félix Bracquemond in hopes he would help market them, "but I am confident that you will find them interesting." Alas, not only was Bracquemond unable to find buyers for the pictures he had brought back from Pont-Aven, but he could not generate any interest in Gauguin's pottery. Far too original and "barbaric" for the time, they were likened by dealers to "sailor's art." What Gauguin himself referred to as "these by-products of my wildest imagination" were too far ahead of the innovative designs of Art Nouveau.

As Gauguin languished in a hospital for days on end, recuperating from a bout of angina, he realized that he was in no position to take proper care of little Clovis. He had, as he put it, "made a fine mess of things." True, he could count on Guillaumin, Zandomeneghi, and Degas for friendship, support, and solace now that he had parted company with Pissarro and the Neo-Impressionists. Granted, he had made a name for himself among his small band of admirers in Pont-Aven, where for the first time the idea of founding a school of painting seemed practicable. ("There can be no denying he ended up exerting considerable influence," Pissarro grudgingly admitted in a letter to his son.) Still, nothing was going his way any more.

It came to the point that he hoped a war would break out. "I shall rejoice to see that day come and I'll not miss the chance to enlist," he confided to Mette in February, 1887. As Gauguin looked for some way out of the frigid, cheerless, hostile capital, his roving imagination began to drift toward places like Madagascar or a country his sister Marie had told him about, Panama. Out there, somewhere beyond the sea, fortune would smile on his boldness. He was groping for an escape route that might lead to the reprieve he so badly needed.

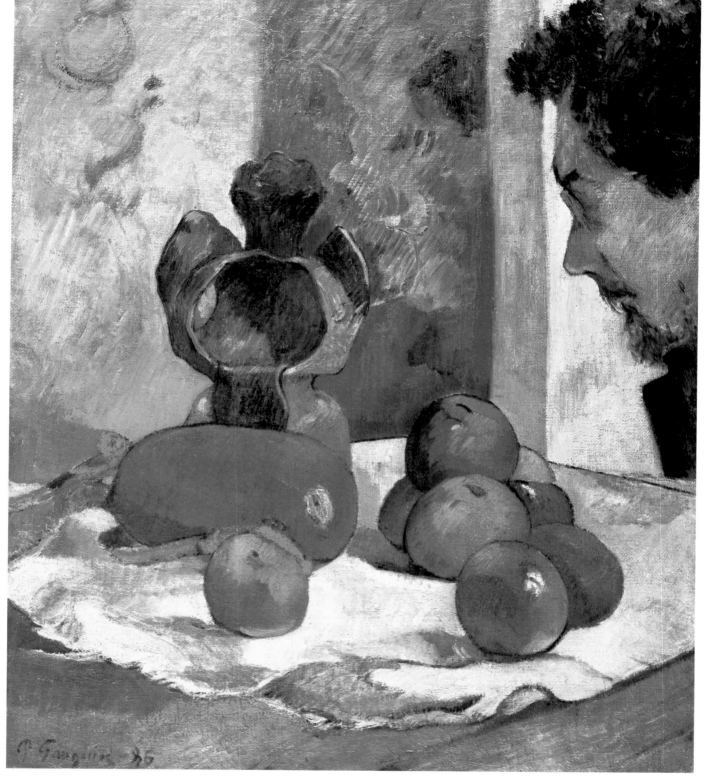

59. Gauguin. *Still Life with Profile of Charles Laval.* 1886

58. Gauguin. Sketch of the vase in *Still Life with Profile of Charles Laval.* 1887

A young, frail painter by the name of Charles Laval had already taken up residence in Pont-Aven when Gauguin arrived in the middle of July, 1886. The older artist and the twenty-five-year-old pupil of Bonnat and Cormon hit it off right away. In this picture, Gauguin shows him scrutinizing one of the first pieces of pottery turned out in the studio of Ernest Chaplet, a ceramist he had met through Félix Bracquemond early that summer. Inspired by Pre-Columbian vessels, this curious vase, seen here next to some Cézannesque apples, was Gauguin's earliest attempt at a primitive style and, hence, one of his prize possessions. "Did you take a pot I made?" he asked his wife in December, 1887. "Take special care of it for me; I treasure it."

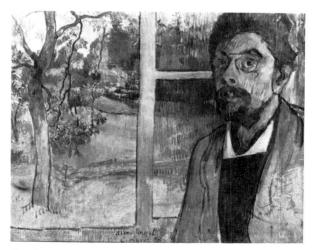

60. Charles Laval. *Self-Portrait* (dedicated to Vincent van Gogh). 1888

45

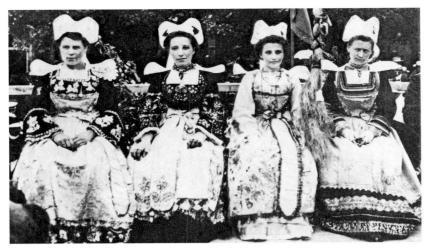

61. Costumes for the Pardon (Breton processional pilgrimage) at Pont-Aven

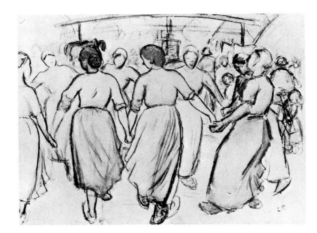

62. Camille Pissarro. *Roundelay.* c. 1884

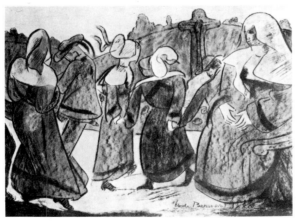

63. Emile Bernard. *Breton Roundelay.* 1888

The title often given this charming picture is misleading, for this "Breton dance" is simply a group of peasant women huddled at a low wall and, in the background, some geese and a lone farmer wearing a hat. Here Gauguin's shift toward Synthetism is unmistakable. Although blurred contours and vibrant colors awash in light suggest a continuing allegiance to Impressionism, he was moving toward cleaner lines (as Pissarro had already done in his Roundelay, and which Emile Bernard took further still). The crisply defined coiffes (headdresses), faces, collars, and arm movements would soon evolve into a decided and generalized preference for broad, heavily outlined areas of flat, unmodulated color. The horizon has been eliminated and the composition foreshortened, both effects reminiscent of how Hokusai (a favorite of Bracquemond) and other Japanese artists tended to reduce their subjects to essentials. "Thank God, I am making headway each and every day," he wrote to Mette on August 15. From now on Gauguin was bent on developing a more distinctive, more subjective approach that would set him apart from the crowd.

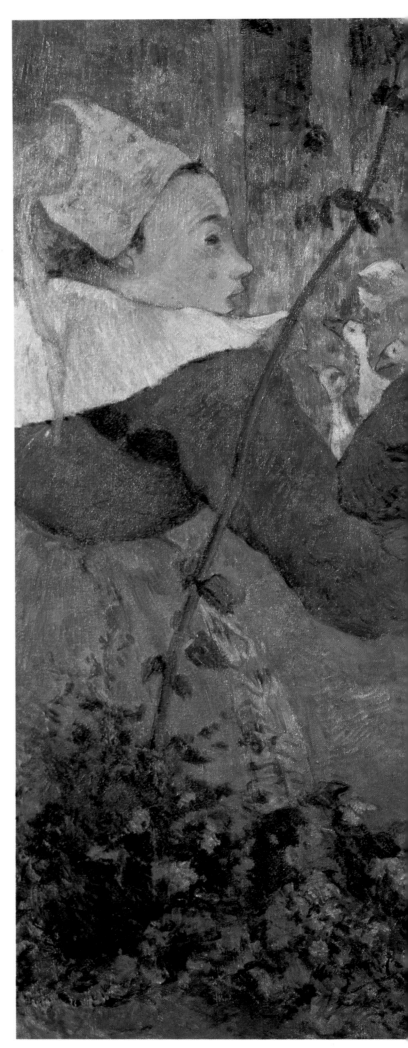

64. Gauguin. *Breton Peasant Women.* c. 1886

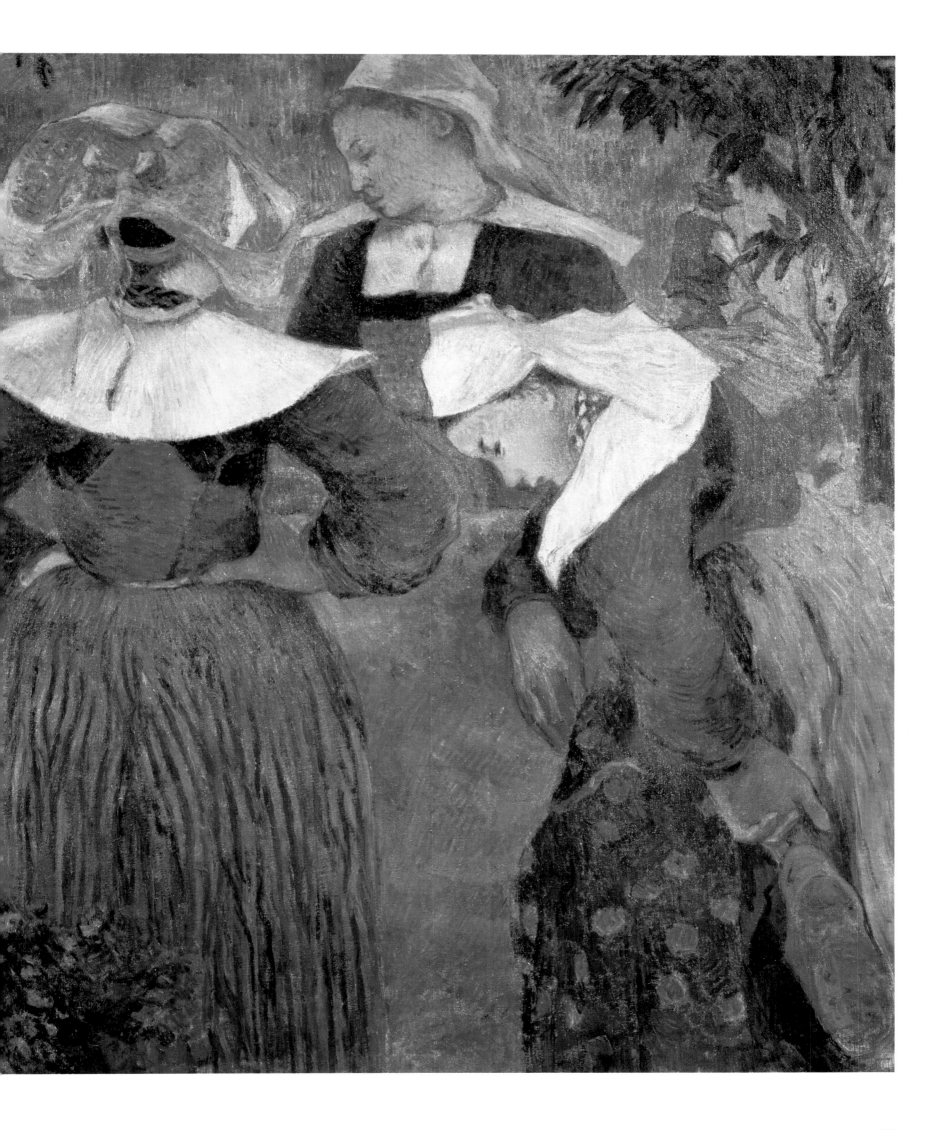

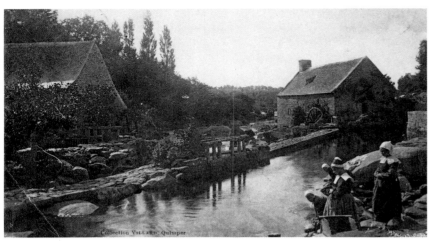

65. Women washing clothes in the Aven, Pont-Aven

I n the "synthetist notes" he jotted down on the opening pages of his sketchbook, Gauguin stressed how important it was for painting to have a balanced, musical quality. "The sense of the colorist is precisely the harmony of nature," he writes, decrying the "dull note" which results from "mingling of colors." Gauguin was attuned to the harmonious relationship between the inhabitants of Pont-Aven, their dwellings of granite and thatch, their animals, and the verdant countryside around them. To his ear, the sound of his wooden shoes against the rocks was "the dull, muffled, powerful tone I seek in my painting."

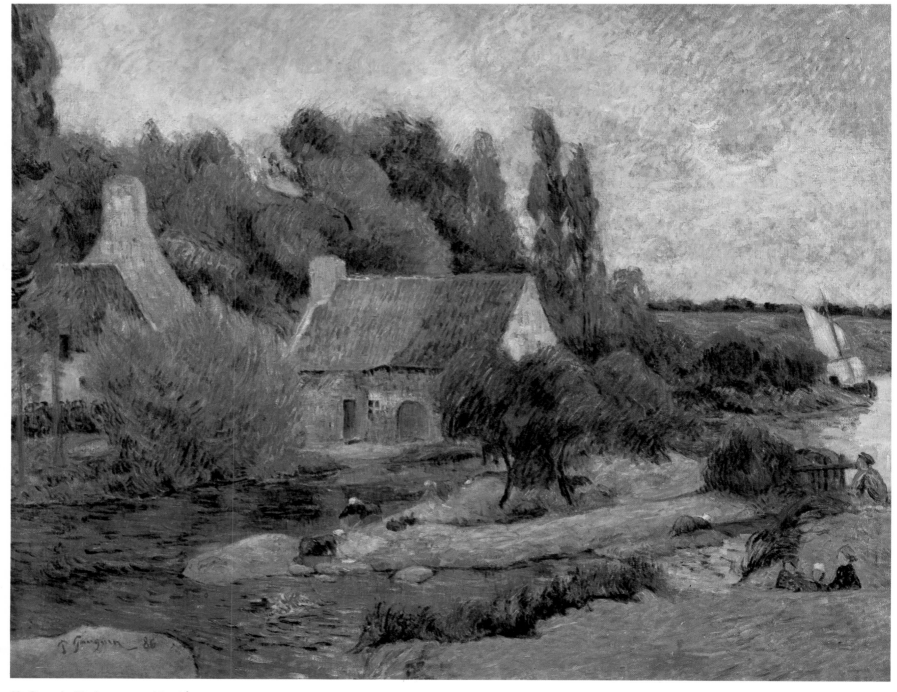

66. Gauguin. *Washerwomen at Pont-Aven.* 1886

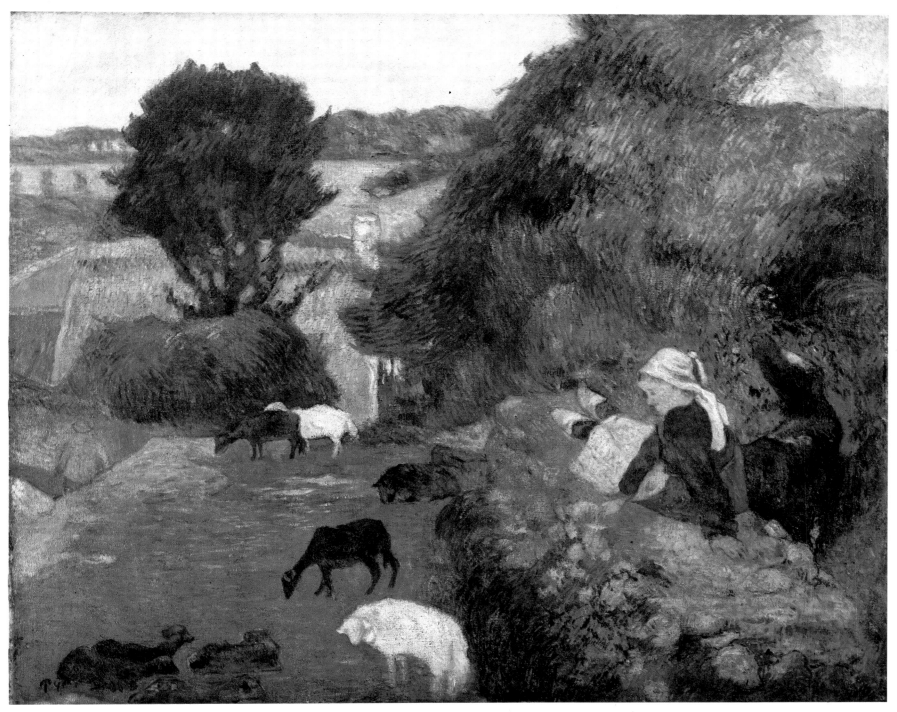

67. Gauguin. *Breton Shepherdess.* 1886

B
ased on sketches Gauguin made of kneeling washerwomen, languid shepherdesses, pigs, sheep, and goats at rest, and thatched cottages glimpsed through foliage, these two landscapes reflect the harmonious tranquility of life in Pont-Aven. Not far from the Maison Gloanec stood the Ty Meur mill, the last water mill on the Aven before the river emptied at Gargantua Rock and into the harbor. In this setting he came to the conclusion that "above man there is nature" and that "thought is a slave to sensation." For Gauguin, painting was "the most beautiful of all the arts," for it allowed "the deepest memories to flood [his] soul," those from within as well as of Brittany.

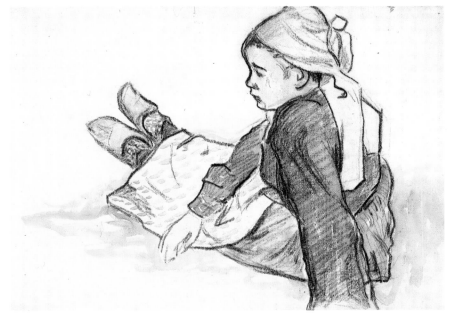

68. Gauguin. *Little Breton Girl Seated.* 1886

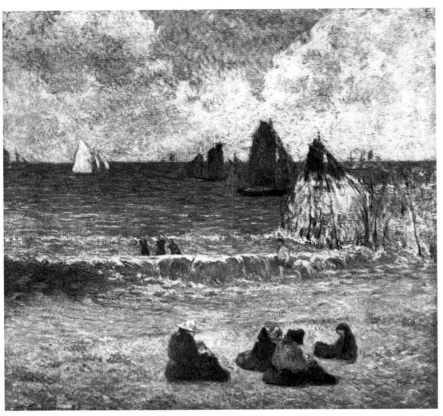

69. Gauguin. *The Beach at Dieppe.* 1885

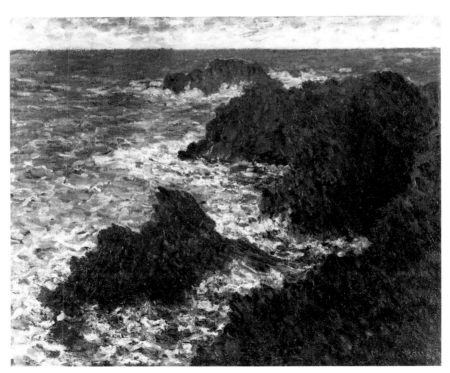

70. Claude Monet. *Rocks at Belle-Ile, Port Domois.* 1886

U ncanny coincidences; similarities, too. Despite their
mutual dislike—or was it incompatibility of temperament?—
Gauguin and Monet were both drawn to Brittany in 1886,
both moved by the wild beauty of its coastline and crashing
waves. Gauguin spent most of the summer in Pont-Aven and
Port-Manech and, thanks to Captain Jacob, a customs official,
discovered Le Pouldu; Monet's stint on Belle-Isle-en-Mer did not
begin until September 12, when he landed at the port of

Le Palais. "I had gotten into the habit of painting the English
Channel and inevitably fell into a pattern," Monet wrote to his friend
Caillebotte. "But the ocean is something else entirely." He was as
far removed from the soothing Norman atmosphere of Honfleur and
Etretat as Gauguin was from the seaside resort of Dieppe, where he
had spent part of the summer of 1885. Monet fought against the
elements to wrest the "impression" they made on him; he "darkened"
his palette to "capture this sinister, tragic presence." Gauguin,

71. Gauguin. *Rocks by the Sea.* 1886

*however, spontaneously succumbed to fantasy, to the delight of
finally visiting a place where spirits roamed and of letting his
imagination run away with him. Already he was looking ahead to
places more exotic than Brittany and he tried to presuade a young
admirer of his, Charles Laval, to join him on a quest for a new kind of
painting. During his first Pont-Aven period, Gauguin was far more
interested in the pastoral scenery and peasant folkways of Finistère
than in its jagged coastline and the sea beyond.*

51

3
Adventure in Martinique

June–September 1887

73. Coastline at Le Carbet, Martinique

"**W**hat I want most of all is to get out of Paris, which is a wilderness for a poor man. My reputation as an artist is growing every day, but in the meantime I sometimes go three days without eating, which undermines not only my health, but my *energy*.... This I intend to restore, and I am off to Panama to live like a *savage*. I know of a little island (Taboga) in the Pacific, a mile off the coast of Panama; it is almost uninhabited, open, and fertile. I am taking my paints and brushes with me, and I shall immerse myself [in nature] far from everyone."

In late March, 1887, Gauguin made it clear to Mette that his decision was irrevocable when he asked her to come to Paris for their son Clovis and to give him a farewell kiss before leaving for America. His motives were twofold and contradictory. On the one hand, by getting back on his feet, he hoped to regain Mette's good will and win back both her and the children. On the other hand, he sought isolation among "noble savages" whose primitive folkways and carefree, accommodating manner—so often mentioned by Pissarro, a native of the Danish West Indies—might breathe new vitality into his art. Despite his first stint in Brittany and the imaginative pottery he had produced with Chaplet, Gauguin could not bring himself to sever his ties to the self-serving Impressionist clique that still overshadowed his work.

But how could objectives so incompatible, so diametrically opposed, be achieved and turned to advantage? Whatever the cost, he had to brush aside his cares, make a clean

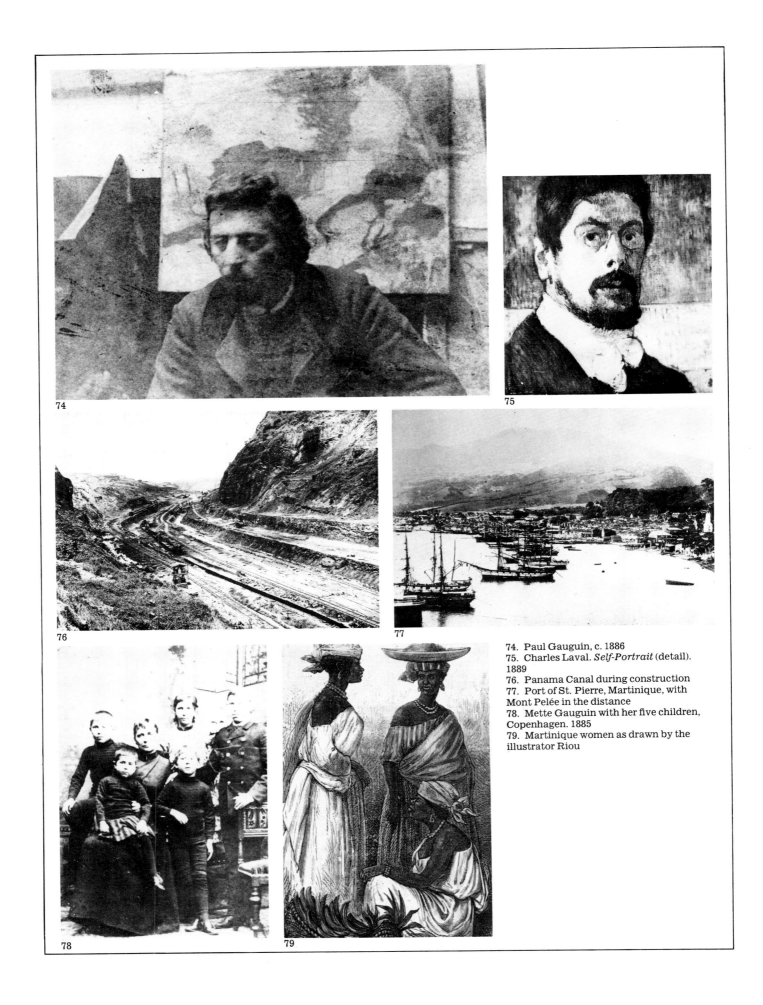

74. Paul Gauguin, c. 1886
75. Charles Laval. *Self-Portrait* (detail).
1889
76. Panama Canal during construction
77. Port of St. Pierre, Martinique, with
Mont Pelée in the distance
78. Mette Gauguin with her five children,
Copenhagen. 1885
79. Martinique women as drawn by the
illustrator Riou

break of it, and, come what may, press on toward milder climes and vividly colored lands—"open and fertile"—and settle down in a Garden of Eden of his very own. It so happens that Taboga, the island that had captivated Gauguin during a stopover on the *Chili* in 1867, lies just off Panama. Investors and adventurers alike were beating a path to the region because the Compagnie Universelle du Canal Interocéanique was cutting through the isthmus at the time. As luck would have it, Panama had, for the past year, been home to his brother-in-law, a merchant from Colombia. Notwithstanding the poor opinion Paul's sister had of him, he felt confident that Juan Uribe would be willing to help him out, especially as Marie was still in France. He would suggest that they go in together on a business venture in Madagascar that he had recently gotten wind of and had been approached about. "By the bye, I am toying with another idea," he wrote to Mette, "and this one's a sure thing. They've made me a splendid proposition."

Tragic Setback in Panama

Armed with his trusty brushes, fresh canvases, and paints (with ultramarine blue predominating), our starving Don Quixote sallied forth. The Sancho Panza at his side was the scrawny, idle, nimble-witted Charles Laval, whom Gauguin had trained near the mills of Pont-Aven. His youthful disciple informed Puigaudeau that out there they would "let the future take care of itself" and "lead the most sensible and most wholesome life imaginable."

Unfortunately, they could not foresee the worsening economic and political straits of the Canal Company, which was about to lay off a good many employees; nor the repercussions on his brother-in-law, who made them feel anything but welcome; nor that the region was highly susceptible to epidemics of yellow fever and outbreaks of malaria and dysentery so devastating that Canal Company officials were compelled to convert the island of Taboga into a special recovery zone and health retreat. This, in turn, spurred locals to put a higher price on their land—and apathy. Last but not least, they overestimated the delicate constitution of young Charles Laval.

They boarded the French steamer *Canada* at Saint-Nazaire on April 10. After weathering rough seas and the overcrowded conditions of third-class travel, they got a fleeting glimpse of the "delectable" life of the West Indies during stopovers in Guadeloupe and Fort-de-France. They disembarked at the Atlantic port of Colón on the 30th; a three-hour train ride later they were in Panama City, on the Pacific coast. Disaster and disappointment awaited them there.

Uribe proved a tightfisted host. The cost of living on Taboga was so high that they had to rule it out completely. To their dismay, they found the Colombians living in Panama insufferable and the police even more unrelenting than the mosquitos. Without further ado, our two heroes backtracked to Colón, where Gauguin got a job with the Department of Public Works, only to be discharged two weeks later. By early May, he was sounding the alarm to his wife and Schuffenecker: he would need money to slip away to Martinique, a "wonderful land where an artist can keep busy and life is cheap and easy and people are friendly." Always a dream in the wake of setbacks. "Our trip has been handled as stupidly as possible and we are, as they say, cleaned out. The devil take all of those people who misinform you!" The devil nearly did take Charles Laval. Just when Bonnat's former pupil had received commissions from a few prominent citizens and was about to generate some income, yellow fever laid him low. He even attempted suicide. However, under

Gauguin's care—Pissarro had turned him into a homeopathy enthusiast—Laval somehow managed to get up and about.

So they sailed to Martinique aboard the *Amérique* and went ashore at the bay of St. Pierre on June 11, still feverish and proud of the way they had come through in the face of adversity. Like a cast of falcons fresh from the charnel house (their own simile), they swooped down on the smiling shores of the "Pearl of the Caribbean," spread out like a magnificent natural amphitheater, its gloomy Fujiyama, Mont Pelée, brooding overhead.

Temptations of the Flesh

After making inquiries in St. Pierre and locating an obliging correspondent in a Monsieur Victor Casimir, 130 Rue Victor Hugo, they went off posthaste into the country, spurred by privation and their irresistible urge to paint. Perhaps they would find a simple little *case à nègres* for rent on a fruit plantation. "The first town you come to as you head south from St. Pierre is Le Carbet," Garaud tells us in *Trois ans à la Martinique*. "The footpath connecting them winds along the coast, cuts through greenery, and is then swallowed up by rocks only to re-emerge on the beach. From morning on, it comes alive with local women from Le Carbet, loping toward St. Pierre to get an early start on selling the coconut milk the Creoles consider such a treat. . . . Beneath the coconut palms I can make out an occasional hut in the gloom; large nets drying on stakes, . . . boats pulled up onto the sand; fishermen pushing a dinghy into the sea. Spellbound, I wonder if this mightn't be Robinson Crusoe's island and these, the savages from whom Friday made his miraculous escape."

With a cluster of accommodating "pickaninnies" in tow, our Crusoe—how pleased he was to have women smiling at him at last, if only in jest—and his gaunt Friday came across a hut to their liking upriver from this village of fishermen and fruit-gatherers. More than anything else, it suited their empty pocketbook.

So many sketches, pastel drawings, and watercolors to turn out right away! So many sun-drenched or shady colors to pick, so many island women to outmaneuver, so many temptations within easy reach! "For the time being," Gauguin wrote to Schuffenecker, "I am confining myself to drawing sketch after sketch to let their character sink in, then I'll have them pose for me." "It's not easy for a white man to hold on to his virtue here," he wrote his wife, "for Potiphar's wives are not lacking. Nearly all of them are dark-skinned, from ebony to dusky white. They go so far as to cast spells over fruit, which they then offer in order to snare you. The day before yesterday, a young Negress of sixteen (pretty, upon my word) offered me a guava that she had split open and squeezed against her nipples. The young girl left, and I was about to eat the fruit when a sallow lawyer who happened to be there snatched it from my hands and threw it away. 'You, sir, are a European and do not know this country,' he said to me. 'You must not eat fruit unless you know where it comes from. This piece, for example, has a spell cast over it; the Negress crushed it against her bosom, so she would certainly have had her way with you later on.' Now that I have been forewarned, I shall not go astray, and you can rest easy about my virtue. I really do hope to see you here one day with the children."

Did Mette really believe him, what with his taking so long to answer her letters? Rumor still has it that Gauguin left some indiscreet chips off the old block scattered about Le Carbet. Night in the West Indies is a time when you can hear plants sighing, when animals shatter the calm with cries so unsettling that Paul and his sidekick would have had

to be paragons of virtue not to join in. Although his emaciated face indicated the toll tuberculosis was taking on him, Laval must have found contentment there. After Gauguin left, he stayed behind a few months to finish his pictures of the swaying models his teacher had shown him how to sketch.

Gauguin was happy there. His paintings became attuned to the sun-drenched coastal scenery around him, cooled at regular intervals by downpours in the rainy season. The domestic and pastoral scenes he stumbled upon, then paused to paint, are astir with the rustling foliage and island merriment around his hut. He took pleasure in teaching his receptive pupil how to take complete command of their lush, soothing, tropical surroundings. "From then on," notes René Huyghe, "his colors become increasingly decisive, intense, violent, never faint, never fitful. This undercurrent of earnestness continued to widen the gulf between him and Impressionist sprightliness."

We do indeed notice a shift in manner. Increasingly preoccupied with stylizing both form and gesture, Gauguin had begun to transcend the fragmented approach of Impressionist painting. The fact that the shapely contours of island women recalled their counterparts in Japanese prints made the transition that much smoother.

What rotten luck to take sick! No two ways about it: he was under some kind of jinx. A serious, persistent case of anemia was but the prelude to malaria, dysentery, and severe hepatitis. For almost an entire month he was at death's door, or so he thought at the time.

"I was far gone and ready to die every night, but I finally rallied," he wrote to Mette about August 25. "But my stomach problems have been sheer torture. Now I get excruciating pain in my liver from what little I eat. Just writing to you is a strain; my mind is becoming unhinged. As you can guess, the last of our money has gone to medicine and visits to the doctor. He says that it is absolutely essential for me to return to France."

Bad Luck and Hope

The shattering realization began to sink in: his ill-conceived escapade had been an undeniable failure, and he was sapped by disease. A few short weeks earlier, he was looking forward to the day he would purchase a plot of land in Martinique and settle down to a "pleasant life" with his reunited family. Now Gauguin was having serious doubts whether his marriage would survive at all. "Oh, my poor Mette, if only I were dead; it would all be over. Your letters give me pleasure and yet they cause me distress that I find overwhelming just now. At least if we hated each other—*hatred toughens*—but you are starting to feel the need for a husband precisely when that cannot be. . . ." Only now did all of the letters Mette sent to Panama reach him, and they implied that she would have gladly gone with him. Too late! But could she have in any event?

The doctor in St. Pierre gave him strict orders to go back to France. Besides, how could he stay here any longer with nothing to live on? Laval was expecting financial assistance from his family, but it was slow in coming. The fact that mail took so long to reach them only heightened their anxiety. Schuffenecker had promised Gauguin 250 francs, but all he had received thus far was 56 francs forwarded to Colón after they had left Panama behind. Little matter: the sum would not have been enough to settle his debts and book passage on a regularly scheduled steamer. Therefore, he took preliminary steps to get the administration to repatriate him. Writing on some old stationery with the letterhead "Dillies and Co., Makers of Waterproof and Rotproof Tarpaulins"—left over from the days when he was the firm's Scandinavian representative—he grumbled to his old chum, Antoine

Favre, about his self-centeredness. But in the very same letter he informs him that "back in France I've got *backing* for a venture *in pottery* that would get me out of the woods for evermore." To escape, to "block out" his money woes, he always projected himself into the future, building castles in Spain with a vengeance, their battlements shimmering in the radiance of his wildly exaggerated expectations. "I feel that with ceramics I'll recover, and *I'll have my painting to boot,*" he declared to Schuffenecker.

<div align="right">

Return to France

</div>

Gauguin did not leave Martinique without attempting, *in extremis,* to make the best of a stint he refused to write off as a complete failure. "I'm hobbling about well enough to make up for lost time and paint a few decent pictures. I'll bring back ten [crossed out] twelve or so paintings, including four with figures far superior to my Pont-Aven days." Parisians had only to sit tight. "What I'm bringing back has real bite to it; despite my weakened condition, my painting has never been so clear, so lucid (lots of imagination, for one thing)."

His ship of dreams may have taken on water on all sides, but not everything was rotten—except, perhaps, in the state of Denmark, where Mette was cooling her heels. The paintings of Gauguin now echoed his song of the islands, never to be forgotten from that time forward! By the middle of November, he was on his way back to France as an excess passenger, just as his grandmother, Flora Tristan, had been in 1833 when she boarded a windjammer in Bordeaux for Peru. And one day the Schuffeneckers at 29 Rue Boulard found Gauguin outside their door—handkerchief to his nose—suffering from a nasty cold.

Snow was falling on Paris. Gauguin held his head high. He may not have had a penny to his name, but somehow he felt freer: he had given his teachers the slip.

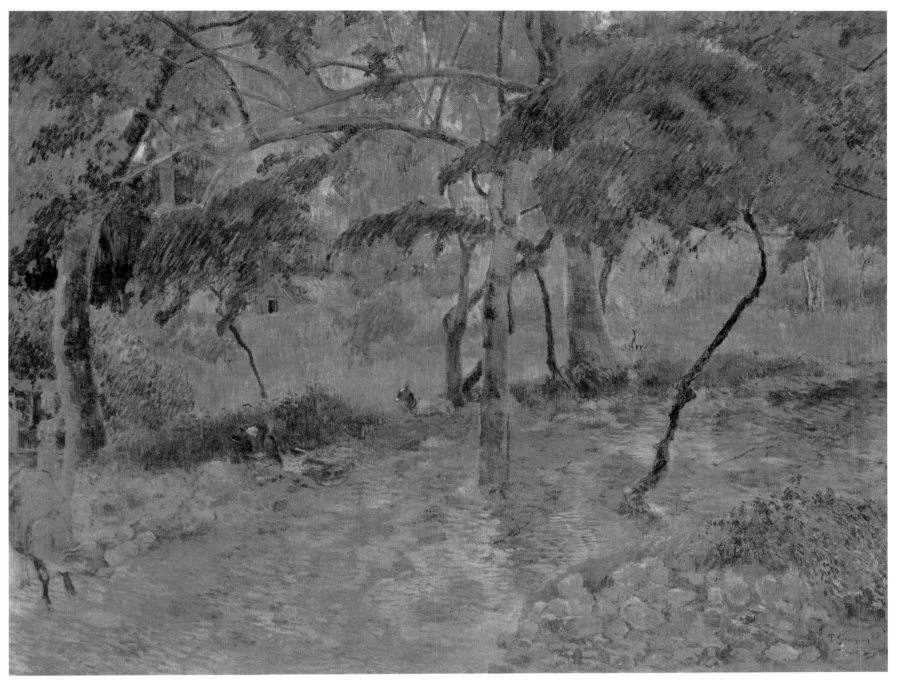

80. Gauguin. *The Pond*. 1887

Camille Pissarro, whose father ran a little general store on St. Thomas, must have spoken to Gauguin about his childhood and youth on this pristine island in the Danish West Indies. Moreover, Gauguin may have had occasion to examine the many drawings dating from this period of his life, those earliest Caribbean landscapes that put Pissarro on the path to Impressionism. We might even ask ourselves if, paradoxically, it was to break away from Pissarro's decisive influence once and for all that Gauguin stopped over in Martinique; that what urged him on was to complete the circle and transcend his teacher on his home turf. And so he did: the rich spectrum he summoned forth to capture the intense tropical light filtering through dense volcanic growth is his and his alone. Now that our "pilgrim" was removed from his usual element, and despite (or because of) his sudden attacks of malaria, Gauguin was on the road to self-discovery. He laid siege to those glowing colors over which he ultimately triumphed in Tahiti. The hamlet of huts that made up Le Carbet, the humble fishermen, the farmers tending their little plots of earth, their primitive way of life, the primordial surroundings—everything provided his art with fresh sources of inspiration.

81. Farmers' huts, Martinique

82. Katsushika Hokusai. *Hodogaya on the Tōkaidō*. 1825–32

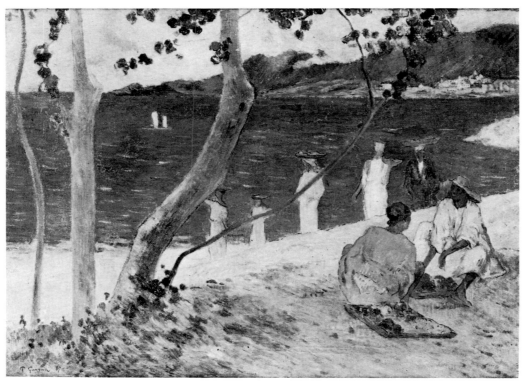

83. Gauguin. *Seashore at Martinique*. 1887

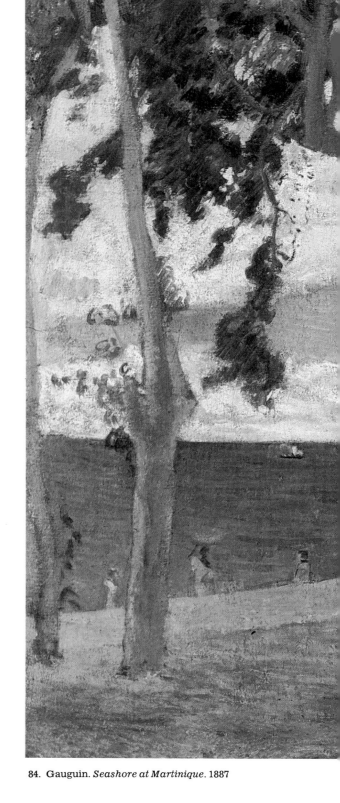

84. Gauguin. *Seashore at Martinique*. 1887

I n these paintings from Martinique we see two different views of the beach skirting the cove of Le Carbet, with the foot of Mont Pelée beyond. No sooner had Gauguin and Laval left Panama and landed at St. Pierre than they found a hut for rent on a fruit plantation. "We have settled into a case à nègres," he wrote Mette Gauguin, "and it is heaven compared to the isthmus. Below us, the sea fringed with coconut palms; above, fruit trees of every variety, and we are twenty-five kilometers from town. Island men and women mill about all day long with their Creole songs and incessant chatter.... The lushest surroundings imaginable, a sultry climate but with cool

spells." Heat and coolness mingled—the same could be said of these uncongested compositions filtered through curtains of trees in a manner reminiscent of Pissarro or the prints of Hokusai. As early as 1860, a number of Western artists had begun arranging pictorial space in a Japanese fashion, giving the onlooker an enticing glimpse of a distant scene—in this case, the sea, some sailboats, and the foot of the volcano—through a foreground latticework of silhouettes and tree trunks. Although the mood here is more indolent than genuinely exotic, how beguiling these landscapes are!

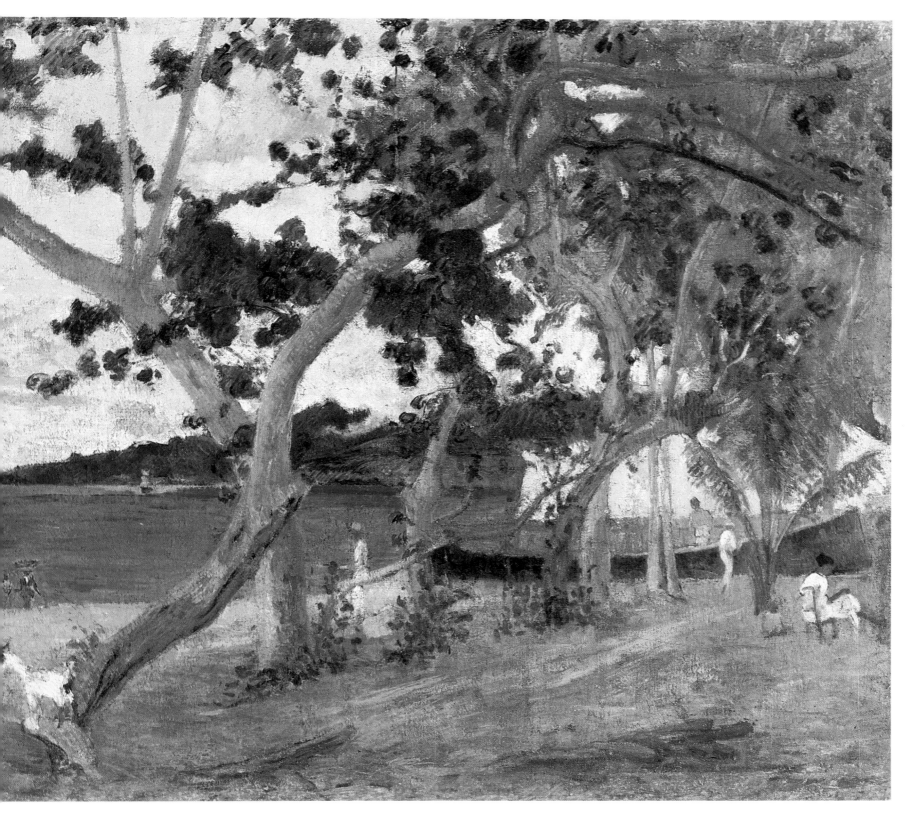

85. Camille Pissarro. *Coconut Palms by the Sea, St. Thomas.* 1856

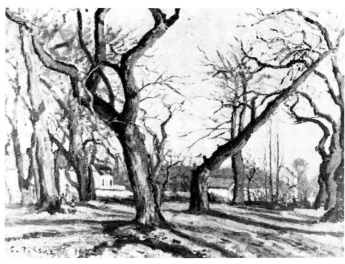

86. Camille Pissarro. *Chestnut Trees at Louveciennes.* 1872

61

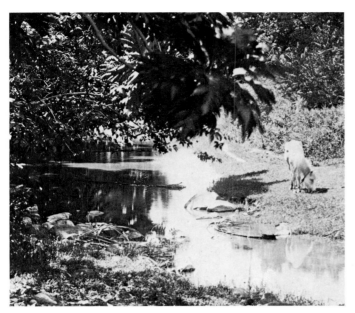

Gauguin painted this, one of the purest landscapes from his Martinique period, along the ridge road leading from Le Carbet to St. Pierre. Here, after climbing to reach the spot, he communed with the multicolored hues of the paradise around him. Two slender branches, straight and parallel, shoot up from a papaw tree, then fan out and bear fruit high above the ground. The snowy whiteness of the sky brings out even more the ultramarine of the bay peeking out at us through broadly rendered expanses of shrubbery. The color of the ground is closer to violet than to orange or faded pink. Gauguin was partial to this evocative tone that lies between mysterious blue and the red of the sun; it recurs in the shady scene the artist exchanged for a study by Van Gogh. This is how he described it in a letter to his sister: "It is a dry river bed with violet-colored mud and stagnant pools of water that reflect a sky of pure cobalt blue; green grass, a pickaninny with a red and white cow, a Negress in blue...." An intimist scene of consummate naiveté that delighted the Van Goghs and marked the beginning of their friendship with him.

87. River in Martinique

88. Gauguin. *By the Pond.* 1887

89. Gauguin. *Tropical Landscape*. 1887

91. Gauguin. Pot in the shape of a Martinique head

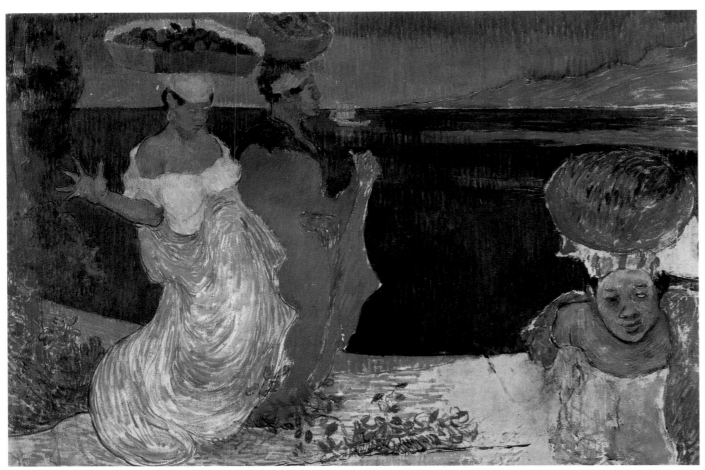

90. Charles Laval. *Landscape, Martinique.* 1887

92. Gauguin. Paintbrush stand. 1887

P issarro's chief objective was to reproduce faithfully the impressions created by nature. He had begun by studying the common people of the West Indies and Venezuela, then, like Millet, turned his attention to peasant life on the outskirts of Pontoise. Gauguin learned his lesson well and passed it on to his youthful companion in misfortune, Charles Laval. "The past three weeks we have been on Martinique, land of Creole gods," he wrote to Schuffenecker. "Below us, the sea and a sandy beach for bathing, on either side coconut palms and other fruit trees for a landscape painter to feast his eyes on. The thing I'm most taken with are human figures. Every day brings a ceaseless coming and going of island women decked out in colorful faded finery, with their endless variety of graceful movements.... They chatter constantly, all the while carrying heavy loads on their heads. Their gestures are quite distinctive, and the movement of their hands keeps time with their swaying hips." Laval mentioned to Puigaudeau that "the endless variety of picturesque subjects the natives provide us with leaves nothing to be desired." At times, we see strings of lithe West Indian women, hips swaying as they carry basketsful of mangos on their heads; elsewhere we see them prattling away on the ground: alternately sprightly and listless, now slaves, now goddesses, "grasshoppers" one moment and "ants" the next. Gauguin often alluded to this title from La Fontaine and later carved it into a wood relief he made for Marie Henry's inn in Le Pouldu.

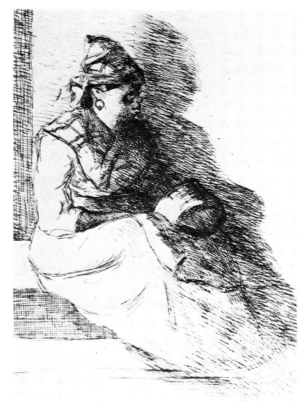

93. Camille Pissarro. *Negress.* 1867

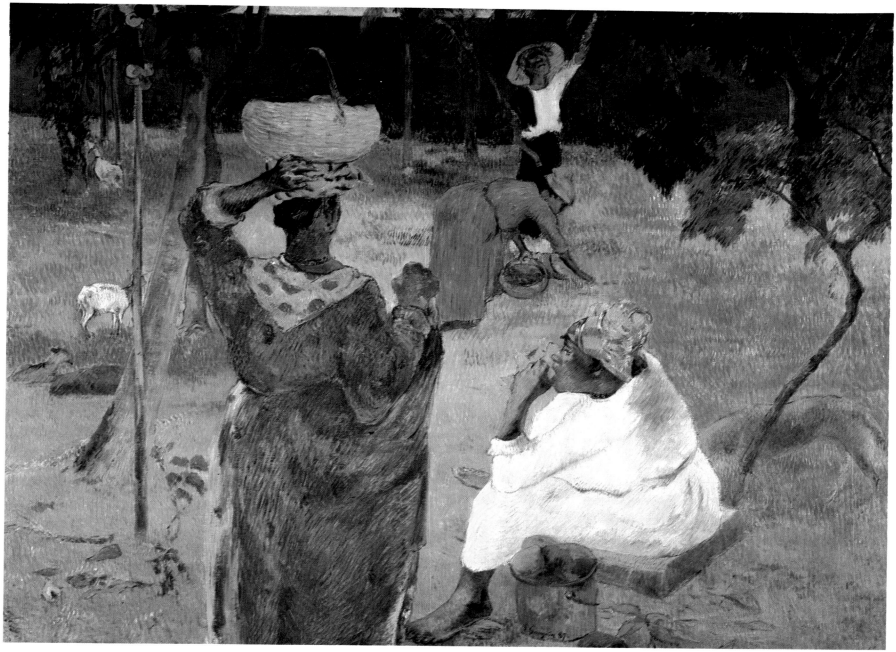

94. Gauguin. *Picking Mangoes*. 1887

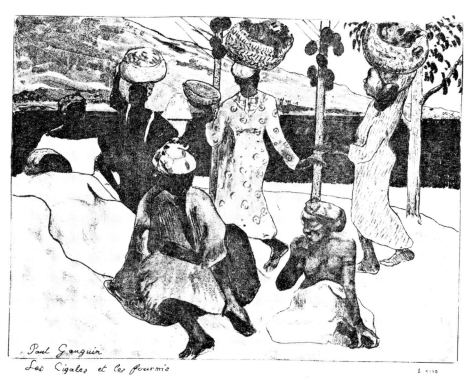

95. Gauvuin. *Martinique Pastoral ("The Cricket and the Ant")*

96. Jean-François Millet. *Peasant Girl Seated by a Haystack*. c. 1853

97. Toyokuni. *Sawamura Sōjurō III*. c. 1798

98. Gauguin. *Self-Portrait with Halo*. 1889

99. Gauguin. *Martinique*

"I whittled with a knife and carved daggar handles: all kinds of little fancies grownups could not make heads or tails of. A little old woman who was a friend of ours exclaimed admiringly, 'He will be a great sculptor.'" Thus Gauguin recalls in Avant et Après *his "second" childhood in Orléans after spending the first few years of his life in Peru. Dreams both young and old came back to him as he lay incapacitated by dysentery in Martinique. He took up carving again and mulled over the subjects he would turn into pottery once he was back in France. Here, in the West Indies, his childhood fantasies were most vividly recalled: reminders of Peruvian sculpture and pottery (some of which his mother brought back to France), wistful memories of his dark-complexioned governesses in Lima. When he returned to Brittany, he carved* Be in Love and You Will Be Happy. *"It's the best and strangest thing I've done," he declared in a letter to Emile Bernard. "Gauguin (like a monster) clutches the hand of a woman who is resisting, saying to her: Be in love and you will be happy. The fox, an Indian symbol of perversity, then small figures in the interstices." The curving line of a capital A—the beginning of everything—separates the sleeping monster sucking his thumb (upper right) from a buxom "Negress." ("Everyone knows I like women when they are fat and skittish," he notes in* Avant et Après.) *He tries to grab her arm with his right hand, but she holds back. Modeled after a Peruvian mummy in the Musée de l'Homme, the woman behind the shaggy fox awaits the hour of her death. In a self-portrait (1889) inspired by a Japanese print, Gauguin assumes the role of a saint or deity with a snake between his fingers.*

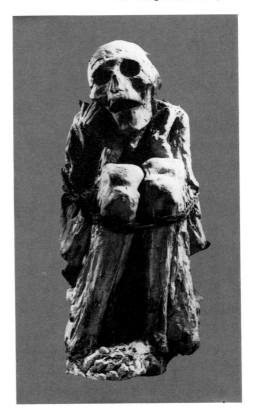

100. Peruvian mummy

101. Gauguin. Sketch of a fox

66

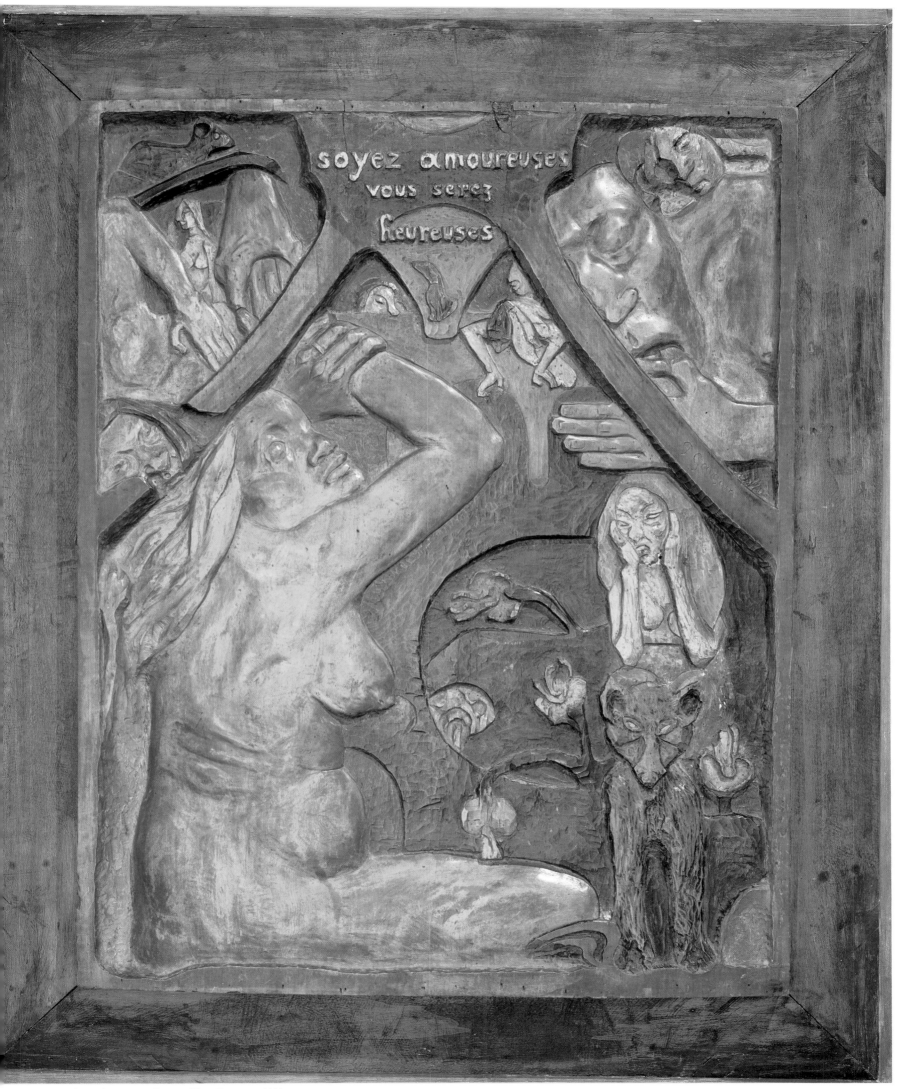

102. Gauguin. *Be in Love and You Will Be Happy*. c. 1889

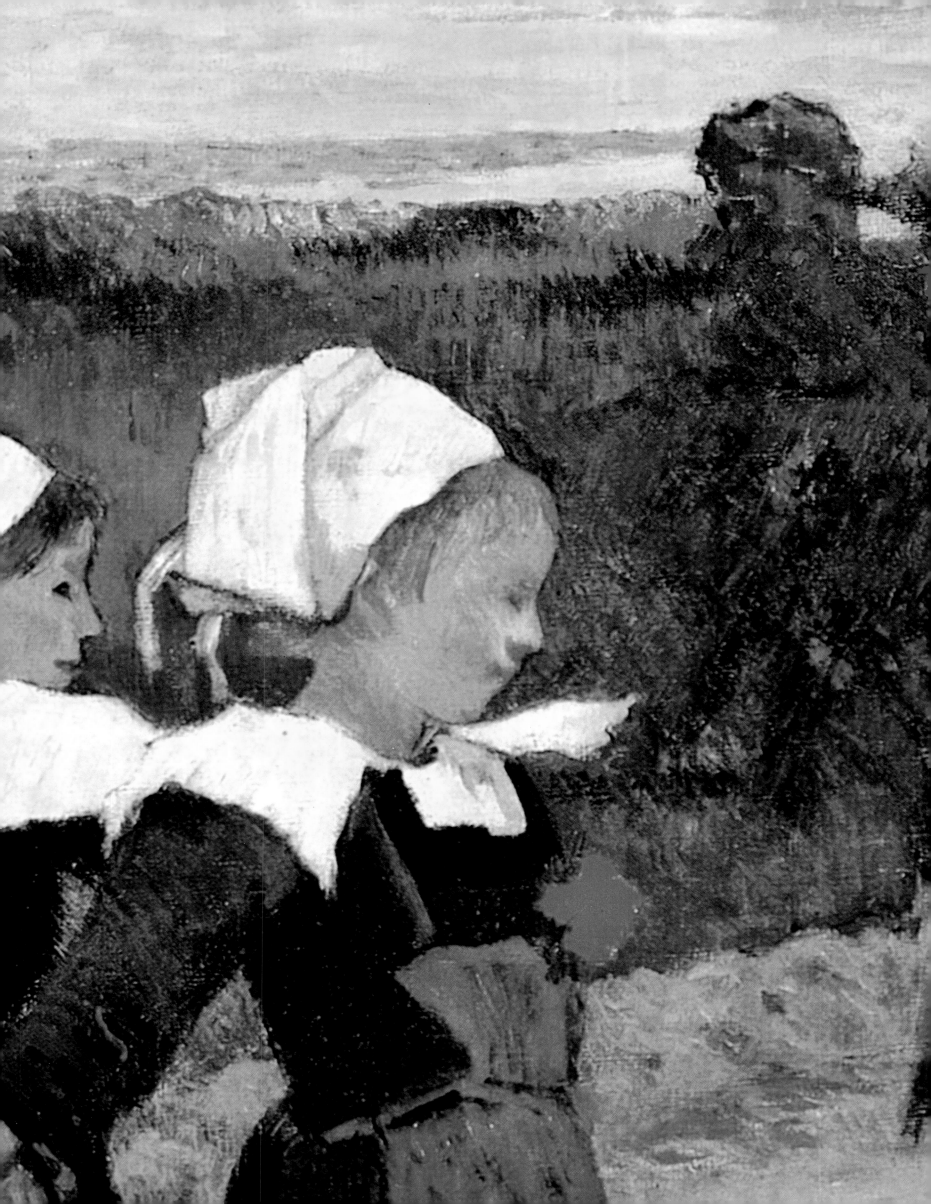

4
Pont-Aven: Gateway to Symbolism

November 1887–October 1888

104. Breton girl in traditional headdress of Pont-Aven

The letdown and nostalgia a person experiences when he comes home from exotic places can turn to deep mental distress if illness and idleness are all he has to look forward to. What rude awakenings awaited the shortsighted Gauguin! Our grasshopper had grown hoarse singing all summer long; now utterly destitute, he was back on the streets of Paris with "ants" swarming all around him.

The Schuffeneckers were kind enough to take him in and did what they could to treat his dysentery. On November 24, 1887, twelve days after his return from Martinique, he took stock of his predicament in a guilt-ridden letter to his peeved wife. "You seem to think that if I am not earning money, it's because I choose not to do so, that I'm not making the slightest effort to find some way out. . . . An artist's duty is to work so that he can become good. This duty I have fulfilled: everything I've brought back [from Martinique] wins nothing but admiration, yet it doesn't seem to get me anywhere."

He went posthaste to Chaplet's, only to learn that the ceramist he once considered a "man of genius," the man on whom he had pinned his hopes of making a living from pottery, had just leased his Rue Blomet studio and set up a porcelain studio elsewhere. Off Gauguin went to see Bouillot, but the sculptor had no need for him. Perhaps Bracquemond might find a way to dispose of the work he had brought back from the West Indies! In the meantime, as scrupulous as ever about honoring his debts, he was again compelled to part

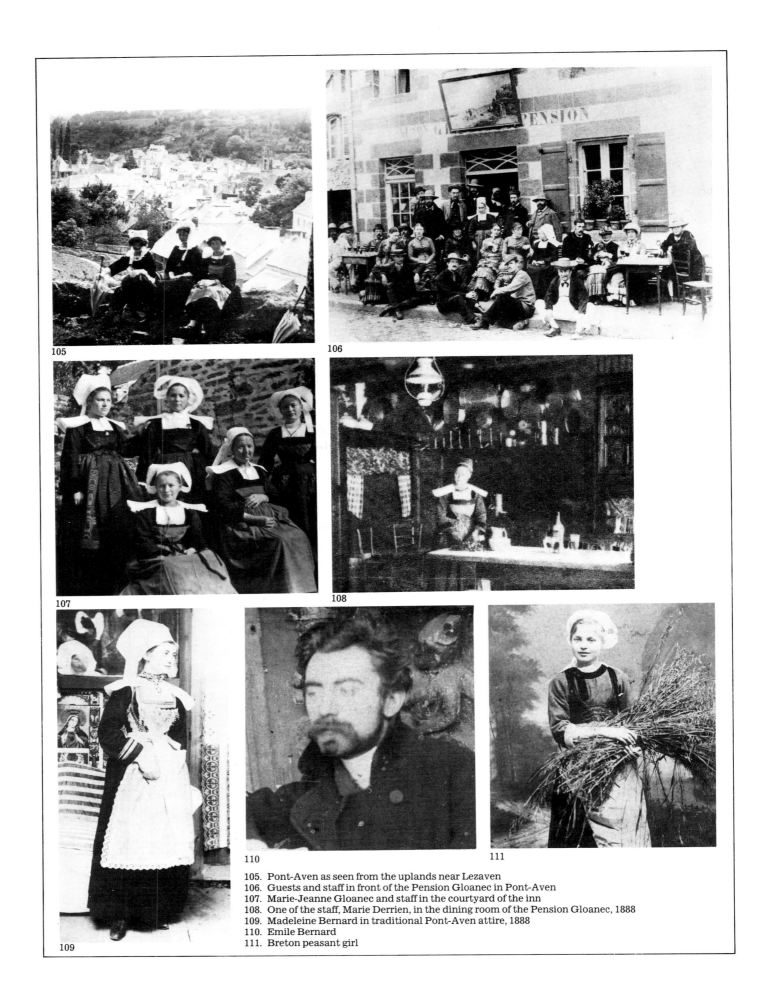

105. Pont-Aven as seen from the uplands near Lezaven
106. Guests and staff in front of the Pension Gloanec in Pont-Aven
107. Marie-Jeanne Gloanec and staff in the courtyard of the inn
108. One of the staff, Marie Derrien, in the dining room of the Pension Gloanec, 1888
109. Madeleine Bernard in traditional Pont-Aven attire, 1888
110. Emile Bernard
111. Breton peasant girl

with a painting from his cherished collection. Mette received his request for a Manet: what a sacrifice that was!

Still complaining of "unbearable intestinal pain," he saw a ray of hope breaking through the gloom. "You are familiar with Goupil's, an art publisher and dealer," he wrote on December 6. "Today, this firm has become the hub of the Impressionists. Little by little, they'll have their clients eating us up...." A letter in early January brought good news. "To come right to the point. Someone from Goupil's came over last Sunday, and he was most enthusiastic about my pictures and ended up giving me 900 francs for three of them and intends to buy others, or so he says."

The art dealer who had so fortuitously discovered Gauguin—courtesy of "good old Schuff"—was none other than Theodorus van Gogh, whose shop at 19 Boulevard Montmartre was affiliated with Goupil's successors, Boussod and Valadon. Encouraged by his brother Vincent, Theo found himself drawn to Impressionist painters and was so taken with the freshness of Gauguin's Martinique landscapes that he paid 400 francs for the privilege of adding a picture entitled *Négresses* to his private collection.

Gauguin Meets Van Gogh

Gauguin took a liking to the Dutch painter and before long was sharing his passion for Japanese prints. (Vincent exerted the same influence on three of his old fellow-students from Cormon's studio—Toulouse-Lautrec, Louis Anquetin, and Emile Bernard—and was instrumental in organizing an exhibition of Japanese prints at Le Tambourin, a Montmartre cabaret.) Get-togethers over a glass of absinthe soon led to exchanges of ideas and pictures. Granted, Vincent was the brother of an up-and-coming dealer, and both of them could claim Armand Guillaumin as a friend. Just the same, there was something about Van Gogh himself that piqued Gauguin's curiosity. Had not Vincent maintained that "real drawing consists of modeling with color" and that a picture had to be "started from the core, the way a piece of fruit does"? Wasn't he the one Cézanne had said "painted like a madman"? Make that "mystic," and, we should add, the soul of generosity. "You are jolly well right to think of Gauguin," Van Gogh wrote to Emile Bernard in May after he had settled in Arles. "There is great poetry in his Negresses, and everything he does has a gentle, forlorn, astonishing quality about it."

Gauguin's spirits were again lifted when he met Georges-Daniel de Monfreid, one of Schuffenecker's old schoolchums from the Académie Colarossi. He shared the artist's love for seafaring, became his confidant, and proved a friend to the bitter end. "I met this odd figure of an artist at Schuffenecker's," he later recalled. "I did not warm up to him very much at first.... His works were a revelation to me. I understood what Gauguin was looking for and, at the same time, sensed the falseness of everything I had been taught about art. What seemed to me at first to be self-contradictory remarks became precepts."

Delighted with the attention Theo van Gogh was lavishing on him and flattered no end that some of his pictures and pieces of pottery were soon on display in his gallery, Gauguin believed that he was getting his big break at last. Other Impressionist painters had shown their work in Glasgow and Brussels; he wanted to follow suit. Moreover, he saw his wife as a go-between for future exhibitions in Sweden and Norway. But this meant he had to get back to work and produce in earnest. And to accomplish that, what more cheerful—and cheaper—setting than Pont-Aven, the spot Gauguin associated with that wonderful summer of 1886?

He stopped giving lessons in the studio he shared with the painter François Flameng (18 Impasse du Maine, near the Montparnasse station). Mette received word that he would be leaving in early February for Brittany, "where I'm going to work 7-8 months straight, steeped in the character of the people and the region they live in, an absolute prerequisite for good painting." In this he was heeding the advice Courbet had once given: "You've got to know a place in order to paint it." Certainly a person needed more than one season to know Brittany inside and out! Besides, the time had come to give Emile Schuffenecker a wide berth. For all his ingenuousness, "good old Schuff" might have found out about the affair his best friend was having with his increasingly distant wife.

And so Gauguin withdrew to the Maison Gloanec in Pont-Aven to spend the long winter months in solitude and repose. His letters to Mette and "Schuff" suggest that, liver and intestinal disorders notwithstanding, he was determined to keep the outside world at bay. "Ever since I left, I have shut off this sensitive heart of mine in order to keep up my mental fortitude. Everything about that part of me is benumbed, so it would be dangerous for me to have my children by my side only to have them go away afterward. You must remember that there are two natures within me, the Indian and the sensitive man. The latter has disappeared, which allows the Indian to go straight ahead without wavering."

"You [Mette] complain about being alone. . . . What about me? I'm all alone in a room of an inn from morning till night. I have absolute silence. Nobody to exchange ideas with."

"Soon I'll have been here a month," he wrote to Schuffenecker. "I indulge in mute contemplation of nature, completely absorbed in my art. . . . You are a true-to-form Parisian. I'll take the country. I like Brittany; I find wildness and primitiveness here. When my wooden shoes ring on this granite ground, I hear the dull, muffled, powerful tone I seek in my painting."

This was, indeed, the direction in which his painting seemed to be headed. Unfortunately, inclement weather hampered his efforts; lack of money made the hail, rain, and mud all the more distressing. Gauguin unburdened himself to Vincent van Gogh, who had already left for Arles in search of the sun. "I don't mean to pressure your brother, but your dropping a line about this matter would set my mind at rest, or at least would give me more patience. My God, but money matters are dreadful for an artist!" He touched Schuffenecker for a loan and appealed to Theo again. ("He [Gauguin] is cleaned out, what with pressing debts staring him in the face," Vincent had forewarned him.) For his part, Vincent was increasingly intent on persuading Gauguin to join him in Arles, as his plan to get Emile Bernard to come south had not materialized. "The two of us can live together on what I spend on just myself," he wrote to his brother in May. "Being cut off is always a losing proposition." Between Vincent in Arles, Theo in Paris, and Gauguin in Pont-Aven, considerable ink was spilled concerning this scheme from spring until autumn.

Cézanne's "Petite Sensation"

"I still have hopes that he [Theo] will wrangle something for me," Gauguin wrote to Schuffenecker in early June. "The Cézanne you ask for is an exceptional gem, and I've already turned down 300 francs for it. I cling to it as I do to life itself and, short of absolute necessity, would sooner part with my last shirt. Besides, who would be insane enough to pay that." Sacrificing a Cézanne would be tantamount to putting out his own eyes: Gauguin was still borrowing ideas from the much admired master of Aix-en-Provence, the better to fathom the geography, climate, and people of a part of Brittany that did not readily yield up its secrets to outsiders. Art relates as much to art as it

does to nature, and it was wrong of Cézanne to complain that Gauguin had "stolen my *petite sensation*." Every artist is indebted to fellow artists for the "discoveries" he makes.

Around the middle of June, Theo sent him a money order for 39.60 francs. In his letter of thanks, Gauguin informed him that he was "busy painting three little girls dancing a Breton gavotte in a hayfield. I think you'll like it. This picture seems original to me and I'm pleased with it as far as drawing is concerned." Now Gauguin was homing in on the goal he had set himself in 1886. "I only use the six colors of the prism," he wrote to Henri Delavallée at the time. "I juxtapose them, blending them as little as possible in order to obtain maximum brightness. Drawing I do as straightforwardly as possible, and I synthetize it."

Mette remembered his fortieth birthday on June 7, but she mentioned how sorry she was that he showed so little concern for his family. He sent back her letter. "See enclosure," he wrote bitterly. "By leaving out news of the children, you'll see how very short and sweet it is." Gauguin's country scenes from this period reveal a decided preference for young, guileless Bretons, as if they were surrogates for the offspring he missed: little cowherds in the fields, lasses in the hay, tykes swimming in the Aven or sparring on the riverbank. His landscapes are suffused in an aura of affectionate but melancholy serenity. "First you dream," he explained to Schuffenecker, "then you paint in tranquility."

"Art is an Abstraction"

He was widening the gap between himself and the quasi-photographic naturalism that most of his contemporaries had subscribed to. While they were busy imitating nature as carefully as they could, he was working out an unprecedented concept of painting: a stylized approach inspired by primitive and Japanese art. "I am in complete agreement with you concerning the unimportance of accuracy in art," he wrote to Vincent van Gogh in late July. "Art is an abstraction; unfortunately, we are becoming more and more misunderstood. . . . Naturally, this pack of boors here thinks I am completely out of my mind."

The irresistible need for idealization that obsessed Gauguin from now on was symptomatic of a yearning to transcend the natural world around him. "Don't copy nature too much," he advised Schuffenecker on August 14, the day before the Feast of the Assumption at the Maison Gloanec. "Art is an abstraction. Derive it from nature even as you dream before it, and think more about creating than about the outcome. The only way to rise toward God is to do as our Divine Master does: create." This was Gauguin's persona: a master, confident in the rightness of his cause and in his higher calling.

He had to weather the needling of the "Pompiers [hacks]" and "Americans" who were "raging against Impressionism"; he had to "threaten them with a fight" before he could have some peace. Nevertheless, his reputation among his "little band" of youthful followers had grown steadily since the beginning of summer. Gauguin looked every inch the bard.

One of the faithful, Ernest Ponthier de Chamaillard—a law-school graduate whose father and brother were Breton lawyers—left us an illuminating account of the artist's imperious behavior. "One day in June of 1888 I happened to be at a public auction in Hénau Castle, near Pont-Aven, when I spotted him in the crowd of nattily dressed peasant women. He was wearing a tight-fitting jersey, a beret, and an extraordinary pair of carved wooden shoes. . . . He spoke simply but with authority as he expatiated on his theories about art. In his opinion, gray did not exist. Every object had its particular form and color, with well-defined contours. The aim of the artist was to make them out. That, together with his passion for line and arabesque, was the gist of his theory. As for his favorite masters, he put Raphael

and the primitives at the top of his list. . . . He talked about these things with such conviction, I felt won over by this engaging artist."

When Chamaillard asked for guidance in his own painting, Gauguin told him to wander along the riverbank and paint what he liked and just as he saw it. "You are devoted to art, that is enough." The beauty of the world lay within oneself. "With this principle as his starting point, he gathered around him all of the young painters who were arriving in Pont-Aven, and he did his utmost to pass on his religious fervor to them." One of the first to enter the fold was the mild-mannered and serious-minded Henry Moret, who came to share his teacher's love for Brittany.

Now that Gauguin's beloved disciple, Charles Laval, had finally come back from Martinique, the two of them were given a table to themselves at Marie-Jeanne Gloanec's rooming house. On Vincent van Gogh's advice, Emile Bernard looked Gauguin up. This time, a friendlier reception awaited him: he was already brimming with admiration for the Master of Pont-Aven and, besides, he had brought along a very pretty sister. "Young Bernard is here," Gauguin wrote to Schuffenecker in August, "and he has brought some interesting things from Saint-Briac. Now *there's* someone who's not afraid of anything!" A few days later, Schuffenecker, who was spending the summer with his family at Yport, received a rapturous letter from Gauguin. "Young Bernard is a decidedly queer sort. . . . What lofty thoughts can be summoned forth with form and color in the absence of religious painting! How very much at home they feel with their feet on the ground, those hacks with their trompe-l'œil of nature. We alone drift aboard the phantom ship with all our whimsical imperfection. How much more tangible infinity seems when we see something ill-defined before us! Musicians have their ear, but we, with our insatiable, lusting eyes, we savor never-ending pleasures. A little while from now, when I have my dinner, the beast will have had its fill, but my craving for art shall never be satisfied."

What had worked this sudden, dramatic change in Gauguin? He had quite simply become infatuated with Emile Bernard's gentle and dutiful eighteen-year-old sister, Madeleine, whose mother had come along as chaperon. Here was the Master of Pont-Aven, intrigued to no end by this "young Bernard" and his charming escort, the beloved sister who sparked a passion that made him feel young again. What an oddity Emile Bernard was, how unlikely a combination of youth's jaunty conceit and the proselytizing fervor of Catholicism! His career as a painter had gotten off to an early start; he could boast contacts with Seurat, Signac, Toulouse-Lautrec, Van Gogh, and Anquetin. Yet, this did not stand in the way of his breathless admiration for Gauguin. The quaint folkways of Brittany captivated him, but at the same time he felt a compelling need to intensify the colors of what he saw, to pare things to essentials.

Around this time, Japanese prints were gaining in popularity, thanks in part to art dealer S. Bing's exhibitions in his gallery and to his magazine, *Le Japon artistique.* Their evocative power inspired Louis Anquetin, another friend of Charles Laval's, to develop a new technique that Emile Bernard picked up from Anquetin himself and demonstrated to artists at Pont-Aven. Edouard Dujardin had recently hailed Anquetin's so-called Cloisonnism as the advent of a new art form. "Primitive art and its extension in our own times, folk art, are symbolic in this fashion," he wrote in the May 19, 1888, issue of the *Revue indépendante.* "The *image d'Epinal* [popular colored woodcuts] proceeds by outlining forms. . . . So does Japanese art. What practical application can we derive from this? . . . The painter draws his design with closed lines and fills the space between with varied hues, the juxtaposition of which is supposed to give the sensation of the general coloration intended, line emphasizing color and color emphasizing line. The painter's work is something like painting in compartments, analogous to cloisonné enamelwork, and his technique amounting to a kind

of *cloisonnisme.*" Anquetin had also schooled Bernard in "the principle of suggestive color." "Yellow creates an impression of sunlight; green, of daybreak; blue, of night; red, of twilight."

The stage had already been set with Bernard's *Buckwheat,* and then came his *Breton Women in the Meadow,* with its bold, partitioned areas of pure color. He had rather the same effect on Gauguin that a ripe apple falling from a tree had on Newton as he pondered the laws of gravity. Bernard was a catalyst, awakening tendencies which until now had lain dormant: one was Synthetism, which Gauguin was later to teach diffident Paul Sérusier in a single dazzling lesson when the two of them went into the Bois d'Amour and Sérusier painted *The Talisman* under his guidance; the other was Symbolism, which Gauguin was to implement to such brilliant effect in *The Vision after the Sermon:* Jacob wrestles with the angel in a blood-red field while praying Breton women look on in wonder. Like him, the artist was pitting himself against his Impressionist forebears, determined to overpower them once and for all on their own turf: nature.

"I painted a picture for a church," Gauguin wrote to Schuffenecker on October 8. "Naturally, it was turned down, so I am sending it off to Van Gogh.... I have sacrificed everything this year—execution, color—for style, forcing upon myself something different from what I know how to do. This is, I believe, a transformation that has not yet borne fruit, but which will.... [Theo] van Gogh has sold 300 francs worth of pottery for me. Therefore, I am leaving for Arles at the end of the month...."

Mme. Bernard was heading back to Paris, daughter in tow, so he asked her to make sure that his latest works found their way to Theo, on whom Gauguin now pinned all of his hopes. He had tried to persuade a number of people to go to Provence with him, to no avail: Chamaillard was head over heels in love with Louise Lamour, the postmistress's niece; Moret had lost his heart to Brittany; Laval had lost his to Madeleine Bernard; Emile Bernard was concerned about his unfulfilled compulsory stint in the military. Gauguin was alone when he finally got together with Vincent van Gogh, who from his outpost in Arles was starting to envy the Pont-Aven phalanstery its merry and productive comradeship.

The Royal Road to Symbolism

The summer months of love and creative exuberance ended abruptly for Paul Gauguin. In a symbolic gesture that meant a great deal to him, he offered his prophetic *The Vision after the Sermon* first to the church in Pont-Aven, then to the one in Nizon, only to have it turned down by their respective curés. Madeleine Bernard, moved more by Laval's delicacy of feeling than by the anguish of a married man, had spurned Gauguin's urgent advances. His close friend, Armand Guillaumin, had not even seen fit to thank him for the self-portrait he had sent him. He no longer corresponded with his wife. Marie-Jeanne Gloanec was dropping hints about back rent for room and board. And the doctor and pharmacist had done what they could for his severe relapse of dysentery and were awaiting payment for services rendered and potions prescribed.

Fortunately, he still had the brothers Van Gogh and the sublime Schuffenecker. "Clearly the road of symbolism is filled with perils," he wrote to "Schuff" from Quimperlé on October 16, "and I have only just taken my first steps on it, but at bottom it is something which is in my nature, and a person must always follow his temperament. I am well aware that I shall be understood *less and less.* But what does it matter if I move away from the others.... You know that when you come right down to it, I am always right about art."

A number of the pastoral scenes Paul Gauguin painted in and around Pont-Aven during the fall of 1888 show a barren, cheerless countryside unrelieved by open sky. Yet, they burst with bold colors (oranges in particular) that come straight from Martinique. In the two reproduced here, the artist draws our attention to the same little cowherd: a simple, but mysterious presence. In one, we see him in front of a calf, adjusting one of his wooden shoes; in the other he gazes pensively while a Breton woman in the foreground bends over to gather some sticks. Taken directly from The Gleaners, *the painting that was Millet's claim to fame throughout France ever since it was shown at the Salon of 1857, her pose inspired Gauguin to make some charcoal sketches and to use it on a number of occasions, just as Pissarro had done before him. However, this stooped body does more than speak of the lowly station of women and children who live off the land. It also symbolizes the very wellspring of Gauguin's inspiration: the return to nature which Jean-François Millet, following in the footsteps of the Le Nain brothers, had demonstrated at Barbizon. They are the soul of humility, and their very pose serves as an example for the painter to follow. He must prove his willingness to put art above self, to lower himself, if need be, to destitution. Like them, he must glean, whether it be sticks with which to rekindle his inspiration, or overlooked spikes of wheat from which new harvests may grow.*

112. The village of Pont-Aven

113. Louis Le Nain. *Back from Haying.* 1641

114. Gauguin. *Winter, or Breton Boy Adjusting His Wooden Shoe.* 1888

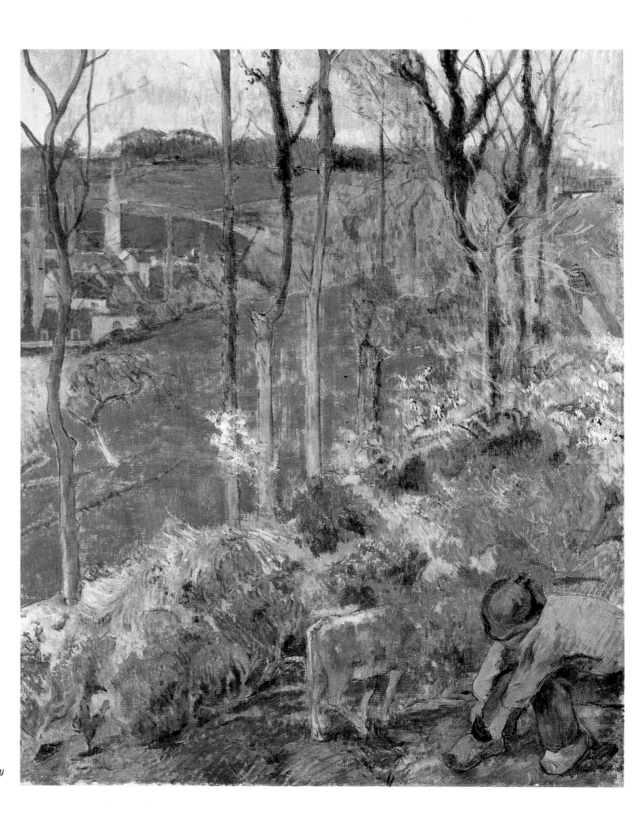

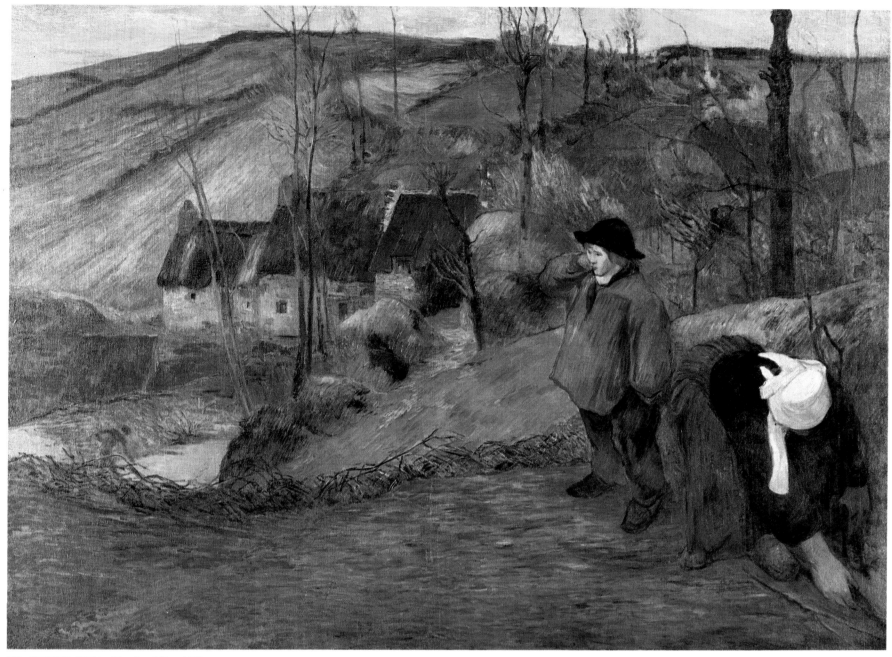

115. Gauguin. *Breton Shepherd Boy.* 1888

116. Breton boy at Pont-Aven

117. Gauguin. *Breton Woman Bending Over*

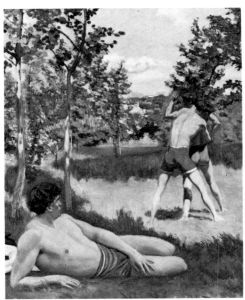

118. Frédéric Bazille. *Summer Scene* (detail). 1869

119. Pierre Puvis de Chavannes. *The Gentle Land* (detail). 1882

120. Gauguin. *Children Wrestling.* 1888

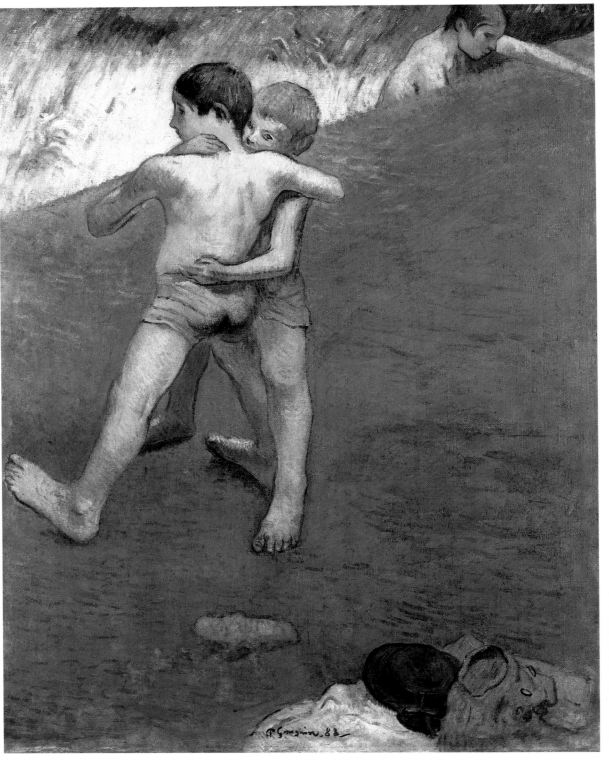

121. Gauguin. *Children Wrestling.* 1888

"**I'**ve just finished a Breton wrestling bout I'm sure will be to your liking," Gauguin wrote to Vincent van Gogh in late July. "Two boys, one in blue shorts, the other in bright red shorts. Another, upper right, climbing out of the water. Green lawn, Veronese green shading off to chrome yellow, with a very unfinished look, like Japanese prints. Above, a pinkish white bubbling waterfall, a rainbow at the edge, near the frame. Below, a daub of white, a black hat and a blue peasant's blouse." "I've just done some nude male figures," he wrote to Schuffenecker, "and there is nothing of Degas about them. The latest shows two boys wrestling near the river, in an altogether Japanese style, by a savage from Peru." Here, Gauguin sounds the

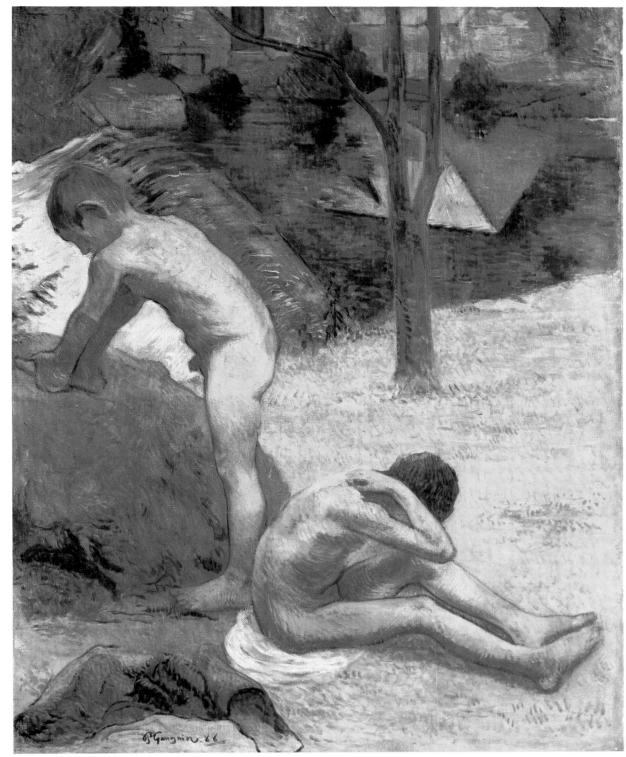

122. Gauguin. *Breton Boys Bathing*. 1888

123. Edgar Degas. *Young Spartans Exercising* (reproduced in part). 1860

124. Gauguin. *Nude Breton Boy*. 1889

obsessive theme of grappling men that recurs in his Vision after the Sermon. *In giving credit to his sources, he failed to mention* The Gentle Land *by Puvis de Chavannes (who himself was quoting Frédéric Bazille's* Summer Scene*); but he did not omit Degas and his* Young Spartans. *Its oranges and pinks reappear in* Nude Breton Boy. *As was his custom, he never divulged all of his pictorial "quotations," choosing instead to emphasize Japanese or Peruvian sources while glossing over more obvious ones. He neglected to point out to Vincent that the frothy features of a water spirit lurk in the waterfall—a subtle touch of symbolism that undercuts the realism of the subject. Gauguin may also have been thinking of the sons he left behind in Denmark.*

125. Spire of the church at Pont-Aven as seen from the Derout-Lollichon fields

126. Gustave Courbet. *The Painter's Studio* (detail). 1855

When haying time came to the Derout-Lollichon fields overlooking the church of Pont-Aven, Gauguin painted several sun-drenched pictures that include his little dog, derived from Gustave Courbet's The Painter's Studio. During this period, Pascal Dangnan-Bouveret, onetime pupil of Léon Gérôme and a highly successful painter of Breton subjects, was turning out able specimens of quasi-photograph realism for the Musée du Luxembourg and the Salon. Emile Bernard, however, had already taken his first bold steps toward Cloisonnist stylization, as the study on the opposite page attests. It now dawned on Gauguin that the lyrical effects he had created with his enameled pottery could be extended to painting. The last rays of the setting sun have suffused the little village of Pont-Aven in a pinkish cast, but the artist has cut the horizon short in order to focus our attention on the trio of crisply defined little girls dancing. The whiteness of their headdresses and collars, together with the two bouquets of red poppies, have been orchestrated into a rhythm that is at once hieratic, yet youthful and serene.

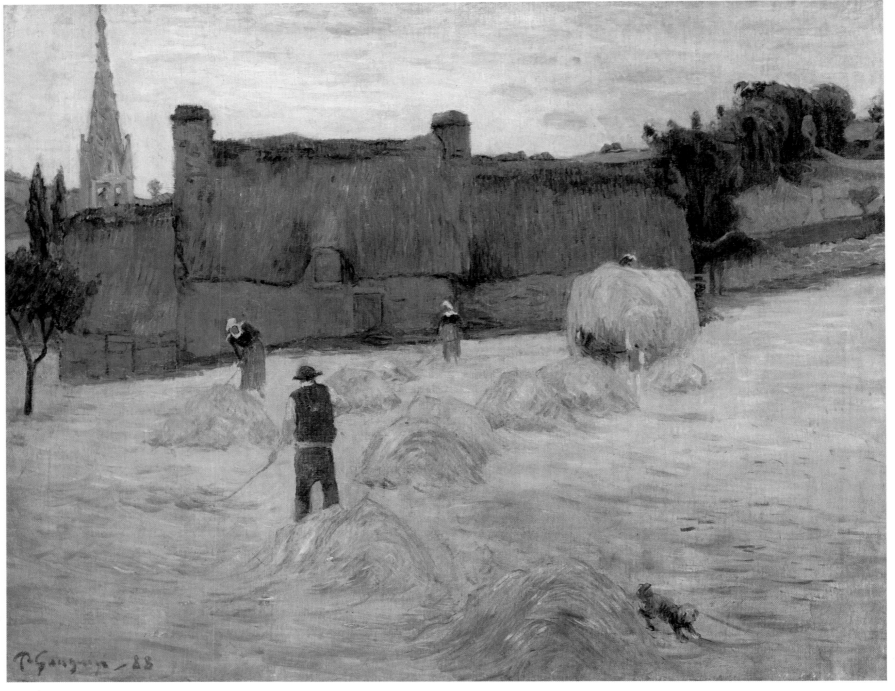

127. Gauguin. *Hay Harvest*. 1888

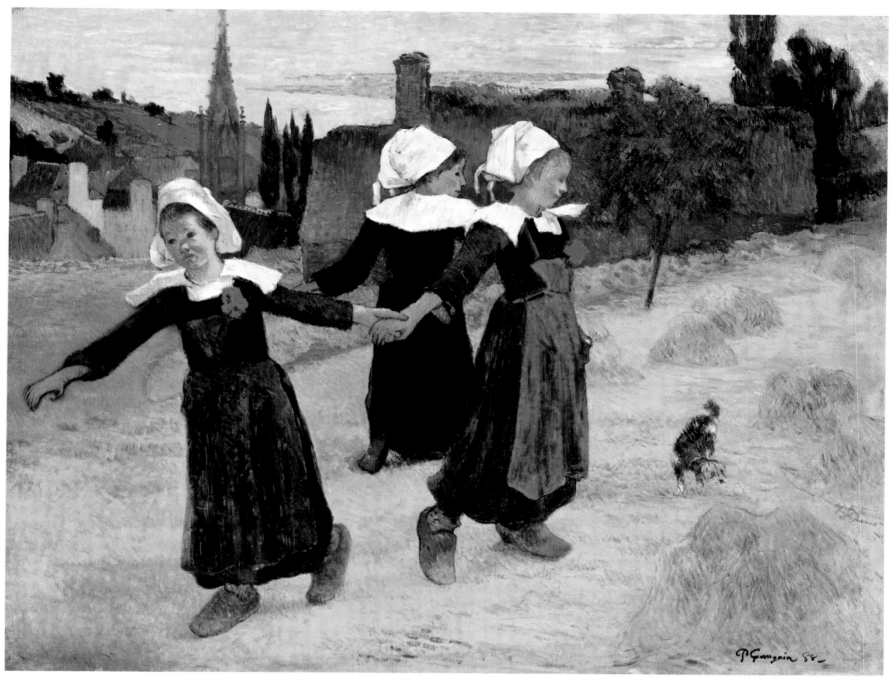

128. Gauguin. *Breton Girls Dancing, Pont-Aven*. 1888

129. Emile Bernard. *Breton Women Seated in a Meadow*. 1886

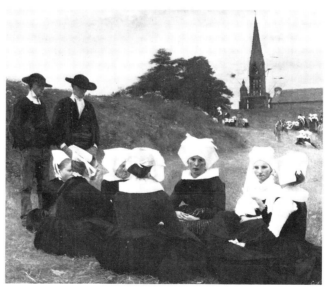

130. Pascal Dagnan-Bouveret. *Breton Women during a Pardon*. 1887

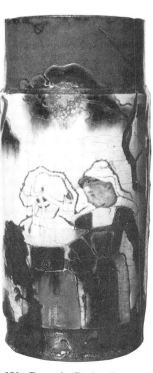

131. Gauguin. *Breton Scene* on a cylindrical vase by Ernest Chaplet. 1886–87

132. Utagawa Hiroshige. *Blossoming Plum Tree.* 1857

133. Elderly Breton woman in mourning clothes

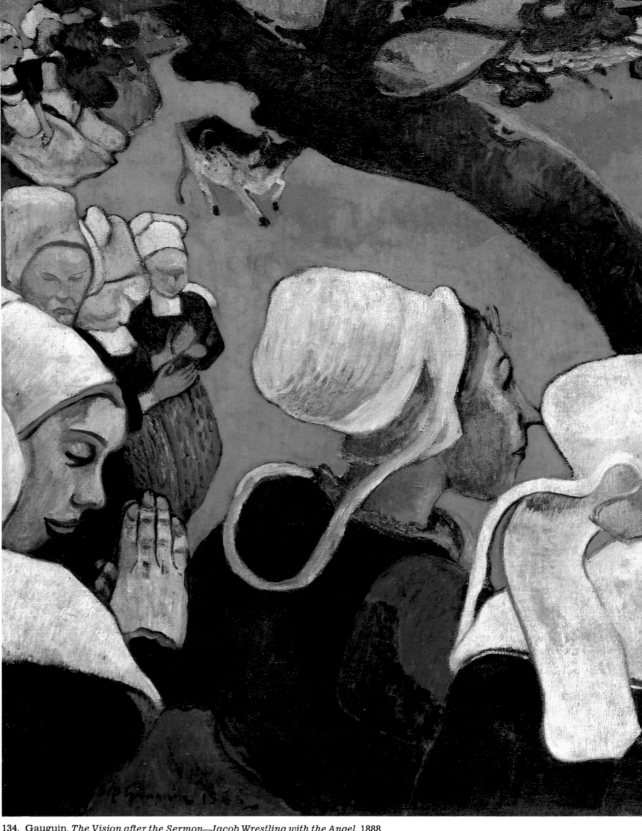

134. Gauguin. *The Vision after the Sermon—Jacob Wrestling with the Angel.* 1888

This landmark in painting, here surrounded by the subjects and artwork that inspired it, was Gauguin's first resounding declaration that in August of 1888 he had embraced Symbolism and its pioneering techniques: the "synthetic" compartmentalization of Cloisonnism and effects drawn from Japanese art. The painter himself attached such symbolic importance to it that he tried, and failed, to persuade the curé of Pont-Aven and the curé of Nizon to hang it in their respective churches. (In this Gauguin may have been harking back to the painting of Jacob Wrestling with the Angel, which Delacroix had done in a chapel in Saint-Sulpice.) How truly allegorical the subject is! As they emerge from Sunday mass, a group of entranced Breton women suddenly see come to life before their very eyes the sermon from the Bible they have just heard. A diagonal tree borrowed from Hiroshige (by way of Van Gogh) separates them from the vision. Like valiant Jacob grappling with the messenger of the Lord and emerging victorious despite a wounded leg, Gauguin pitted himself against his Impressionist elders in order to transcend the natural world. Mustering his strength and fortitude, he shunned divisionism for broad areas of flat, unmodulated color. The heavy outlines bring to mind cloisonné enamelwork, the lead tracery of stained-glass windows, and the technique of Emile Bernard, whose Breton Women in the Meadow opened Gauguin's eyes to Cloisonnism.

82

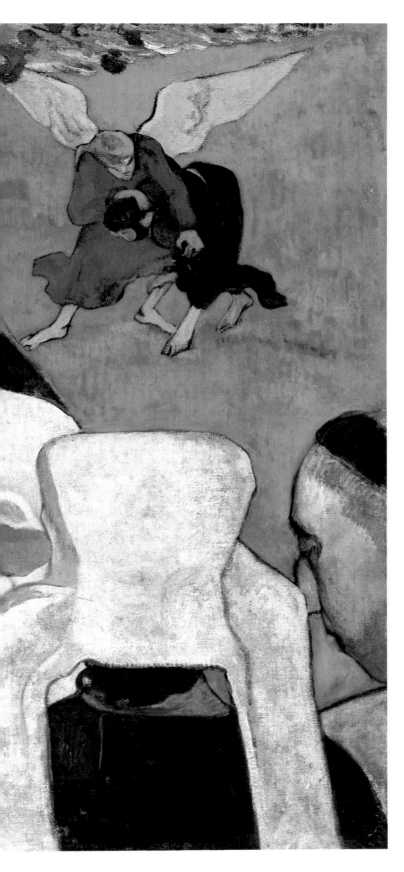

135. Katsushika Hokusai. *Wrestlers*, from the *Hokusai Sketchbooks*. 1814–49

136. Eugène Delacroix. *Jacob Wrestling with the Angel* (detail). 1827

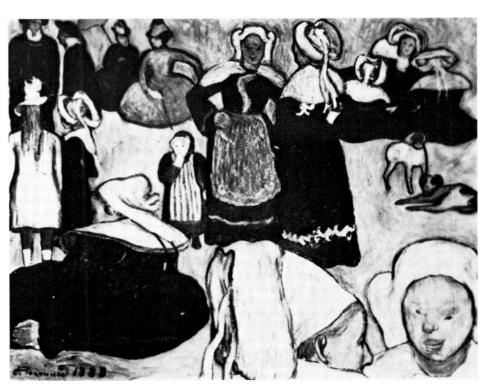

137. Gauguin. Sketch from a letter to Van Gogh. 1888

138. Emile Bernard. *Breton Women in the Meadow*. 1888

"**G**auguin and Bernard now talk of 'painting like children,'" Vincent van Gogh reported to his brother Theo. Gauguin (who turned forty on June 7) and his entourage of young painters became the butt of Salon painters, academicians, and Americans. "Here all of the Americans are raging against Impressionism," he wrote to Schuffenecker. The painter probably went out of his way to nettle his adversaries when he did some pictures of dogs and cats. Clearly he borrowed this oversimplified style and view from above from Japanese prints, and nowhere is his debt to them more apparent than in the still life we see here. For Marie-Jeanne Gloanec's birthday, Gauguin, in accordance with house custom, was about to hang a Japanese-looking, Cézannesque still life with pears on the wall of the pension when one of the boarders, shocked to see a composition without a background, took offense. "Whereupon," Maurice Denis later recalled, "Gauguin came up with a ruse. He credited the still life he had just painted to the unpracticed brush of Bernard's sister and signed it 'Madeleine B.'" She had stolen his heart.

139. Katsushika Hokusai. *Animals* from the *Hokusai Sketchbooks*. 1814–49

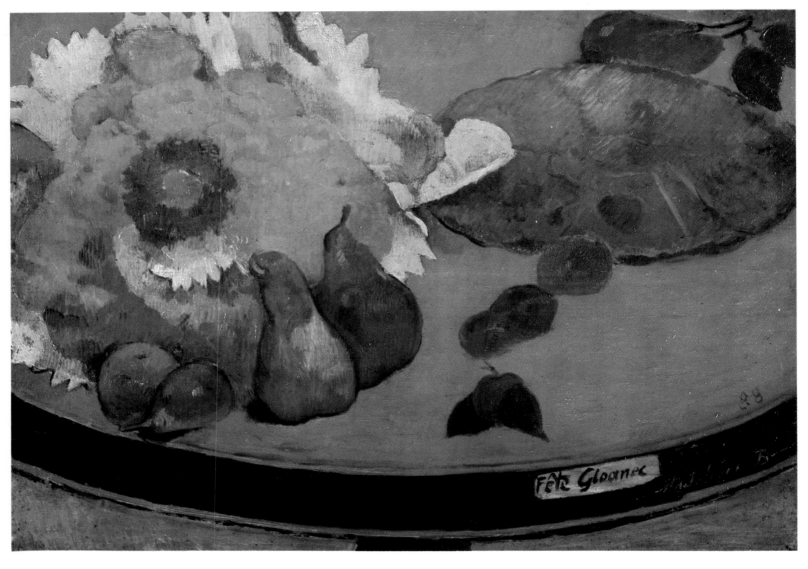

140. Gauguin. *Still Life: Fête Gloanec*. 1888

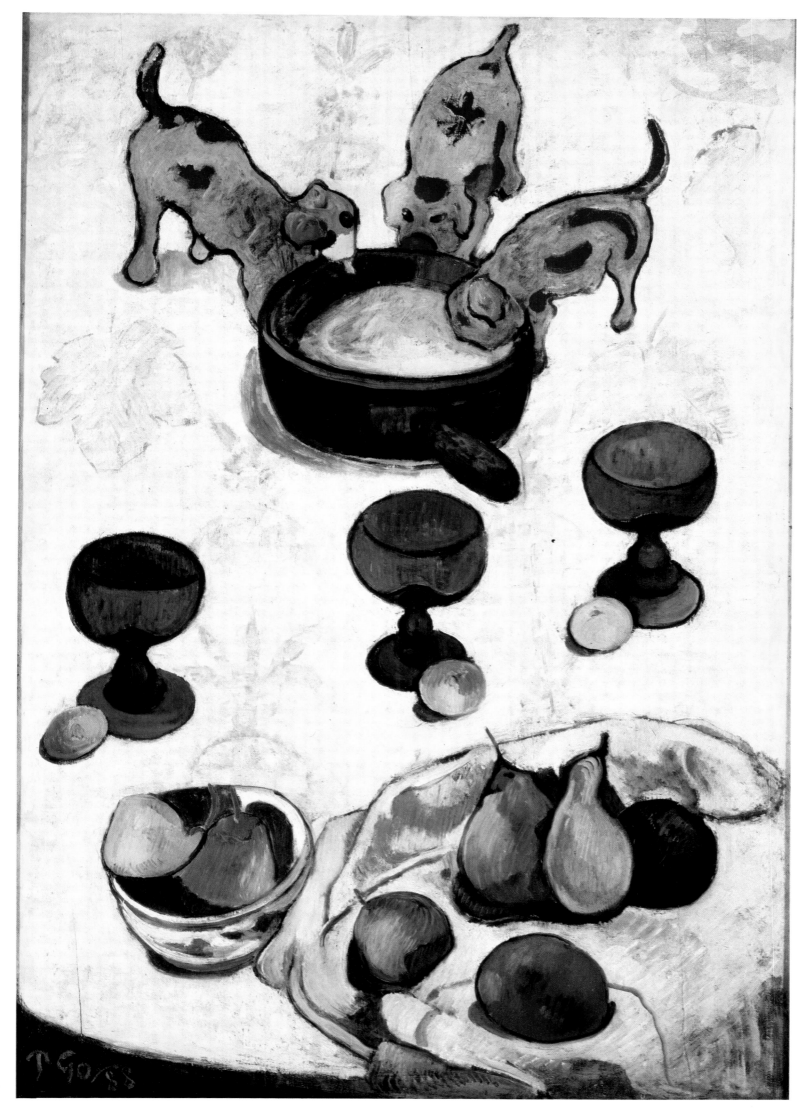

141. Gauguin.
Still Life with
Three Puppies.
1888

142. Hiroshige II. *Snow in the Kiso Mountains*

143. Bois d'Amour, Pont-Aven

144. Breton women in the Bois d'Amour, Pont-Aven

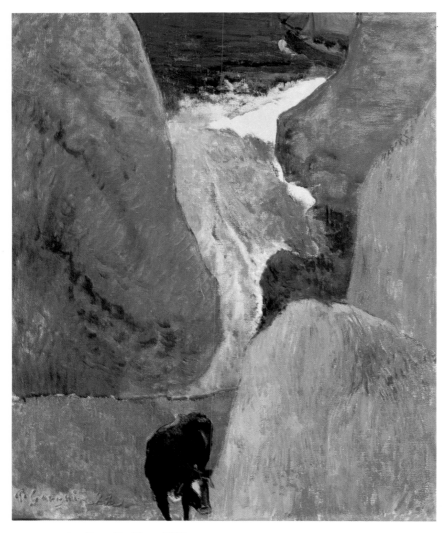

145. Gauguin. *Above the Abyss.* 1888

146. Paul Sérusier. *Landscape of the Bois d'Amour—The Talisman.* 1888

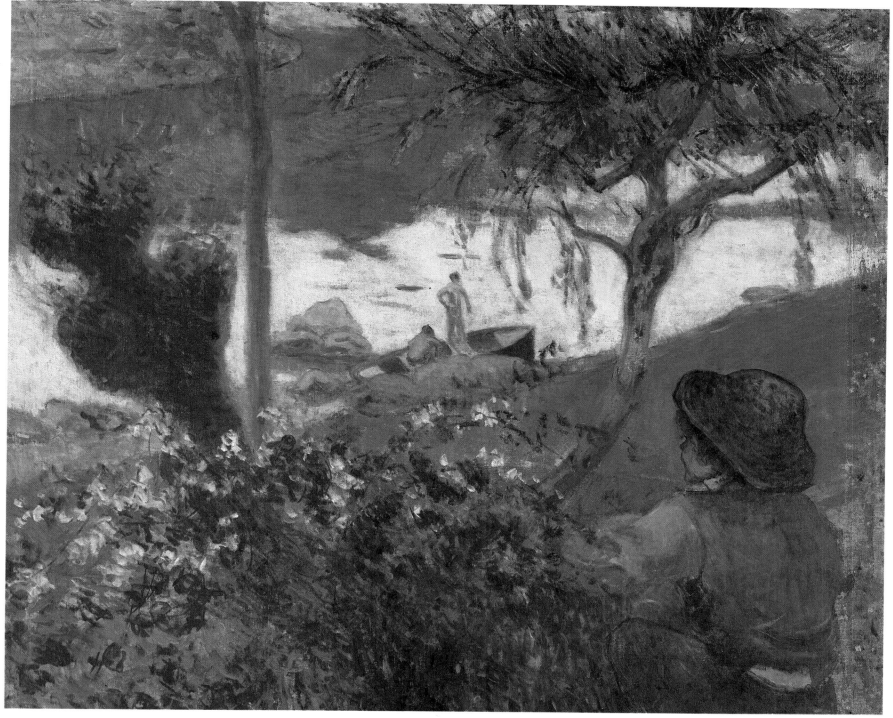

147. Gauguin. *The Blanche River.* 1888

One sunny October day in 1888, Gauguin and a companion made their way deep into the Bois d'Amour, to a spot along the Aven River where they could see the black slate roof of the Moulin Neuf peeking through the trees. There, Paul Sérusier, who had asked Gauguin for guidance, painted under his mentor's watchful eye the famous rough sketch which his schoolmates back at the Académie Julian subsequently dubbed The Talisman. *"How does that tree look to you?"* Gauguin asked him. *"Is it yellow? Well then, put down the loveliest yellow on your palette. And that shadow is blue, isn't it? Paint it as blue as you can. And those leaves over there, wouldn't you say they are red? Use vermilion!"* There could be no turning back now. With a simple cigarbox lid for a support, his pupil not only put the theory of Synthetism into practice, but carried it to extremes. Local legend had it that the gleaming surface of the Aven (also known as the Blanche River) could work miracles, but it was more than a river that had bewitched Sérusier. He had come under the spell of Paul Gauguin. Like the abyss on the opposite page, this in-depth view of the Aven from the left bank, downstream from the Ty Meur water mill, brings to mind both The Talisman and the receding space of Japanese prints.

148. Breton boys swimming in the Aven

E mile Bernard was deeply attached to his sister Madeleine, who was all of eighteen when their mother and she traveled to Pont-Aven to spend summer vacation with him. Gauguin fell in love with her at once; but so did Charles Laval, who ended up winning her heart. The Bois d'Amour is the setting for Emile Bernard's My Sister Madeleine. In Gauguin's portrait of her, however, there is an obvious reference to Degas: the feet of ballet dancers in a picture just above her head. As we look at her searching, sarcastic expression and the pair of blue slippers beside her, we are reminded of the portrait Degas painted of Rose de Gas (1867), or the one of Mademoiselle Dobigny, a model who also sat for Corot and Puvis de Chavannes. "A painting requires some mystery, something vague and whimsical," declared the painter of young ballet dancers. Gauguin's treatment of Captain Jacob from the back (below) recalls the broadly rendered napes and shoulders of Ingres's odalisques. "Until now," Degas stated elsewhere, "nudes have always been shown striking poses that presuppose an audience. My models are ordinary, unaffected people concerned with nothing except whatever it is they happen to be doing at the time." No doubt Captain Jacob is shown here rowing toward Le Pouldu on one of the outings he would arrange during the summer.

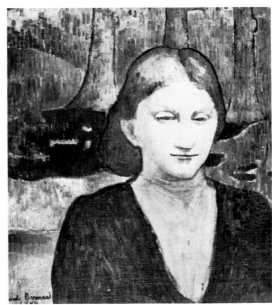

150. Emile Bernard. *My Sister Madeleine.* 1888

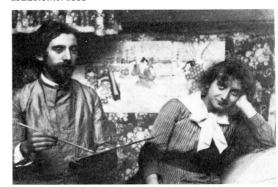

151. Emile Bernard and his sister Madeleine

149. Gauguin. *Captain Jacob.* 1888

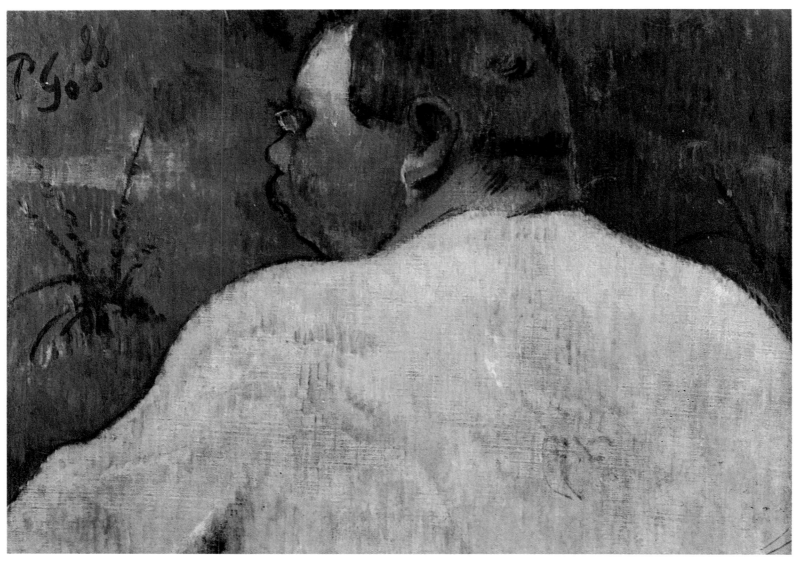

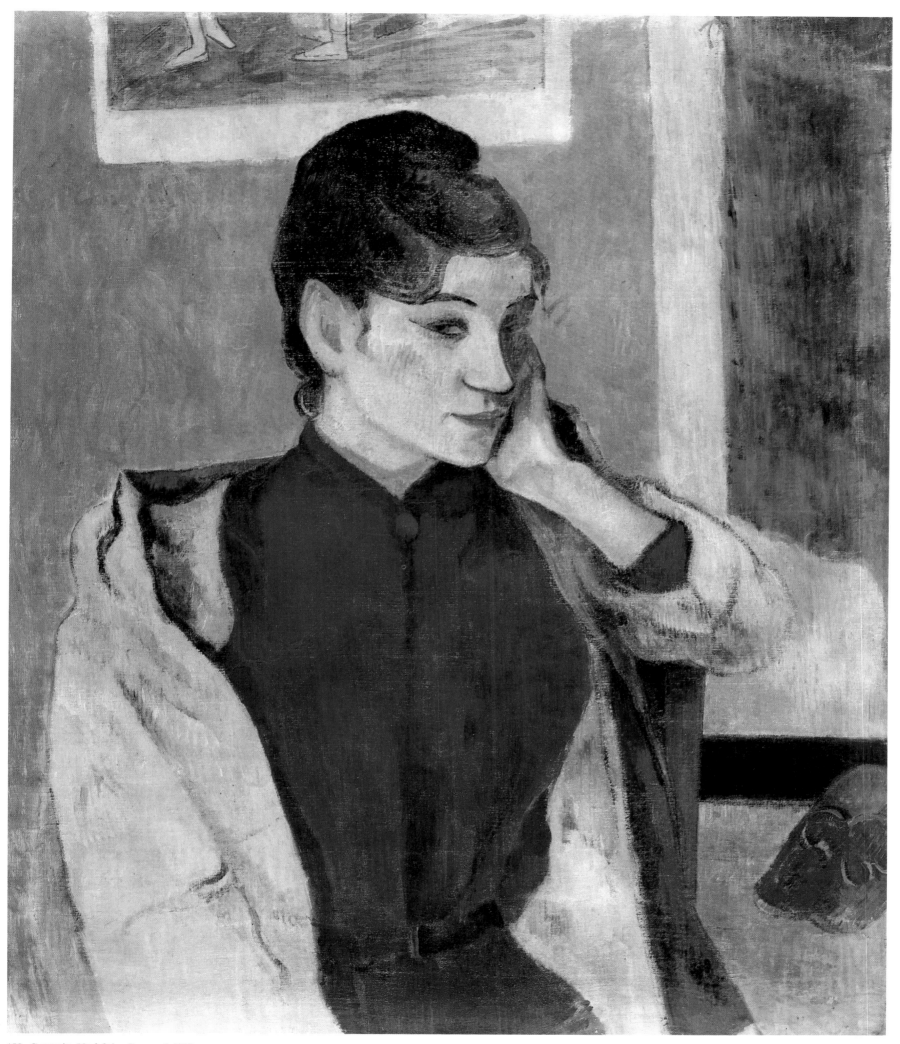

152. Gauguin. *Madeleine Bernard*. 1888

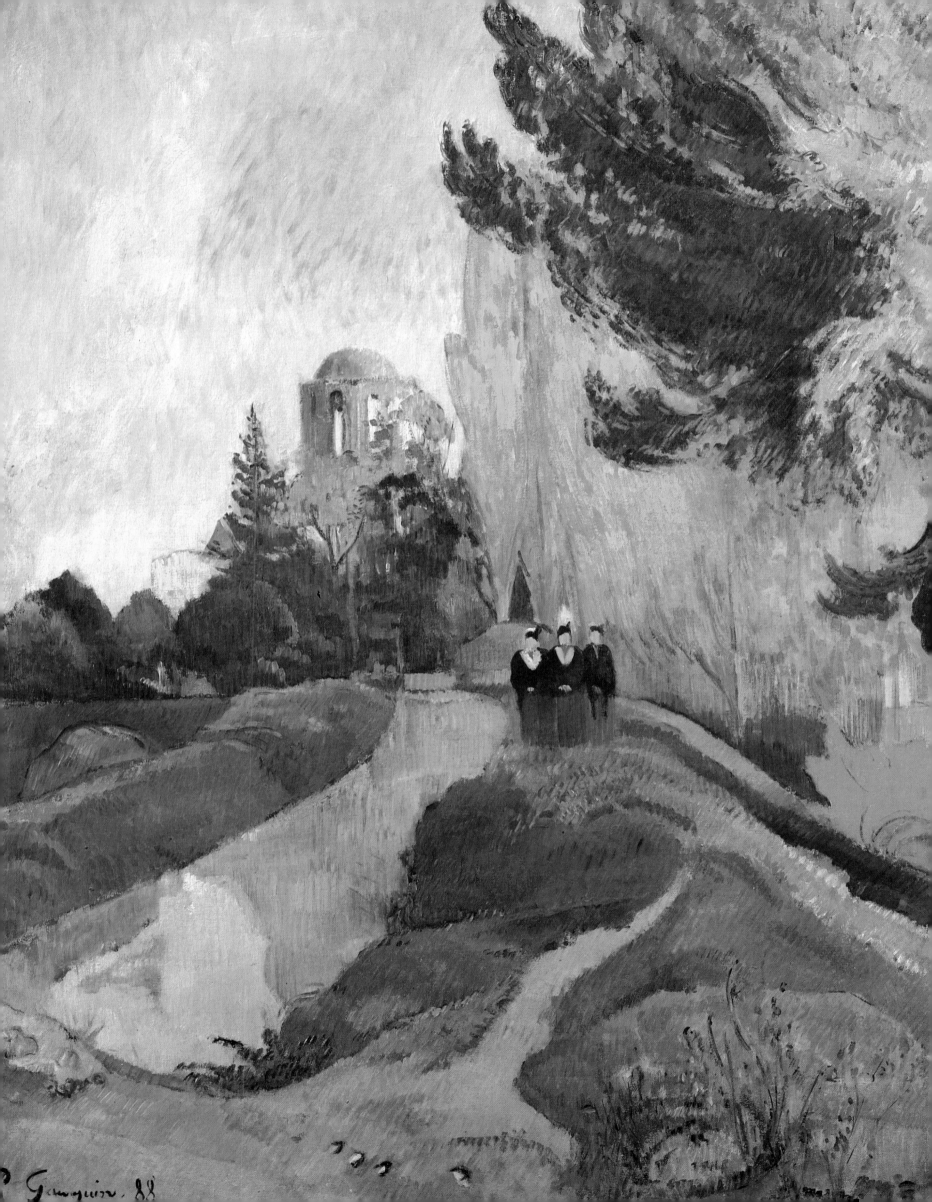

P Gauguin. 88

5

Escapade to Provence: Gauguin and Van Gogh in Arles

October–December 1888

154. The Alyscamps at Arles

Paul Gauguin sent Madeleine Bernard a wistful letter and boarded the train at Quimperlé on Sunday, October 21, 1888. Two days later, the exhausted artist got off at the Arles station; it was 5:15 in the morning. He had finally come south to join Vincent van Gogh.

For several months now, Vincent had stopped at nothing—self-sacrifice, forbearance, the devoted collusion of his beloved brother Theo—to coax Gauguin to move in with him and set up that Studio of the South on which he pinned all his hopes. Wherever they went, surely Emile Bernard, Charles Laval, Henry Moret, Ernest de Chamaillard, and many others would follow. Basking in comradeship, a whole constellation of painters would bring about a rebirth of art, just as Rousseau, Millet, Daumier, and Diaz had done not so long ago at Barbizon. With the "Japanese" sun of Provence shining overhead, they would pool their inspiration and modest resources while Theo, from his end in Paris, would attend to money matters. What a fine, productive brotherhood it could be! At any rate, such was Vincent's dream.

Gauguin only half believed in it; it was Vincent's brother's business acumen he was really counting on. Theo, he reasoned, could very well prove to be both an effective dealer and a source of unstinting confidence. A few steps from the railroad tracks, the majestic Rhone silently bore his hopes southward. The person Van Gogh later described as "the

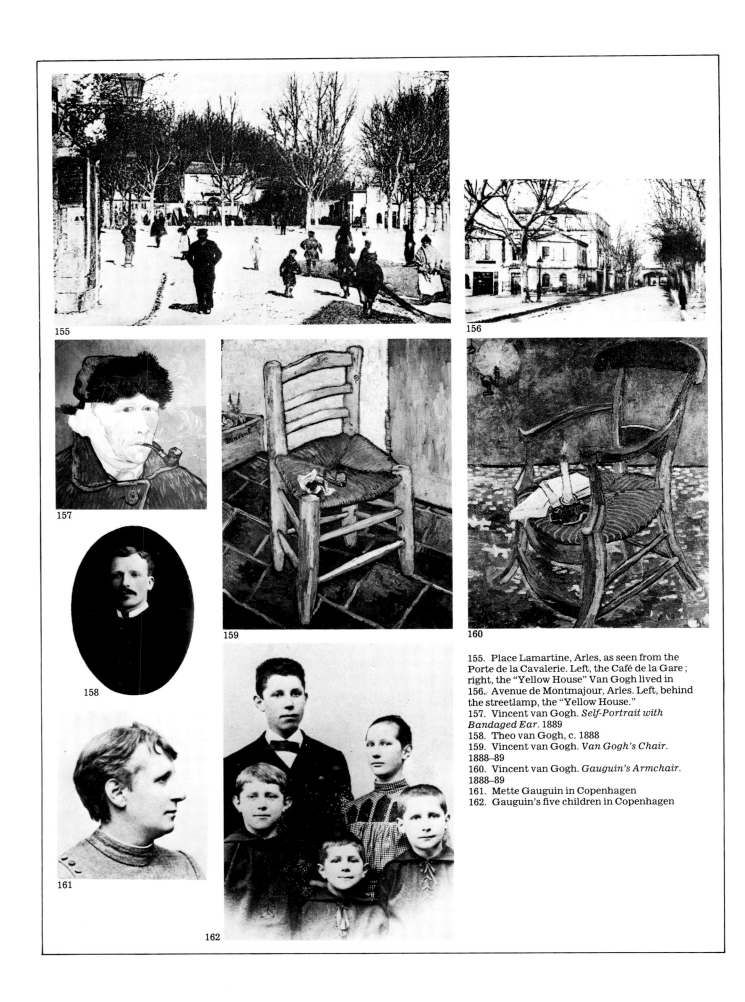

155. Place Lamartine, Arles, as seen from the Porte de la Cavalerie. Left, the Café de la Gare ; right, the "Yellow House" Van Gogh lived in

156. Avenue de Montmajour, Arles. Left, behind the streetlamp, the "Yellow House."

157. Vincent van Gogh. *Self-Portrait with Bandaged Ear*. 1889

158. Theo van Gogh, c. 1888

159. Vincent van Gogh. *Van Gogh's Chair*. 1888–89

160. Vincent van Gogh. *Gauguin's Armchair*. 1888–89

161. Mette Gauguin in Copenhagen

162. Gauguin's five children in Copenhagen

man who came from afar and who is going far" watched the day break through the golden mists.

But he was too early! Reassured by the arrival he had waited so long for, Vincent was sleeping the sleep of the just. The day before, he had proudly shown Gauguin's self-portrait to the proprietor of the Café de la Gare; so when Monsieur Ginoux saw the mustached traveler brimming with manly self-confidence, he recognized him immediately. "Yer 'is pal!" He served up a bowl of coffee and pointed across the Place Lamartine. Monsieur Van Gogh lived in the right half of that little yellow house over there, between Monsieur Crevoulin's grocery and the Avenue du Montmajour. (While under the spell of Provence, its tenant painted a touching picture of the *maison jaune,* and that is all that remains of it today.) Vincent had bent over backward to provide what amenities he could.

Gauguin roused his friend from his dreams and made no comment about the untidy "appointments" that smacked of confirmed bachelorhood. No sooner had he moved in than he found himself being dragged into town by a guide nearly as excited as the angel of Bethlehem announcing the coming of the Messiah.

They crossed the stark, level square and ambled along the edge of the little public garden—the setting for their pictures of women walking against the mistral wind—took the Calvary Gate past the battlements, and ended up in the nearby Rue des Récolets. From here one could reach most of the establishments in the red-light district. In the one run by Mme. Virginie, Vincent indulged in what he called his "hygienic" practices; Paul, who had no intention of living a monk's life in Arles, followed suit. The proprietress and young Gaby (alias Rachel)—she was the Dutchman's favorite, though she was as shy as he was—did them the honors of the house. ("Hygiene and regular copulation, with independent work, and a man can muddle through. I can just see you now," he wrote a month later, "Schuff the Virtuous, wide-eyed at these earthy words! Take things easy, eat well, screw well, work ditto, and you'll die happy." "In Gauguin," Van Gogh reported to Bernard, "blood and sex prevail over ambition." From there they proceeded to the amphitheater, the crown high above Arles that burst with commotion whenever there were bullfights or celebrations held by the *félibrige* society. The ancient, fun-loving city that Vincent found so delightful only bored his companion. "I am all at sea," he later confided to Emile Bernard. "I find everything here—the scenery, the people—so petty, so paltry."

They paused in front of the hieratic portal of Saint Trophime—"so cruel, so monstrous, like a Chinese nightmare," according to Vincent, although Gauguin did not concur in the least—made their way along the Promenade des Lices, and finally reached the wonderful Allée des Alyscamps. A pall of nostalgia hung over the huge sarcophagi, forever bereft of their dead. Gauguin was fascinated by the unofficial escort of desecrated tombs and golden poplar trees leading to the pale polygonal tower of the Chapel of St. Honorat.

Romanticism versus Primitivism

Discussions between the two friends about theory—that art was as much a "thing of the mind" as of the senses—got off to a good start. However, they did not see eye to eye when it came to preferences in art. As Vincent realized that his opinions did not meet with Gauguin's approval, his dismay gave way to intransigence; for here was a serious stumbling block to the future community of painters Gauguin himself was supposed to lead. Had they misjudged each other: wrong partner, wrong time and place, or, worst of all, wrong ideal?

Van Gogh was inspired to paint like Daumier or Monticelli; Gauguin was reminded of Puvis de Chavannes, with a Japanese flavor. Vincent rejected Ingres, Raphael, Degas, and Cézanne, the very artists Gauguin idolized. Vincent would talk about the Bible; Gauguin, about the *Odyssey*. "He is a romantic and I lean rather toward the primitive," wrote Gauguin. As he walked along the embankments of the river, near the drawbridges over the canals, an enraptured Van Gogh was transported back to his native Holland. But the painter of Pont-Aven was already longing for the sunken footpaths of his adopted Brittany, his circle of youthful admirers, and Madeleine, the "mystic muse" of that sweet summer past.

"Between the two of us," Gauguin later wrote in *Avant et Après,* "one a volcano, the other seething also, but within, a struggle was in some way brewing." Although they thought highly of each other, were both diligent workers, and influenced each other in subtle ways, a strange rivalry, with just a hint of jealousy, developed between them. Abetted by absinthe, it was to intensify and chafe until that inevitable, shattering night before Christmas. No sacrifice was too great for Vincent if it increased the chances of salvaging his Studio of the South—none except his right as a painter to impregnate nature with something incalculable and divine, just as his obstinate *Sower* casts seeds to take root where they may. For his part, Gauguin was more concerned with gathering in the fruits of his labor.

Money Woes, Mortal Wounds

We shall probably never know all there is to know about that secret struggle on the banks of the Rhone, but it brings to mind the one between Jacob and the Angel—a Jacob who had not forgotten that on the other side of the river he had left behind a wife (eager for his money because she could not have his fidelity) and five children with no father to love them. He was doing battle for them, too! The two artists' friendship had already soured, but he had to make the best of it and put up a front so as not to dampen his dealer's spirits. "Degas thinks very highly of Gauguin's work," Theo reported to his sister Wilhelmina on December 6. "He is even tempted to stop by and pay him a visit in Arles. How happy they are!" he added, referring to his brother and Gauguin. "That's what I call living."

Unfortunately, the inconvenience of cramped quarters was to outweigh the joy of unfettered creativity. Somehow or other, they did what they could to get along better, as Gauguin later recalled in *Avant et Après.* "In a box there would be so much for our 'hygienic' nighttime strolls, so much for tobacco, so much for unforeseen expenses. . . . We stopped going to our little restaurant, and with the help of a little stove I did the cooking, while Vincent laid in the provisions. . . . Once, however, Vincent tried to make a soup, but how he mixed the ingredients I cannot say. No doubt the same way he did his colors on his canvases. At any rate, we couldn't eat it. . . . On the wall he wrote in chalk: *Je suis sain d'Esprit, Je suis Saint-Esprit* [I am of sound mind, I am the Holy Ghost]."

For the painter of sun, stars, cypress trees, and frenzied wheat fields, this may have been a way of warding off the insanity he felt creeping up on him even before Gauguin came to Arles. "I do not believe that my madness is persecution mania," he had already declared to his soulmate, the gentle Theo, "since in a state of overexcitement my feelings lean rather toward preoccupation with eternity. . . . Just the same, I must beware of my nerves."

Gauguin was increasingly wary of them, too. Whenever he had to broach touchy subjects—earning income, cutting corners—he "could only do so with much caution and considerable wheedling" not in keeping with his nature. Vincent, for his part, reproached himself endlessly for not being able to find buyers for his paintings. All the while, each of

them kept in touch with Theo and close friends as much to set their own minds at rest as to reassure those near and dear to them.

October 27. Gauguin to Theo: "Your brother is indeed a bit jittery, but little by little I hope to quiet him down."

October 27. Vincent to Theo: "The things he tells me about Brittany are most interesting. . . . All the same, he still likes what he sees, just as I do, and is intrigued above all by the Arlésiennes."

November 5. Vincent to Theo: "He is working on some women in a vineyard, absolutely first-rate stuff. . . . Also, a picture of the same night café I painted. I've done two paintings of falling leaves that Gauguin liked, I think."

November 6. Vincent to Bernard: "Now here's something that will interest you. We've made a few excursions to the brothels, and it is likely that we'll end up going there frequently to work."

November 14. Gauguin to Theo: "Good old Vincent and Gauguin the shrew are still getting along well together. . . . But hang it all, this blasted rainy weather is a dreadful nuisance. Can't go outside, so we've taken to painting without models."

November 22 or thereabouts. Gauguin to Theo: "I've just sent out a roll of canvases parcel post: some women dancing; a night café; a landscape, or three graces at the temple of Venus [the actual subject is the Allée des Alyscamps]; pigs; the grape harvest, or the pauper woman. The latter two are rather virile, I think; if people say they're on the vulgar side, it's because the southern sun brings out the lust in us!"

Around December 3. Vincent to Theo: "Gauguin working a great deal. . . . He's working on a portrait of me that I expect he'll finish up, but at present he's doing more landscapes. . . . You know he's been asked to show work with Les Vingt. He's already taken it into his head to settle in Brussels, which I'll admit would be one way for him to see his Danish wife again. In the meantime, he's been doing pretty well with the Arlésiennes. . . . He's a married man but doesn't act very much the part."

Around December 15. Gauguin to Mette: "Enclosed 200 francs. Kindly *acknowledge receipt*. . . . If it's not too much of a strain, you might avail yourself of the opportunity to send me news of the children. I have heard nothing about them for a very long time."

The Breaking Point

Tension between Paul and Vincent continued to mount. Even their humble friends—Lt. Milliet, a Zouave and amateur painter, Mr. and Mrs. Ginoux, the postman Joseph Roulin and his wife, the "regulars" from the brothel—could not take their minds off it any more. With the situation threatening to come to a head, Gauguin decided to settle things once and for all and discussed his future course of action with Theo. "I should be grateful if you sent me some of the money you've taken in from my pictures," he wrote in a long letter dated December 18. "All things considered, I must return to Paris. Vincent and I simply cannot live together without complications, due to incompatibility of temperament, and both he and I need peace and quiet for our work. He is a man of remarkable intelligence whom I think very highly of and whom I leave with great regret. . . ." By and by, however, he regained his composure. "Dear Monsieur Van Gogh. Kindly look upon my trip to Paris as a figment of the imagination and, therefore, the letter I wrote you as a bad dream. . . . We were in Montpellier. . . ."

Montpellier is where Gauguin had copied Delacroix's *Mulâtresse* in 1883; and with this visit still fresh in his mind, he had suggested, probably to relieve tension, that Vincent and

he go to see the extensive collection in the Musée Fabre. The excursion did not help straighten things out between them; in fact, it had just the opposite effect. "Our discussions are *extremely electric*," Vincent reported to his brother. "Sometimes we come out of them with our heads as tired as a battery after it has been discharged." What's more, there was something about Delacroix's portrait of Bruyas that disturbed him deeply. "A gentleman with reddish-brown hair and beard who's a dead ringer for you or me . . . made me think of those lines from Musset: 'Wherever I set foot, a wretch garbed in black would come and sit by us and watch us like a brother.'" The striking resemblance only made the anguish more palpable, for he sensed that the fate of his relationship with Gauguin had already been sealed. "You see such strange things when friends try to live together as equals, and I'll close now because you always say 'Time will tell.'" For his part, Gauguin was discussing matters with Schuffenecker. "You are waiting for me with open arms, and I thank you for that, but unfortunately I'm not coming yet. . . . My situation here is very awkward. I owe a great deal to [Theo] Van Gogh and to Vincent, and although we've had our differences, I cannot be cross with an excellent fellow who is sick, is suffering, and asks for me. . . . In any event, I am staying here, but my departure will remain a possibility. Legend has it that the Inca came straight from the sun, and thither shall I return."

How much longer could Gauguin put up with the stress and strain? He was taking too much upon himself. Like a sleepwalker, Vincent would get up at night and come toward his bed. "What's the matter, Vincent?" Gauguin would ask as gently as possible, then send him back to bed.

They were having a glass of absinthe together one Saturday evening—December 22, to be exact—when they got into a heated discussion. Could it have had to do with the marketability of their work? More likely than not. Vincent threw his glass at Gauguin, who promptly grabbed him and escorted him out of the café. Before long Vincent was in bed, sleeping it off. The next day, while Van Gogh was apologizing for having offended him, Gauguin calmly told him that, lest he throttle him the next time, he had better take his leave and that he intended to inform Theo of his decision.

What a tense, tightlipped, heart-rending Sunday that must have been! During dinner, Gauguin suddenly got up from the table and went out into the square for a breath of fresh air. As Gauguin later told it in *Avant et Après*, Vincent, wielding a razor, caught up with him and mumbled, "You are uncommunicative; I shall do likewise." But, overpowered by the look Gauguin gave him, he headed back to the *maison jaune*. He then cut off part of his left ear, rushed to the brothel, and, like a wounded bullfighter, presented it to Rachel. It was 11:30 P.M. He went home, closed the shutters, lighted a lamp near his window, and shrouded his bloodstained body in his sheets. Rachel—she had fainted, but come to—and a flustered Mme. Virginie called the police. On the morning of the 24th, officers searched the premises and found Vincent lifeless. Gauguin, who had spent an almost sleepless night at the hotel, arrived at the scene to find crowds milling about. The police accosted him.

"What have you done to your pal?"

"What do you mean?"

"Come, come, . . . you know perfectly well what we mean. He's dead."

"I would not wish a moment like that on anyone," Gauguin later confessed.

After he regained consciousness, Vincent asked for Gauguin, his pipe and tobacco, and their cash box. They took him to the hospital. Not wishing to see Van Gogh again, Gauguin wired Theo to come down and help his brother, who was suffering from an "attack of high fever with delirium." Gauguin left Arles posthaste and took refuge with the Schuffeneckers in Paris.

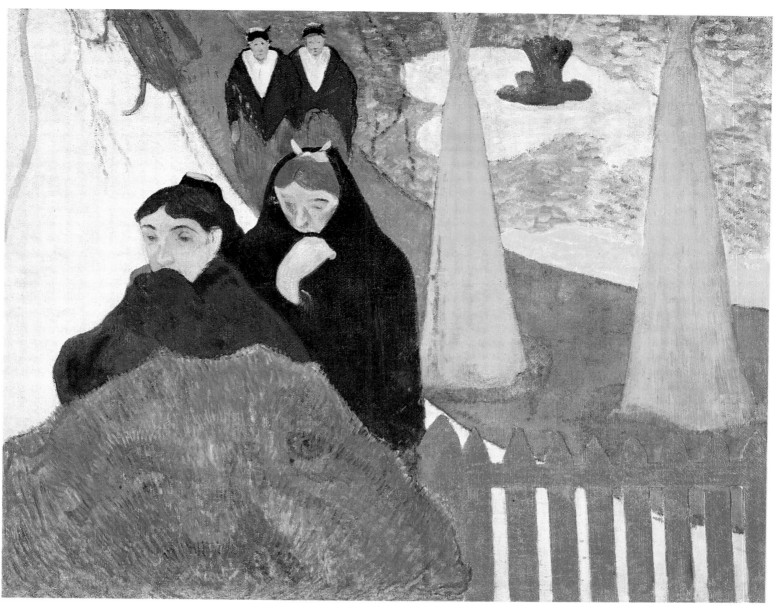

163. Gauguin. *Old Women of Arles*. 1888

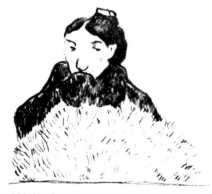

164–65. Gauguin. Studies for *Old Women of Arles*

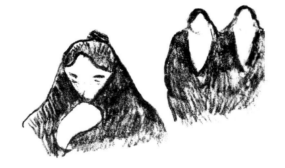

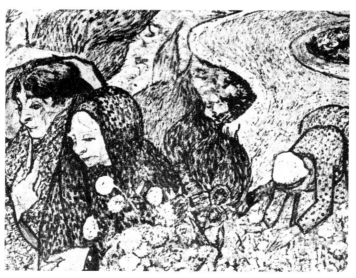

166. Vincent van Gogh. *Memory of the Garden at Etten*. 1888

I n late November, 1888, both Van Gogh and Gauguin painted some Arlésiennes walking against the chilling mistral in the public garden opposite the "yellow house" they were living in at the time. Both of them opted for Japanese-inspired composition and a similar palette ranging from blue to orange and red. Reminded of his mother strolling in the family garden back in Etten (as he later wrote to his sister Wilhelmina), Vincent remained under the sway of Pointillism. Gauguin, however, leaned toward a decidedly synthetic approach. He gave his version of the scene an almost religious quality and went so far as to sketch the face of a monster in the bush in the foreground. "It's strange," he wrote to Emile Bernard. "Vincent is inspired here to paint like Daumier, I on the contrary like Puvis with a Japanese flavor. The women, with their Greek beauty and shawls falling in folds like the primitives, are like Greek friezes." He gave the Arlésienne leading this procession the features of Madame Ginoux, whom he later painted in Café at Arles.

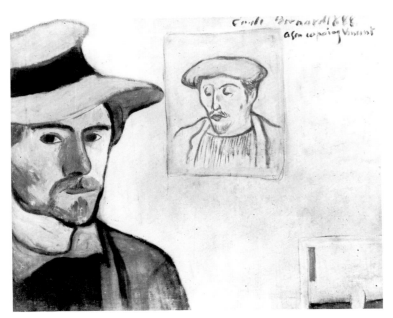

167. Emile Bernard. *Self-Portrait: à son Copaing Vincent.* 1888

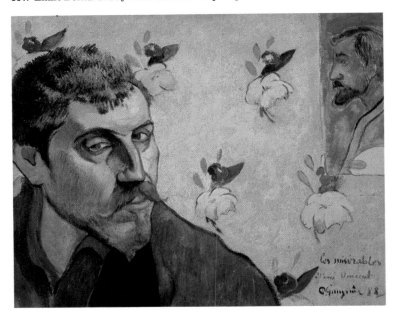

168. Gauguin. *Self-Portrait: "Les Misérables."* 1888

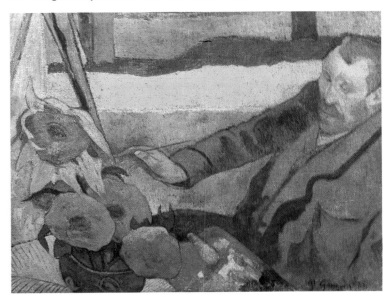

169. Gauguin. *Van Gogh Painting Sunflowers.* 1888

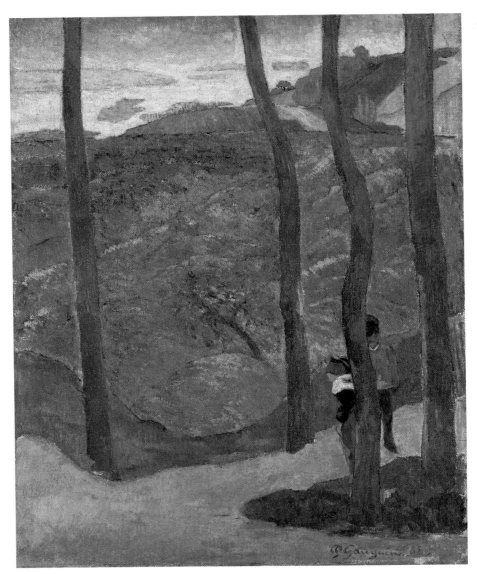

170. Gauguin. *Landscape with Blue Trees.* 1888

estiges of a friendship that was as unstable as it was intense, these illustrations attest not only to a flurry of portrait-exchanging, but to the subtle influences that Van Gogh and Gauguin exerted on each other. Before Gauguin joined him in Arles, Vincent had asked both him and Emile Bernard to send him their self-portraits from Pont-Aven in exchange for his. He already had a portrait of young Emile's grandmother: its heavy outlines and stylized features, inspired by the exaggerated, masklike faces of Kabuki actors, may have later influenced Gauguin's portrait of Madame Roulin. (In the background of the portrait of Madame Roulin we see a path from his Landscape with Blue Trees.) "I have my eye on young Bernard," Gauguin wrote to Van Gogh. "Maybe I'll do him from memory, but in any event it will be an abstraction." On October 8 he wrote to Schuffenecker. "I've done a portrait of myself for Vincent It is, I believe, one of my best pieces of work A brigand's head, at first glance, a Jean Valjean [Les Misérables] who also personifies a discredited Impressionist painter." Gauguin later told in Avant et Après how he did Vincent's portrait. "I hit upon the idea of painting his portrait while he was painting the still life subject he was so fond of—sunflowers. When the picture was finished, he said to me, 'It's me all right, but me gone mad!'" To his brother, Vincent declared: "It's me all right, but extremely tired and charged with electricity." Even then he had a premonition of his breakdown.

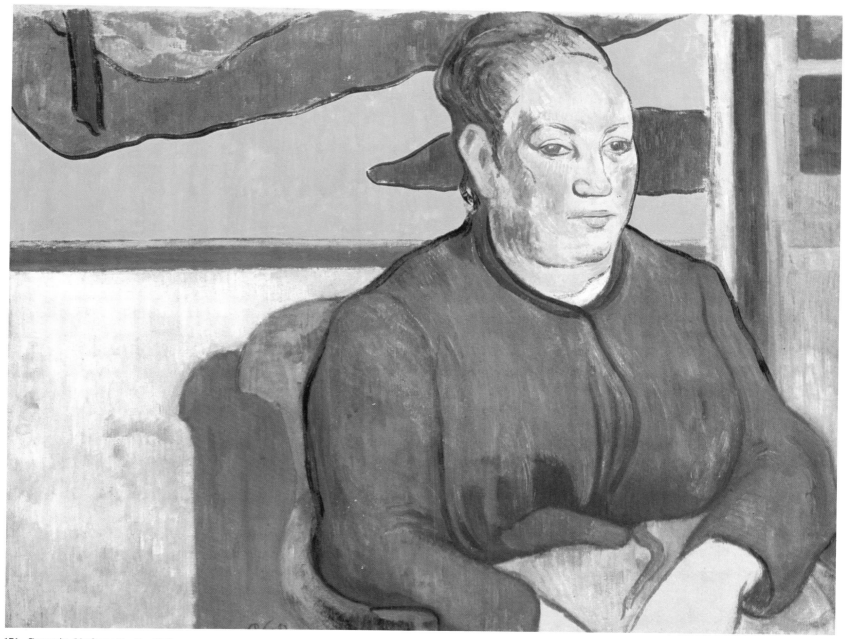

171. Gauguin. *Madame Roulin*. 1888

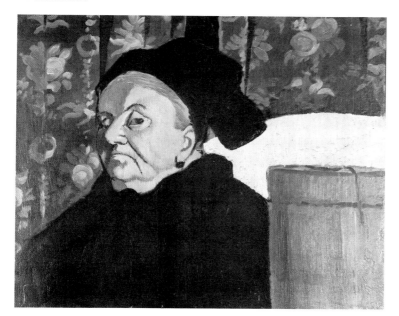

172. Emile Bernard. *Portrait of the Artist's Grandmother*. 1887

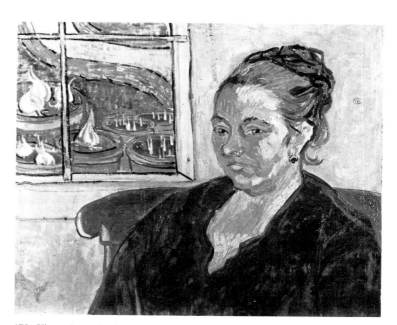

173. Vincent van Gogh. *Portrait of Madame Augustine Roulin*. 1888

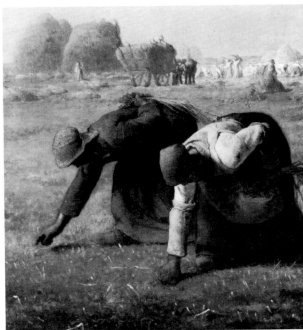

176. Jean-François Millet. *The Gleaners* (detail). 1857

174. Camille Pissarro. *Washerwoman.* 1878–81

175. Gauguin. *Washerwoman* (sketchbook)

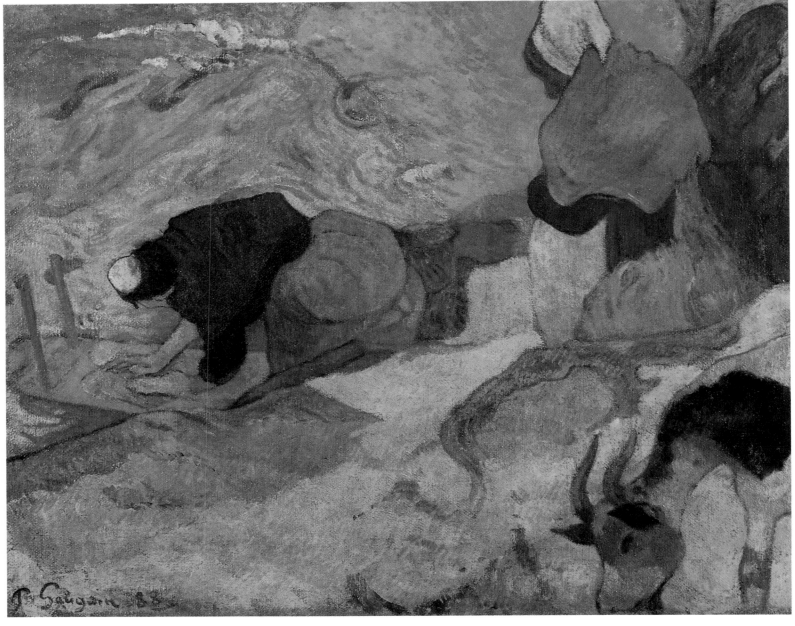

177. Gauguin. *Washerwomen.* 1888

100

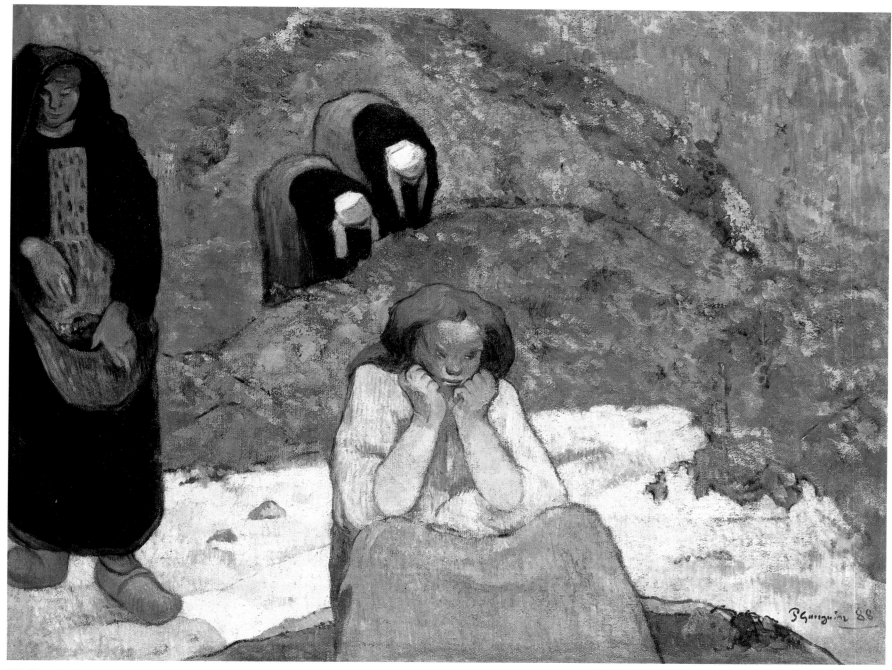

178. Gauguin. *Grape Gathering: Human Misery.* 1888

I n the spring of 1888, Van Gogh painted some washerwomen rinsing
their laundry in the Arles canal, not far from the drawbridge over the
Langlois. That fall, Gauguin painted the same subject, borrowing
from drawings by Pissarro, just as Millet's gleaners later served as models
for some women picking grapes in a setting that also inspired Van Gogh.
He described his Grape Gathering: Human Misery *to Emile Bernard as
follows.* "Purple vines forming triangles against an upper area of chrome
yellow. On the left, a Breton woman of Le Pouldu in black with a gray
apron. Two Breton women bending over in light blue-green dresses with
black bodices. In the foreground, pink ground and a pauper woman with
orange hair, white blouse, and a skirt (verditer mixed with white). All
done in heavy outlines filled with almost uniform colors laid on very thick
with a palette knife on coarse sackcloth. . . . I have put some Breton
women into it—so much the worse for accuracy." The wretched woman
with Mongolian features seems to embody the plight of women in all their
misery. Possibly a reincarnation of the sensational Peruvian mummy in
the Musée de l'Homme, this disconsolate figure crops up repeatedly in
other paintings, wood reliefs, and engravings by Gauguin. Above all, she
brings to mind the figure huddled at the left of Baron Gros's Napoleon
Visiting the Plague-Stricken at Jaffa *(1804), which Jean Benner reprised
in* Young Woman in a Ravine near Caprile, Salon of 1881.

179. Jean Benner. *Young Women in a Ravine near Caprile.* 1881

101

"**M**me. Ginoux, Mme. Ginoux, your portrait will hang in the Louvre in Paris!" Gauguin prophetically exclaimed as he tried to persuade the wife of the proprietor of the Café de la Gare to sit for him. Judging by her ironic smile, Mme. Ginoux seems to have her doubts. He placed her in the foreground of the same bistro Van Gogh had already painted, which was a stone's throw from their maison jaune. Behind the billiard table in back of her we see at one table the postman Roulin and three contemplative prostitutes; an exhausted customer is slumped over another table shared by a Zouave who is staring vacantly into space. A trail of smoke wafts across the room, lending a touch of nostalgia to what Gauguin considered the somewhat too "vulgar" atmosphere of this intimist scene. It delighted Vincent, however, who was so inspired by Mme. Ginoux's stately, aloof demeanor that he painted her portrait a number of times. Here, in Gauguin's Café at Arles, the walls serve as a fiery red backdrop to contrasting midnight-blue figures already lost in their evening thoughts; a cat purrs at the foot of the billiard table. On a charcoal sketch of Mme. Ginoux, he noted, "Eye not so close to the nose; sharp edge at nostril." The finished portrait hangs not in the Louvre, but in the Pushkin Museum in Moscow.

181. Gauguin. *Café at Arles (Madame Ginoux)*. 1888

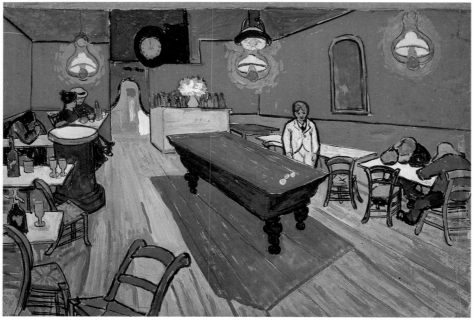

180. Vincent van Gogh. *The Night Café*. 1888

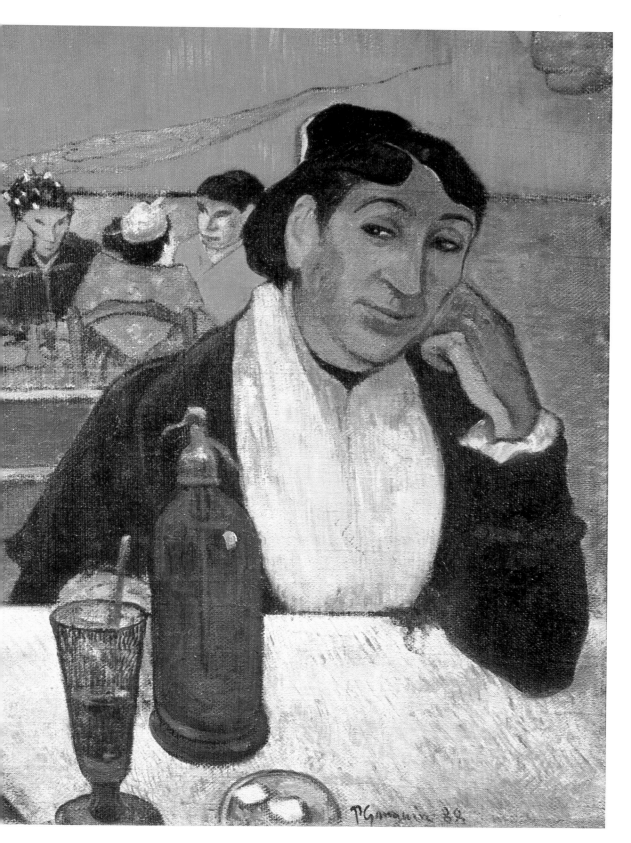

182. Gauguin. *L'Arlésienne: Madame Ginoux.* 1888

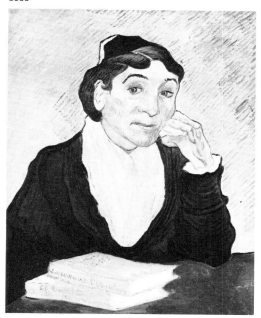

183. Vincent van Gogh. *L'Arlésienne: Madame Ginoux.* 1890

184. Vincent van Gogh's house in Arles, the "Yellow House," before its demolition

185. Vincent van Gogh. *The Yellow House.* 1888

103

186. Gauguin. *The Yellow Haystacks*. 1889

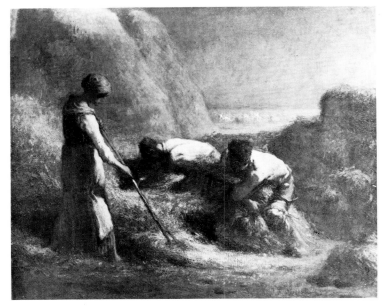

187. Jean-François Millet. *The Haybinders*. 1850

In Racontars de Rapin (1902), a long article written in the Marquesas Islands, Gauguin inveighed against art critics for their stupidity and pretentiousness. He also singled out Jean-François Millet as one of the preeminent painters of the second half of the nineteenth century. One thing is certain: his admiration for Millet was as deep and abiding as that of his mentor Pissarro and his friend Vincent van Gogh. Long before Gauguin, the peasant painter from the Cotentin had celebrated the Virgilian beauty of country life and demonstrated at Barbizon how cleansing and fruitful a return to the earth could be. Gauguin's The Yellow Haystacks owes as much to Millet's The Haybinders—the ones Théophile Gautier thought so highly of—as to the golden harvests of Finistère. Thus, from one generation to the next, the giants of painting prompt one another, suggesting moods and prescribing forms. Witness one artist's tribute to his predecessors: Woman in the Hay and the naked back already painted by Delacroix and Millet.

188. Gauguin. *Woman in the Hay*. 1888

189. Eugène Delacroix. *Death of Sardanapalus* (detail). 1827–28

190. Jean-François Millet. *Nude* (Study for *Les Regrets*). c. 1846

191. Gauguin. *Study for "Woman in the Hay."* 1888

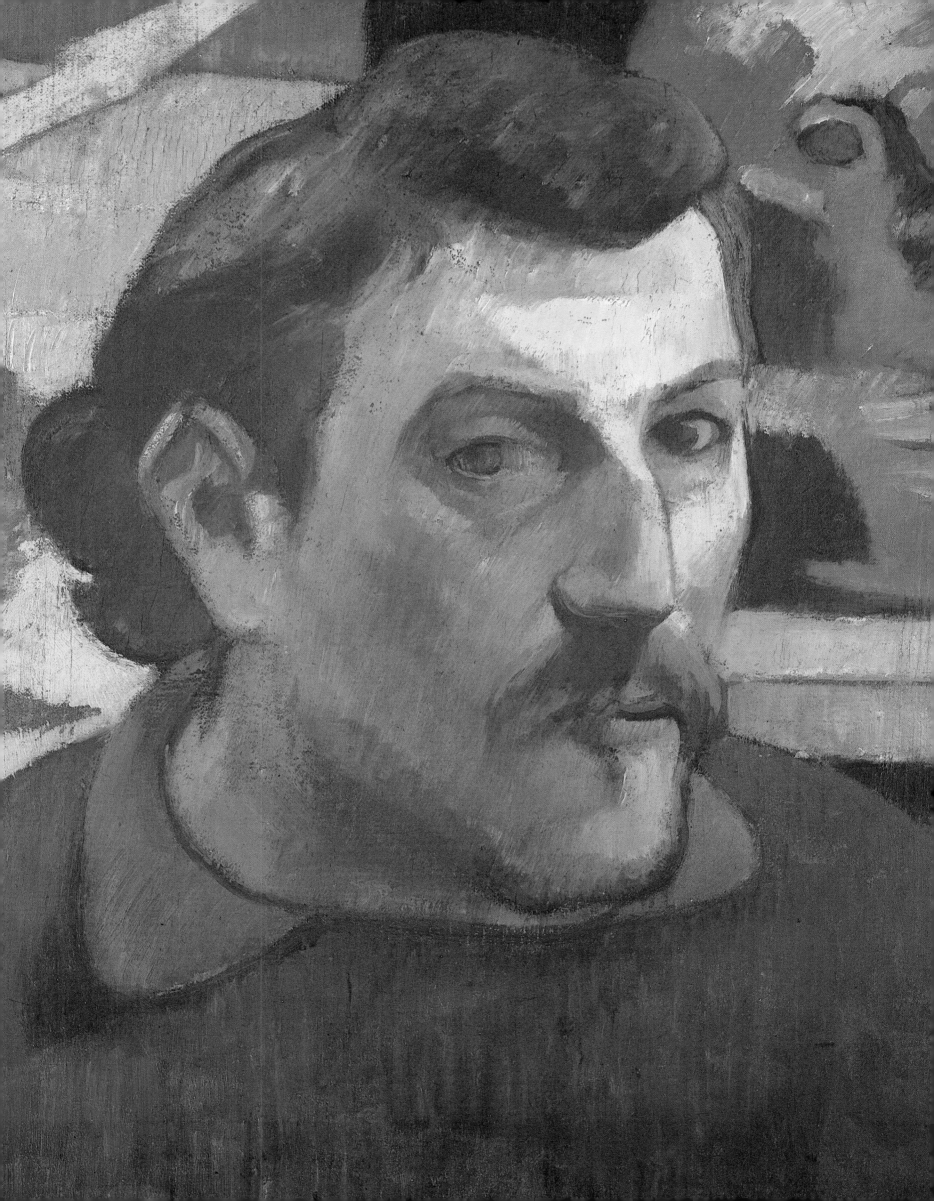

6

The School of Le Pouldu and Dreams of Departure

January 1889–March 1891

193. Paul Gauguin, c. 1889

A few months after Gauguin stole out of Arles, Vincent van Gogh cautioned his brother against the "shortcomings of that holy terror," that temperamental friend of his. "It is appalling, the turmoil of [his] incompatible desires and needs."

How true that was. Gauguin no longer had a clear idea of what he would do next, where he would go next, to what comforting female companion he could pour out his troubles. His unfulfilled wishes were many and conflicting. Should he return to Denmark and thereby win back his family? Proceed to the exhibition of Les Vingt and perhaps settle in Brussels? Head back to the Caribbean? Backtrack to Pont-Aven and bask once again in the cheerful ambiance of his budding school of painting? Last but not least, he was eager to capitalize on the upcoming World's Fair that was the talk of Paris in 1889. Here was his chance to flaunt his Synthetism for all to see, to make a dramatic move that would set him apart from the common herd of Impressionists and Neo-Impressionists.

Now that Theo van Gogh had neatly reimbursed him for the expenses he had incurred in Arles, Gauguin thought it best not to depend too heavily on the Schuffeneckers' hospitality. On January 5, 1889, he rented a studio (25 Avenue Montsouris) "where I sleep," as he put it to Vincent at the end of the month; his downstairs neighbor was the caretaker. Having made numerous inquiries about current opportunities, he shut himself up and, on Theo's advice, turned out ten zincographs of Martinique, Breton, and Arles

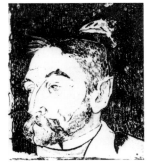

194

195

196

197

198

199

200

194. Poster announcing the exhibition organized by Gauguin and his friends at the Café Volpini during the Paris World's Fair, 1889
195. Catalogue cover for the Volpini exhibition
196. Gauguin. *Portrait of Mallarmé with a Raven*. 1891
197. Grands Sables beach at Le Pouldu and the house called "Le Pendu," motif of a Gauguin painting
198. Gauguin. Sketched self-portrait as an Indian
199. The Saint-Maudet Chapel overlooking Le Pouldu
200. Polychrome Breton statue in the chapel
201. "La Buvette de la Plage," Marie Henry's inn at Le Pouldu
202. The dining room of "La Buvette de la Plage," Le Pouldu, 1924. On the wall, left to right: *Joan of Arc* by Gauguin, *Breton Women Stretching Hemp* by Meyer de Haan, and *Goose* by Gauguin (see also 418)

201

202

subjects in black ink on yellow paper—"a series of lithographs for publication so that I can get some exposure." He did some sketches of market porters at work in Les Halles, dabbled in pottery again, and began the quizzing portrait of "good old Schuff" and family. "The Schuffeneckers have lots of nice things to say about you," he later wrote to Mette. "You rate high with Schuffenecker when he compares you with his pest [of a wife]. There's another one who's had it up to here with marriage." That wasn't the only thing distressing him: business in Paris was going from bad to worse, "with Stock Market crashes occurring daily."

Business was no better at the exhibition of Les Vingt in Brussels. Not one of Gauguin's pictures was sold, though they did win high praise from Octave Maus, founder and secretary of Les Vingt. "I find the primitive quality of his painting as appealing as the charm of his color schemes," he wrote in the March 2 issue of *La Cravache*.

Gauguin did not know what to do next and in February took refuge in Pont-Aven. He later unburdened himself to Emile Bernard. "Moments of doubt, results that always fall short of our expectations, scant encouragement from others—all this helps to flay us with thorns. . . . In the end, painting is in a constant struggle against matter. . . . Corot, Giotto attract me with something quite apart from the solid qualities of their painting. You know the high opinion I have of what Degas is doing, and yet there are times when I feel that he lacks that certain something over and above: a heart that beats. The tears of a child are something, too, though there is not much learning in them."

It was this "extra measure of feeling" inspired by plain women and their guileless children that Gauguin went off to rediscover in Pont-Aven while all of Paris swarmed about the Eiffel Tower in breathless anticipation of the World's Fair. Marie-Jeanne Gloanec cheerfully extended credit to him. However, aside from occasional visitors—there was old Lapuce, so named because his shoulder had a nervous twitch—Gauguin had no one to talk to at mealtime.

The painter was fidgety, too, with impatience. He did not wish to look on from the sidelines while art exhibitions opened at the World's Fair. Starting in early May, the whole world would be pouring through its gates into the Champ de Mars, site of a palace set aside for the Centennial Exhibition of the fine arts establishment (not counting a dozen Manets and a sprinkling of Monets and Pissarros). But no Gauguins!

An Exhibition for "Our Group"

Not far from the official art section stood the Café des Arts, whose owner, an Italian by the name of Volpini, was still waiting for some mirrors that were supposed to have been delivered in time for the opening of the fair. Schuffenecker hit upon the idea of asking Volpini if he would be willing to hang pictures by some painter friends of his instead. Gauguin jumped at the chance as soon as he got word of the scheme and wrote back to Schuffenecker at once. "Bravo! You've pulled it off! See [Theo] Van Gogh and attend to everything until the end of my stay here. Bear in mind, though, that this is not an exhibition for the *others*. Consequently, let's arrange it for a small group of friends, and from that point of view I wish to be *represented* as much as possible." He drew up a list of ten of his paintings and suggested that Guillaumin, Bernard, Ray, Fauché, Vincent van Gogh, and Schuffenecker contribute another forty. "That should suffice. I, for one, refuse to exhibit with the *others*—Pissarro, Seurat, etc. It's our group!"

When Theo objected to seeing Vincent admitted to the World's Fair "through the service entrance," as he put it, Gauguin replied by way of explanation that "I've coordinated this

little exhibition at the *Universelle* to demonstrate what had to be done *en masse,* to show that it could be done at all." And the conclusive proof that he had done the right thing was that "Pissarro and the *others* don't like my exhibition; *therefore,* it must be good for me." Guillaumin pulled out, but Anquetin and Georges-Daniel de Monfreid filled the void. In the end, the walls of Volpini's café were covered with almost one hundred pictures by an impromptu group, which posters announced as "Impressionist and Synthetist." Gauguin showed seventeen paintings in all, and, as the catalogue pointed out, an album of lithographs by Paul Gauguin and Emile Bernard was "available on request."

"A Still Unknown Part of Myself"

While in Paris to take in the fair, Gauguin went into raptures over the Far Eastern sections, lingered in the Javanese village, and enthusiastically described Hindu dances to Bernard. "The art of India is all here, and it is exactly like the photos I have of Cambodia." He urged Bernard to meet him there. "I'm coming back this Thursday because I have an assignation with a mulatto woman." Another of his favorite attractions was Buffalo Bill's cowboy show.

Alas, as the days wore on, it became increasingly clear that the Volpini exhibition was not destined to win public acclaim. The critics waxed ironic. "To get near these pictures," wrote Félix Fénéon in *La Cravache* (July 6, 1889), "you run a gauntlet of sideboards, beer pumps, tables, the bosom of Monsieur Volpini's cashier, and an orchestra of young Muscovites whose bows unleash music unrelated to the polychromatic works displayed in the huge room." But Aurier countered with a piece in *Le Moderniste* at the urging of Emile Bernard. "In most of the works shown, and especially in those by Gauguin, Bernard, Anquetin, etc., I seem to have noticed . . . a marked tendency toward a synthesis of line, composition, and color, as well as an effort to simplify the means of expression, which struck me as most interesting at a time when mere cleverness and outright trickery are the rule." Moreover, the show had caught the attention of the fledgling painters from the Académie Julian, the future Nabis. Back in the fall of 1888, Maurice Denis, Bonnard, Vuillard, Roussel, Ranson, and Maillol had been captivated by Sérusier's *Talisman;* and it was at Sérusier's urging that they went to inspect the pictures in the Café des Arts. Spellbound, they realized then and there that, as Maurice Denis later put it, "a painting, before being a war horse or a nude woman or an anecdote, is essentially a flat surface covered with colors arranged in a certain order." Lastly, had it not been for this exhibition, Charles Filiger, a Colarossi student who purchased an album of Gauguin's lithographs, and Jacob Meyer de Haan, a Dutch friend of Theo van Gogh, might never have discovered his work. Later on, they were to become two of Gauguin's staunchest friends in Pont-Aven and Le Pouldu; De Haan, in particular, was to prove as openhanded as he was docile.

It had been a rebuff nevertheless, and Gauguin headed back to Pont-Aven. Before long, the little village of mills was inundated by students from the Académie Julian: Filiger, his friend Colin, Moret, Jourdan, and Bouffar, who gave him boxing lessons. The Master thought it best to steer clear of the crowd. "What I want," he wrote to Bernard, "is to explore an as yet unknown part of myself!" Sérusier, too, longed for the "plain, barren wilderness of the coast." Meanwhile, Captain Jacob was escorting Gauguin to a rugged spot at the mouth of the Laïta River: Le Pouldu, a tiny hamlet in Clohars-Carnoët, almost squarely on the border between the Finistère and Morbihan departments. Arm in arm,

Gauguin and Sérusier made their way to the juncture of the Quimperlé and Clohars-Carnoët roads, checked into the Hôtel Destais on June 20, and made ready to share not just a room, but a "frenzied idealism" and predilection for Symbolism.

However, Gauguin did not sever all ties to his home away from home on the Aven; he shuttled back and forth between Le Pouldu and Pont-Aven a number of times. Besides, the prospect of setting sail for distant Tonkin was very much on his mind: that "terrible itching for the unknown" had come over him again when he discovered the captivating Annamese at the World's Fair. For the time being, however, he had lost his heart to Le Pouldu. "I am at the seaside, in a fishermen's inn near a little village of 150 souls," he wrote to Mette, "and I live here as a peasant and am looked upon as a savage. I spend 1 franc a day on food, 2 sous on tobacco. So, it can't be said I've been pampering myself, . . . and I am not getting any news of the children. . . ." Ten years later, when Gauguin was in Tahiti, Maurice Denis mentioned the possibility of reassembling the pictures from the Volpini show for an exhibition. "Back then," the painter replied, "I wanted to dare *everything,* first to liberate, as it were, the younger generation, then to work so that I might acquire a little talent."

Meyer de Haan also provided Gauguin with exhilarating companionship. "He really has his nose to the grindstone," he reported to Theo van Gogh, "induced by the air and lots of things that appeal to him. I like what he's doing. . . ." No sooner had they set up housekeeping in the Buvette de la Plage than De Haan took a fancy to the fetching innkeeper, Marie Henry (nicknamed Marie Poupée). In the autobiographical *Si le grain ne meurt* (If It Die), André Gide tells of his unexpected stopover in her establishment and subsequent discovery of the astonishing pictures some of the guests had painted.

Gauguin's Gang

Perhaps the advice André Gide later gave Nathanaël in *Les Nourritures Terrestres* was an allusion to the time when he witnessed the birth of the school of Le Pouldu: "What matters is not the things you look at, but the way you look at them." In any event, it would have been an apt motto for Gauguin and his cohorts. True, Gauguin had held court for admirers at the Maison Gloanec in Pont-Aven, but not to the extent he did at Marie Henry's inn. Le Pouldu was where the ingenuous, multicolored, symbolist soul of this painters' commune really coalesced. What bewitched them more—their distinguished, mystifying herald or the mystery and lightheartedness of Brittany—we cannot say.

"When I look back on that period of my life," Colin later wrote, "I cannot help seeing Gauguin as a Christ figure and us as his disciples. Devotion was the order of the day, and we loved things with religious fervor. The moneychangers in the temple were vilified with no less zeal." Another account comes down to us from Camille Maufra. "I arrived in Pont-Aven on July 14, 1890, or thereabouts. I had been there for several days . . . when a cart filled with what looked like a band of gypsies pulled into the square and stopped at the threshold of the inn. I sensed a gust of anger sweeping over some people. 'It's them Impressionists,' they said. One by one, they stepped out of the rustic cart: a tall redskin of a fellow, a blond-haired man with a head like Christ's, and a diminutive hunchback sporting a scarlet fez. Another old gent who had a frozen smile on his face was the last to alight. The redskin was Gauguin and the others, his disciples De Haan, Sérusier, and Filiger. . . . A friend of mine from Nantes, John Flornoy, had told me about Paul Gauguin, so I took the liberty of introducing myself to him. Halt! The young blond-haired man with the Christ-like head was standing guard at the door. 'If you deign to listen to the Word of the

Master, enter.' . . . De Haan, the little hunchback, sat opposite the Master. A native of Holland, he spoke French with some difficulty even though he was perfectly versed in our language; so he served up the following metaphor: 'We here are the crystal beads of a chandelier whose gleaming diamond, Paul Gauguin, adds brilliance and luster to everything.' I listened in. They discussed art and painting, and the thing that struck me most about the first meeting was this: all the talk was about applying pure colors, and it seemed to me that the most highly prized color was viridian along with chrome yellow.... There was dancing and merrymaking the next day. Like an overgrown child, Paul Gauguin fairly burst with glee, and the whole crew followed suit. I myself did likewise with a tall Dane, Y.-F. Willumsen, and his young wife. Moret was there, too. . . . The following day, the cart continued on its way to Le Pouldu."

Gauguin left Le Pouldu on February 7, 1890, but returned in late June and stayed on until November. He corresponded regularly with Theo van Gogh until Vincent committed suicide in Auvers-sur-Oise on July 29, 1890, a piece of news he took with supreme detachment. Now and again, the painter would expound on his unbridled ambition. "Today you are of the opinion that my latest works are better than the ones before," he wrote to Theo in late November of 1889.... I am trying at the same time to express a general state rather than a single idea, to cause someone else's eyes to get an impression that is unfocused, undefined. To *suggest* suffering does not mean a particular kind of suffering; purity in general, not a particular kind of purity." On the subject of God, he conceded, "I do not understand Him yet myself. Since He is infinite, my whole life is not enough to reach Him, find Him, fathom Him."

Many influences were brought to bear on Gauguin during his stint in Le Pouldu—the evangelical zeal of Vincent van Gogh, the theosophical leanings of Paul Sérusier, the biblical slant of Meyer de Haan, the mysticism of Filiger—all of which caused his yearning for transcendence to come to the fore as he painted Breton subjects. However, there were dips as well as peaks, severe letdowns as well as high hopes, and moments of creative impotence.

Dreams of Departure

Whether in Marie Henry's inn or in the studio he and Meyer de Haan rented together for a while in the nearby Villa Maudit, Gauguin seemed bent on having a good time with his chance acquaintances. Now and again his behavior verged on the outlandish. He flirted with Marie Henry's maidservant (who had become Meyer de Haan's mistress), helped Sérusier and Filiger decorate the walls, ceiling, and windows of the dining hall in the inn, rented a piano in Lorient to learn to play "intuitively," gadded about fields and cliffs letting out Indian war whoops, skulked about farms pretending to be a ghost, . . . only to sink into the depths of despair whenever the weather turned gloomy.

"Nothing remains of all my efforts this year but a hue and cry from Paris that reaches me here and discourages me so much that I am afraid to paint any more, and I drag this old body of mine along the shores of Le Pouldu while the north wind blows. . . . My soul is gone. Sadly it looks at the gaping pit before it, a pit in which I see a disconsolate *family* with no support from their father, not one heart to pour out my suffering to!" This in a letter to Bernard.

His thoughts were indeed with them, more so than he led people to believe. But with news from Copenhagen dwindling to an occasional report (as when his son Pola miraculously survived a fall from a third-story window), he ended up putting them out of his mind, or nearly so. "In your brief letter," he wrote to Mette, "you say that you believe me to be quite

miserable and you rightly say, Why weep over it? But wrongly that our lives are in shambles. Obviously, it doesn't do any good to weep. You cannot eradicate the past, but sometimes you can forget it."

The inner voice goading him to leave Europe for good made itself heard in his letters to his wife. "May the day come (soon perhaps) when I can go off and escape to the woods of some South Seas island and live there in ecstasy, in peace, and in art. With a new family, far from this European struggle for money. There, in Tahiti, in the still of beautiful tropical nights, I shall be able to listen to the soft, murmuring music of my heart beating in loving harmony with the mysterious creatures around me. Free at last, with no money worries, I shall love, sing, and die."

Return to the "Primitive State"

He wavered between Tonkin and Madagascar as he tried to secure "some post or other" or a special commission in the colonies through the kind offices of Countess de Nimal, an ardent admirer of Impressionism and a sometime visitor to Le Pouldu. There were consultations with Odilon Redon, whose wife hailed from the island of Réunion. Finally, he set his sights on French Polynesia.

Gauguin wanted to involve Emile Bernard and Meyer de Haan in the scheme he had been longing for ever since his stint in Arles: to start up a Studio of the Tropics. It was, in fact, Bernard who persuaded him to choose Tahiti over Madagascar, although Gauguin wrote, "True, Tahiti is a paradise for Europeans, but the trip is much more expensive." He needed money, people willing to purchase the paintings that Theo van Gogh was finding so difficult to dispose of. "The more I think about it," Gauguin wrote to him from Le Pouldu in July of 1890, "the more my mind is made up to go off and work like a savage in earnest. Everything urges me on in that direction: solitude, the East I've only had a glimpse of and which has yet to find an exponent in Europe." Alas, Theo's mind became unhinged after Vincent's death, and Gauguin vented his spleen to Bernard. "No two ways about it: I am hounded to no end by bad luck! Van Gogh's illness has dealt me a nasty blow, and if Charlopin doesn't come across with the wherewithal to go to Tahiti, I'm done for. . . . God, but it's taking a long time!" (Dr. Charlopin, a physician and inventor with patents to his credit, had met Gauguin through Louis Roy, a painter and former schoolmate of Schuffenecker's at the Lycée de Vanves.)

After finding accommodations with the Schuffeneckers in their new quarters at 12 Rue Alfred-Durand-Claye, in the Plaisance district, Gauguin spent the winter of 1890 roaming the streets of Paris, trying to turn connections with friends into the bolt from the blue that would vindicate his genius. Touched by grace, Charlopin finally promised to purchase 5,000 francs' worth of paintings, but he did not follow through and ended up settling for a few pieces of pottery. So there was Gauguin, his illusions dashed and nothing to show for it. His imagination had steered him wrong again.

"The reasons you give me for remaining in Europe are flattering rather than designed to convince me," he explained to Odilon Redon when the painter tried to bolster Gauguin's confidence. "My mind is quite made up, and now that I am back in Brittany I've had a change of heart. Madagascar is still too close to the civilized world. I shall go to Tahiti, and I hope to live out my life there. In my estimation, my art which you like is only in an embryonic stage and down there I hope to cultivate it for no one but myself in its primitive and savage state."

Obliging as ever, Emile Bernard bent over backward to help Gauguin. He managed to sell some of his paintings and appealed to critic Albert Aurier on his behalf. Gauguin returned to Paris in November, 1890, only to have a serious falling out with Schuffenecker. Consequently, when Georges-Daniel de Monfreid, whose studio at 55 Rue du Château was located near the Vaugirard ateliers, offered to take him in, the artist took him up on it. His mind was now set on one thing only: arrange for a successful auction of his work and raise enough money to settle in Tahiti. Even his intimate relationship with Juliette Huet, a young seamstress and a friend of de Monfreid's mistress, Annette Belfis, could not distract him from his *idée fixe*. (She was carrying his child when he set sail for Polynesia on April 1, 1891.) What he needed was to create a flurry of interest in his prophetic work by exaggerating its importance as the advent of a new art form. To do this, however, he had to attract the notice of the newspapers and literary circles of a capital obsessed at the time with Symbolism, a movement that had Verlaine as its augur, Mallarmé its leader, and Charles Morice its bard. Since Symbolist was the thing to be, let them be it!

"Be in love, be mysterious, be Symbolist," Signac wrote derisively when Gauguin took to hanging about the literary cafés of the Odéon. "Be Boulangist, be always dapper, be grenadine, only begone, blasted Gauguin!" The Symbolist writers who congregated at the Café Voltaire in particular were struck by "the blunt personality of the man, the breadth of his theories (with shoulders to match), the penetrating, intuitive look in his eyes, the racy carelessness of his speech, the peculiar way he clothed ideas of absolute purity and nobility in sailors' and painters' slang."

Aurier introduced him to his friends at the *Mercure de France;* Charles Morice went to see what Mallarmé could do for him. On January 15, 1891, Mallarmé wrote to Octave Mirbeau on Gauguin's behalf. "This uncommon artist who, I believe, has been spared few torments in Paris, feels the need to withdraw into isolation and near-savagery. . . . Only, he could do with an article." Someone had to kick off a press campaign aimed at attracting potential buyers to the auction of thirty paintings scheduled to take place at the Hôtel Drouot on Monday, February 23. The first article appeared in the February 13th issue of *Le Gaulois;* Charles Morice hailed Gauguin as one of the preeminent masters of Symbolist painting. On the 16th, Octave Mirbeau, writing for the *Echo de Paris,* stressed the significance of "an art as complicated and yet as primitive, as clear and yet as obscure" as Gauguin's, "a strangely cerebral and enthralling œuvre, still uneven, but poignant and superb even in its unevenness."

The Sale at the Hôtel Drouot

Feverish and extremely anxious, Gauguin wrote Mette a week before the auction. "I am dashing off these few lines, for I am very much on edge. The day of my sale is at hand: next Monday. All preparations have been fully attended to, and I'm waiting to compile all the articles before sending them to you. By the way, they have created quite a stir in Paris, and the art world is seething with excitement. . . . If my auction generates enough money I'll go to Copenhagen and will get there by about March 2." All told, the auction brought in 9,860 francs, an average of over 300 francs a painting. His *Vision after the Sermon* alone fetched 900 francs.

"My dear Mette, I am sending you the main articles. The sale took place yesterday and turned out fine. It wasn't overwhelming, mind you, and hardly up to the hopes raised by the [preview] of the day before. Still, the moral victory is tremendous, and I believe it will bear fruit in the near future. I shall be in Copenhagen Thursday. . . ." Gauguin traveled north to

bid his wife and children farewell. "His wife and two eldest children, Emil and Aline, met him at the Copenhagen station," Pola Gauguin later recalled. "He looked unfamiliar, and it showed on their faces. His long hair and slight plumpness did not fit in with their recollection of him. . . . Many conflicting emotions were tugging at Mette's heart. . . . She found him so altered that the distressing prospect of resuming their life together outweighed the affection she would have liked to show him; for she pitied him as much as she pitied herself. . . . The strongest bond was between the father and the two eldest children, especially Aline. . . . She was the one who most appreciated the happiness of having her father, because she had missed him the most." "Later on, I'll be your wife," Aline said to her father, who had checked into a room at the Hotel Dagmar for fear that staying with Mette might result in a sixth child. Sad at heart, he took leave of his family.

On March 15, with the backing of Clemenceau and Ernest Renan's son, Ary, he delivered a petition to the Minister of Public Education and Fine Arts in hopes of securing an official mission to Tahiti. "I plan to go to Tahiti in order to work on a series of pictures, and through them I intend to capture the light and character of the country."

The Symbolists' Farewell Banquet

In his momentous article in the March issue of the *Mercure de France,* "Symbolism in Painting: Paul Gauguin," Albert Aurier proclaimed that henceforth a work of art should be *idéiste,* Symbolist, synthetic, subjective, and decorative. Gauguin was hailed as the sole "painter of Symbolism" worthy of the title; neither Pissarro nor Emile Bernard ever forgave him. "Originally, his plan was to take me with him to Tonkin," Bernard later recalled. "Since this was leading nowhere, he soon opted for Tahiti instead; he had just read about it in a book by Pierre Loti. I was supposed to go along, but we had a falling out. . . . Our quarrel was more my doing than his, and my sister took my side against him. She saw how unselfishly I looked after Gauguin, and she was aware of everything he owed me. Being proclaimed the leader of the Symbolist school—that made her blood boil. She reproached him, and so did I. Once, when he availed himself of an opportunity to make his feelings known to us, Gauguin replied rudely in a drunken outburst, for he had imbibed a great deal of absinthe that day, and you could tell so from his breath. That was the parting of the ways. . . ."

Madeleine had leveled an accusation to his face: "Monsieur Gauguin, you have broken your pledge and are doing the greatest harm to my brother, who has been the true originator of the art which you now claim for yourself." Could that be the same Madeleine he was once so fond of? "If you knew how Gauguin fawned and cringed to get himself elected (that is the word) a man of genius, and how craftily he went about it," Camille Pissarro later wrote to his son Lucien. "You had no alternative but to help him climb. Anyone else would have recoiled in shame! Knowing the straits he was in, I myself was left with no choice but to write to Mirbeau on his behalf. . . . The apprehensive middle class, caught off guard by the tremendous clamor of the underprivileged masses, by the overwhelming demands of the common herd, feels the need to lead the people back to superstitious beliefs. . . . This Gauguin has sensed the trend. For a long time now I've seen what this bitter enemy of the poor, of the worker, is getting at. Therefore, this trend must breathe its last—a death rattle, nothing more!"

On Monday, March 23, 1891, the Symbolists gave a farewell banquet in Gauguin's honor at the Café Voltaire. "Yesterday, they held a banquet in my honor," he boasted to his wife, "and there were forty-five people present—painters, writers—with Mallarmé presiding.

Verses, toasts, and the warmest tributes to me. I assure you that three years from now, I'll have won the battle that will allow us—you and me—to live safe from difficulties. You'll rest and I'll work. Perhaps one day you'll understand what kind of man you chose to be the father of your children. I am proud of my name. . . ."

Well, not as proud as all that. Now there could be no backing out of the great voyage everyone was expecting him to undertake. Even that distressed him. "Farewell, dear Mette, dear children. Love me well. When I come back, we'll remarry. It is therefore a betrothal kiss I send you today. Your Paul."

The Minister of Fine Arts not only granted him an (unremunerated) official mission, but saw to it that he received a thirty percent reduction in the price of a ticket on a shipping line. To the surprise of an overjoyed Charles Morice, Gauguin broke down on his way home from the minister's office. The two of them went to a café, whereupon Gauguin poured out his soul to him. "I have never been so unhappy. Listen to me. . . . I haven't been able to support my family or my vocation . . . and today, when I have reason to hope, I feel more terribly than ever the horror of the sacrifice I have perpetrated and which cannot be undone." He proceeded to burst into tears.

"To Steep Myself in Unspoiled Nature"

He had lost nearly all of his friends: Pissarro, the Van Goghs, the Schuffeneckers, Emile and Madeleine Bernard, Meyer de Haan (who had been taken ill and returned to Holland), and Guillaumin, who now steered clear of him. Already distraught at the prospect of leaving his children for so long a period of time, he learned that his wife was furious because she had not received her share of the proceeds from the auction. He left Juliette Huet to fend for herself in Paris, but gave her a sewing machine and recommended her to his new friend, de Monfreid. That she humbly resigned herself to her fate only added to his mortification. From now on, it would be just him and the unknown destiny that awaited—and frightened—him. Would he be up to the task he had set for himself? "I am going away to be at peace, to rid myself of the influence of civilization," he once explained to the writer for the *Echo de Paris*. "I want to produce nothing but art that is simple, very simple. To do that I need to steep myself again in unspoiled nature, to see nothing but savages, to live their life, with no other concern but to convey, as a child might, what my mind conceives, abetted only by primitive means of expression, the only right ones, the only true ones."

Standing on the platform of the Gare de Lyon, he was about to board the train that would take him to Marseilles; from there he would set sail on the *Océanien* on April 1. He embraced Charles Morice, Sérusier, and two other painters who had recently been accepted into the synthetist fold: Ballin and Verkade. Verkade, who later became a monk, recalled the scene in *Le Tourment de Dieu:* "The farewell was brief and touching. After we embraced, Gauguin disappeared into the train. He was visibly moved."

The artist had jotted down some instructions concerning his works and their value on a sheet of paper and given it to de Monfreid. There were also seven photographs which Gauguin asked him to distribute to a few friends. One of them was for Juliette Huet.

Gauguin once said of Odilon Redon, "He gives his work a believability that turns dreams into reality." His own dreams were about to come true.

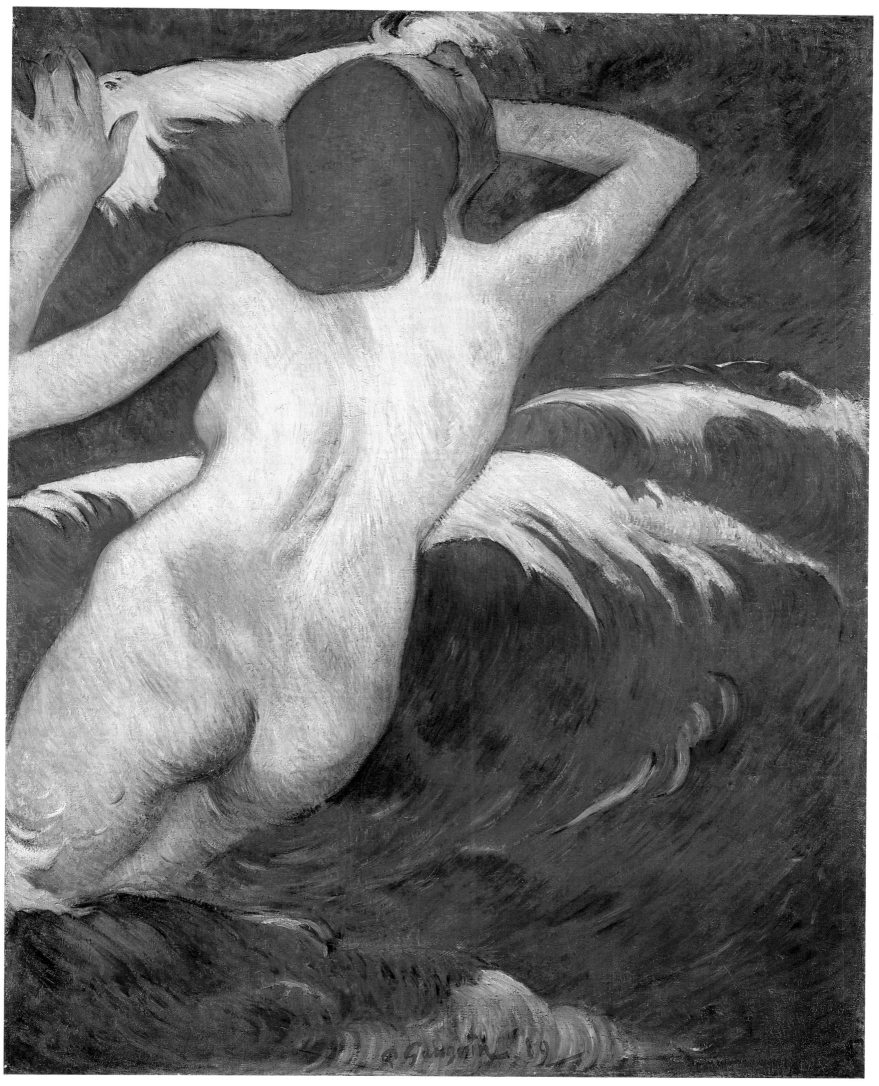

203. Gauguin. *Woman in the Waves (Ondine)*. 1889

205. Gauguin. *Madame Schuffenecker*

206. Jeanne Schuffenecker, age 12

204. The Schuffenecker family

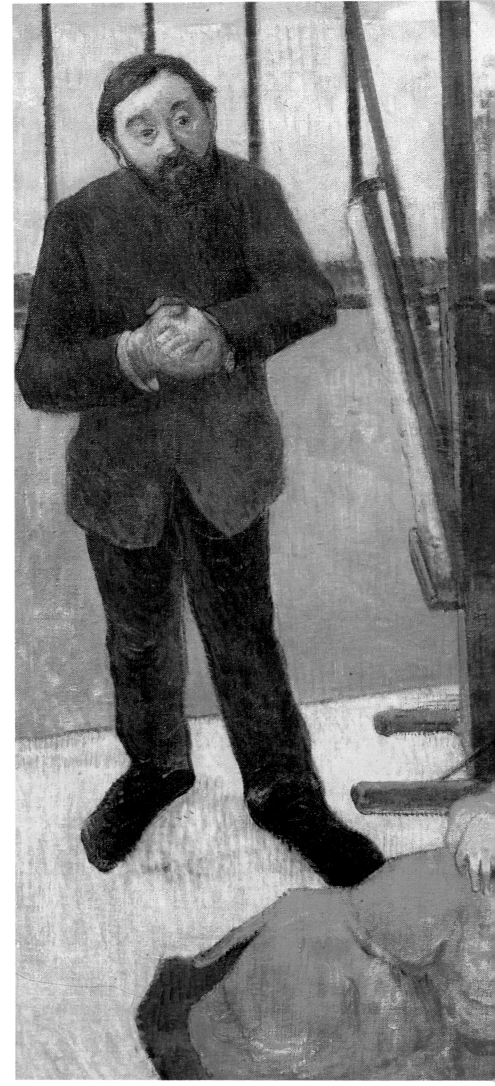

207. Emile Schuffenecker. Sketch of his daughter

"Good old Schuff" and his family gathered in the studio of his residence at 14 Rue Alfred-Durand-Claye (14th arrondissement) for this portrait, which probably dates from late spring of 1889. It is filled with symbols and allusions, some humorous, some touching the heart. We see Jeanne, little Paul, and Louise Schuffenecker (Gauguin's mistress, so the story goes) warming themselves by the stove. A Cézanne and a Japanese print hang on the wall behind them; a grid of windowpanes opens out to a view beyond, a technique borrowed from Japanese art. (Manet made use of the same effect by positioning a mother and child against the iron grill of the Gare Saint-Lazare.) Gauguin, who was staying with the Schuffeneckers at the time, pokes gentle fun at his host: Emile's slippers seem too big for his feet, and he is rubbing his hands together in doltish self-complacency. We are not shown the canvas on Schuffenecker's easel; surely it is second-rate. As the artist commented to de Monfreid in 1893, "He [Schuffenecker] was cut out to be an ordinary workman, or a janitor, or a small shopkeeper." The most ironic touch is the way Gauguin contrasts Louise's starched, guilt-ridden stiffness and the oafish rigidity of the trusting husband who gazes longingly at her. His subtle, classical bust of Mme. Schuffenecker is a striking likeness.

208. Gauguin. *The Schuffenecker Family*. 1889

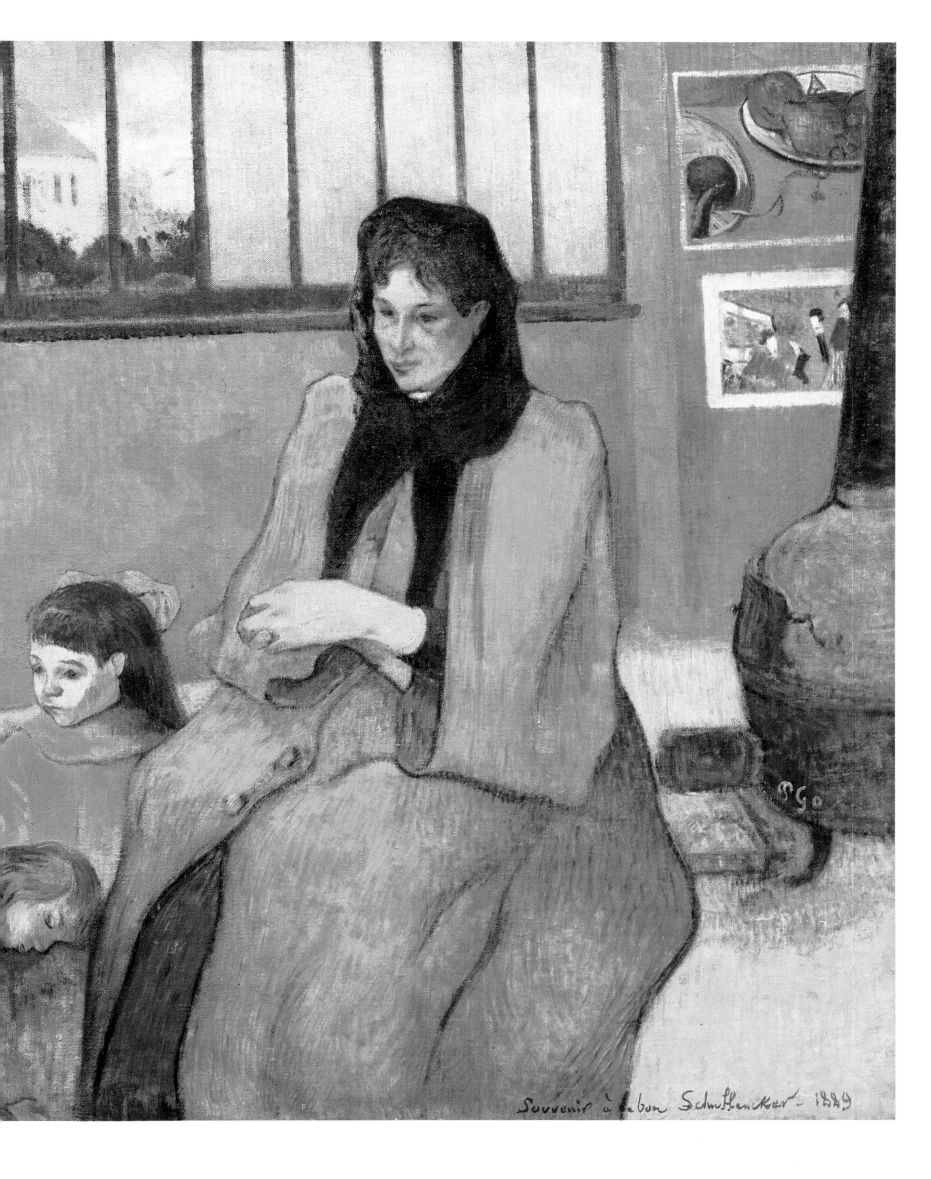

Souvenir à le bon Schuffenecker – 1889

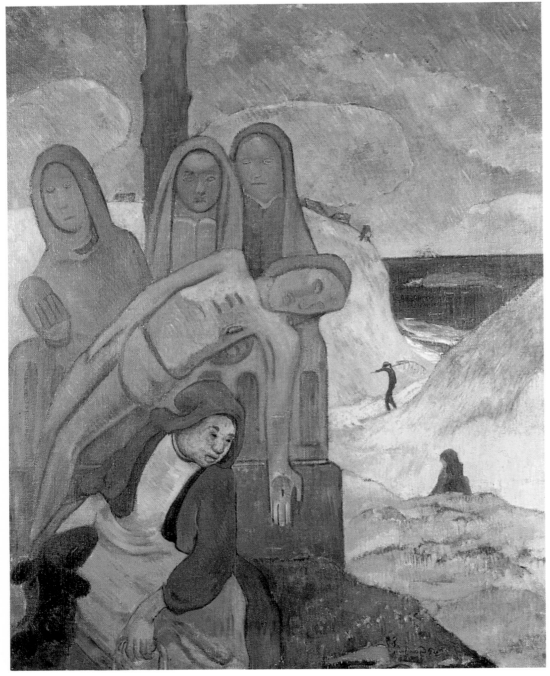

209. Gauguin. *Breton Calvary: The Green Christ.* 1889

G auguin jotted down some notes on a visiting card after contemplating the stone Pietà next to the church of Nizon, near Pont-Aven. "Calvary—cold stone—from the ground—Breton visualization—by a sculptor who conveys— religion through—his Breton soul—with local costumes. . . ." Curiously, he relocated this wayside cross to within sight of the dunes of Le Pouldu and the sea; a lone Breton woman grieves at Christ's feet. "Since deceptive outdoor effects do not appeal to me," he declared to Vincent van Gogh, "my aim is to imbue these disconsolate figures with the wildness I see in them, and which is also in me. Here in Brittany, the peasants have a medieval air about them. . . ." On another visiting card he scribbled some notes suggesting that he identified himself with no one less than Christ in Gesthemane. "Christ— special pain of betrayal as applied to Jesus today—and tomorrow—small incidental group—dark tonal scheme throughout—dark colors and supernatural reds." "This year," he wrote to Vincent van Gogh, "I have tried incredibly hard to work and think. I have something at home I have not yet sent out and which I think will be to your liking . . . violet ground, a vermilion-haired Christ wrapped in a dark ocher garment." However, Van Gogh thought no more of it than he did of Emile Bernard's painting, which Gauguin praised for its "imaginative style." But he also thought the head of Judas in Bernard's painting (above the soldiers) was modeled after his own. A premonition of the sense of betrayal both of them felt when they went their separate ways?

210. Gauguin. *Holy Images*

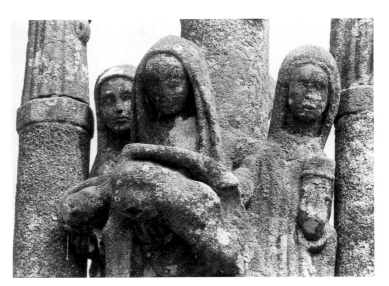

211. Breton Calvary at Nizon

120

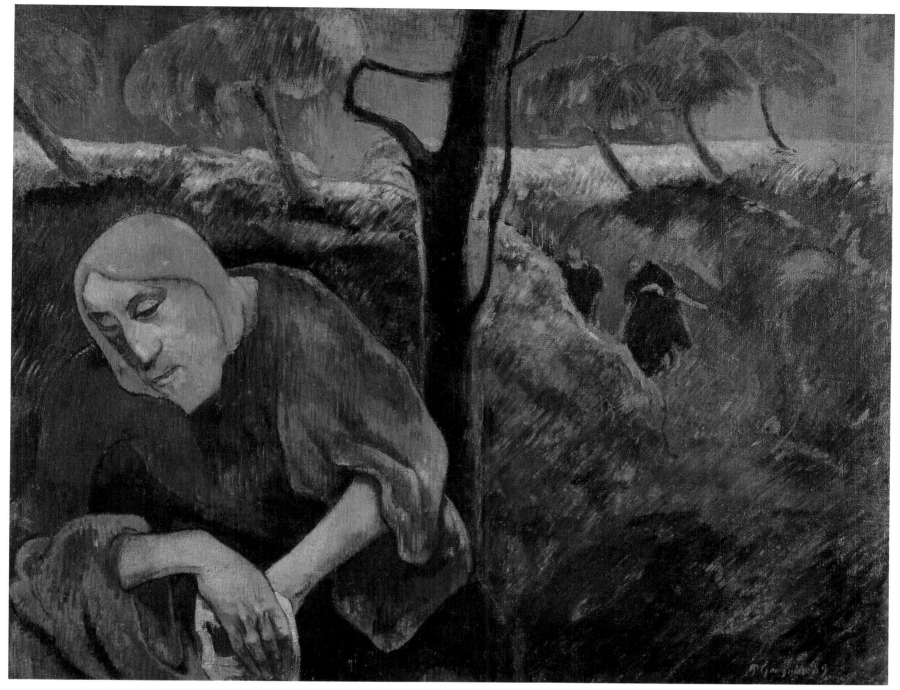

212. Gauguin. *Agony in the Garden*. 1889

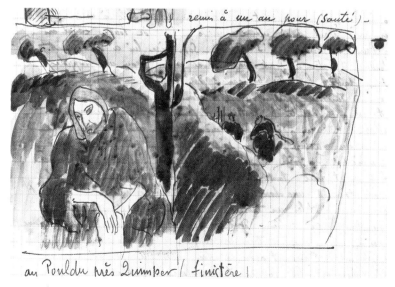

213. Gauguin. Sketch from a letter to Vincent van Gogh, November 1889

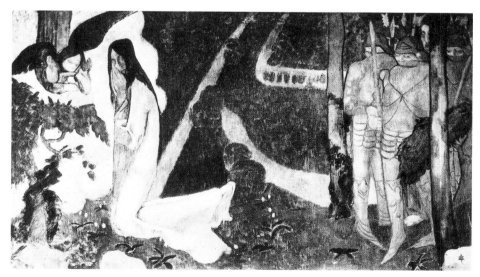

214. Emile Bernard. *Christ in Gethsemane*. 1889

"**S**till fearful of the Lord and the parish priest, Bretons hold their hats and all of their implements as though they were in a church," noted Gauguin, who added that "their attire, influenced by the superstitions of Catholicism, is likewise almost symbolic." Their devotion made a deep impression on the painter, and he was intent on assimilating it. Soon Gauguin found an even more mystical soul in Charles Filiger, who was to join him on this quest for the supernatural in Le Pouldu. Both of them were unusually receptive not just to the simplicity and reverence of Breton folk art but to the humility of the peasants themselves, to their innate sense of sanctity. Gauguin was struck, for one thing, by the rugged simplicity of the yellow crucifix in the Trémalo Chapel, which overlooks the Bois d'Amour at Pont-Aven. However, The Yellow Christ it inspired was relocated to the middle of a field of ripe wheat, with crimson blotches for "synthetized" trees and three grieving Breton women praying at Christ's feet. We see this painting, albeit reversed, in the mirror he used for a self-portrait; but alongside it sits a Peruvian-inspired ceramic object in the shape of a human head sucking his thumb. The searching look in the painter's eyes suggests that he is wavering between Redemption through Christ and the path symbolized by this gruesome throwback to his childhood fantasies in Lima. Filiger was torn, too, except that in his case it was between Messianic sublimation and a physical attraction to boys that drove him to despair. Their symbolic paintings tell of their narcissism and also of their willingness to offer up their lives on the altar of art.

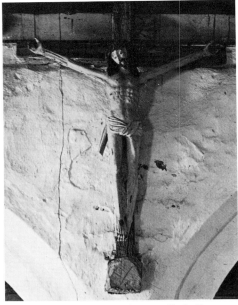

216. The polychrome wooden crucifix in the chapel of Trémalo, 17th century

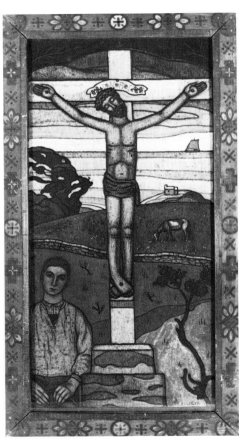

217. Charles Filiger. *Crucifixion*

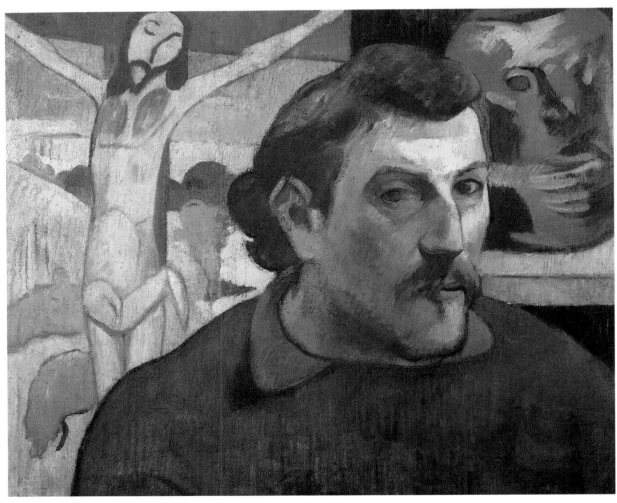

215. Gauguin. *Self-Portrait with the Yellow Christ.* 1889

218. Gauguin. Tobacco jar with self-portrait. 1889

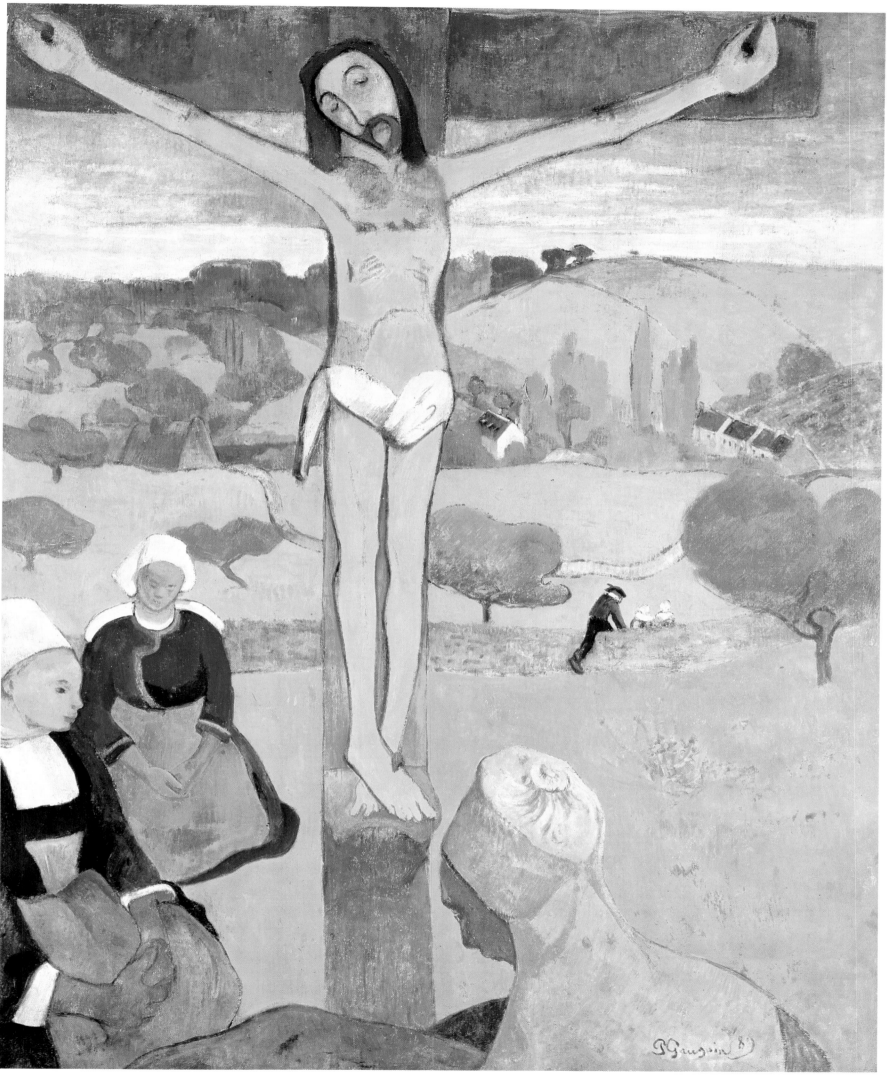

219. Gauguin. *The Yellow Christ*. 1889

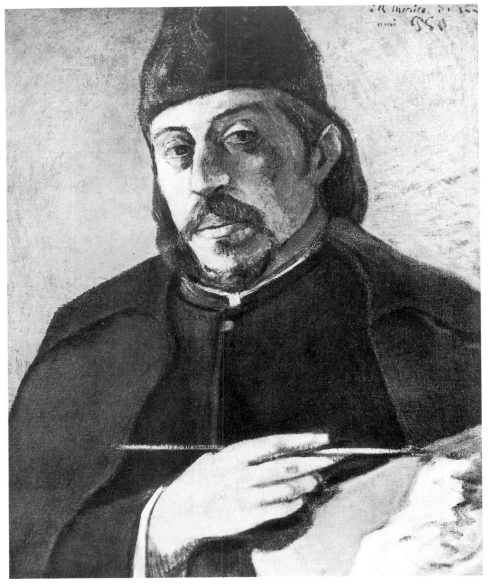

220. Gauguin. *Self-Portrait with Palette*.
c. 1891

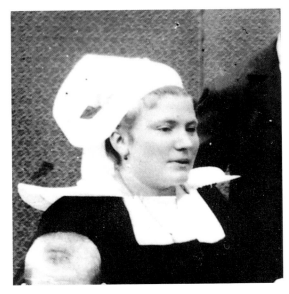

222. Angèle Satre

223. Ando Hiroshige. *Sekiya Hills from Masaki*.
1857

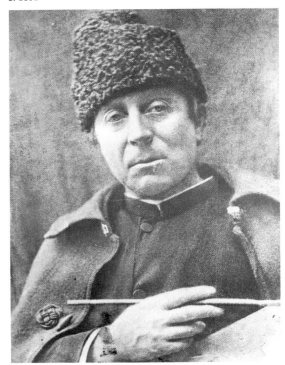

221. Gauguin with a palette

The woman who sat for La Belle Angèle (*Mme. Angèle Satre, wife of the future mayor of Pont-Aven*) recalled how she came to be one of Gauguin's models. "*He was so pleasant and so needy, and we were fond of him.... He was always telling my husband that he wanted to paint my portrait.... While he was working, he would never let me look at his canvas.... My mother said to me, 'It seems that last night the artists got into a fight over your portrait. What a lot of fuss they're making because of you!'.... When he showed it to me, I said to him, 'How dreadful!'.... Gauguin became very sad and told me that no portrait of his had ever turned out as well as that one.*" Van Gogh attempted to describe it to his brother. "*It is a portrait arranged on the canvas like the oversized heads in Japanese prints.... The woman looks a little like a young cow, but there is something so fresh and yet so homespun that it is very pleasant to behold.*" Adopting the "picture-within-a-picture" technique that Japanese artists customarily used as they contemplated landscapes through their own windows (which were often round), Gauguin introduced for the first time what might be called a "split field." But there is more than one portrait here. In addition to the Breton woman, he has depicted a Pre-Columbian statue, thereby juxtaposing his "primitive" sources—Peru, Japan, and Brittany—which he would eventually fuse with Impressionism. He painted the Self-Portrait with Palette *after a photograph of himself.*

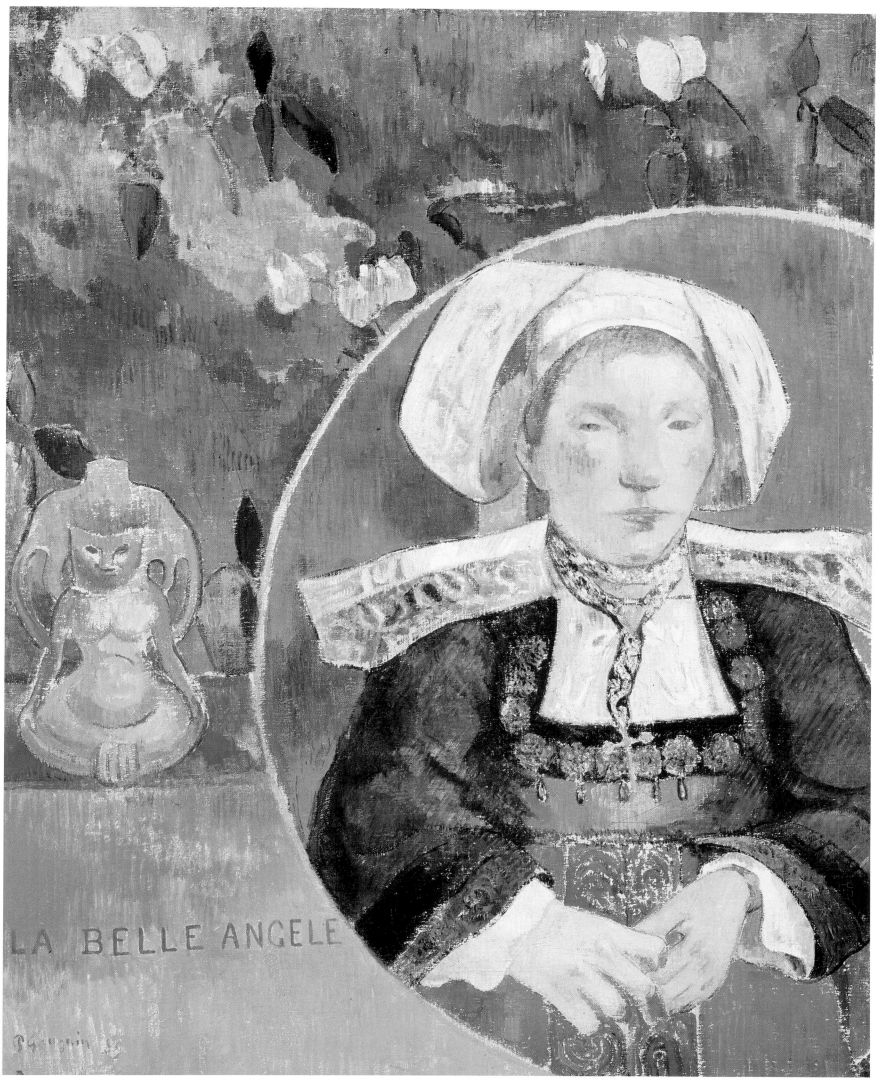

224. Gauguin. *La Belle Angèle: Portrait of Madame Satre.* 1889

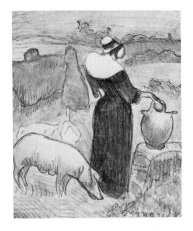

226. Emile Bernard. *Breton Woman on Her Farm at Pont-Aven.* 1886

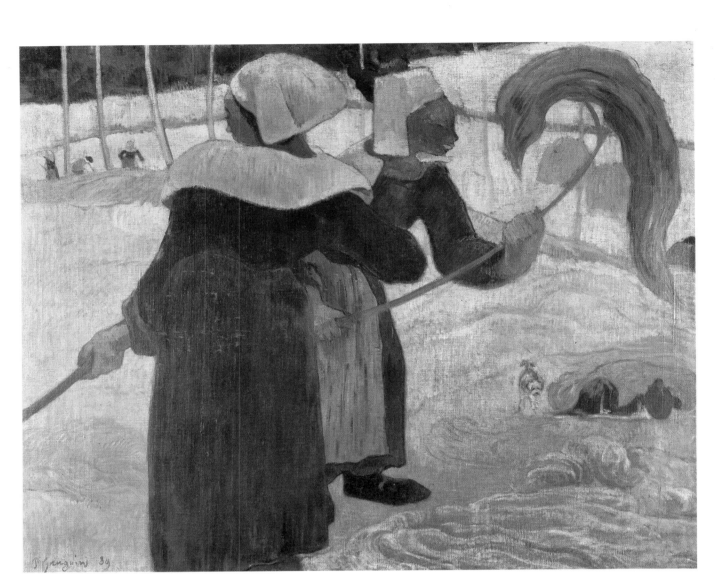

225. Gauguin. *Breton Haymakers.* 1889

227. Gauguin. *Breton Haymakers*

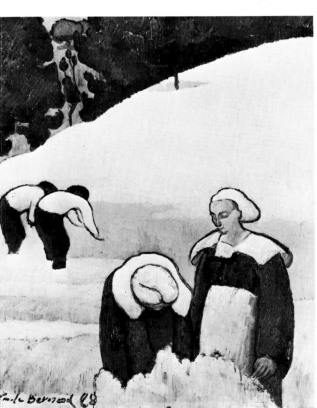

The Breton paintings from this period of Gauguin's life in Le Pouldu show a new tendency toward crisply outlined subjects, human and animal alike; Emile Bernard's watercolor (1886) and painting (1888) leave little doubt who was responsible for it. Here is how Bernard himself described his Breton Landscape: The Harvest. "*In 1888 I painted a picture that was to be hung in the dining room of the Maison Gloanec.... It showed two men and two women harvesting wheat in a field surrounded by trees. Its novelty, its frankly uncompromising nature started trouble among the fifty or so boarders, and Mme. Gloanec was asked to take it down. This was done after volley upon volley of bread pellets were thrown at it.... Gauguin asked me for the picture and offered me a canvas in exchange.*" Now cloisonné (compartmentalized), synthesized color would come into its own, set a fashion, and be displayed in Volpini's café during the 1889 Paris World's Fair. In all likelihood, the pair of yoked oxen, like those in Christmas Eve (*a landscape of Pont-Aven in the snow*), were inspired by Egyptian bas-reliefs. And if we look beyond the wonderfully dense blues and vigorous, expressive, ritualistic movements of Breton Haymakers, *we will find a touch of Courbet—the artist's trusty little dog sniffing in the hay.*

228. Emile Bernard. *Breton Landscape: The Harvest.* 1888

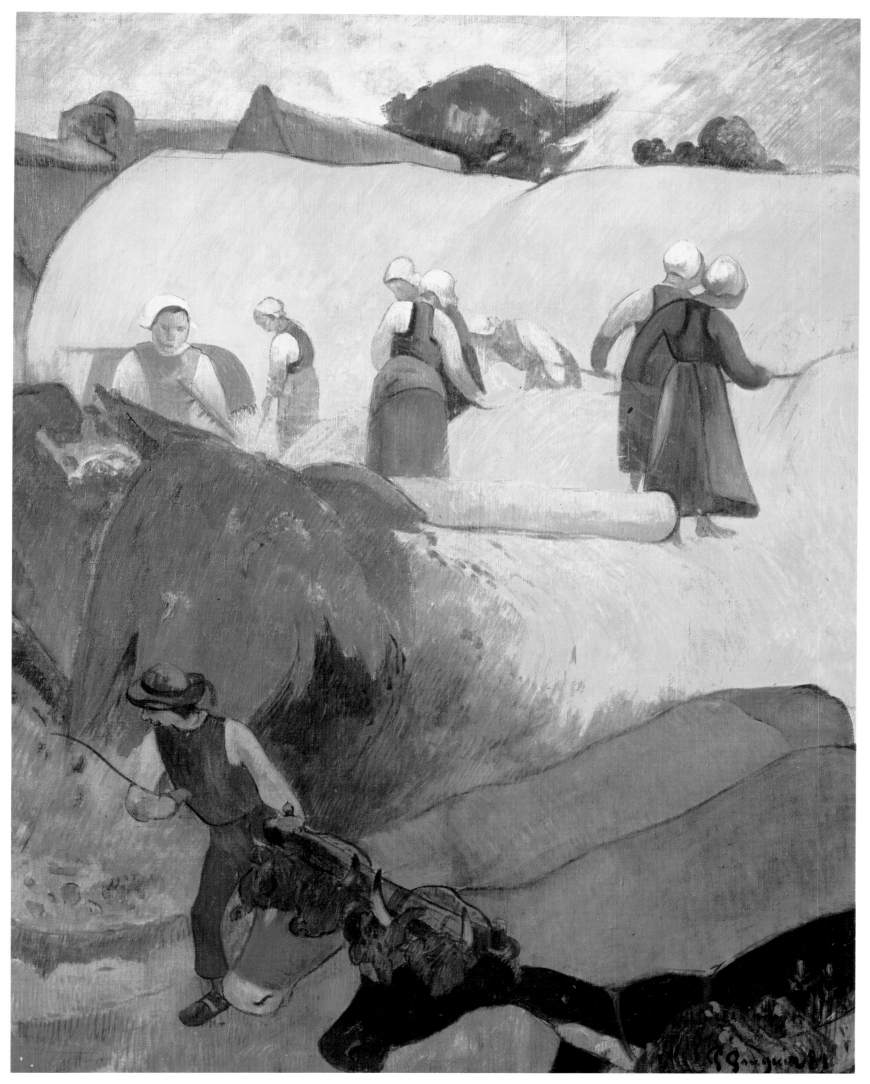

229. Gauguin. *Harvest in Brittany.* 1889

230. Well at the Kersellec farm

231. The Kersellec farm today

233. Gauguin. *The Blue Roof: Farm at Le Pouldu.* 1890

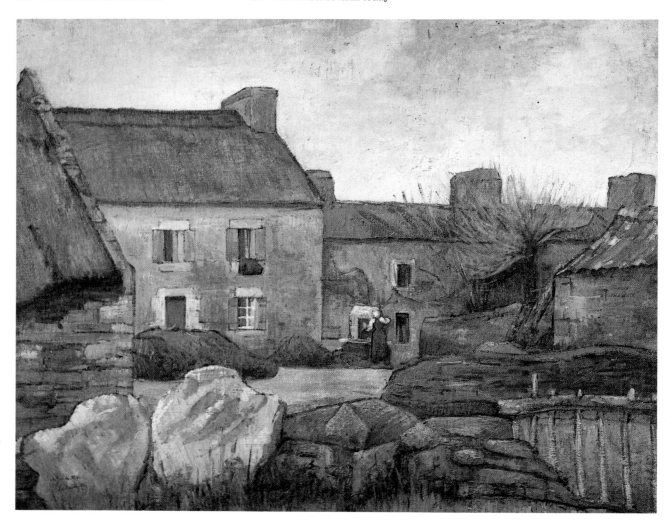

232. Jacob Meyer de Haan. *Farmyard and Well at Le Pouldu.* 1889

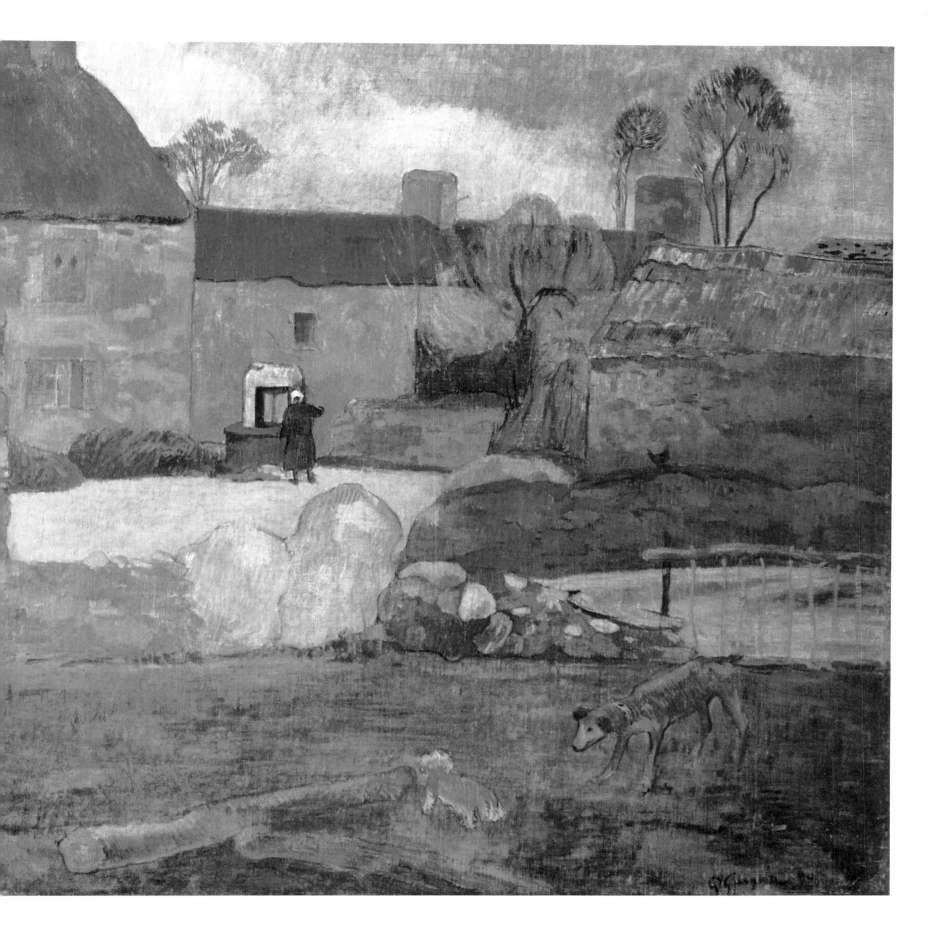

Viewed from a greater distance than Jacob Meyer de Haan's Farmyard and Well at Le Pouldu, Gauguin's The Blue Roof: Farm at Le Pouldu takes in an area in front of the rocks and stone embankment: here his little dog seems to have piqued the curiosity of the farmer's dog. The two scenes are so similar that one wonders if Gauguin had a hand in the landscape his "pupil of Impressionism" was painting. Perhaps the teacher followed up De Haan's effort with a version of his own in order to drive the lesson home. Although some believe that Gauguin was somewhat jealous of the Dutchman's affair with Marie Henry, the two of them were on good terms at the time. This farm in the tiny hamlet of Kersellec, not far from the inn, provided Marie with milk and eggs; in those days, the tile-roofed building on the right served as a creamery. Despite the pinks, Gauguin's colors are as subdued as those of Meyer de Haan, who professed the greatest admiration for Rembrandt. Just the same, both of them managed to capture the homespun flavor of the farm and well, which stand in Le Pouldu to this very day.

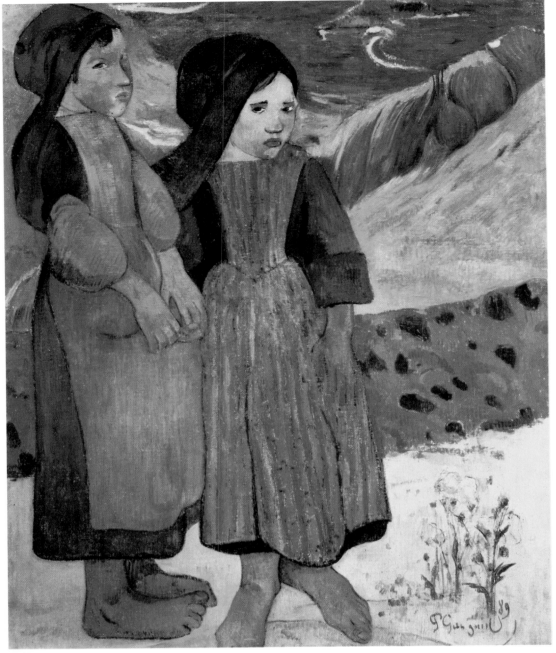

234. Gauguin. *Two Little Breton Girls by the Sea.* 1889

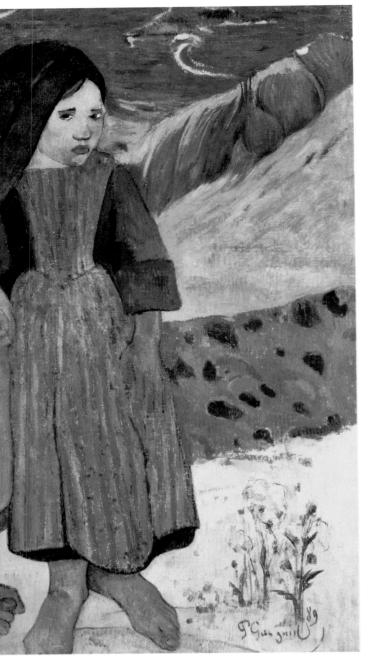

235. Paul Sérusier. *Three Little Girls at Le Pouldu.*
c. 1890

236. Gauguin. *Head of a Peasant Girl*

237. Gustave Courbet. *The Burial at Ornans* (detail). 1849

Bursting with lyrical freshness, Among the Lilies: Breton Landscape with Children and Dog *resorts to only one specific "quotation": Gustave Courbet's hunting dog. Gauguin may have had a photograph of Courbet's painting, which belonged to his guardian, Gustave Arosa, before it was sold at the Hôtel Drouot on February 25, 1878. This dog, which reappears in Courbet's* Burial at Ornans, *points the way to an undeniable thematic, perhaps also compositional, kinship between Gauguin's* Little Breton Girls by the Sea *and the little girl surrounded by the bereaved peasant women of Ornans. Even the cliff in the background recalls the one in Courbet's* Burial, *which created a public uproar all over again when it was admitted into the Louvre in 1882. "Letting it into the Louvre is a repudiation of all beauty," "Sâr" Péladan wrote two years later. "As for me," Gauguin later confessed to Emile Bernard, "nothing remains of all my efforts this year but a hue and cry from Paris that reaches me here and discourages me. . . . Mechanically I do some studies, but my soul is not in them and looks at the gaping pit before it." He was longing to set out for the tropics.*

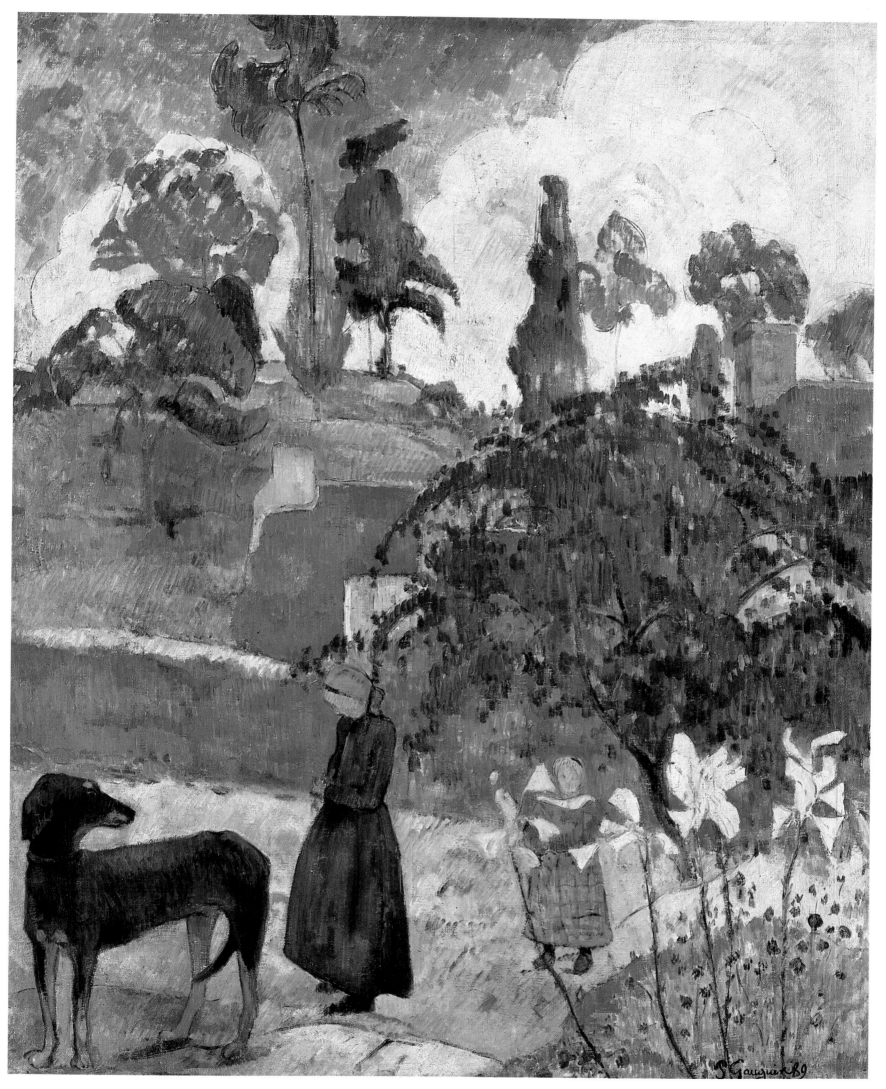

238. Gauguin. *Among the Lilies: Breton Landscape with Children and Dog.* 1889

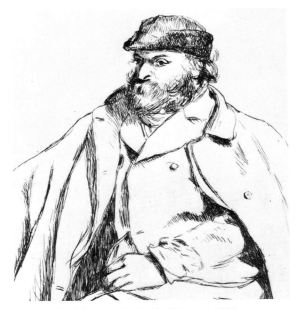

239. Camille Pissarro. *Portrait of Cézanne.* 1874

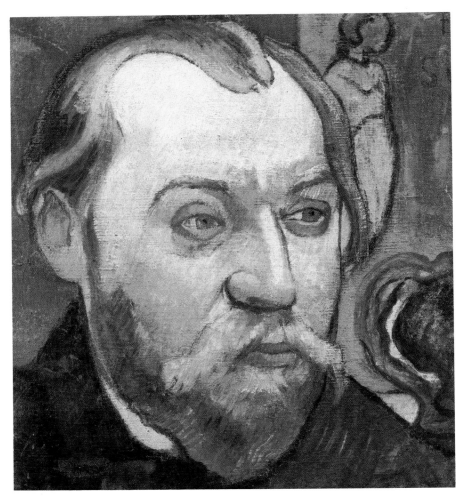

240. Gauguin. *The Painter Roy* (detail). 1889

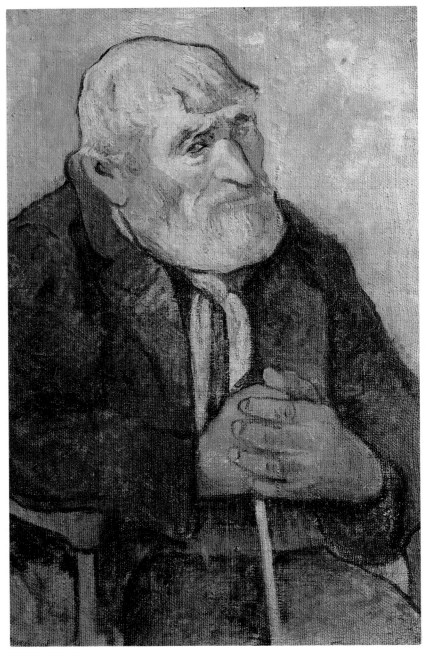

241. Gauguin. *Old Man with a Stick.* 1889

The same mood runs through these various portraits, all of which date from Gauguin's Le Pouldu period: the old "chief" who did odd jobs at Marie Henry's inn; Marie Henry herself, whose bashful, doll-like beauty earned her the nickname Marie Poupée; and two different portraits of her lover, Jacob Meyer de Haan. In Gauguin's colored oak bust of De Haan, we see a brood hen perched atop the Dutchman's cap (possibly a sly allusion to his infatuation with her). The somewhat sinister tone they all share brings to mind Pissarro's perfunctory portrait of Cézanne, which Gauguin had had a chance to see when he was painting with his former mentor in Pontoise. The pensive Meyer de Haan, like the painter Roy, is shown slipping into that supreme state of contemplation the Buddhists call nirvana. (De Haan himself acknowledged his debt to the Japanese in his Self-Portrait.) For the first and only time in his career, Gauguin has included books in one of his paintings: Thomas Carlyle's Sartor Resartus and Milton's Paradise Lost. Literally translated "tailor retailoring clothes," Carlyle's title sums up his "philosophy of vesture" and the spiritual growth of the protagonist, who comes to understand that true happiness lies in regaining the faith of his childhood and that, under the perishable raiment of the world, the Divine Spirit is in a state of continual self-renewal. And Paradise Lost reveals the depth of Milton's spiritual anguish as it recounts the tragic fall of man and Satan's glorious revolt. The bust of Meyer de Haan was given a place of honor on the mantel of the dining hall in the inn of Marie Henry, his mistress.

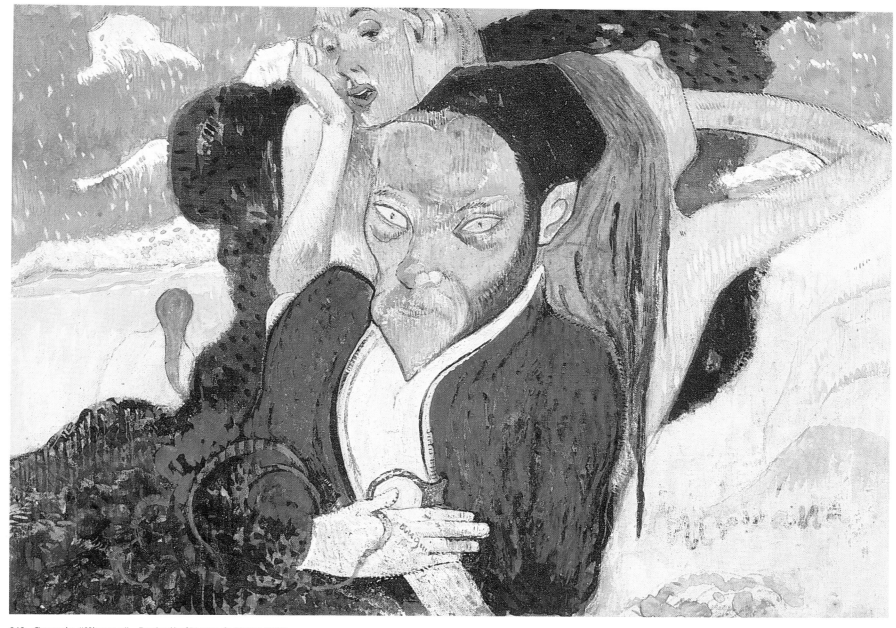

242. Gauguin. *"Nirvana" – Portrait of Meyer de Haan.* 1889

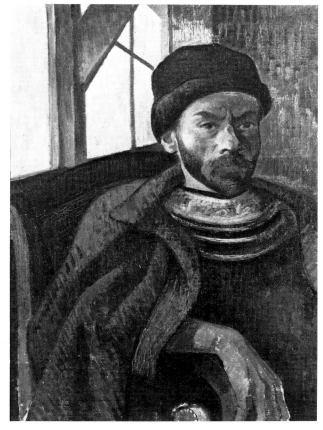

243. Jacob Meyer de Haan. *Self-Portrait in Breton Costume.* c. 1889

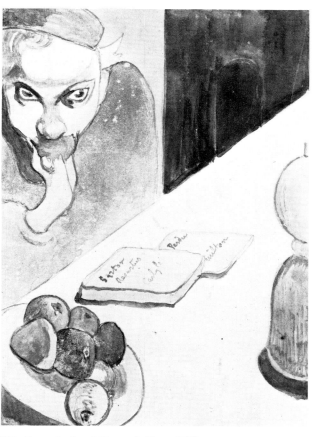

244. Gauguin. *Jacob Meyer de Haan.* 1889

245. Gauguin. *Bust of Meyer de Haan*

246. Gauguin. *Bonjour, Monsieur Gauguin.* 1889

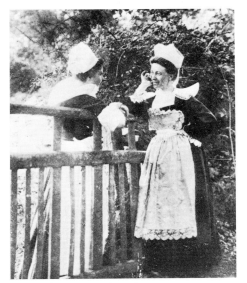

247. Breton women at a gate

248. Jean-François Millet. *Shepherdess Seated on a Rock*

249. Gauguin. *Breton Women at a Gate.* 1889

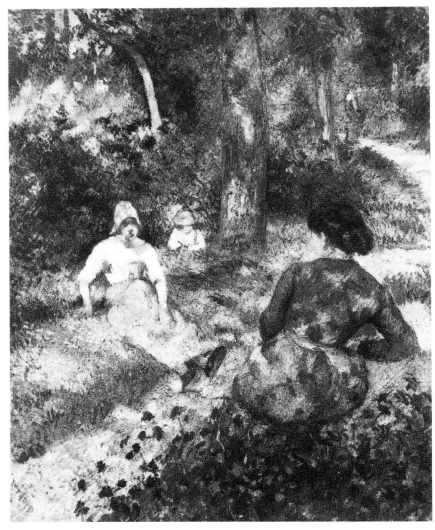

250. Camille Pissarro. *Peasant Women at Rest.* 1881

"**G**reat minds think alike," the saying goes, "*just like peasant women meeting at a fence in the fields.*" *Gauguin had admired Gustave Courbet's* Bonjour, Monsieur Courbet *when he visited the Musée Fabre in Montpellier; hence,* Bonjour, Monsieur Gauguin *is both a tribute to a celebrated painting and a way of symbolizing his "encounter" with Brittany; it was also a nod to Pissarro, whose shepherdesses at rest, like Gauguin's, can be traced back to Jean-François Millet's pioneering work at La Hague and Barbizon. Indeed, the censure that critics heaped upon the painter of* The Angelus *in his day might just as well have been leveled*

at them. For example, Paul de Saint-Victor found fault with the way he exaggerated rusticity and overstated poverty: "Millet's peasants have gradually reverted to savagery." Edmond About noted: "His figures have a deliberately roughcast look, as though they were chiseled in rock." This was precisely the lesson that had stuck in Gauguin's mind. He came to believe that a return to the earth, to the crude but Virgilian folkways of peasant life, was the surest way to make art a deeper, more meaningful experience. "I'll take the country! I like Brittany. I find wildness and primitiveness here," he wrote from Pont-Aven.

251. Gauguin. *The Gate*. 1889

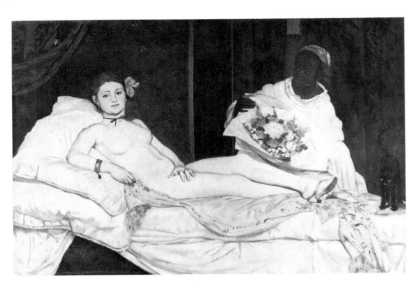

252. Gauguin. *Olympia after Manet.* 1891

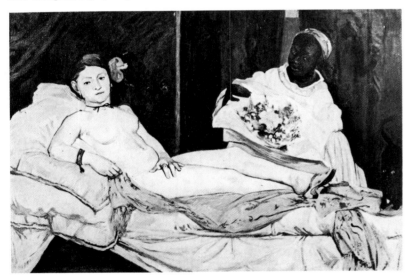

253. Edouard Manet. *Olympia.* 1863

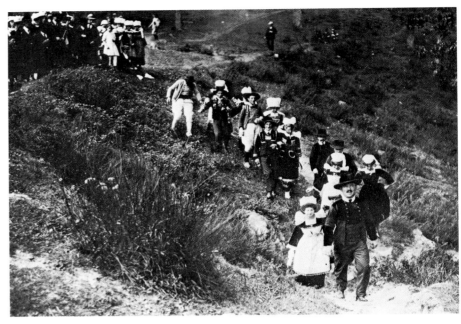

254. Breton wedding party strolling through the Bois d'Amour, Pont-Aven

255. Gauguin. Study for *The Loss of Virginity.* Early 1891

When Manet's Olympia *was first exhibited at the Salon of 1865, Zacharie Astruc penned some lines of verse for the occasion: "When, weary of dreaming, Olympia awakens, a gentle envoy brings spring in on dusky arms...."* Much hostile ink had been spilt over it ever since; but there were admirers, too. After Olympia *was hung in the Musée du Luxembourg in 1890, Gauguin was given permission to paint a copy of it.* This he accomplished in eight days, but he found the museum environment so exasperating that he decided to finish it from memory at home. *Manet made several studies of his young model—Victorine Meurent, who had sat for the* Déjeuner sur l'Herbe—*before rendering his daring subject in oils.* But in his mind's eye he also saw the head of Titian's Venus *(with her little dog) and Goya's* Maja Nude *(with her cushions). Likewise, Gauguin asked his mistress, a young milliner by the name of Juliette Huet, to pose for* The Loss of Virginity. *But as he gazed at*

her he beheld Manet's Olympia, *Emile Bernard's* Madeleine in the Bois d'Amour, *and possibly also Holbein's* Christ in the Tomb *(Kunstmuseum, Basel). (Charles Filiger had a copy of the German painting, and Gauguin marveled at its tragic realism.) Gauguin has visualized the subject as a sacrifice with ritualistic overtones.* As spring awakens all around her, a maiden is about to lose her virginity: she is outstretched, but her legs are drawn together, and on her breast we see a lascivious fox (an "Indian symbol of perversity," to quote the artist). *A canopy of pink overspreads the fields and coast of Le Pouldu; in the distance, a wedding procession; and on the horizon, the Isle of Groix takes on a bluish cast. (Legend had it that "he who sees Groix sees his Cross.") This symbolic painting was purchased by Charles Filiger's friend and patron, Count Antoine de la Rochefoucauld.*

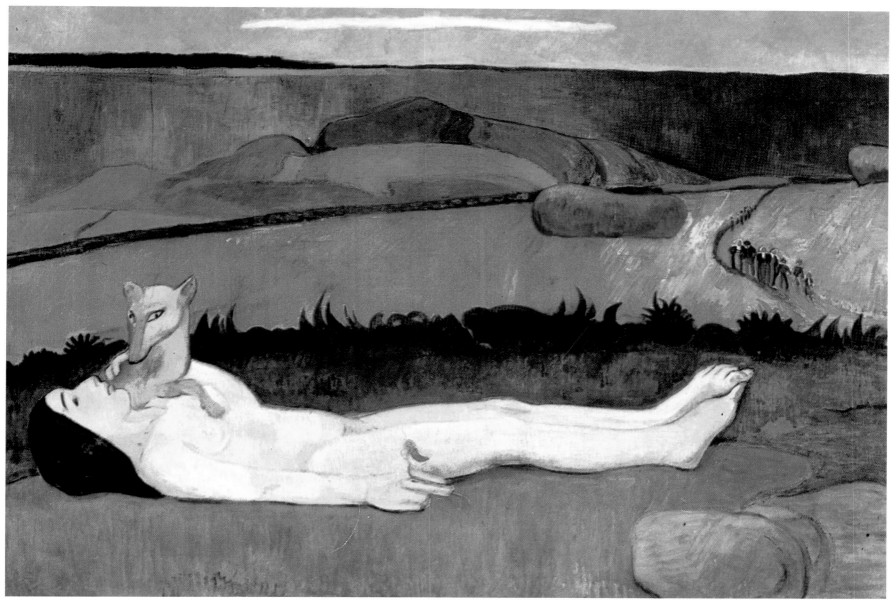

256. Gauguin. *The Loss of Virginity (Spring Awakening)*. 1891

257. Hans Holbein. *Christ in the Tomb*. 1521

258. Emile Bernard. *Madeleine in the Bois d'Amour*. 1888 (reproduced in part)

Cézanne once complained that Gauguin had "stolen my petite sensation." It was not thievery, however, but a loan, a way of expressing heartfelt admiration. Gauguin confirmed this in Avant et Après (Intimate Journals) as his life drew to a solitary close in the Marquesas Islands. "In a fruit dish, ripe grapes spill over the rim; on the tablecloth, green and plum-red apples mingle. The whites are blue, and the blues are white. What a damn good painter that Cézanne is!" There was also tribute of a different kind: Gauguin's Portrait of Marie Derrien (or Lagadu, Breton for black eyes) is strongly reminiscent of Cézanne's portraits of his wife. In back of her we see a still life by the master of Aix, a purchase Gauguin could afford back when he was earning a respectable wage as a stockbroker. An osmosis of sorts has taken place between the still life and the portrait proper; the table at which the subject is seated seems to be a continuation of the painting on the wall behing it. His still life with a statuette is further proof that he did not work in a cultural vacuum, for his West Indian "Negress" is overcome by rose blossoms, which waft a fragrant reminder of Fantin-Latour.

259. Paul Cézanne. *Fruit Bowl, Cloth, Glass, and Apples.* 1879–82

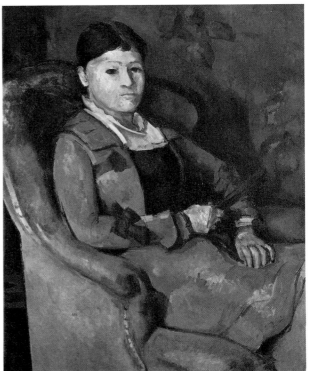

260. Paul Cézanne. *Lady with a Fan (Madame Cézanne).* 1879–82

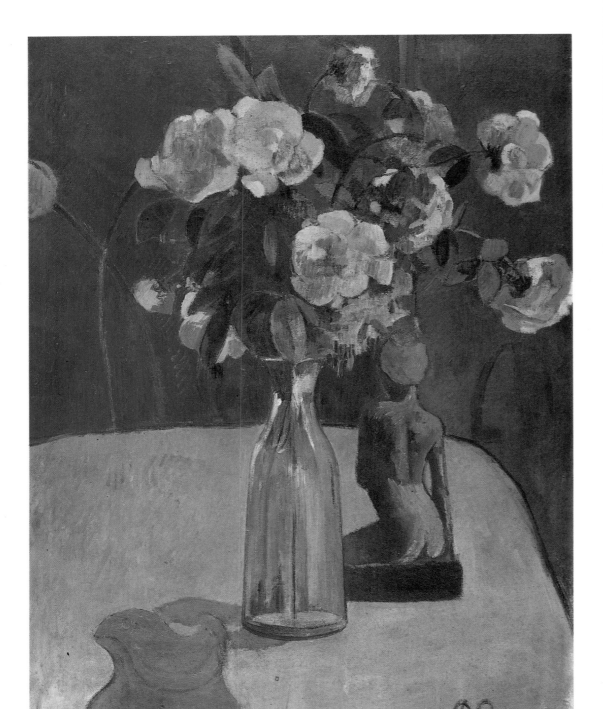

261. Gauguin. *Roses and Statuette.* 1890

262. Gauguin. *Statuette of a Martinique Woman.* 1888–89

263. Gauguin. *Portrait of a Seated Woman* (also known as *Portrait of Marie Derrien*). 1890

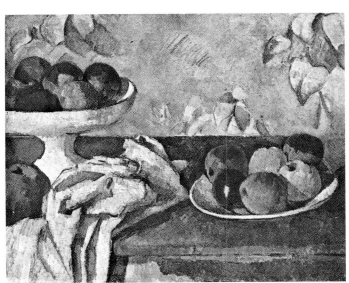

264. Paul Cézanne. *Fruit Bowl, Cloth, and Dish of Apples.*
1879–82

A bowl of apples on a metal garden chair seems innocuous enough, but the iron strips fan out like a web of temptation. This still life, like most of Gauguin's paintings from Le Pouldu, is signed "P. Go."—a streamlined abbreviation as stimulating as the English command it echos, and a symbol of his pressing need to get to the heart of things. As Gauguin attempted to pare his still life to essentials, to turn it into a focused, coherent, uncompromising whole, he steered clear of Cézanne's analytical approach and continued to take his cue from the Japanese aesthetic of simplification. As he wrote to Emile Bernard at the time, "The future takes shape from top to bottom." He was eager for "pure" painting, just as his friend Vincent van Gogh tried to express everything in some shoes, or a straw-bottomed seat, or a candlestick on a rickety armchair. Now he was overcome by "a terrible itching for the unknown," by an irresistible urge to "dare everything." This temptation Gauguin expressed in the allegorical Exotic Eve: the fruit that imparts all knowledge beckons amid the unblemished simplicity of a Garden Primeval that is the wellspring of art.

265. Gauguin. *Fruit Dish on a Garden Chair.* c. 1890

266. Portrait of Gauguin's mother

267. Gauguin. *Exotic Eve.* 1890

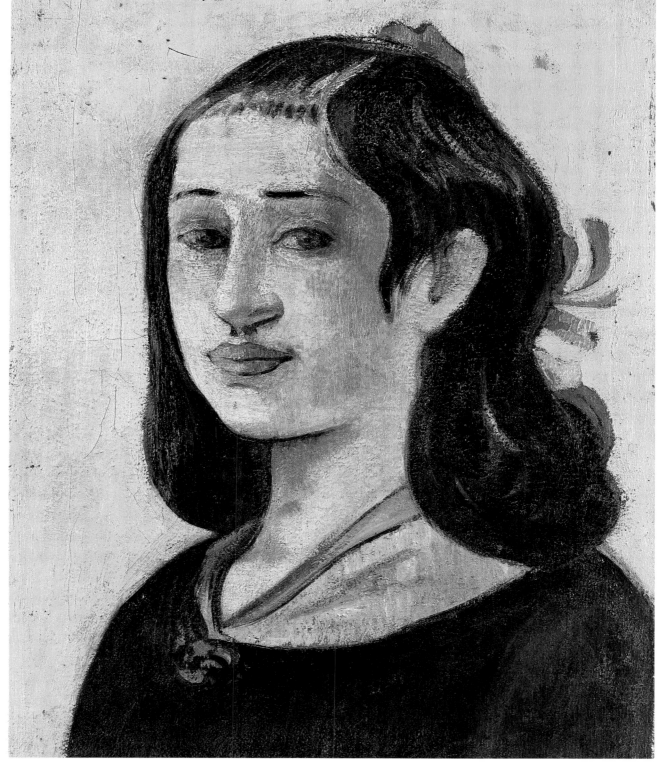

268. Gauguin. *The Artist's Mother (Aline Marie Chazal).* 1890

"How charming and pretty my mother was when she donned her Lima attire! All you could see through the silk mantilla covering her face was her eyes, so gentle and imperious, so clear and affectionate!" Such was Gauguin's tender recollection of his mother from his childhood in Peru. With the help of a half-length portrait he inherited after her death, he did his best to capture both her haughty demeanor and the cajoling twinkle in her eye. Perhaps those lines from Vigny came to mind as he transformed her into an Exotic Eve tempted by the forbidden fruit: "Half-opened like almonds, her big eyes are afire with the pleasure they arouse." Striking the same pose as a bodhisattva from Borobudur (Gauguin had a photograph of this), his Eve would be hard put to challenge her son's sense of humor: he has surrounded her with Martiniquan scenery and placed her between a "naive" snake and a rooster covering a white hen. "I should like to write the way I paint my pictures," he declares at the beginning of Avant et Après, "that is, just as I please, as the spirit moves me." Punctuated by sarcastic little anecdotes, this autobiographical work concludes with the observation that "yesterday's reality becomes a fable," after which he describes the landscape before him in the Marquesas as his life drew to a close. "The sun has returned, the lofty coconut palms lift up their plumes again, and man does likewise; the time of deep sorrow is past; joy is with us again; the mother smiles at her child." His painting was an unending quest for that Paradise Lost that he increasingly sought as a means of escape.

141

269. Kunichika. Portrait of a Japanese Kabuki actor. c. 1880

270. Vessel in the shape of a head. Pre-Columbian, Peru

271. Gauguin. Vase as self-portrait. 1889

F ew of Gauguin's still lifes are as fraught with meaning as this magnificent picture; the protean genius underlying it is as unmistakable as the message it is trying to convey. A Japanese print hangs on a sunny wall so yellow that Van Gogh could have painted it. Wearing make-up that gives his head a ghostly appearance, the actor in the print casts a sidelong glance at a bouquet of exotic flowers. On the faded pink tablecloth sits Gauguin's Pre-Columbian-style pot in the shape of his own head, but the wildflowers in it are wilting. Its eyes, too, are turned toward the vase of robust blossoms. Likewise, our onetime resident of Peru had set his sights on the Far East and the Pacific as a refuge from the decay of Western civilization; there, he hoped, fresh sources of inspiration awaited him. Gauguin sensed that, without this self-imposed exile, his art would wither and die. The remote area of Finistère he had moved to was not exotic enough; already he pictured himself in Tonkin or Tahiti. "I am an outsider here, an Indian in exile," he once exclaimed in a moment of deep depression. He had to get away, to the "great beyond."

272. Gauguin. *Still Life with a Japanese Print.* 1889

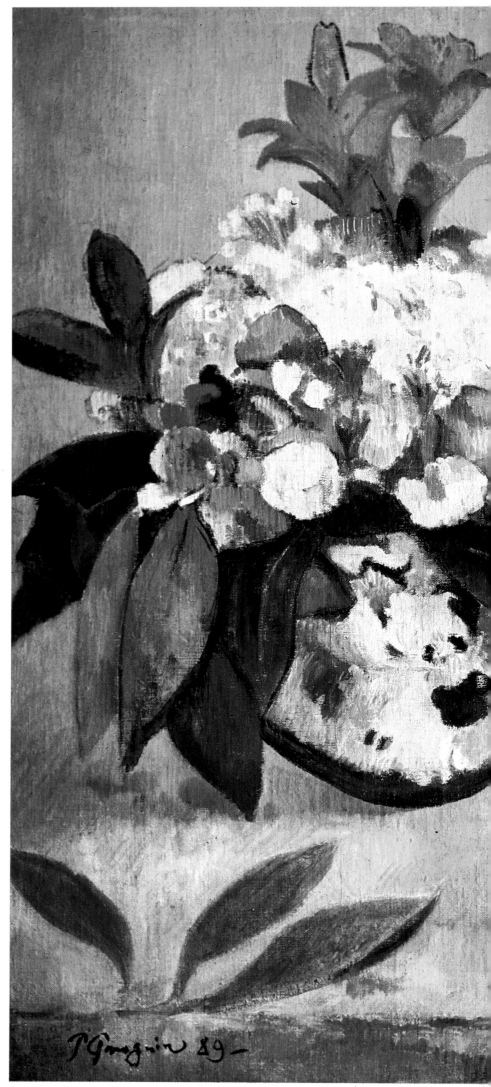

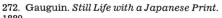

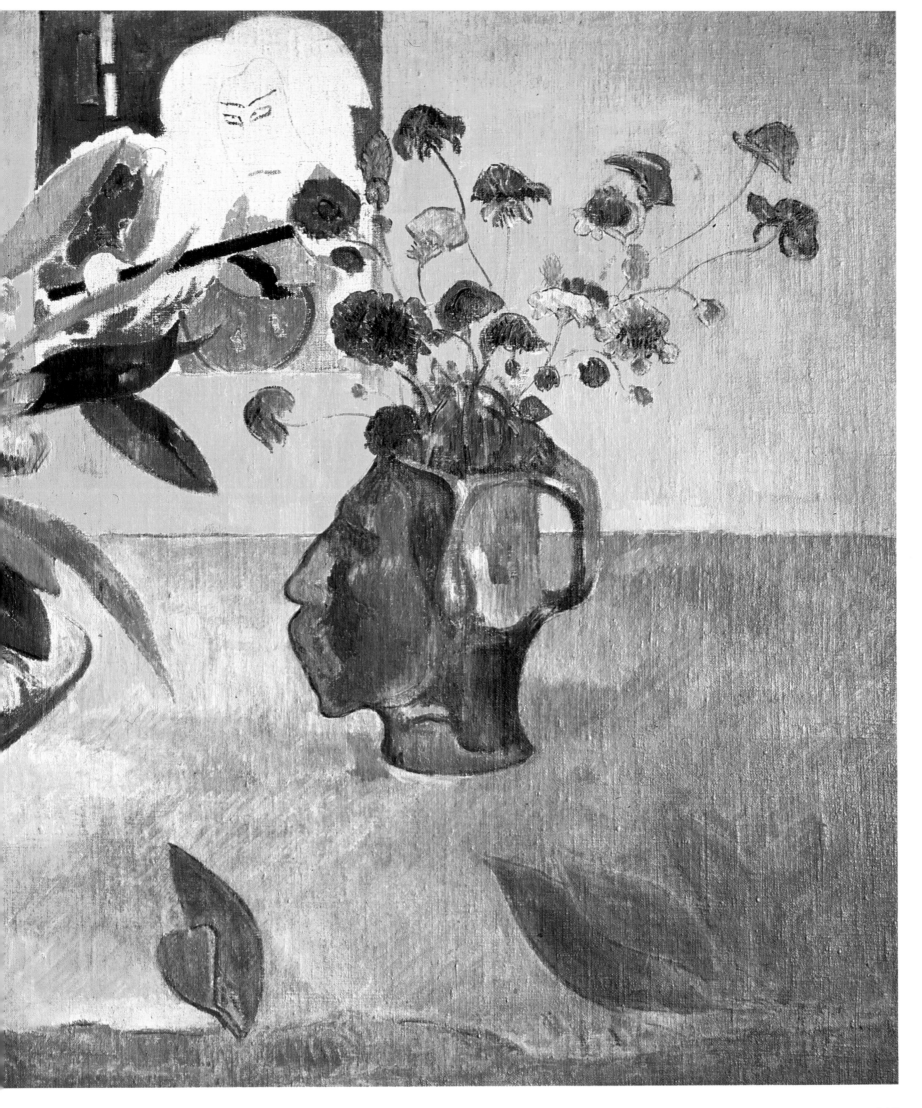

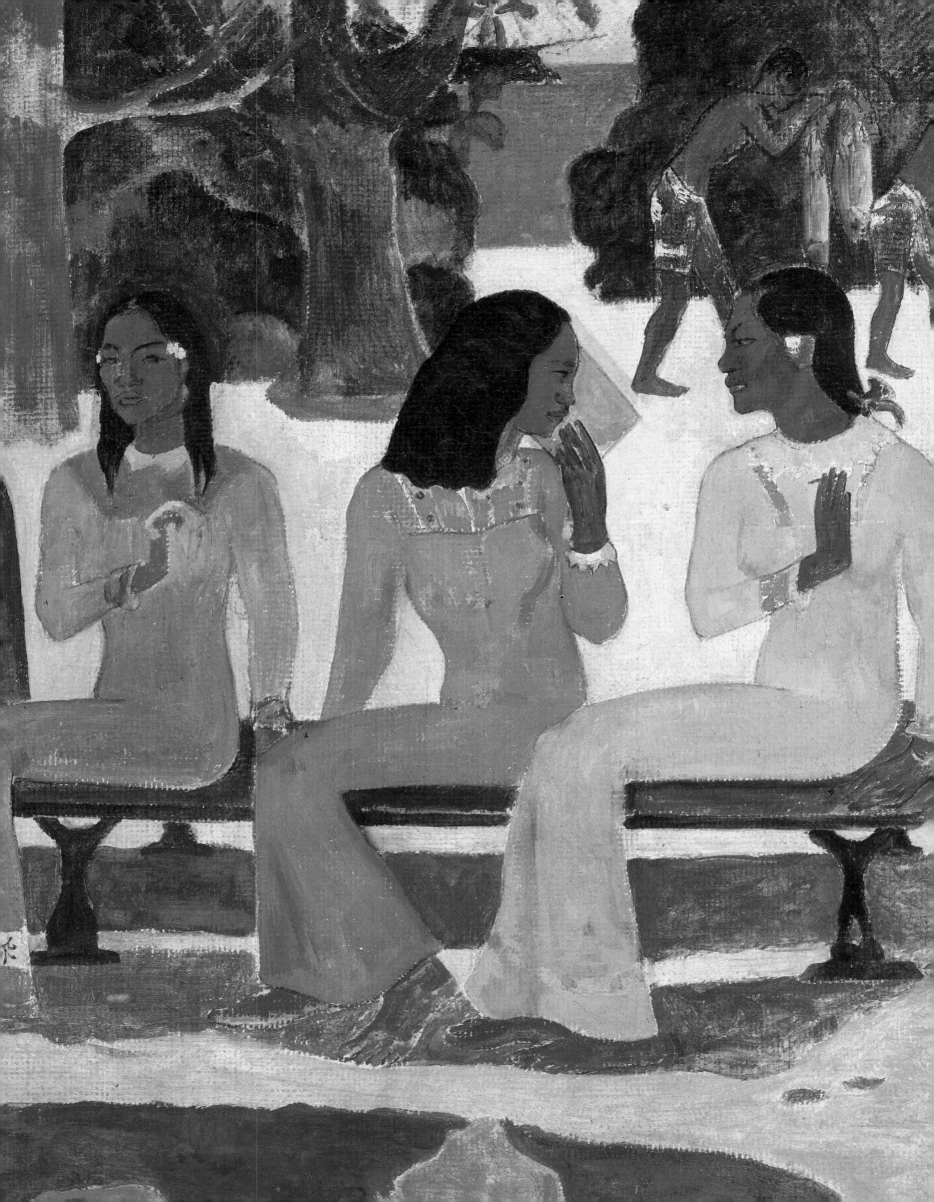

7

Tahiti:
The Studio of the Tropics

April 1891–August 1893

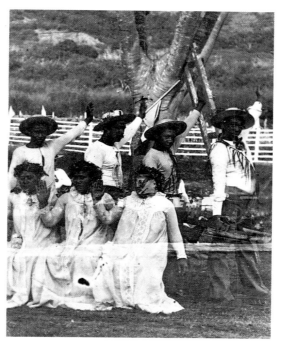

274. Tahitian women performing an *aparima*, or song with pantomime

Second-class passenger Paul Gauguin boarded the *Océanien* on April 1, 1891. After making its way across the Mediterranean and through the Suez Canal, the ship put in at Aden on the 11th. The founder of the "Studio of the Tropics" found the "useless crowd" of pretentious colonial officials tiresome and dropped a line to Monfreid. "Kiss Juliette with all your heart as though it were I. . . ."

April 16. The next port of call was Mahé, in the Seychelles Islands, where he drew some sketches of monkeys and other subjects. He would gaze dreamily at the sea, oblivious to everything except the escort of porpoises alongside the steamer. After stopovers in Australia, the vessel finally reached Nouméa on May 12. The letter he wrote to Mette at this time is peppered with cutting remarks. "What a strange colony. . . . The wealthiest people are freed convicts. One day, they will run the whole show. It's enough to make you want to commit forgery and live it up. Then, if you are convicted, just wait a while and you'll wind up quite happy. In short, everybody finds happiness in his own way."

When the Director of the Interior in New Caledonia learned of Gauguin's mission, he secured a place of honor for him aboard *La Vire*, a transport vessel due to set sail for Tahiti on May 21. The artist struck up a friendship with Marine Captain Swaton, who later introduced him to officers and prominent government officials in Papeete.

On June 8, the day after his forty-third birthday, a "feverishly expectant" Gauguin sighted his Promised Land, his *noa noa* ("fragrant one")! His account of the first stay in

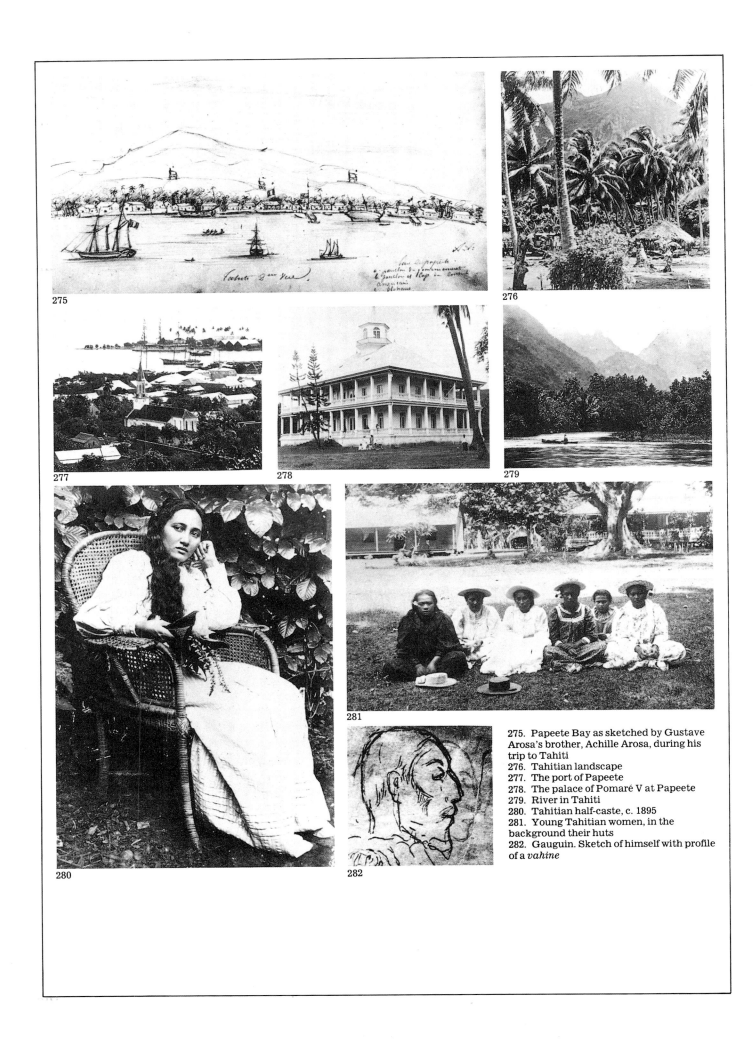

275. Papeete Bay as sketched by Gustave Arosa's brother, Achille Arosa, during his trip to Tahiti
276. Tahitian landscape
277. The port of Papeete
278. The palace of Pomaré V at Papeete
279. River in Tahiti
280. Tahitian half-caste, c. 1895
281. Young Tahitian women, in the background their huts
282. Gauguin. Sketch of himself with profile of a *vahine*

Tahiti, *Noa Noa,* opens with a description of that moment. "We caught sight of strange zigzagging fires on the sea: fishermen. A black cone with jagged indentations loomed against the murky sky. As we rounded Morea, Tahiti came into view. A few hours later, as day broke, we slowly made our way toward the reefs and glided into the channel. . . ." Gauguin's fondest hopes had been attained.

"It Was the Tahiti of Yesteryear I Loved"

Awaiting him in Papeete was one Lieutenant Jénot, who was not prepared for Gauguin's impressive bearing. "Tall, erect, powerfully built, with a look of profound contempt even though he was inquisitive and . . . probably uneasy about the work that lay ahead. The most riveting thing about Gauguin was his long, salt-and-pepper hair, which cascaded over his broad shoulders from under a huge felt cowboy hat. . . . And so the natives nicknamed Gauguin *taata vahine* (man-woman) that very day. . . ." His alert eyes took in everything and everyone.

At ten o'clock, he was brought in to see Governor Lacascade, onetime deputy of Guadeloupe and now the official in charge of the "French Colonial Settlements of Oceania." Even as Lacascade gave him the "V.I.P." treatment, he wondered if the ulterior motive of Gauguin's so-called artistic mission might not be administrative espionage. Gauguin was made to feel very welcome at the Cercle Militaire of Papeete, and this prompted him to make the following prediction to his wife. "It won't be long, I think, before a few lucrative portrait commissions come my way. They are all asking me if I'm willing to do them. Tomorrow I am going to see the royal family. All of which is publicity, and how tiresome!"

But it was not to be. King Pomaré V died before he could grant the artist an audience. On June 16, Gauguin attended his lavish funeral and witnessed a splendid competition of plumed Polynesians, "the last remnants of ancient grandeur." The loss distressed him deeply. "When he died, so did Maori tradition. Now it was really done for. Alas, civilization with its soldiery, trade, and officialdom triumphed."

Realizing that Papeete had come under the mindless sway of European mores, Gauguin became bitterly disappointed. "The dream which brought me to Tahiti was cruelly belied by the present: it was the Tahiti of days gone by that I loved." He never had a chance to experience it firsthand, hence the yearning for the past that pervades all the work from Tahiti.

With Jénot's help, he rented a little house behind the cathedral and met the lieutenant's friends. One of them had a son who tried to teach him Tahitian; but Gauguin had no gift for languages and soon gave up the idea. He preferred to roam through run-down native enclaves rather than associate with rich French settlers and move in "correct" social circles. He made merry with the prostitutes of Papeete and spent more than he should have; the leading citizens of the capital looked askance and steered clear of him. The hoped-for portrait commissions did not materialize.

"Life in Papeete started to sap not only his funds, but the man himself," Jénot later recalled. "He came to us one morning in serious condition, spitting blood. He had to be treated for it. There were problems stemming from the erratic arrival of money from France. . . . He often complained to me about his financial difficulties." Gauguin did his best to put it all out of his mind during the orgiastic festivities in honor of Bastille Day. There he met Gaston Pia, a schoolteacher from Paea, who brought him to his place on

the west coast of the island—a lovely spot that appears in a number of superb paintings. "Nature," Gauguin observed, "grudges us but a few symbols. We get an idea, a sensation, a feeling. That is all we have, yet that is what we call reality: a multiform fiction." During the World's Fair of 1889, Tetuani, one of the eighteen native chiefs of Tahiti, had invited Gauguin to pay him a visit at Mataiea, his domain on the south coast. He now decided to take him up on it. "I had a feeling that by living side-by side with the natives, in the bush, I would, if I were patient enough, gradually overcome the distrust of the people, and I would *know*." That is to say, he would understand what it was that had drawn him to the other side of the world.

He took along his *vahine,* a capricious half-caste aptly named Titi ("Let us nest"); but before long he tired of her shallowness. He was offered the spacious house of a Polynesian villager by the name of Anani, but he turned it down for his very modest bamboo hut at the mouth of the Vaitara, near the beach. By Christmas he had painted some twenty pictures, practicing what he had preached to his disciples: "Let everything radiate calm and inner peace. Avoid motion in a pose. Each one of your figures must be in a static position." He maintained that "every sincere artist is the pupil of his model." His Tahitian models, for their part, had a knack for holding relaxed, supple poses, but he did not know whether to attribute it to a meditative self-absorption inspired by the gods, or to the stupefying, mind-numbing effect of their tropical surroundings.

The artist got his provisions from a little store run by a Chinaman, who relieved him of what money he had left. There was no alternative but to find a sinecure with the colonial administration. On learning that there was an opening for magistrate in the Marquesas Islands, he wrote to the uncommunicative Charles Morice and instructed him to have Clemenceau put in a good word for him. But when Gauguin approached Lacascade with the idea, the governor thought he had taken leave of his senses: he lacked the "special skills" required for the post. Compelled to borrow money here and there, the painter grumbled to Paul Sérusier about "that despicable Morice." "I am at the end of my tether," he added, "and I must go back. How? WITHOUT MONEY. On the other hand, I want to stay. I have not completed my work. . . ."

"Something Indescribably Mysterious"

Gauguin began to sell his belongings: his hunting rifle went to a lawyer by the name of Goupil. It was at his place that the artist chanced upon a two-volume edition of *Voyages aux îles du Grand Océan, contenant des documents nouveaux sur la géographie physique et politique, la langue, la littérature, la religion, les mœurs, les usages et les coutumes de leurs habitants* (1837) by Jacques-Antoine Moerenhout. A prosperous merchant and consul of the United States, then of France, to Tahiti, Moerenhout set down the legends of Oceanian mythology as told to him by Tahitian elders. His book was a crucial source of ethnographic information for Gauguin's *Ancien Culte Mahorie,* an anthology of ancient Polynesian religious beliefs with thirty-seven watercolor illustrations. This initial compilation, in turn, provided much of the text for the more literary *Noa Noa.*

There was much in these sacred traditions to fire the imagination: the creation of the universe, and how Polynesia and the social structure of island clans came into being. Unfortunately, these myths, like the Maoris themselves, were fast falling victim to colonization and conversion. Gauguin started to incorporate local legends into his pictures, and the delight he was taking in them is obvious in several of his letters to Mette. "I am rather

pleased with my latest works, and I feel that I am beginning to absorb the Oceanic character. . . . Tahiti is not without charm, and the women, if not beautiful in the strict sense of the word, have something indescribably subtle and infinitely mysterious about them." If he was already contemplating a move to Dominique—"a small island where there are only three Europeans and where Oceanians are less spoiled by European civilization"—it was to get even closer to the natives. Another reason, however, was because life in the Marquesas was far less expensive. In virtually all of his letters to his wife, to de Monfreid, Sérusier, and Morice, the artist deplores not having the "funds" that are supposed to be forthcoming from France, and which he feverishly awaited every time a ship pulled in. A French naval officer put down 400 francs toward a portrait of his Tahitian wife; in the meantime, Goupil suggested Gauguin take a temporary job in Paea guarding the effects of a man in bankruptcy.

The *Cahier pour Aline*

On June 12, 1892, he wrote to the Director of Fine Arts that his mission to Tahiti had made it possible for him to study local folkways and scenery. But, he added, "however thrifty one may be, life in Tahiti is very expensive and travel burdensome." Therefore, he asked to be repatriated to France.

Gauguin was eating less and brooding more. His thoughts drifted to his children. Gazing at the photograph of them on the wall of his hut, he would think: they are growing up without me. He was particularly sensitive when it came to Aline, and the thought of Mette's being overly strict with her elicited an emotional response. "I know full well that she takes a little after me, and that is why you treat her rather as though she were a stranger." He suggested that Mette start their daughter on the guitar instead of making her take piano lessons. "She could accompany me in my old age. I must confess, my mandolin (and I play pretty decently now) is not much of a companion here where I am all alone. But music is my great distraction." Another of his distractions was putting together a book of "random and disconnected notes, like dreams, like life, all made up of bits and pieces." The dedication reads *à ma fille Aline,* but he never got the chance to present it to her in person. Polynesian sculpture may have inspired the stylized head of a young woman that graces the cover of *Cahier pour Aline.* A reproduction of a Corot painting—an Italian woman playing the mandolin—is pasted on the other side of the cover. On the endpaper we find a clipping of a favorable article by Jean Dolent that begins as follows: "I like poets infinitely. Infinitely! Poetry is Faith. . . ." Toward the back of the notebook are more articles, as well as the preface Octave Mirbeau wrote for the catalogue of the auction that was held just before Gauguin left Paris. The *Cahier pour Aline* also contains excerpts on art by Edgar Allan Poe and Richard Wagner as well as Gauguin's own observations on politics, mores, women, and love. Here and there we find an occasional aphorism or piece of advice: "A kilo of green is greener than a half-kilo. . . . Perhaps you will understand why a tree trunk in a painting must be bluer than it is in real life." He explains how he came to paint *Spirit of the Dead Watching (Manao Tupapau)* and draws a sketch of it. "You will always find nourishment in the primitive arts," he notes. Elsewhere, "If I gaze straight ahead into space, I have a vague awareness of infinity; yet, I am the point of origin. From this I should understand that there is a beginning and that there is no end. But that does not account for the mystery; all it does is give me the mysterious sensation of the mystery." This, then, is the hidden essence of Gauguin's art. It imparts to us an enigmatic impression that the world around us is in

continual and never-ending flux. Like Pascal, we stand in awe of "the eternal silence of infinite space." Beyond his solidly structured forms and glowing, sensuous colors, the real genius of Gauguin lies in his ability to convey a kind of metaphysical bewilderment. We are being swept along, but where? How solitary man is as he contemplates the destiny of the world!

The lines from Verlaine he copied in the *Cahier pour Aline* suggest the depth of his spiritual distress:

> I came a quiet orphan,
> Tranquil eyes my only riches . . .
> My life is sinking into
> A slumber dark and deep . . .

"Which is right?" he asks himself. "In Europe, human mating is an outgrowth of love. In Oceania, love is an outgrowth of mating." Then he quotes "Sâr" Péladan, founder of the Salon of the Rosicrucians. "You act the way you feel; you live by the principles which are to your liking." Words for a self-styled Epicurean to live by!

The Gold of Tehura's Face

So completely did Gauguin embrace native customs while in Mataiea that he married a thirteen-year-old girl in accordance with the Tahitian ritual described by Pierre Loti. In *Noa Noa* he tells us how his strange, but opportune, meeting with Teha'amana (later called Tehura) came about.

The artist had suffered through several months of dispiriting loneliness after dismissing his simpering mistress, Titi. One fine day, he decided to undertake a voyage of discovery to Taravao, a village located at the isthmus that joins the main island to the peninsula to the east. His neighbor and landlord, Anani, and his wife had misgivings about the excursion, but he assured them that he would return. When he got as far as Taravao, he borrowed a horse from the local gendarme and headed north toward Faaone. A native, who knew the mounted wayfarer to be a painter, accosted him. "Hey, man who creates men! Come eat with us!" He followed the man to his hut, where a woman asked him where he was going and why. "To Itia, to look for a wife," he replied without thinking. A quarter-hour later, "while wild bananas, shrimp, and a fish were being brought in for a Maori meal, she came back, followed by a tall girl who held a small bundle in her hand. Through the extremely sheer pink muslin of her dress you could see the golden skin of her shoulders and arms. Two nipples swelled out from her breasts."

They suggested that he take Teha'amana (Tahitian for "she who gives strength") as his wife. His heart racing, Gauguin nervously asked if she was frightened of him. "Aita! (no)." Then, if she wished to live in his hut forever. "Eha! (yes)" was the reply. Finally, if she had ever been sick. "Aita!" The ceremony completed, Gauguin (or Ko-ki, as the Tahitians called him) headed back to Mataiea, bride in tow. When he dropped off the horse in Taravao, the gendarme's French wife seemed incensed that Gauguin had taken a Tahitian wife.

"I started working again, and happiness dwelled in my house," he tells us in *Noa Noa*. "The gold of Tehura's face flooded the inside of our abode and the surrounding countryside with joy and light. . . . Tahitian paradise, *nave nave fenua*. . . . And the Eve of

this Paradise became more and more submissive and affectionate. I am permeated with her fragrance: *noa noa!* She came into my life at just the right moment." She also began to make her presence felt in Gauguin's paintings, which now struck a more euphoric note.

How apt were the Tahitian words he was fond of using to describe his sensuous love for Teha'amana: *nave nave* (sexual pleasure) and *noa noa,* the heady scent given off by flowers and by bodies redolent of fragrant coconut oil. The relationship opened up a world of hedonistic delights, and more: through her Gauguin began to enter into "a great many mysteries which until now have remained impenetrable." He found himself "probing my inner self, not nature," delving into his own background and past emotional experiences. To be sure, as he painted this girl and her companions he was influenced by Italian primitives, Botticelli, Michelangelo, Delacroix, and Degas, by bas-relief friezes from Egypt, Greece, and Borobudur. However, he also gave free rein to his unconscious, his fantasies, his anguish. His canvases became symbolic screens upon which the artist projected, among other things, his distressing jealousy, not only of the inconstant Teha'amana, but of the allegedly unfaithful Mette. (Oddly enough, he still insisted that she abide by her marriage vows.) He noted the refrain from a Tahitian chant entitled *Oviri,* or "Savage":

> Behold the starry pall of night.
> My heart is taken by two women:
> Both of them are wailing
> While my heart and the flute sing.

Two women, so different, and yet how they complemented each other! One of them was middle-class, importunate, stoical; the other, instinctive, supplicatory, languid. He could no more do without the latter than he could forget the former, the mother of his lawful offspring. Besides, he learned that Mette had been instrumental in getting him into the Free Exhibition of Modern Art scheduled to take place in Copenhagen the following spring (1893) and that she had managed to sell some of his Breton paintings for 1,500 francs. He did not receive any of the proceeds, however. "The poor woman needed the money," he wrote to de Monfreid in March, 1893. "That doesn't matter. Things are going well for me in Denmark." There was other news. "Soon I shall be a father again, in Oceania. For heavens' sake, I can't help sowing my seed everywhere. . . ."

The prospect of becoming a father did not trouble him much, for he knew that in Tahiti a child was "the most beautiful gift one can give" and that children "go to whoever wish to be foster parents." Besides, he reasoned, Teha'amana would see to it that the child would not be born.

"Stone Broke"

To "put some money aside" for the return trip to France, Gauguin sent a fresh batch of paintings to his friend de Monfreid, urged him to sell them, and tried to collect the money which (according to a letter from Maurice Joyant, director of the Boussod and Valadon Gallery) had been turned over to Charles Morice, whom Gauguin accused of out-and-out thievery. As if being, as he put it, "stone broke" was not enough, there was the disheartening news that Albert Aurier had died. "We really are down on our luck. First Van Gogh, then Aurier, the only critic who really understood us and who may have been quite useful to us one day." He even contemplated giving up painting when he got back to

France and taking a position as an "inspector of drawing in the lycées." "I can't even indulge in a cup of tea because of the high cost of sugar," he complained to his wife.... "If you had sent me the money from the last painting, you would have saved my life."

At long last, de Monfreid and Mette sent him 300 francs and 700 francs, respectively; but his debts came to more than 500 francs. He was still awaiting the go-ahead Tahitian officials had to receive from Paris before they could repatriate Gauguin at government expense. Hoping to set sail aboard the *Durance* on May 1, he returned to Papeete with Teha'amana and rented a little house and porch in the district where Jénot and his friends lived. He painted the windowpanes to escape the unhealthy curiosity of his landlady, Mme. Charbonnier.

Departure for New Caledonia and Teha'amana's Tears

On May 25, the mail schooner brought, in extremis, an order from the Colonial office authorizing the governor to have this "painter in financial distress" transferred to France, costs to be borne by the Ministry of the Interior. Officially classified "pauper in steerage," Gauguin tried to secure an officer's cabin aboard the cruiser *Duchaffault*, but the contemptuous Lacascade protested. Fortunately, Captain Manseron and his crew extended him every courtesy and had him join them at mess. The *Duchaffault* set out for New Caledonia on June 14.

For all the privation he had endured, this two-year stint in Tahiti had, all in all, not been unproductive: he had "produced sixty-six paintings" and "a few pieces of ultra-savage sculpture." One of his last pictures from this period, a portrait of his *vahine*, bears the inscription *Merahi metua no Tehaamana,* "Teha'amana has many relatives." But that could not make up for the distressing prospect of her separation from Gauguin, perhaps forever.

"I saw Teha'amana for the last time when I left the dock to board ship," Gauguin later wrote in *Noa Noa.* "She had spent the past few nights weeping. Worn out, dejected, she sat with her legs hanging over a rock and her broad, powerful feet skimming the surface of the briny water. The flower she had put behind her ear had fallen to her knees, wilted."

He had sacrificed her to the greater glory of Paul Gauguin. At last, he thought, Paris would be his for the taking!

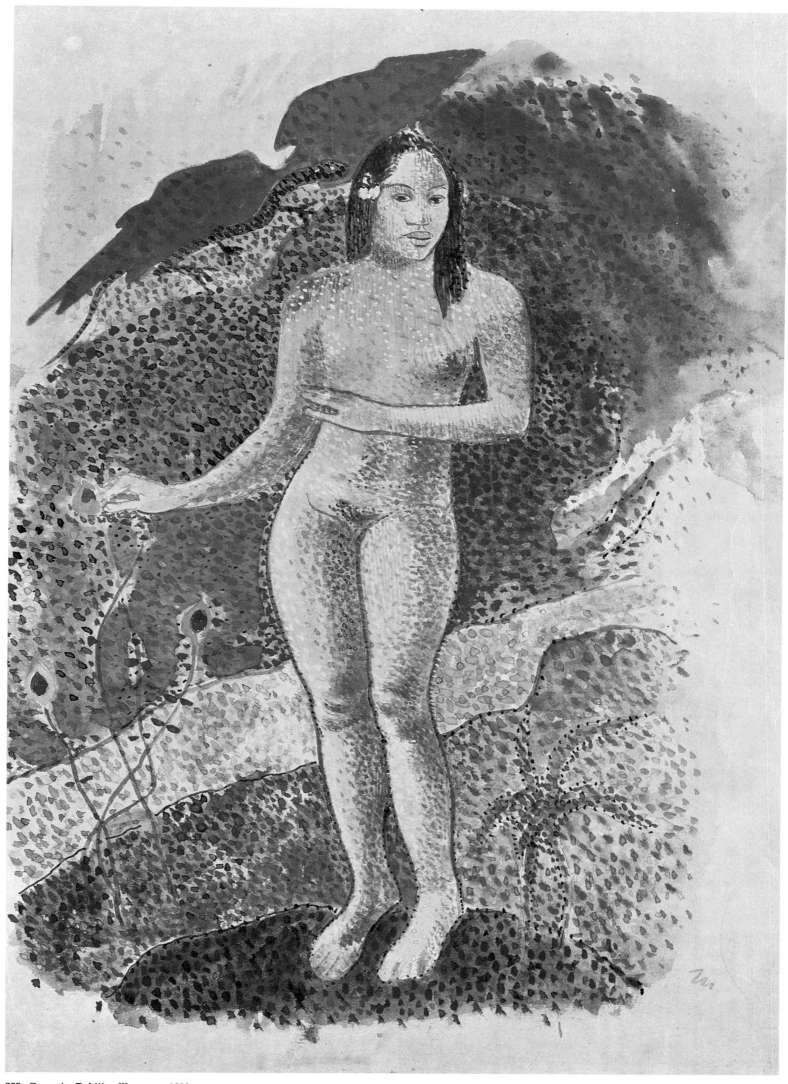

283. Gauguin. *Tahitian Woman*. c. 1892

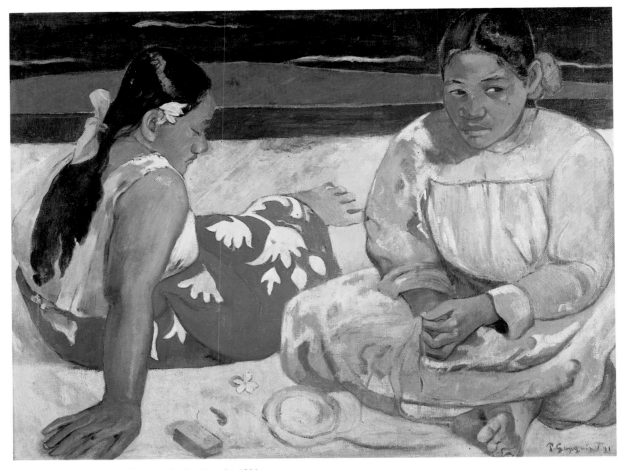

284. Gauguin. *Tahitian Women (On the Beach)*. 1891

285. Charles Chaplin. *Little Harvester Sleeping by a Wall*. c. 1878

286. Tahitian woman, c. 1890

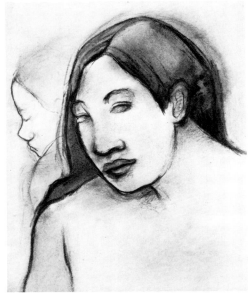

287. Gauguin. *Head of a Tahitian Woman*

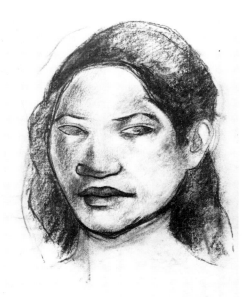

288. Gauguin. *Head of a Tahitian Woman*

"I understand how these people can remain seated for hours, for days at a time without uttering a word and gazing mournfully at the sky," Gauguin wrote to his wife twenty days after setting foot on Tahiti. "I feel that all this is about to envelop me, and just now I have a feeling of extraordinary restfulness." With nothing but his experiences on Martinique to go by, he expected that the primitive life he had finally rediscovered in Tahiti would bring a kind of instant happiness. Instead, his initial reaction was to succumb to the languid yearning of the South Seas. Since Papeete had become too Westernized for his taste, he moved to the seaside district of Mataiea. His hut—no doubt the one we see as a picture on the wall in Revery—stood "kilometer 45" near the sea. As Louis Le Négrier, the district leader, later recalled, "He lived there with a native girl, seldom the same one, for he was an inveterate skirt-chaser."

Gauguin attempted to capture this mood of tropical melancholy in portraits of his island women, here seated on the beach or in a rocking chair. In Tahitian Women (On the Beach), *the red dress and pink blouse boldly contrast with the yellow sand and green sea; in* Revery, *the vermilion* pareo (cloth) *stands out against the blue backdrop of the hut.* Gustave Arosa had taken a photograph of Chaplin's painting, which Gauguin had brought with him; it may have inspired not only the cross-legged pose of his pink vahine but her contemplative listlessness. He also captured the same "shifty-eyed look of animal cunning" that he mentions when describing Vaituani in Noa Noa.

Opposite:
289. Gauguin. *Revery (Woman in Red Dress)*. 1891

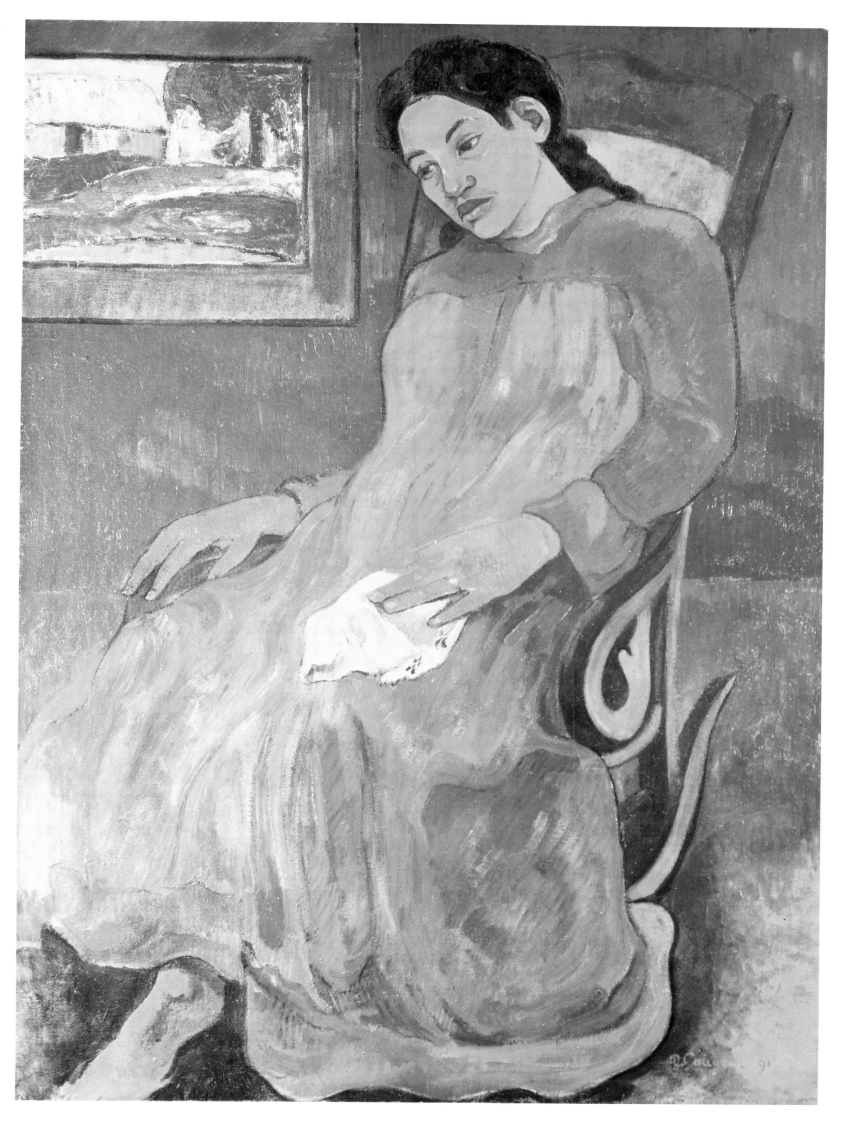

290. Bas-relief, Temple of Borobudur, Java

291. Sandro Botticelli. *Primavera* (detail).
c. 1478

Gauguin described his Polynesian We Greet Thee, Mary (Ia Orana Maria) *in a letter to his friend and correspondent de Monfreid. "An angel with yellow wings points out to two Tahitian women Mary and Jesus, also Tahitian. Nudes dressed in* pareos, *a kind of flowered cotton cloth that is wrapped as one likes about the waist. Very dark background of mountains and flowering trees. Dark purple footpath and emerald green foreground; on the left, some bananas. I am rather pleased with it." What he neglected to tell de Monfreid—not that it mattered, since Gauguin refashioned all of his pictorial sources into something fresh and original—was that he had Fra Angelico to thank for his pale pink and blue angel, the Javanese temple of Borobudur for the two*

Tahitian women in prayer, and Botticelli's flower-bedecked Primavera *for both the winsome expression of his Mary and the lush vegetation around her. In the foreground of this symbolic, blissfully harmonious composition we see a still life with bananas which reappears in* Noa Noa *and in* Tahitian Repast, *a naive Last Supper that is "primitive" in more ways than one. Home to both a Catholic school run by nuns and a Protestant mission, the district Gauguin lived in was the most Christianized on the island. The natives around him believed with a trusting, heartfelt faith which made Gauguin all the more receptive to the primitive art of Italy and the Far East.*

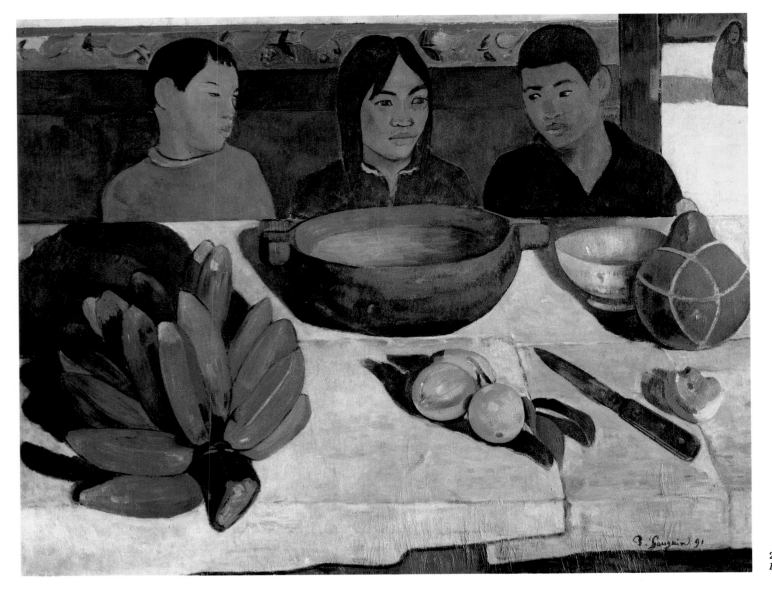

292. Gauguin. *Tahitian Repast (The Bananas)*. 1891

156

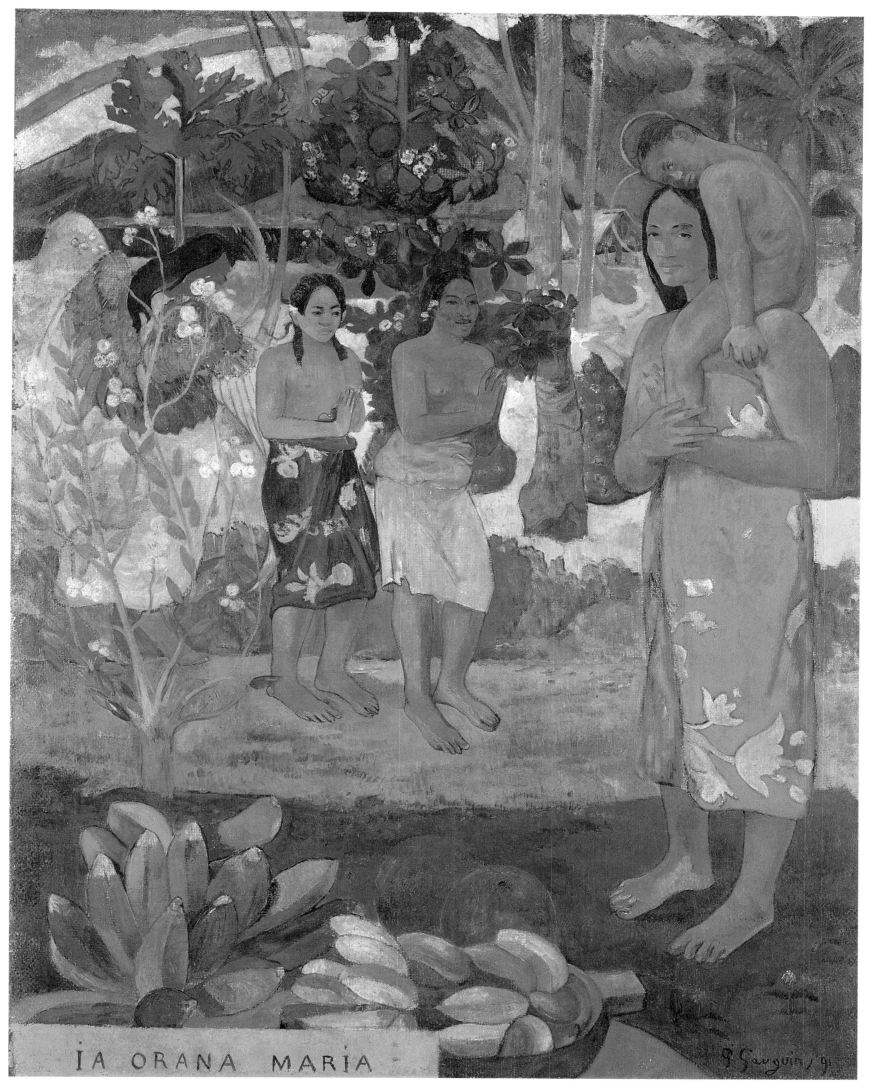

IA ORANA MARIA

293. Gauguin. *We Greet Thee, Mary (Ia Orana Maria)*. 1891

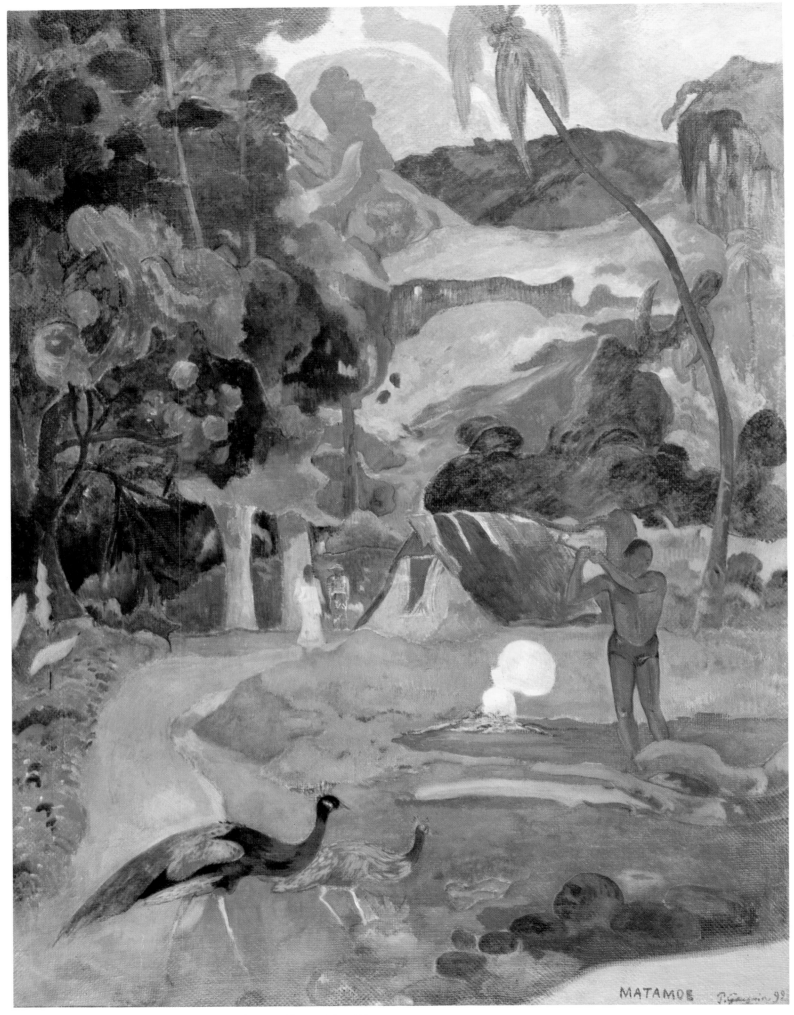

294. Gauguin. *The Dead Tree (Matamoe)* or *Landscape with Peacocks*. 1892

295. Parthenon frieze (detail)

296. Parthenon frieze (detail)

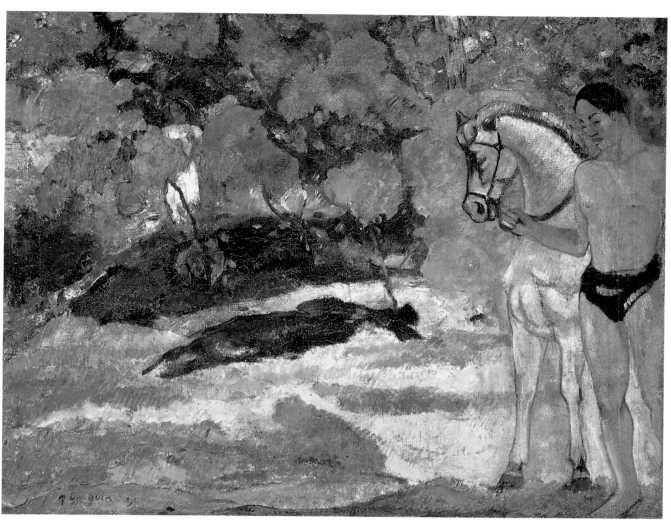

298. Gauguin. *In the Vanilla Grove, Man and Horse.* 1891

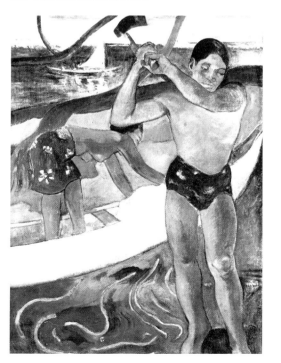

297. Gauguin. *Man with an Ax (The Servant of Pia).* 1891

G ustave Arosa had photographed the plaster casts which Choisel-Gouffier had made from some Phidias sculptures, and Gauguin based several pictures showing everyday life in Tahiti on Arosa's collotypes. He describes one of these scenes in Noa Noa. *"It is morning. On the sea, at the water's edge, I see a dugout canoe, and in the dugout canoe a woman; on the shore, a man, almost naked. In a supple, harmonious motion, the man raises with both his hands a heavy ax that leaves a blue imprint against the silvery sky and, below, its incision in the dead tree: the warmth the centuries have stored up in it day by day will be reborn in a flaming instant."* In another section of Noa Noa, reminiscent of Gide's writing, he tells of the time he went into the bush with Jotefa to cut down some wood. The disquieting beauty of the youth's androgynous body aroused a craving that Gauguin could only overcome by diving into a cold waterfall and flailing rosewood trees with an ax. *"When I worked my chisel into that piece of wood, I could smell . . . the scent of victory and rejuvenation."* But if Phidias was the inspiration for his graceful ephebe, the synthesized wonders he worked with peacocks, trails of sensual colors, and watery arabesques recall the refinement and stylization of Japanese prints.

159

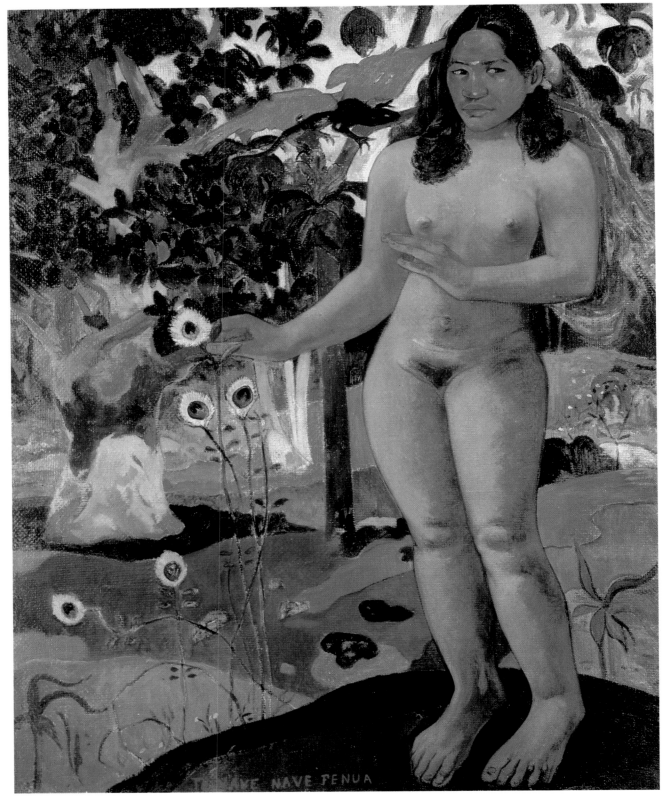

299. Gauguin. *Delicious Earth (Te Nave Nave Fenua).* 1892

300. Bas-relief, Temple of Borobudur, Java

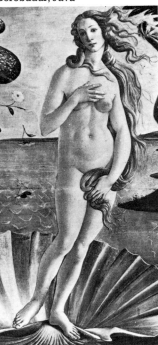

301. Sandro Botticelli. *The Birth of Venus* (detail). c. 1485

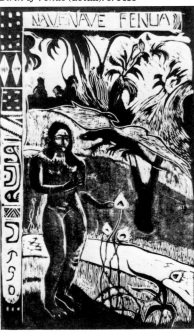

302. Gauguin. *Delicious Earth (Nave Nave Fenua).* c. 1891–93

G auguin derived the tilted hips of his Exotic Eve *(1890) from a relief from Borobudur; here, in what is probably a reference to an Oceanic myth, we see the pose again.* According to local legend, Ohina, "goddess of the bosom of the earth," slept *with the first god, Taaora, and gave birth to Tefatou, the force that moves the earth.* Arms *extended, the allegory of* Delicious Earth *as depicted here strikes her swaying pose to the right of the painting's central axis; and, as in Botticelli's* The Birth of Venus, *the life force comes from the left. Whereas in the latter it is Aeolus that provides the life-giving puff of air, here we see a mysterious black lizard with fiery wings that seems to be whispering a message from the world beyond.* More massive and golden than Venus rising from the sea, the body of Ohina emerges *from the ground as fluid and glowing red as lava.* Likewise surrounded by pink blossoms that *seem suspended in air, her triangular face registers a similar expression of emotion and expectation.* "I am partial to drawing figures," he wrote at the time. In Woman with Mango, *the orange of the face and mango conspire with a yellow wall to create a tempting luster that must vie with the religious blue of her dress.* Here, jarring chromatic contrast is the source of the *figure's radiance.* Gauguin excelled in this type of commanding portrait.

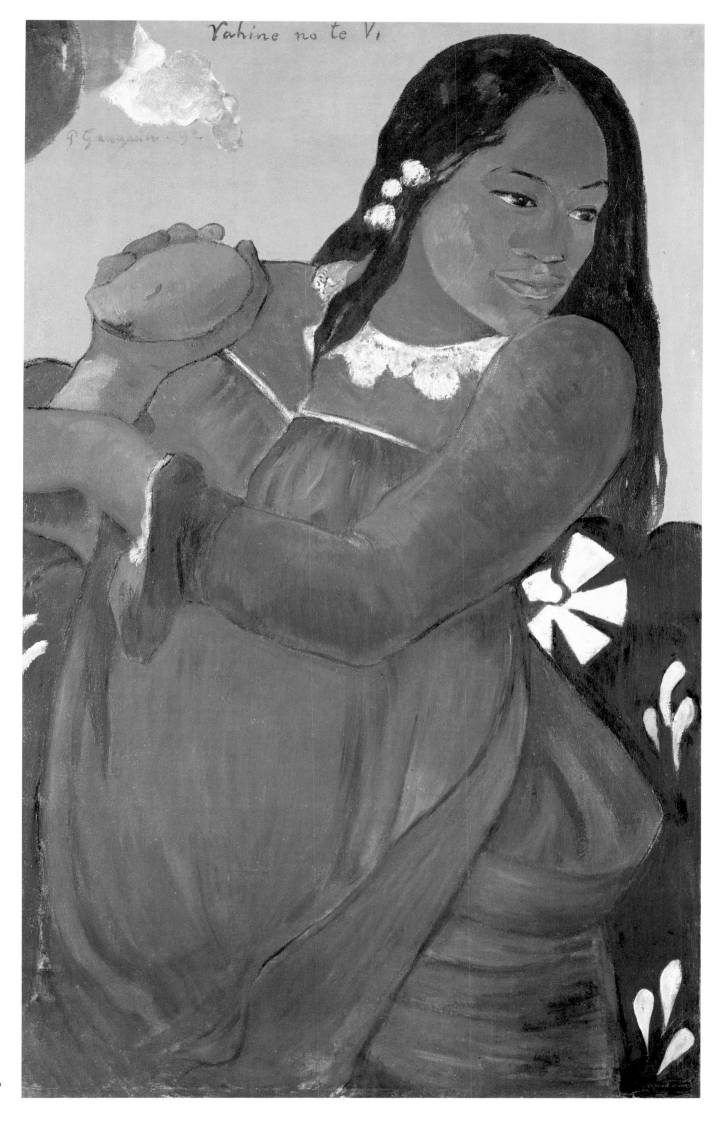

303. Gauguin. *Woman with Mango (Vahine No Te Vi)*. 1892

EXPOSANTS

Paul Gauguin	E. Schuffenecker	Emile Bernard
Charles Laval	Louis Anquetin	Louis Roy
Léon Fauché	Georges Daniel	Ludovic Nemo

304. Gauguin. *At the Black Rocks*. 1889

305. Ando Hiroshige. *Pine Like a Full Moon in Ueno Park*. 1857

The nude woman seen from behind is a subject that reappears in a number of Gauguin's pictures, including the engraving he did for the catalogue of the Volpini exhibition in 1889. During his first Breton period, he positioned her against a haystack in Arles; here, she is about to jump into the water. Her companion is undoing her *pareo* to join her and perhaps swim toward the angler with rod and line in the distance. There is no horizon. Spellbound, our eyes are riveted to the swirling trees to the left, the undulating area of mauve in the foreground, and the curling crests of the Japanese-inspired waves. Gauguin may also be harking back to the decorative patterns of stained-glass windows. When he learned that de Monfreid had begun working with this medium, he wrote back: "I congratulate you, and by forcing you to decorate, it can only do you good. But beware of modeling. The simple stained-glass window, attracting the eye by its divisions of color and form, is still the best. A kind of music. And to think that I was cut out to do decorative art and have been unable to make a success of it. Stained glass, furniture, faience—what have you. That is where my real gifts lie, much more than in painting proper."

306. Gauguin. *Fatata Te Miti (By the Sea)*. 1892

"4" />

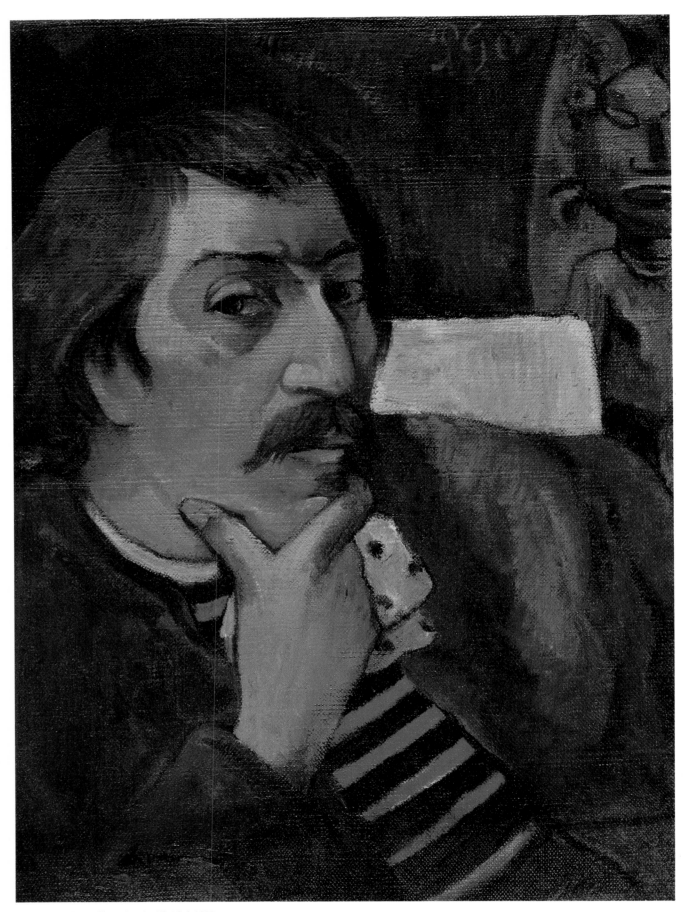

307. Gauguin. *Self-Portrait with Idol.* 1893

308. Gauguin. *Hina*, statuette
of the goddess

309. Paul Gauguin, 1891

I n Self-Portrait with Idol *(painted after a photograph of the artist wearing a
Breton waistcoat and leaning on his elbow) we see part of Gauguin's
statuette of Hina. The domain of this Maori goddess, he points out in* Noa
Noa, *"is limited to the elements of air and water, of the earth and the moon." She
induces reverie and flights of fancy. He has his eye on Tehura, his mistress, who
is shown lying on her stomach and wondering what he is about to do with her; yet,
he looks as uneasy as she does.*

In Spirit of the Dead Watching, *Gauguin described his impressions of this very young* vahine *in a letter to his wife (December 8, 1892).* "In this position, a trifle, and she becomes indecent. Yet, I wanted her that way: I find the lines and movement interesting. Then I gave her face a somewhat frightened expression. . . . By tradition, these people are very much afraid of the spirits of the dead. A European girl would dread being caught in this position (the woman here, not at all). I had to explain this terror in as unliterary a way as possible, such as it used to be done. . . . General color scheme: dark, sad, frightening, like a death knell to the eyes. Violet, dark blue, orangish-yellow. . . . There are some flowers in the background, but they are not supposed to be true-to-life; since they are imagined, I made them look like sparks. For Polynesians, the phosphorescences of the night are the spirits of the dead; they believe in them and dread them. To finish the picture, I put in a ghost, nothing more than a little old woman, because the only way the girl can picture the spirit of a dead person . . . is in terms of the person herself, that is, as a human being like her."

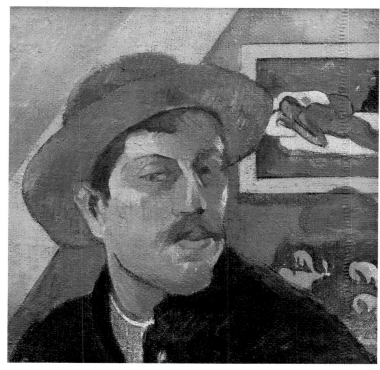

310. Gauguin. *Self-Portrait with Hat* (detail). 1893

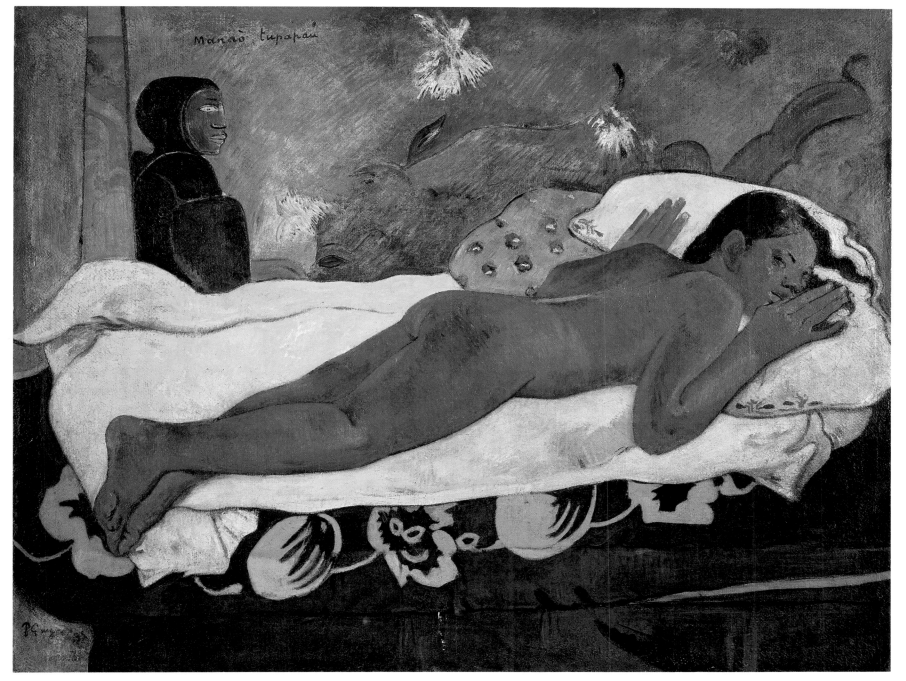

311. Gauguin. *Spirit of the Dead Watching (Manao Tupapau).* 1892

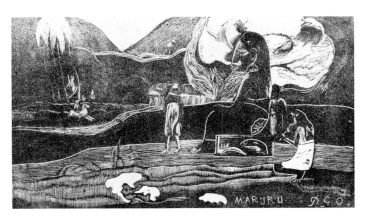

312. Gauguin. *Maruru*

313. Gauguin. Drawing of a Marquesan earplug. c. 1895

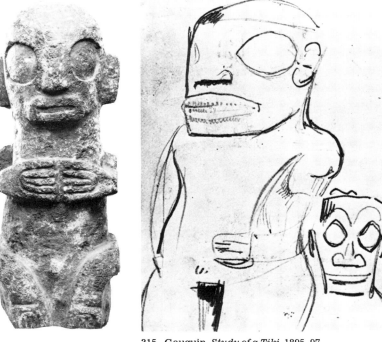

314. Tiki, stone statue from the Marquesas Islands

315. Gauguin. *Study of a Tiki*. 1895–97

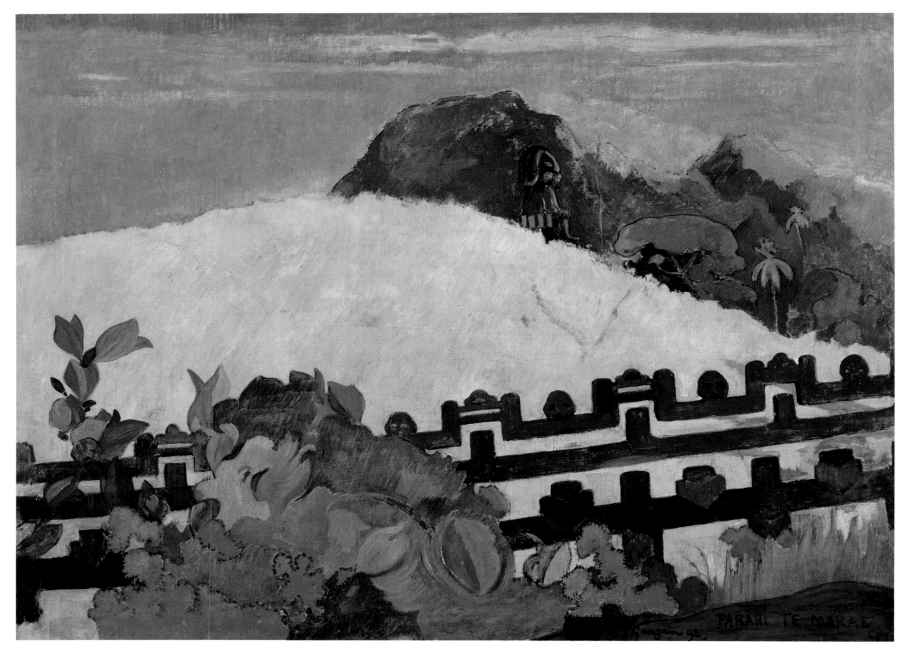

316. Gauguin. *Parahi Te Marae (There is the Temple)*. 1892

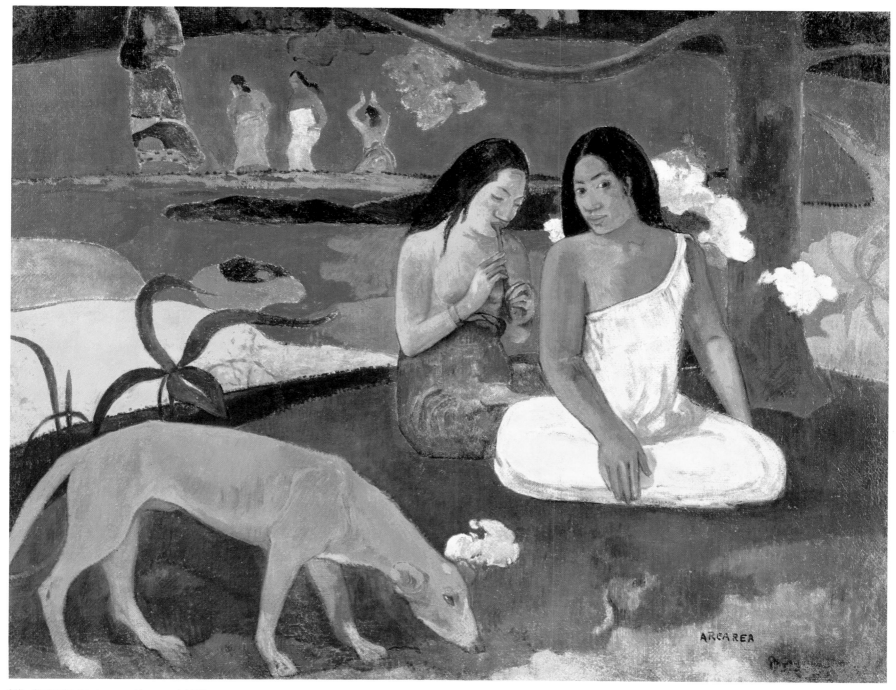

317. Gauguin. *Joyousness (Arearea)*. 1892

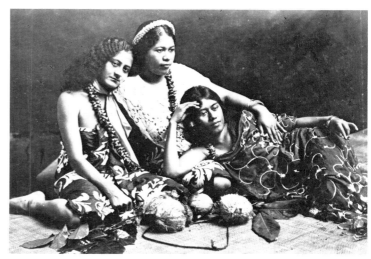

318. The rest, Tahiti. c. 1910

T he idol looming on the horizon of these two religious paintings, Joyousness (Arearea) *and* There Is the Temple (Parahi Te Marae), *may have been copied from a photograph of a* tiki. *It attests to the artist's new desire to incorporate Maori art into his own, with special emphasis on the Marquesans and what he later described admiringly as their "incredible sense of decoration." Designs from tattoos, decorative sculpture, and everyday objects began to surface in his drawings; then, unobtrusively, they found their way into his paintings. "Here, then, is an accurate picture of Tahiti," he later wrote in* Noa Noa *after making the following observation: "Nature grudges us but a few symbols. An idea, a sensation, a feeling—that is all we have, yet that is what we call reality: a multiform fiction." Such is the case with* There Is the Temple. *Crisply outlined against the golden hill, the fence guarding the unseen Tahitian temple harks back to Japanese prints; yet, the designs carved into it were copied directly from a Marquesan earring. "I held the brush, the Maori gods guided my hand," Gauguin later observed in* Noa Noa. *Poetic license, perhaps: but contrary to what that hyperbolic statement implies, Oceanic mythology—as told him by his mistress, Tehura—had already lost currency in Tahiti.*

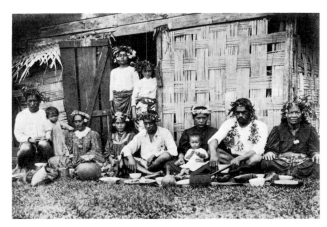

319. Tahitian meal, c. 1895

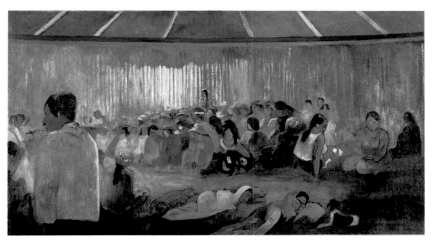

320. Gauguin. *Te Fare Hymenee (House of Song)*. 1892

321. Gauguin. *Noa Noa*, folio 63

322. Gauguin. *The Valley*. 1892

A few excerpts from Noa Noa *may shed light on the bold burst of exuberant color with which the painter has flooded this valley.* "A gaping mountain, a fearsome crevice stopped up with an enormous stand of mango trees against the rock. Between the mountain and the sea stood a hut of burao wood. Near my hut stood another, smaller one: fareamu *(house for eating)."* "The landscape, with its bold, fiery colors, dazzled and blinded me. In the old days, I would always hold back, always miss the obvious.... Yet, how simple it was to go ahead and paint [things] as I saw them, to put a red or a blue on my canvas without so much forethought. Why was I reluctant to let all that joyous golden sunlight wash across my canvas? Tiresome old European habits, diffidence

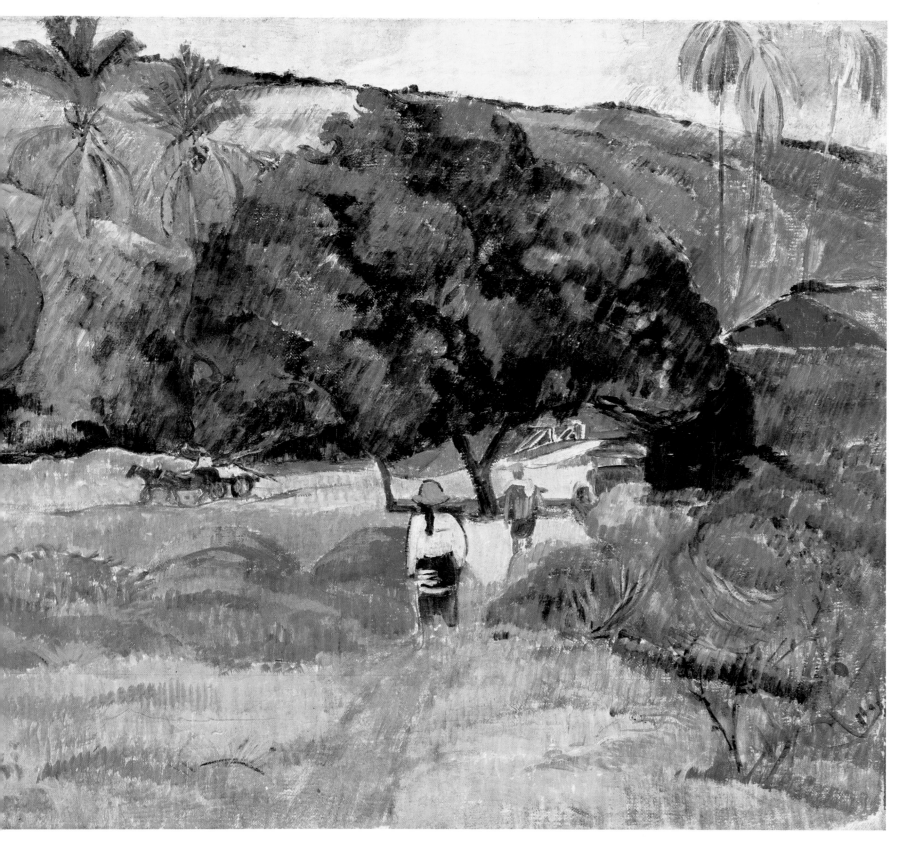

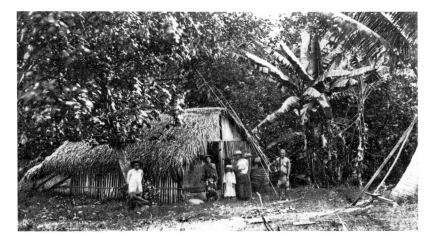

323. Native hut, Tahiti, c. 1891

of degenerate races!" And so Gauguin took off like a young man on horseback, cutting through the countryside. "I am good," he wrote to Mette, "because I never allow myself to be sidetracked by others, because I do what is within me." He also describes what he saw at a huge wedding celebration in Mataiea. "Much eating and drinking, and an hour later the speeches begin.... These are delivered in a methodical, systematic way, but it is a peculiar sort of eloquence competition, full of unexpected occurrences." This is probably the subject of House of Song. The woman sleeping in the foreground reappears in Noa Noa: "The gods of yore have kept a place of refuge for themselves in the memory of women."

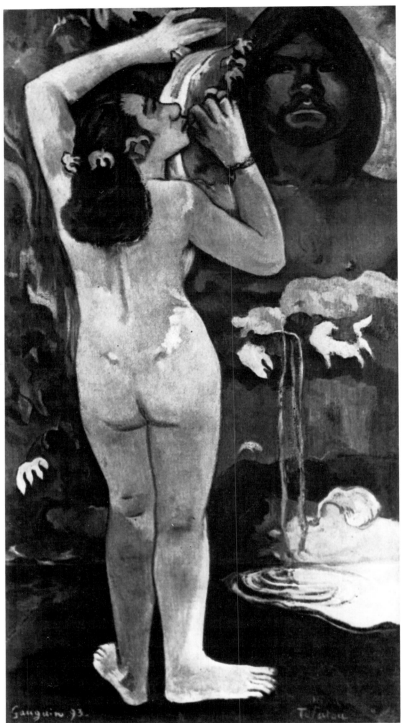

324. Gauguin. *The Moon and the Earth (Hina Te Fatou).* 1893

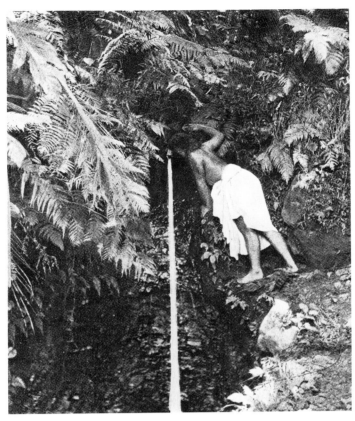

325. Tahitian man at a mountain spring

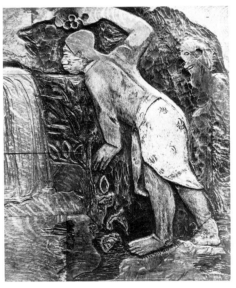

326. Gauguin. *The Source*

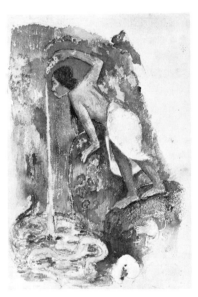

327. Gauguin. *Mysterious Water (Pape Moe).* c. 1893

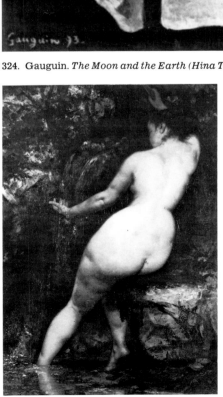

328. Gustave Courbet. *The Source.* 1868

Travelers have leave to lie, the saying goes. "All of a sudden," Gauguin tells us in Noa Noa, "there was a sharp turn and I caught sight of a naked girl standing against the rock face, which she was not so much holding on to as caressing with both her hands. She was drinking at a spring gushing from very high up in the rocks. When she finished drinking, she took some water in her hands and let it trickle down between her breasts.... The instant she saw me, she dove in, shouting 'Taehae!' (savage). I rushed to look into the water: nobody. Nothing but a huge eel slithering between the little pebbles on the bottom." Actually, the painter was only daydreaming before an old photograph of a Tahitian man bending over to drink amid some ferns; even these Gauguin idealized. He goes on with his tale. "It was evening. The moon was rising, and as I gazed at it I recalled the sacred dialogue that legend says took place at this very spot. Hina said to Tefatou, 'Make man rise up again after he dies.' 'No,' replied the God of the Earth to the Goddess of the Moon. 'I shall not restore him to life. Man shall die, plants shall die and so shall those who feed upon them; the earth shall die ... it shall cease to exist and shall not be born again.' 'Do as you like,' Hina replied. 'I shall cause the Moon to be reborn.' And that which was Hina's continued to exist, and that which was Tefatou's perished, and man must die." Courbet had died, but an admiring Gauguin had not forgotten his nude woman from The Source, whom he thus made come back to life.

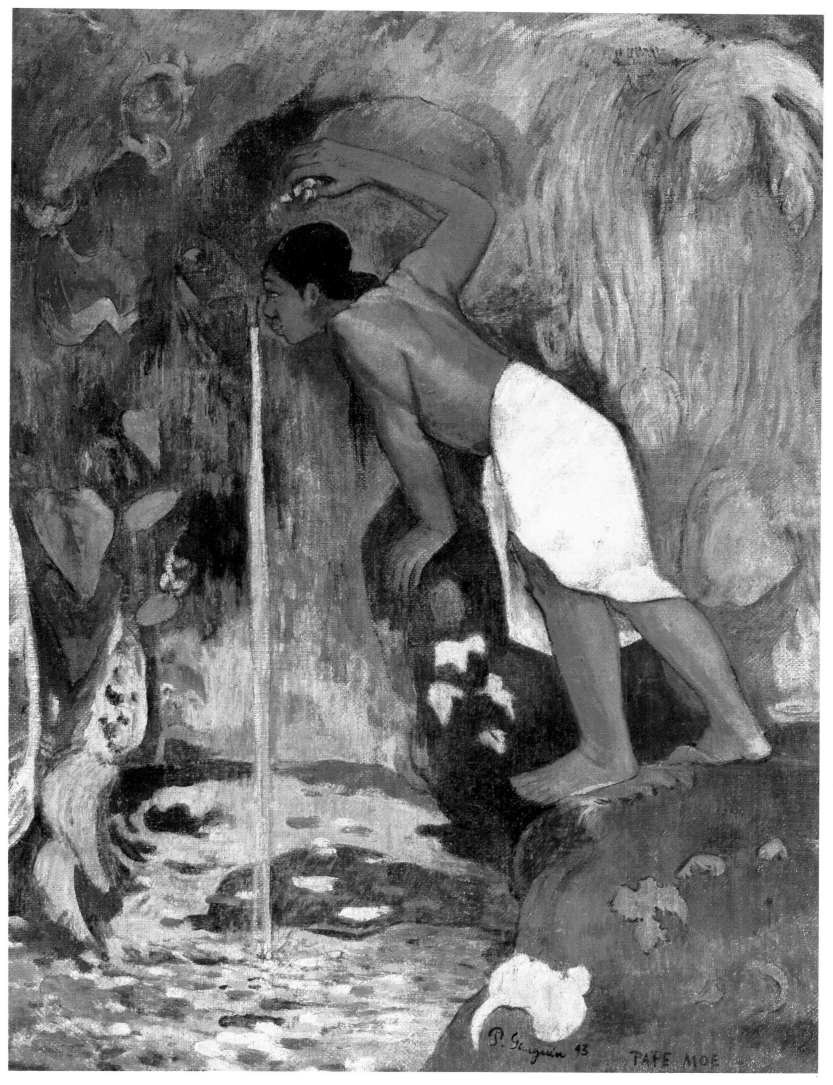

329. Gauguin. *Mysterious Water (Pape Moe)*. 1893

330. Gauguin. *Under the Pandanus Tree (I Raro Te Oviri)*

331. Tahitian bearer

332. Dinner in the city. From an Egyptian tomb, c. 1500 B.C.

334. Gauguin. *The Market (Ta Matete)*. 1892

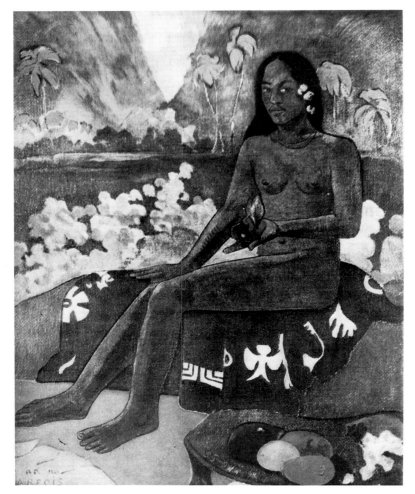

333. Gauguin. *The Seed of the Areois (Te Aa No Areois)*. 1892

As two men bearing fish pass by beneath the trees, five Tahitian women in long, brightly colored dresses pose on a green bench. Their hieratic rigidity (and, in some cases, hairstyle) recall ancient Egyptian counterparts. Gauguin had a photograph of a Theban fresco from the 18th Dynasty, but he also had one of Hope, a little painting by Puvis de Chavannes which so intrigued his young

vahine *that she asked if it was a portrait of his wife.* The
woman seated in the middle reappears in The Seed of the
Areois, *an orientalized restatement of Puvis de Chavannes's
allegory.* According to Maori myth, Areois women practiced
prostitution on their island of Bora Bora. *Gauguin may be
referring to this accepted custom in* The Market, *whose title
fits in with these Egyptian-style Tahitians who sell their bodies*

*under the watchful eye of the matron standing on the
right.* One of them seems happy as she holds a letter in her
hand, but the one next to her, in the middle, is clutching a
handkerchief. *The sea is nearby, and we can just make out
the prow of an approaching sailboat.* Presumably, they are
waiting for their future lovers to come ashore.

173

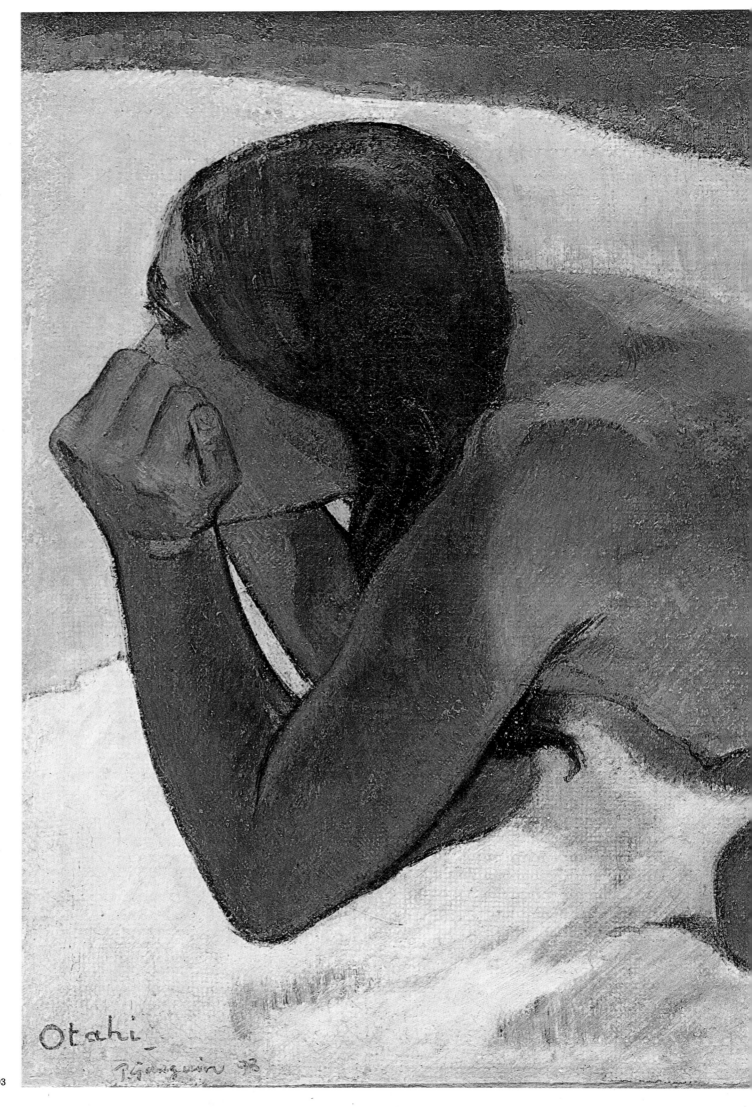

335. Gauguin.
Alone (Otahi). 1893

174

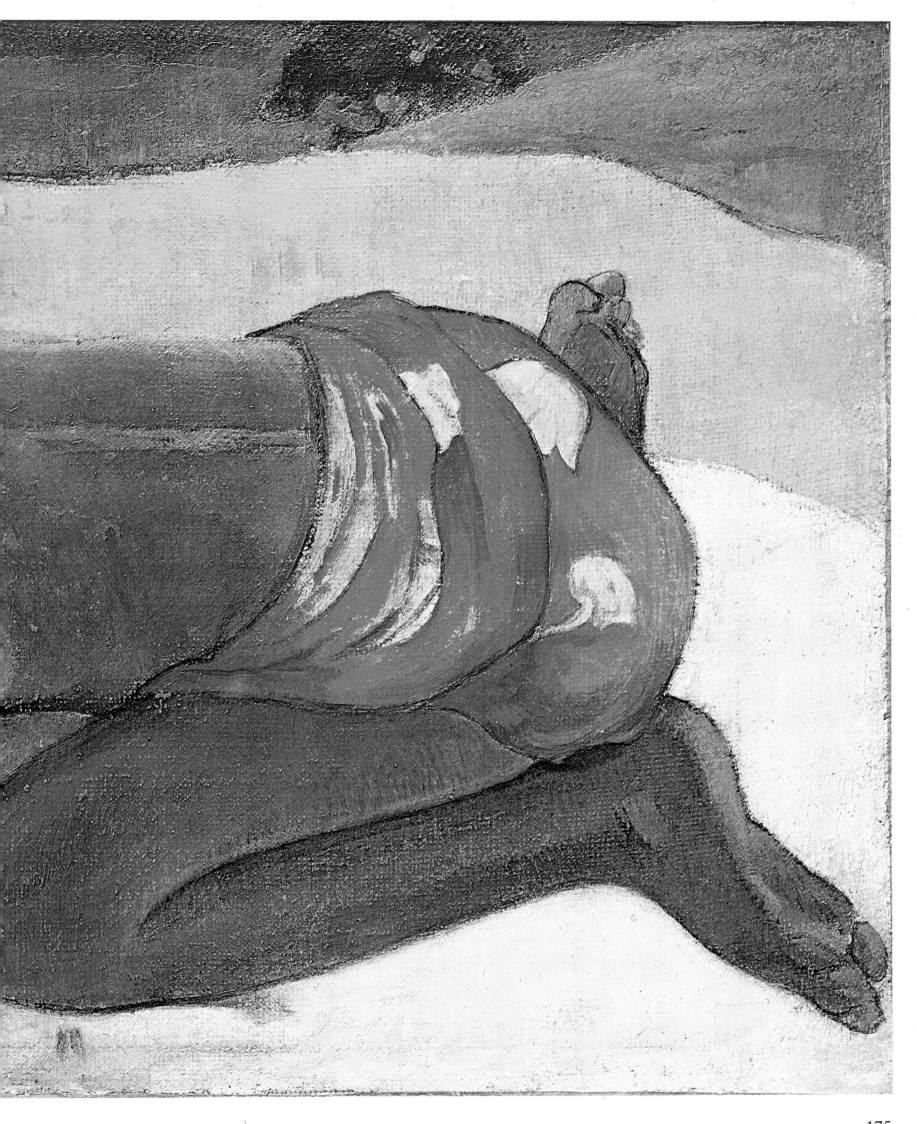

336. Gauguin. *Crouched Figure*

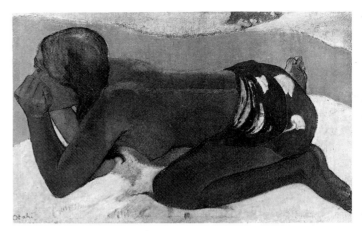

337. Gauguin. *Alone (Otahi)*. 1893

338. Katsushika Hokusai. *Crouched Figure,*
from thē *Hokusai Sketchbooks* (1814–49)

Whatever were the sources of Alone, *certainly they were the Japanese or Egyptian sources Degas also drew on for his charcoal sketch* Crouched Female Nude—*the crisply defined pose of the squat, relaxed* vahine *suggests expectation, entreaty, supplication. It reappears in* Mary Magdalene, *a red-chalk engraving after a woodcut that Alfred Jarry later published in* L'Ymagier *(Number 3, April, 1895), as well as in the carved design in* The Dining Room (Te Fare Amu). *The theme of forlorn solitude expressed in the title* Alone *is sounded again in* When Will You Marry? *With an inquisitive look in her eyes (shared by her companion), the potential bride seems to be pointing to herself and about to undress. Her bulky, joyously colored body dominates a rustic setting that bursts with promise. Whereas Otahi is confined to her beach and Mary Magdalene is prostrate with grief at the feet of the crucified Christ, this girl is turning her back on solitude. She is about to rise to her feet; happiness is her lot. These contrasting figures clearly indicate that Gauguin suffered from a kind of cyclothymia, alternating between fits of despair and surges of euphoria. When he dedicated the* Cahier pour Aline *to his fifteen-year-old daughter, he noted that "her nobility of heart and mind will, thank God, keep her from being startled and tainted by contact with the demoniacal mind nature has given me." "In Europe," he observed, "human mating is an outgrowth of love. In Oceania, love is an outgrowth of mating. Which is right?" He wavered between nostalgia and seduction.*

339. Edgar Degas. *Crouched Female Nude*

340. *Prince Sudhana Bowing.* Borobudur, Java

341. Gauguin. *Mary Magdalene at the Foot of the Cross.*
c. 1895

176

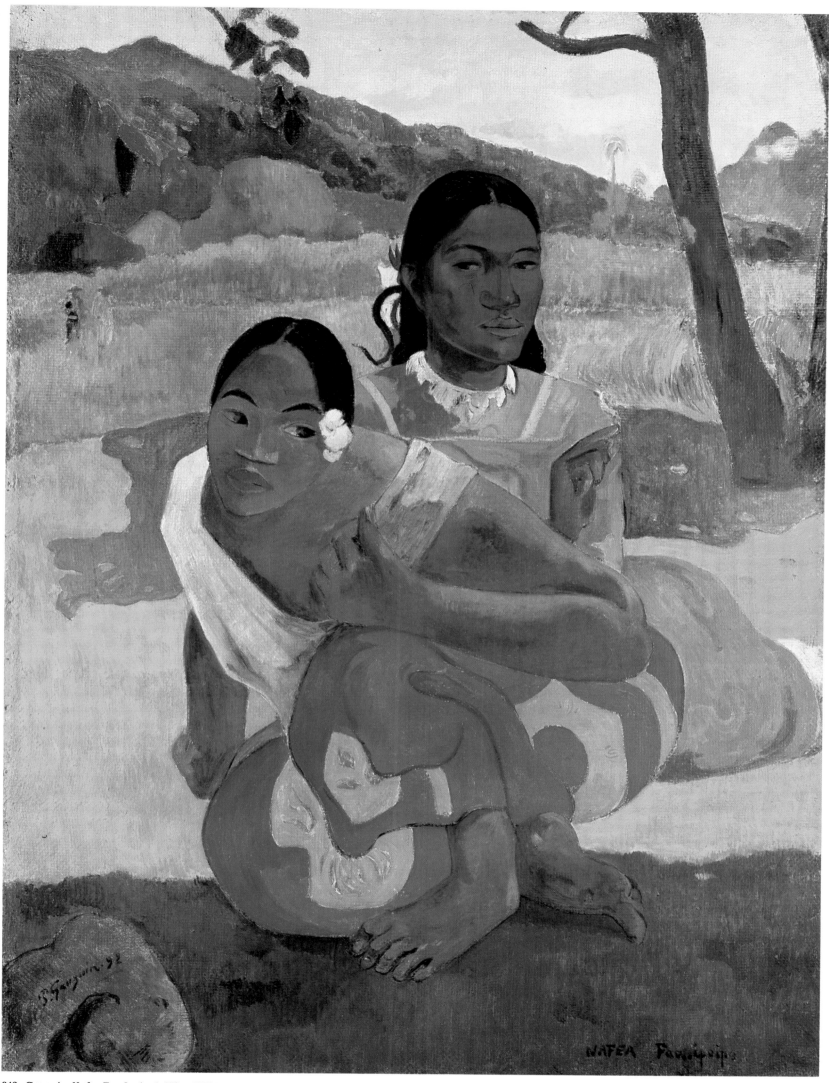

342. Gauguin. *Nafea Faa Ipoipo? (When Will You Marry?)* 1892

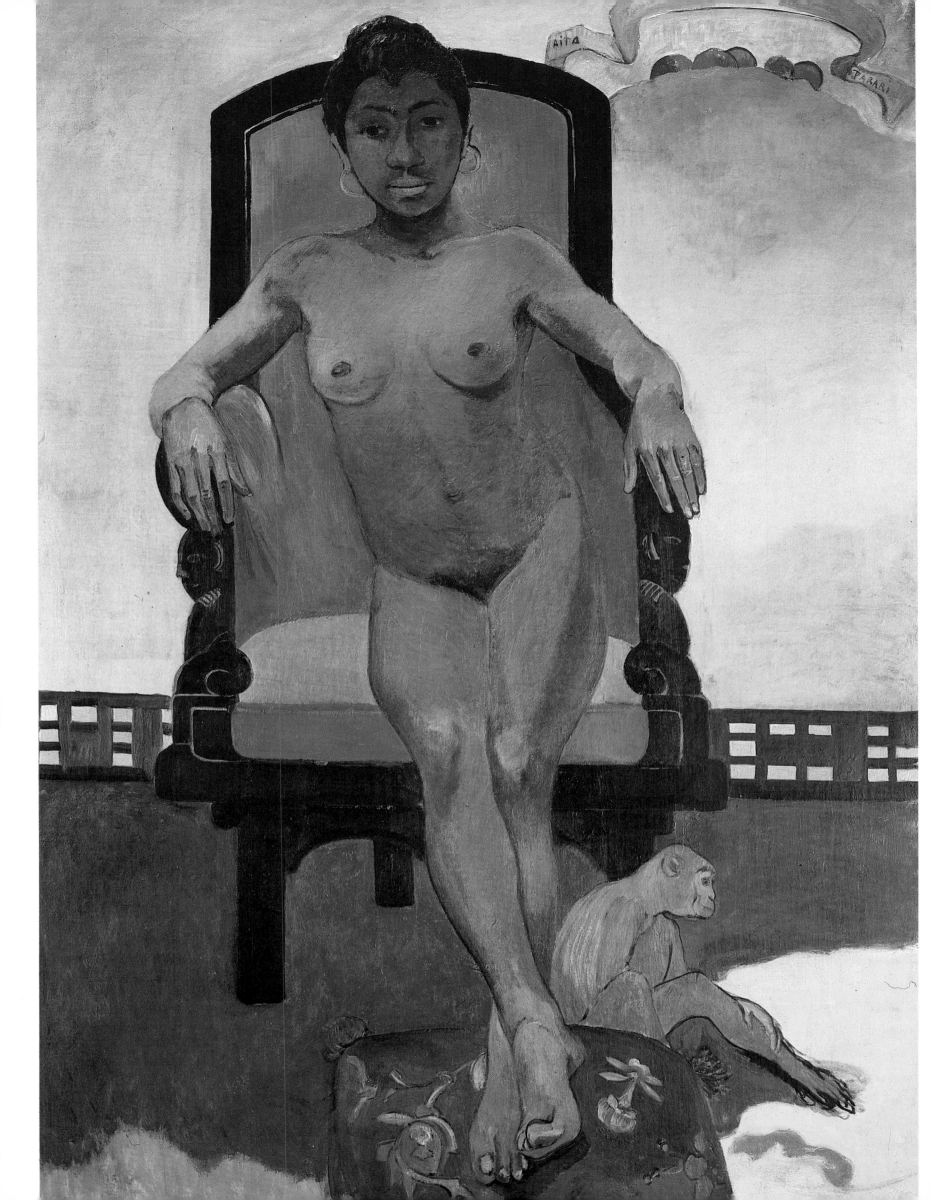

8
Return to Europe

September 1893–July 1895

344. Annah la Javanaise, 1898

Gauguin had to spend more than twenty days in Nouméa before setting out on the final leg of his return trip to France. On August 30, 1893, the steamer *Armand Béhic* put in at Marseilles. The artist had four francs in his pocket.

He immediately wrote to his wife and de Monfreid, begging for help. The crossing had been a dreadful, appalling ordeal; the only way to escape the crush of soldiers and livestock was to pay a surcharge for a second-class ticket. He was anxious to know how his paintings had fared at the Copenhagen exhibition.

Having received a money order for 250 francs from Sérusier, Gauguin caught the next train for Paris and rushed to the Boussod and Valadon Gallery, only to learn that all of his unsold pictures had been left in de Monfreid's care. Then, on Degas's recommendation, he went to see Paul Durand-Ruel, the prominent Impressionist dealer, who agreed to arrange for a show of Polynesian paintings in his gallery. He took his meals at Chez Charlotte, and through the good graces of the owner found a room near the Académie Colarossi. One of his neighbors was the painter Alphonse Mucha, who let him use his studio. There was no stopping him now: he would take Paris by storm! Then came the timely news that Uncle Zizi had died. The gods really were smiling on him now!

Having received a telegram from Mette informing him that his father's unmarried brother, Isidore Gauguin, had died in Orléans on September 9, he went to Orléans to settle

345

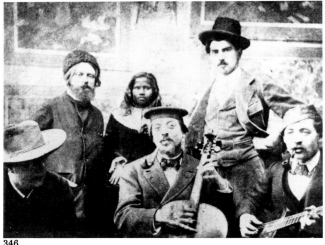

346

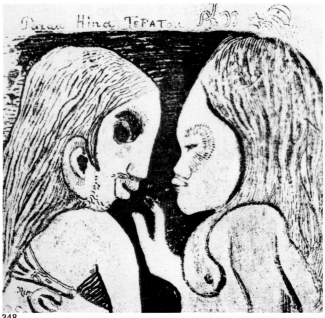

348

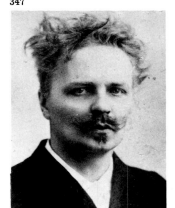

347

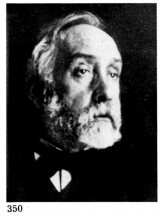

349

350

345. Gauguin in front of his painting *Te Faaturuma (Sullen Woman)*. 1893–94
346. In Gauguin's studio, 6 Rue Vercingétorix, Paris: Annah la Javanaise behind the cellist Schneklud
347. Exterior of Gauguin's studio, 6 Rue Vercingétorix, Paris
348. Gauguin. Catalogue frontispiece for his exhibition at the Durand-Ruel Gallery, November, 1893
349. The Swedish playwright August Strindberg
350. Edgar Degas

the estate, which he had to share with his sister, Marie Uribe. "Fortunately, my uncle has had the good sense to die," he announced to de Monfreid, "and his *pittance* of a legacy will enable me to stay afloat and will go a long way toward helping me get my exhibition ready." He also told de Monfreid that he wished to get in touch with Juliette Huet and asked him for her address. But Juliette was keeping to herself in Vanves (where the artist saw his two-year-old daughter for the first time) and balked at the prospect of moving in with Gauguin. Besides, was he all that keen on it? The person he really needed was Mette, especially now that she was good and jealous of his Tahitian mistresses. He affectionately invited her to bring their "Petit Paul" to Paris for a visit, but he also urged her to send the Tahitian pictures she had retrieved in the wake of his abortive exhibition in Denmark. On November 4, at the Durand-Ruel Gallery, he planned to "make a dramatic move on which our whole future hangs." For her part, Mette was up in arms: her husband stood to inherit 15,000 francs and had not so much as intimated that he intended to share it with her. She vented her spleen in a letter to Schuffenecker. "If he needs to see us, he knows where to find us. I, for one, am not about to run all over the world like some madwoman! With him, you never can expect anything. He'll never think of anything but himself and his own welfare. He is wholly absorbed in contemplating his own magnificence."

However, the notary in Orléans had not yet settled his claim on the estate. Gauguin had an exhibition to prepare, and that required money. He approached Roujon, the director of fine arts, who promptly showed him to the door. "Your art is too revolutionary not to create a scandal." A few friends just back from vacation provided for his immediate needs. Although Charles Morice, himself penniless, could not even pay back what he owed from previous sales of Gauguin's paintings, the poet and art critic did agree to do what he could through connections and articles to publicize the upcoming sale at Durand-Ruel's. To enlighten the public about the master of the Studio of the Tropics and how he turned his exotic surroundings into an original source of inspiration, they also agreed to collaborate on a book about Tahiti. Morice would write poems based on Gauguin's account of his stay on the "fragrant isle"—hence, the title *Noa Noa*—and there would be illustrations by the painter. Thanks to Morice's listlessness, however, Gauguin died before this splendid undertaking could come to fruition.

The Exhibition at Durand-Ruel's

The exhibition and sale that opened at Durand-Ruel's Rue Laffitte Gallery, on November 4, showcased fifty paintings which Gauguin himself had lovingly restored and framed. They were priced at between 2,000 and 3,000 francs apiece, the going rate for works by Manet, Monet, and Renoir. Feeling fairly self-confident, he wrote to Mette not without irony, "At last I'll know whether it was *madness* to leave for Tahiti."

If not madness, then certainly a curious aberration, at least as far as the dumbfounded visitors were concerned. To be sure, a few men of letters had positive things to say. Mallarmé, for one, marveled that one could put "so much mystery into so much brilliance"; Mirbeau, writing for the *Echo de Paris*, admired the "supreme elegance, intense fear, intellectual irony, and wonderful color of the work Gauguin has brought back." By and large, however, the public was taken aback, if not aghast. "Degas is the only admirer," Pissarro assured his son Lucien. "Monet and Renoir find all of it just plain bad. I saw Gauguin, who went on about his theories on art and assured me that the younger ones should immerse themselves in wild, far-off sources: therein lay their salvation. . . . He is

always poaching on someone else's ground; at present he is plundering the primitives of Oceania!" By no means was Pissarro the only one to wax cruel. Art critics clicked their tongues piteously at the "poor crackpot" or suggested that he bring over a genuine Maori painter who could make his home in the Zoological Garden.

"All of his grandiose plans lay in ruins," Morice later recalled. "No one had any inkling of the distress that gripped his heart. . . . Though spurned by all, not for a single moment did he doubt that he was right." True, he could take heart from the exceptions. Degas was one of the few to actually purchase anything. As he left the gallery, the grateful Gauguin presented him with a carved cane and simply said, "You have forgotten you cane." There was also Ambroise Vollard, an up-and-coming dealer who had just opened a gallery of his own on Rue Laffitte. Charles Morice grieved over this setback in the *Mercure de France* (December, 1893). "Perhaps he will set out once again . . . far from our decay and from these cliques. We are the ones who shall have driven him away. Already he is saying, 'I don't want to see Europeans anymore.'"

Gauguin put up a front of indifference and self-composure, trying not to show how deeply humiliated he really felt. "You ask me if I sold lots of paintings," he wrote to his daughter Aline. "Unfortunately not, otherwise I should take great pleasure in sending you some pretty little things to put under your Christmas tree. You see, my poor children, you mustn't be cross with your father if there isn't plenty of money at home. The time will come when perhaps you'll know that there's not a better one on earth."

Uncle Isidore's Legacy

Stung by Mette's recriminations, he sent her only 1,500 francs out of the 13,000 francs he received as his share of the estate. He paid off his debts and found that he still had the tidy sum of 10,000 francs to do with as he pleased. Now he could afford more spacious accommodations. His landlord on Rue de la Grande Chaumière told him of a place for rent near the Montparnasse Station, at 6 Rue Vercingétorix: two studio-like rooms with balcony in a wooden house built with materials left over from the 1889 World's Fair. Before long, Gauguin's new quarters in the Plaisance district of the capital were furnished and decorated with mementos from Tahiti and reproductions of paintings by his favorite artists: Puvis de Chavannes, Manet, and Degas, with works by Botticelli, Cranach, Holbein, and Michelangelo mixed in. There were also originals by Van Gogh, Redon, Cézanne, de Monfreid, and Schuffenecker. Gauguin painted intertwined Tahitian designs on the windows, and the inscription over the door read *Te Faruru* (Here We Make Love).

While in Brussels for an exhibition of his work at the Salon de la Libre Esthétique (February 16–22), Gauguin and the poet Julien Leclercq, a young neighbor who had become the painter's secretary, made an excursion to Bruges to see the Memlings. "Such wonders, my dear fellow," he wrote enthusiastically to de Monfreid. "Afterward, when you see Rubens (beginning of naturalism), it all falls apart."

In a review of the Brussels exhibition (*Essais d'art libre,* January, 1894), he censured both Pissarro ("His peasant women are undecided, being widows of both Millet and Seurat") and Denis ("I look for signs of individuality in him, to no avail"). But he had only the highest praise for Berthe Morisot, Carrière, and Redon, "that extraordinary artist whom people are determined not to understand."

Like a high priest, Gauguin hosted literary and artistic receptions in his Rue Vercingétorix studio, which was painted entirely in chrome yellow. Friends would drop by every Wednesday or Thursday to pay their respects to him and his latest mistress, Anna

Martin, a young Singhalese called Annah la Javanaise, whom Vollard had sent over as a model "on approval." (Approve he did.) Juliette came calling for old time's sake, but Annah la Javanaise sent her packing. However, Annah got along fine with little Judith Molard, whose stepfather, the musician William Molard, lived in the same house. She would help serve tea and cakes to special guests as well as "regulars," including Morice, the sculptor Paco Durrio, and the Breton painters Maufra, Sérusier, Lacombe, Ranson, and Roderic O'Conor. There were musicians such as the cellist Schneklud, poets such as Jehan Rictus, Scandinavian artists, the playwright Strindberg. They played the piano, the mandolin, the guitar; there was dancing, laugh-filled sessions of charades. Flanked by Annah and her monkey, Taoa, Gauguin would pontificate from his Louis-Philippe sofa and do his best to tease the flustered Judith. "This is mine, all mine," he once said to her as he cupped her nubile breasts.

Gauguin and Annah la Javanaise

Guests were also treated to readings from the future *Noa Noa*. Gauguin had finished ten polychrome woodcuts for the project, but Charles Morice was taking his time with the poems. It was spring, so the painter decided that he might as well make an excursion to Brittany with Annah and their little monkey. Henceforth, reconciliation with Mette would be out of the question. "If the letters you intend to write in future are to be like the ones since my arrival, I would ask you to desist. My work is not yet finished, and I must live." He harbored resentment over the fact that she had sold his choicest paintings—including a Cézanne he prized more than anything else in his collection—to his brother-in-law, Georges Brandès, who refused to part with a single painting, no matter how much was offered.

Before leaving Paris for Brittany, Gauguin published an article in *Essais d'art libre* entitled "Sous deux latitudes," in which he compares the disappointment of life in Paris with the exhilarating atmosphere of Tahiti. He concludes with "Suppose we head out again for the 17th parallel; . . ." but for now, he would bide his time. Meanwhile, disheartening news awaited him in Le Pouldu: Marie Henry had shut down her inn and absconded with the thirty pictures Gauguin had left behind in November, 1890. He looked up Charles Filiger, but the painter had withdrawn to a little room on a farm and was keeping to himself. Wladyslaw Slewinski, a Polish painter he had met at Mme. Charlotte's on Rue de la Grande Chaumière, was renting a house in Le Bas-Pouldu, near the frothy mouth of the Laïta River. There Gauguin found shelter and camaraderie, but he then decided to head back to the place that had opened his eyes to Brittany in the first place: Pont-Aven. Marie-Jeanne Gloanec had just expanded to a more spacious establishment on the main square; the artist checked in with the flighty Annah and their mischievous monkey. The outlandish threesome attracted a little band of hangers-on that included, among others, the prepossessing Irishman Roderic O'Conor, Emile Jourdan, and Armand Séguin, along with their female companions, lawful or otherwise. Again Gauguin rented his old studio in the country house at Lezaven so that they could all work together. He would drag his merry crew off on excursions to surrounding areas.

On the 25th of May, as they were strolling along the docks of Concarneau, a little fishing village, some children started to tease Annah and her monkey. First they made faces, then they threw stones. Séguin grabbed one little boy by the ear, whereupon the boy's father rushed out of a café and started fighting with Séguin. Gauguin rushed to help his disciple, who dove into the water. Panic-stricken women let out shrieks as some sailors joined in,

turning it into a free-for-all. During the scuffle, Gauguin caught his foot in a hole and broke his shinbone just above the ankle; his enraged foes kicked him repeatedly with their wooden shoes. The police finally broke it up, and Gauguin was brought back to Pont-Aven in pitiful condition. The fracture he had sustained was serious enough to keep him confined to his hotel bed for more than two months. He simply could not shake his "bad luck," as he put it.

Séguin attended to him, and Gauguin reciprocated by giving him lessons in painting. The "law of derivatives," the Master maintained with great authority, was far superior to the notion of complementary colors. As he saw it, juxtaposing certain secondary colors packed more of an expressive punch than did juxtaposing primary colors. For example, green (yellow mixed with blue) was more evocative near dark purple (red mixed with blue) than it was near yellow. To prolong the lesson, Séguin would pretend not to understand; Gauguin would start bellowing and the monkey would start whining. Bewildered by all the contention, Annah would run to the Breton maidservants for protection as he brandished his revolver.

Unable to sleep, the artist injected himself with morphine or drank wine and spirits until he passed out. Although fearful that "the poet may overshadow the storyteller," he reminded Morice that his poems for *Noa Noa* were long overdue. He suggested that Molard send Judith to Pont-Aven, unless he deemed it "ill-advised from the point of view of propriety." Then he decided to sue the fishermen of Concarneau and demanded 10,000 francs in damages. On August 23, the court of summary justice in Quimper sentenced his assailant to eight days in prison and ordered him to pay a paltry 600 francs compensation. So much for justice!

Disgusted with the political collusion between Breton tribunal and Breton defendant, saddened by the death of Taoa after the monkey had ingested a poisonous yucca flower, all alone now that Annah had become testy and returned to Paris, and "weary of the never-ending struggle with the Imbeciles," Gauguin notified his Parisian friends that he really would be leaving this time, either for Samoa or Polynesia. He would sell "the whole kit and caboodle for whatever it will fetch. Farewell, Painting, except as a diversion. My house shall be made of carved wood."

Leaving Forever Despicable Europe

First, however, if Gauguin was to retrieve the work he had left in Le Pouldu, he would have to win his lawsuit against Marie Henry. On August 28, the judge at Pont-Aven disqualified himself. Chamaillard's brother was an attorney, so the artist asked him to argue the case in civil court at Quimperlé. Gauguin was unperturbed, even sanguine about the outcome, but on November 14, the court dismissed his claim as "groundless" and ordered the plaintiff to pay costs. In light of the fact that, on November 7, 1890, he had "departed for Paris and Tahiti with no intention of coming back," and that "so far as furnishings are concerned, possession is title," Gauguin no longer had any right to the thirty pictures he had produced in Le Pouldu. They were to remain in Marie Henry's residence in Moëlan. That was the *coup de grâce*. All he thought about now was getting out of "despicable Europe" as quickly as possible.

Limping, lonely, sad at heart, Gauguin returned to Paris. As if his wife's indifference to his accident were not disheartening enough, another unwelcome surprise awaited him: Annah had made off with everything of value in his studio. His paintings were all that remained.

He took stock of his financial position: "completely ruined," in his own words. As far as women were concerned, he was at wits' end. Gauguin tried to convince himself that hope need not be a prerequisite for initiative, nor success for perseverance. A few friends would come through *in extremis* to bear him out. Feeling badly for having neglected *Noa Noa,* Charles Morice contacted art critics Roger Marx, Arsène Alexandre, and Gustave Geffroy; a banquet in Gauguin's honor was planned for November 22 at the Café des Variétés. "There is no getting away from it any more, even among the most outspoken of his former detractors," wrote Morice in *Le Soir.* "Whenever they state that they do not understand that 'genius,' *that* is the word they must utter when they speak of *that* painter." On December 2, Gauguin held an impromptu exhibition of watercolors and wood reliefs in his studio on Rue Vercingétorix. Despite glowing write-ups by Morice, it went almost unnoticed. The time had come to go for broke.

"You'll Have to Shift for Yourself"

If he was to leave France with—or, he was hoping, despite—Séguin and O'Conor, he would have to generate some income from a sale. Since he was peeved with Durand-Ruel, friends prodded him into holding a grand auction at the Hôtel Drouot. After seeing the triumphant premiere of Strindberg's *The Father* at the Théâtre de l'Œuvre, Gauguin hit upon the idea of asking him to write a preface for the catalogue. Out of friendship for Ida Molard, who was also Swedish, the playwright sent back a long letter explaining that if he had to turn down the request, it was because he could not "grasp" his art. "But I know that this admission will neither surprise nor offend you, for it seems to me that the enmity of others only strengthens you. Your individuality, desirous of remaining intact, delights in the aversion it inspires." He justified the refusal by describing how Gauguin's "turmoil of sun-filled paintings had haunted me in my sleep last night. . . . You have created a new earth and a new heaven, but I do not feel at ease in the midst of your creation. It is too ablaze with light for a lover of chiaroscuro like me. And in your paradise there dwells an Eve who is not my ideal." Then, the author of *A Madman's Defense* likens Gauguin to a primitive who detests civilization, a Titan who is jealous of the Creator, a child who takes his toys apart to make new ones. The letter ends with the following envoy: "Bon Voyage, Master. Only, do come back and look me up again. Perhaps by then I shall have learned to understand your work better, and that will enable me to write a real preface for a different catalogue in some other Hôtel Drouot, for I am starting to feel an enormous need to turn savage and create a new world." Gauguin printed Strindberg's letter in its entirety in his catalogue, followed by a brief note of his own that concludes with a question: "Is not a glimpse of happiness a foretaste of nirvana?"

The auction at the Hôtel Drouot took place on Monday, February 18, 1895. Out of forty-seven paintings only nine were sold, two to Degas. The bids came to 19,664 francs; however, allowing for expenses, commission, and the pictures Gauguin had to buy back, the sale netted a grand total of 1,430 francs. When he saw Gauguin "bawling like a child," Maxime Maufra asked him over for supper at his place on Boulevard de Clichy. The irksome Mette demanded her share of the proceeds, eliciting a scathing rejoinder. "At 47 I will not sink into poverty, and yet, I am on the brink of it. But when I am down *no one* on earth will help me back to my feet. 'You'll have to shift for yourself,' you write, and there is great wisdom in that. That's just what I'm set on doing."

Suffering from chronic bronchitis, Gauguin longed to bask in the Polynesian sun once

more and as soon as possible, even now that Séguin and O'Conor had decided against going with him. What held him back now was a memento that a consoling prostitute had left after an evening in a dance hall: a spreading rash, telltale sign of syphilis. Since the mercury treatment for his "sorry affliction" would take several months, he postponed his departure for Tahiti and spent the interim in Chaplet's workshop. There he created his superb and terrifying *Oviri*, a female figure with bulging eyes, strangling a monster as it impregnates her womb with its seed. When the Salon turned it down, Gauguin vented his ire in *Le Soir*, decrying "the banality of the ceramic art establishment." On May 13, in the course of a lengthy interview with Eugène Tardieu, a reporter for the *Echo de Paris,* he stated that "the only way to break new ground is to go back to nature, to the dawn of humanity."

A Lean Wolf, but Without a Collar

Gauguin contacted a few art dealers, including Levy and Chaudet, and received assurances that he would not be left in the lurch. On May 6, he bade farewell to de Monfreid, who left for the Pyrenees but protested his devotion. He also attempted to answer Emile Bernard's charges in the *Mercure de France* that he, Gauguin, had capitalized considerably on his influence. After selling a few paintings here and there, the artist got ready to leave France for good.

Charles Morice said goodbye to him in the June 28 issue of *Le Soir*. "Tomorrow, a great artist who is positively sick of . . . this Western world of ours is leaving Paris, France, Europe behind, with no intention of coming back."

The *Australien* was scheduled to set sail from Marseilles on July 3; Paul Gauguin would be on board. He balked at any mention of a farewell dinner, but a final get-together did take place at his studio on Rue Vercingétorix. "I was sick at heart," Judith Molard later recalled in her *Memoirs*. "While I was serving tea for the last time, with slices of cake on huge mother-of-pearl shells, Gauguin, overcome by some savage impulse, danced an *upaupa,* relishing ahead of time his return to his element."

Moved by Judith's distress, he invited her to see *Les Cloches de Corneville* at the Théâtre Montparnasse, where she implored him to let her see him off at the Gare de Lyon. Although he would rather have gone to the station alone, he agreed. When he boarded the train on July 2, the farewell committee had grown to the Molard family (William, Ida, and Judith) and Paco Durrio. All of the hugging both nonplussed Gauguin and made him all the more aware of how lonely he really was. Perhaps to boost his morale he was thinking about the parallel Degas had once drawn when a young man asked his opinion of Gauguin. "You know La Fontaine's fable about the starving wolf that meets up with a well-fed dog. Well, Gauguin is the lean wolf, only without the collar."

351. Gauguin. *Tahitian Woman in a Landscape.* 1893

352. Gauguin. Cover originally planned for *Noa Noa*. 1891–93

55

When Gauguin returned to Paris in 1893, he planned to publish a literary account of his first stay in Tahiti as a joint venture with the poet Charles Morice. However, as René Huyghe discovered while going through the illustrated manuscript of Gauguin's Ancien Culte Mahorie *for a facsimile edition (Pierre Berès, 1951),* Noa Noa *actually had its beginnings in this miscellany of oral traditions. Gauguin claimed that these myths were told to him by his* vahine Tehura; *in point of fact, he drew heavily on Moerenhout's* Voyages aux Iles du Grand Océan (1837). *Be that as it may,* Noa Noa *(which Gauguin revised during his second Tahitian period) is illustrated not only with photographs and woodcuts, but also watercolors, some of which Gauguin painted directly on the page while others he took from* Ancien Culte Mahorie *and pasted into his manuscript. The pages shown here are from the manuscript which the Louvre acquired from Georges-Daniel de Monfreid in 1925. (Left to right, upper row: ff. 55, 67, 75; lower row, 63, 173, 172; above, the cover of* Noa Noa *as originally designed by Gauguin; below, de Monfreid's version.* Noa noa *is Tahitian for "the fragrant one.")*

353. Gauguin. Cover of *Noa Noa* (Charles Morice edition)

354. Gauguin. *Noa Noa,* folios 55, 67, 75 (above), 63, 173, 172 (below)

188

Chapitre IV

Le Conteur parle

Mes voisins sont devenus pour moi presque des amis. Je m'habille, je mange comme eux. Quand je ne travaille pas je partage leur vie d'indolence et de joie, avec de brusques passages de gravité.

Le soir, au pied des buissons touffus que domine la tête échevelée des cocotiers, on se réunit par groupes, — hommes, femmes et enfants. Les uns sont de Tahiti, les autres des Tongas, puis des Arorai, des Marquises. Les tons mats de leur corps font une belle harmonie avec le velours du feuillage, et de leurs poitrines cuivrées sortent de vibrantes mélodies qui s'atténuent en s'y

au monde qui m'ait tenu ce langage. — ce langage d'enfant, n'est-ce pas car il faut l'être, pour s'imaginer qu'un

artiste soit quelque chose d'utile...

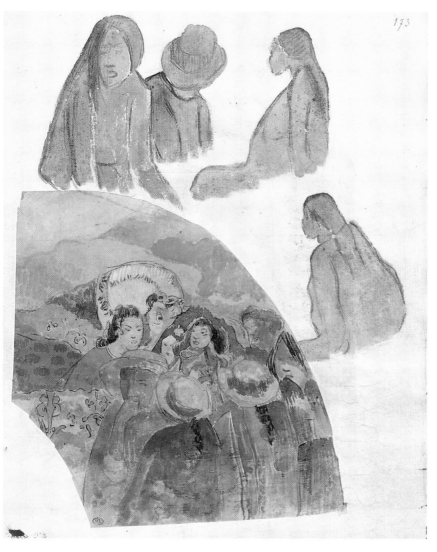

La fleur qu'elle portait auparavant à son oreille était tombée sur ses genoux, fanée.

FIN

355. Bearers with offerings. Egyptian bas-relief, 2475–2180 B.C.

356. Gauguin. *Maori Woman as an Idol*

357. Gauguin. *The Day of the God (Mahana No Atua)*. 1894

T*he allegorical* The Day of the God (Mahana No Atua) *is probably inspired by the Oceanic myths that Gauguin attempted to recapitulate in the illustrated* Ancien Culte Mahorie. *"They depicted their chief deity as the creator of the two major forces . . . one active, the other passive, that is, the soul and the body; one spiritual and hidden, the other material and manifest; in a word, matter and that which infuses it with life. From this concept of a coexistent, dichotomous God, of which all things that make up the entire universe are composed, they have made two distinct beings." Wearing a headdress of sacred feathers, the idol perched atop the rock-altar at the center of the painting is probably the "intelligent component of the godhead," heaven itself; Taaora, the male principle. A pair of Egyptian-inspired women under the tree to the left bear him gifts, while the lagoon on the right forms a backdrop for two women in vermilion pareos dancing in his honor. A female figure reminiscent of the heroines of Puvis de Chavannes daintily dries her hair; the recumbent, fetuslike figures on either side of her—one facing one way, one the other— symbolize the divine ambivalence. She is "the purely material component (or body) of the godhead, the female principle known as Hina." At her feet we see a swirling, multicolored magma out of which the nascent forms of the universe are about to coalesce.*

One of the lessons Gauguin taught Armand Séguin was that the law of complementary colors was absurd and should be superseded by the "law of derivatives": to achieve greater intensity, juxtapose secondary colors. Green, for instance, which is a mixture of blue and yellow, is less beautiful against yellow than against dark purple (blue and red). A theory of optics not unlike the mythic theory of the Oceanic godhead!

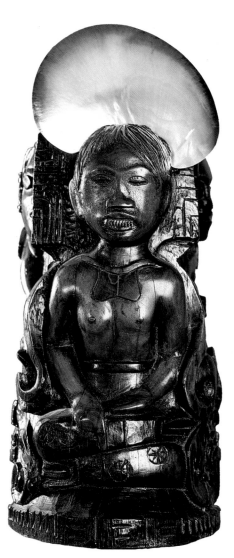

358. Gauguin. *Shell Idol.* c. 1893

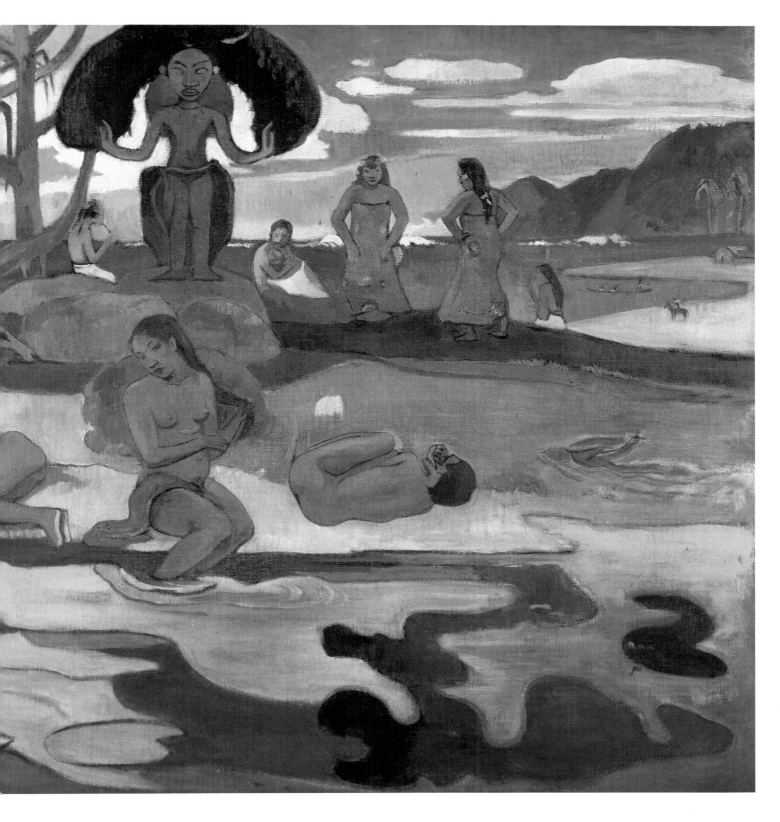

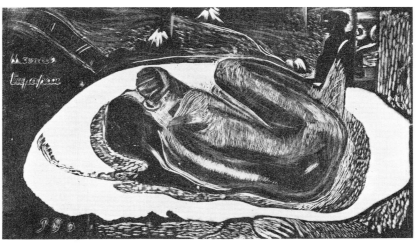

360. Gauguin. *Spirit of the Dead Watching (Manao Tupapau)*. c. 1891

359. Pierre Puvis de Chavannes. *Girls by the Seashore* (detail). c. 1879

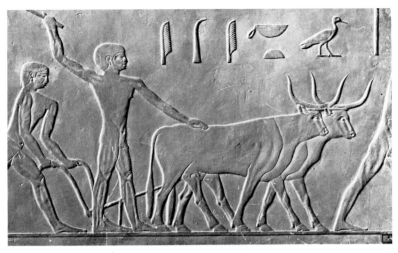

361. Plowing fields. Egyptian bas-relief, c. 2400 B.C.

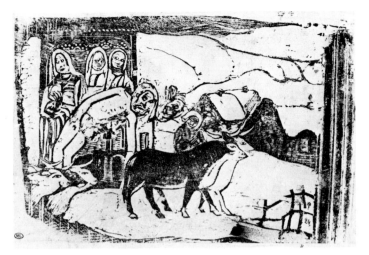

362. Gauguin. *Noa Noa*, folio 182

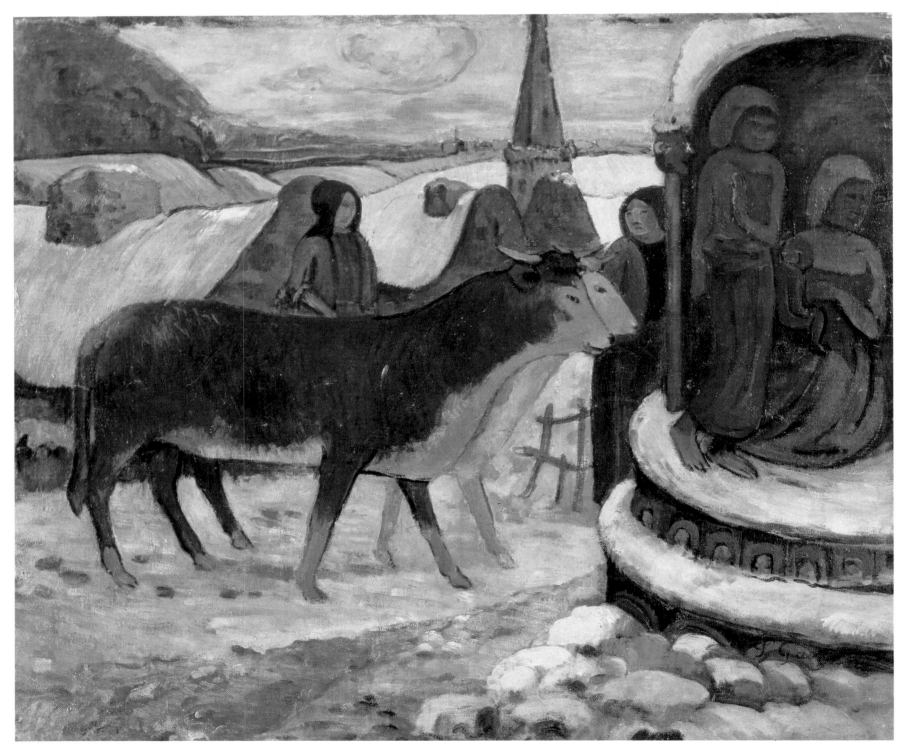

363. Gauguin. *Christmas Eve*. 1894

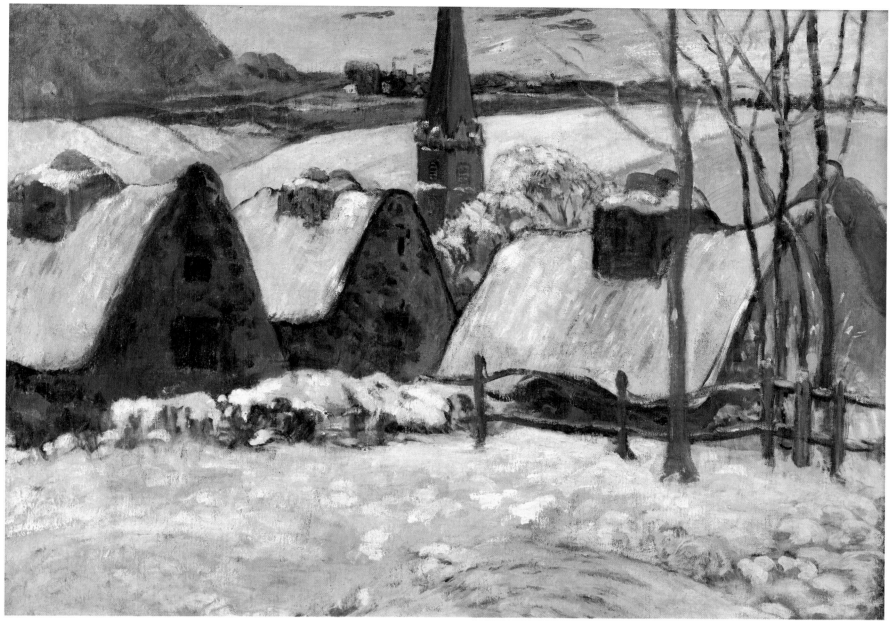

364. Gauguin. *Village in the Snow.* 1894

365. Utagawa Hiroshige. *Kambara: Snow in the Evening*

366. Gauguin. *Paris in the Snow.* 1894

W hen Gauguin's belongings were auctioned off after his death on the island of Dominique, Victor Segalen purchased Village in the Snow, which the painter had brought with him to Polynesia in 1895. (The auctioneer put it on the block upside down and facetiously dubbed it Niagara Falls.) Another painting that found its way to the South Seas was the marvelous Christmas Eve: two massive, Egyptian-inspired oxen plod toward a stone manger as the sun rises over snow-clad

Pont-Aven. (In a woodcut version of the scene, the oxen are moving away from the Nizon Pietà). Both pictures are in the same vein as Paris in the Snow, a view of the city from the windows of the artist's studio during the winter of 1894–95. A sign on a shopfront reads Neuf occasion (New/Used). The fleecy texture, reminiscent of Japanese ukiyo-e prints, bespeaks a lyrical wistfulness he tried his best to keep alive.

367. Gauguin. *The Angelus in Brittany.* 1894

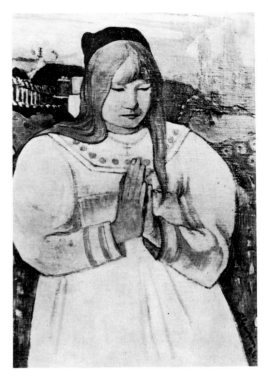

368. Gauguin. *Breton Girl Praying.* 1894

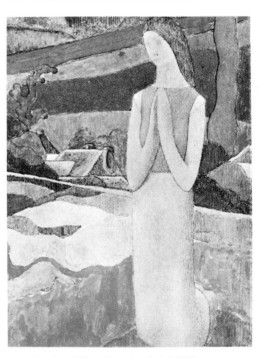

369. Charles Filiger. *Praying Saint.* 1892

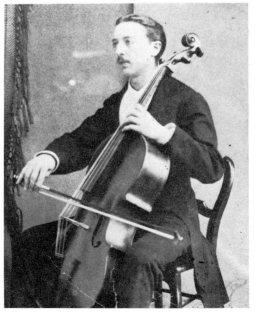

370. The Cellist Fritz ("Upaupa") Schneklud

The cellist Fritz Schneklud was one of the "regulars" at the musical and literary salons Gauguin held in his studio at 6 Rue Vercingétorix. He appears in a photograph of some friends gathered around Annah la Javanaise, and Gauguin probably referred to it as he painted this portrait of Schneklud playing his instrument. The position of the hands is exactly the same, but he intensified the look of concentration on the cellist's face to convey the inner effect of the music on him. Gauguin also played host to the painter Maxime Maufra and his young Breton bride—"I had to have a virgin," was his explanation for marrying a very young girl—and the two of them would reminisce about the good old days in Pont-Aven. The meditative mood of Breton Girl Praying, symbolized by her large clasped hands, recalls the Praying Saint of the mystic Charles Filiger and Millet's The Angelus (by way of Gauguin's monotype interpretation of the subject, The Angelus in Brittany). "The act of prayer, pointing the way to Heaven with two clasped hands, envelops her in the soul of the Saints," he notes in Noa Noa. He presented this sensitive picture to Roderic O'Conor, an Irish painter who had met Gauguin in Pont-Aven and struck up a friendship with him. (Charles Morice once said of O'Conor that he tended to an "oversentimentality" akin to that of Charles Filiger.) By signing his monotype "One Man of Samoa," was Gauguin trying to persuade O'Conor to go to Tahiti with him? "But really, can you see me setting out for the South Seas in the company of that maniac?" O'Conor reportedly said later to Alden Brooks, although we really do not know if he felt the urge to do so, the urge to heed the call of the open sea.

194

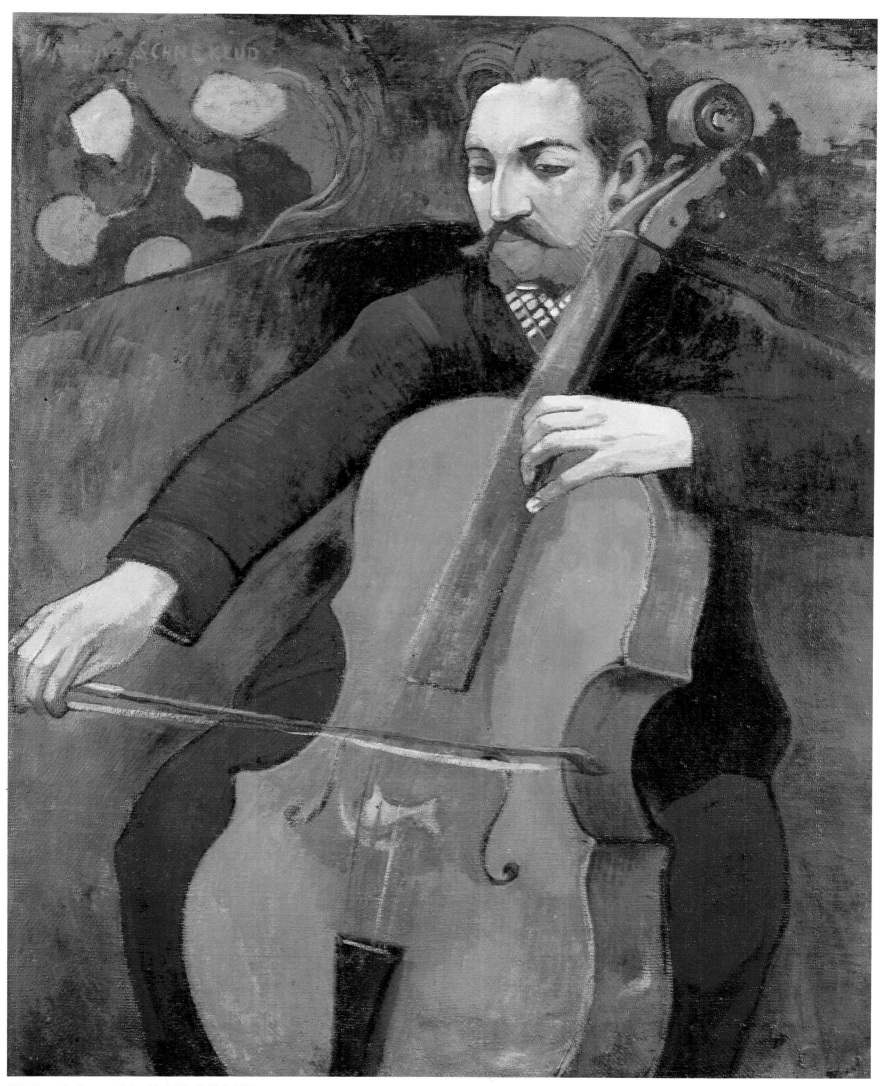

371. Gauguin. *Upaupa Schneklud (The Cellist)*. 1894

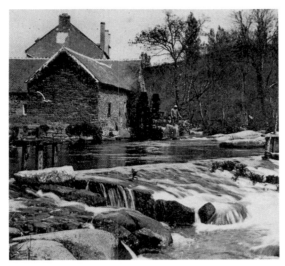

372. Mill at Pont-Aven

373. Stepping stones
near the Mill at
Plessis

In the fall of 1894, as his final stay in Pont-Aven was drawing to a close, Gauguin painted the Moulin David (formerly known as the "Paper Mill"), a subject that appears in a number of pictures by his painter friends. Located on the right bank of the Aven, the Moulin David stood just upriver from the mouth of the Penauros creek and overlooked Le Poche-Menu, an outcropping of rocks where local boys would go swimming. Here began the path leading to the Bois d'Amour, which we can get a glimpse of in the upper part of the picture. This view is from the left bank of the Aven. Two Breton girls and a pointing dog stand at the foot of a slender poplar tree, a perpendicular that divides the composition in half. Opposite the mill at left, the swirling lines of the river; to the right, the fauve colors of the groves lay siege to the pines crowning the hill. For Gauguin, they were the spark that rekindled the memory of the glowing colors that had set his canvases ablaze in Tahiti. The last landscape he painted in France before heading back to Polynesia, The David Mill, with its daring color combinations, helped lay the groundwork for Fauvism.

374. Gauguin. *The David Mill.* 1894

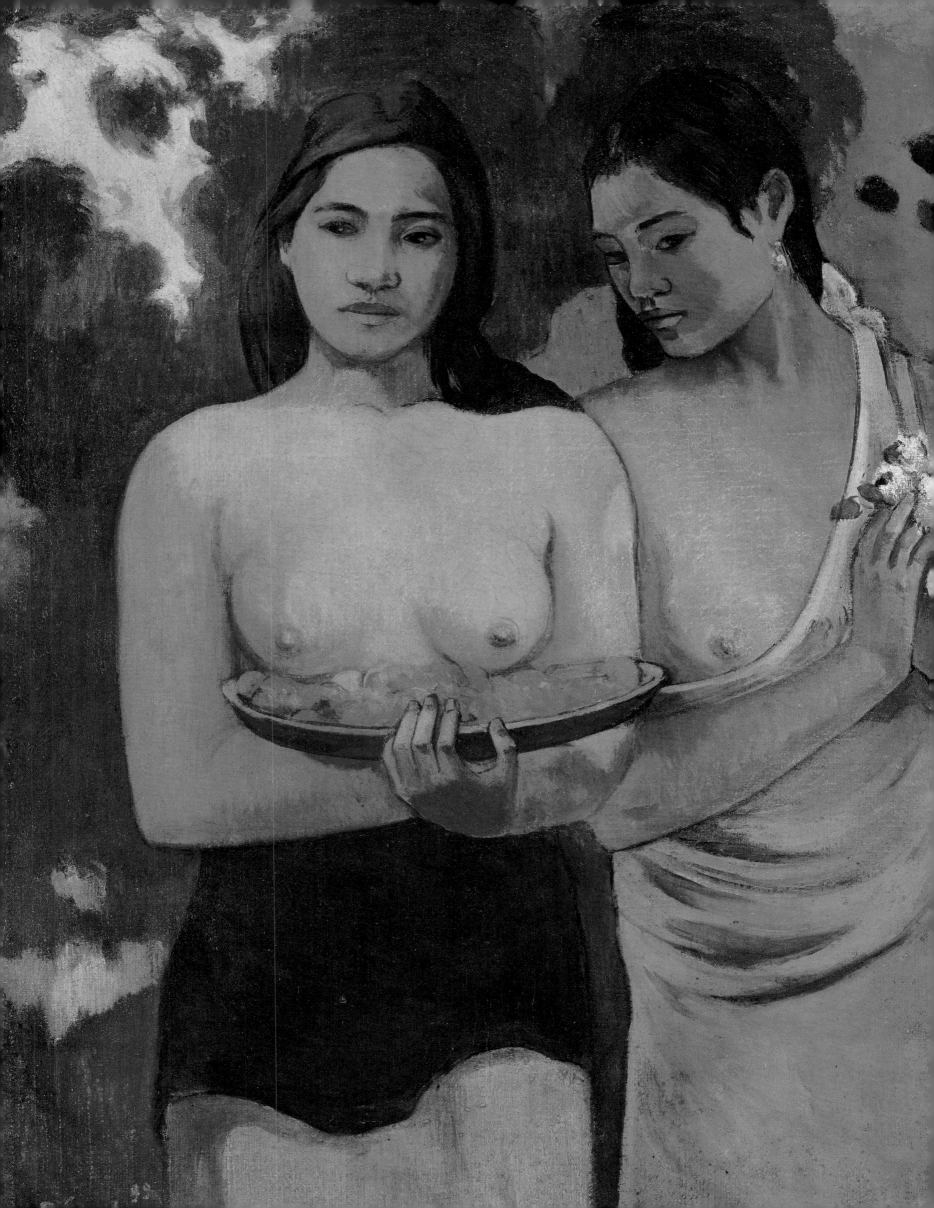

9
Tahiti Revisited: Exuberance and Gloom

August 1895–September 1901

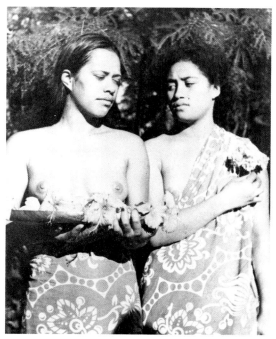

376. Two Tahitian women posing

Gauguin reached Sydney on August 5, 1895, and proceeded at once to New Zealand in hopes of catching the steamer that would take him to Tahiti. He just missed it. Moping about Auckland and, as he put it in a letter to Molard, "spending money foolishly and to no purpose," he took advantage of the stopover to visit the ethnographic museum. On September 9, the *Richmond* put in at Papeete, where the painter rented a small villa from his former landlady, Mme. Charbonnier. But he decided to press on, since "the capital of this Eden, Tahiti, in now lighted by electricity!"

The new governor, Pierre Papinaud, had served as sub-prefect in Prades, Pyrénées-Orientales, and knew the Monfreid family quite well. He gave Gauguin a warm reception and even invited him to take part in Commissioner General Chessé's expedition to annex the "refractory" areas of the Windward Islands—Bora-Bora, Raiatea-Tahaa, and Huahine—to French Polynesia. The painter was taken with the prospect. He boarded the *Aube,* along with the Papinauds and a dozen government officials; they set sail from Papeete on September 26. The young monarchs of Huahine and Bora-Bora offered no resistance to French domination. "There was speechmaking, shouting, and singing," Gauguin wrote enthusiastically to Molard. "Four days and four nights of extraordinary rejoicing, just like on Cythera." The queen of Bora-Bora even decreed that all laws pertaining to marriage would be rescinded while festivities were in progress so that her guests might enjoy themselves without restraint. But her counterpart on Raiatea-Tahaa fiercely stood her

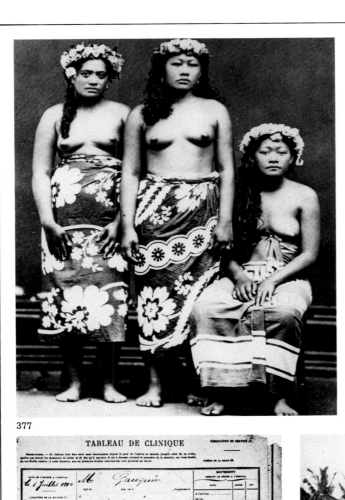

377

378

379

380

381

382

383

384

377. Tahitian *vahines*, c. 1890
378. Gauguin. *Tehura*. 1891–93
379. Gauguin's carved wooden cane
380. Museum in Auckland, New Zealand, where Gauguin examined Oceanic sculpture on August 26, 1895
381. Chart for "Paul Gauguin, pauper" during the artist's hospitalization in Papeete, July 6–14, 1896
382. Gauguin's hut in Punaauia, 1897
383. Gauguin's beloved daughter Aline, January 1897, in Copenhagen, shortly before her death
384. Page one of *Les Guêpes*, no. 25 (February 1901), with an editorial by Gauguin entitled "Les Pédants"

ground, a turn of events that distressed Gauguin. "We must have canonfire, burning, killing—the handiwork of civilization, so it seems. I do not know whether my curiosity will get the better of me and induce me to watch the fight. I confess I'm tempted to do so. On the other hand, I find it revolting." As it turned out, he was spared the ordeal. On October 6, Commissioner General Chessé decided that his "distinguished observers" should be sent back to Papeete.

During the few pleasure-filled weeks he spent in the capital, the painter struck up friendships with a number of government officials; Agostini, chief of the Public Works Department, and Lemasson, the postmaster, shared his keen interest in photography. In November he decided to relocate to a spot on the west coast near the superb beaches of Punaauia; this put him only twelve kilometers from the capital. The lagoon here was sheltered by trade winds and commanded an unsurpassed view of the island of Moorea. After leasing some land near the shore from a French settler, he proceeded to build a traditional oval hut which he described in a letter to de Monfreid. "Picture a large sparrow cage railed in with bamboo canes, its roof thatched with palm leaves, divided into two areas by my old studio curtains. . . . Every night, impish little girls climb into bed with me; I had three to attend to yesterday. . . . My former wife got married while I was away, and I was compelled to cuckold her husband. Although she did run away for a week, she cannot stay here with me." In point of fact, Teha'amana decided to return to Ma'ari, her young, handsome Tahitian husband, because of the appalling ulcers which were now spreading over the legs of her former spouse.

"They Mean Nothing to Me Now"

Now Gauguin made up his mind to "put an end to this rough-and-tumble life, get a sensible woman into the house, and work without interruption." He took as his next *vahine* Pau'ura a Tai (later called Pahura), a girl of fourteen and a half who lived in a nearby hut. Had he been frugal, he would have had no trouble living on his store of provisions for months at a time. However, he admitted to de Monfreid, "Whenever I have money in my pocket and hope in my heart, I spend recklessly. I am at the end of my tether in no time." And squander he did. An obliging host, he invited both Tahitian neighbors and European friends from Papeete to help themselves to his two-hundred-liter cask of red wine. Before long, he was grumbling to all of his correspondents about not receiving proceeds from the sale of paintings he had left with dealers (Chaudet, Levy) or with friends (Maufra, Molard, Schuffenecker). When the painter found out that Mette had badgered Schuffenecker into sending her a batch of his paintings, he lashed out at her. "A Danish wife never gives herself; she sells herself and that's that. . . . I shall therefore have to go on living alone, with no affection whatever from my loved ones. . . . For a long time I have meant nothing to them; from now on, they shall mean nothing to me. Subject closed."

Of all of Gauguin's correspondents, none was more faithful, or appealed to more often, than Georges-Daniel de Monfreid, who now received instructions to locate some fifteen collectors willing to pay 160 francs each for one painting a year. He asked Schuffenecker to see if Count Antoine de la Rochefoucauld would provide him with an allowance on par with what he was making available to Charles Filiger. He sounded the alarm to everyone he could think of and expected every mail boat to work a financial miracle.

Already vexed by the "money woes" that run through all of his letters, Gauguin soon became obsessed with the distressing sequelae of the fracture he had sustained in Brittany

and the syphilis he had contracted in Montparnasse. "My strength is gone," he moaned to de Monfreid, "sapped by sleepless nights and days of suffering with my foot." Unable to withstand the pain any longer, he was admitted to the hospital in Papeete on July 6, 1896, classified "pauper" (that is, insolvent). Doctor Buisson noted at the time that he had "a sore situated on a toe of the left foot" and that he suffered from eczema "which has attached itself to the sore and spread over the foot and lower part of the left leg." Gauguin was treated and given calming injections of morphine. But there was no keeping him away from the prolonged pageantry of Bastille Day festivities. Barely recovered, he signed himself out of the hospital four days later.

He sounded out the governor about possible assistance, but Papinaud had to return to France. Then Gauguin remembered a valuable contact he had made during his first stay in Tahiti: Auguste Goupil. Since then, the lawyer had made a fortune in business and boasted a magnificent house in Outumaoro, not far from where Gauguin lived. The painter offered to do a portrait of his nine-year-old daughter, Jeanne, who went by the Tahitian name of Vaité. The results met with Goupil's approval; Gauguin was asked first to eat with the family, then to give painting lessons to his elder daughter. (Like Gauguin's daughter, she was eighteen and named Aline.) But the lawyer-turned-businessman was a self-complacent prig whose trite tastes in art rubbed Gauguin the wrong way; it took only two months for the painter's patience to give out. Late in October, 1896, Goupil and Gauguin parted company.

Pahura was expecting and gave birth in December, but their baby girl died a few days later. Thank God, she was Protestant. The parish priest of Punaauia, outraged by an "indecent" sculpture of a nude woman that the artist had placed amid the flowers in his garden, had already warned all Tahitian Catholics not to associate with him. However, good news came on December 27 in the form of a check of 1,200 francs from Chaudet, the art dealer. Now euphoric, Gauguin wrote a letter to Séguin on January 15, 1897. "I sit at my door, smoking a cigarette and sipping my absinthe, and I enjoy every day without a care in the world. And a fifteen-year-old wife serves up humble fare, all for a ten-franc dress once a month. I ride on horseback or in a carriage when I so desire. All this belongs to me... Yes, I shall die here if I can manage to sell 1,800 francs' worth [of work] a year."

On March 3, Gauguin sent eight paintings to de Monfreid by way of the medical officer aboard the cruiser *Duguay-Trouin*. One was a self-portrait inscribed *à l'ami Daniel,* a gift to his faithful correspondent; another was a nude study of Pahura entitled *Nevermore.*

Nevermore! In a terse letter Mette informed her husband that Aline had died in Copenhagen on January 18. "The news did not move me in the least," he claimed in a letter to *l'ami Daniel.* Later, however, he let his true feelings be known to Molard. "I confess to my shame that upon receipt of a short letter from my wife announcing the bad news, my eyes were dry, and I have not answered. . . . Ever since I was a child, misfortune has pursued me. Never any luck, never any joy. Everything always against me, and I cry out, 'God Almighty, if you exist, I accuse you of injustice and spitefulness.'"

Then came yet another calamitous turn of events. The owner of the land his hut stood on died, and his heirs were forced to sell the property. There was no alternative but to purchase a plot of ground elsewhere and take out a loan at the Caisse Agricole. He had another hut built five hundred meters from the old one, but got deeper into debt in the process. Hounded by creditors, he pressed his debtors back in France, who turned a deaf ear. Eczema had now spread to both his legs; his neighbors and their horrified daughters saw the bandages and assumed he had leprosy. When conjunctivitis made it impossible for him to paint, he channeled his energy into writing "The Catholic Church and Modern Times," a desultory but virulent essay that takes the missionaries to task for their

self-serving attitude toward the natives. He also accuses the Catholic Church of perverting the teachings of Christ, corrupting the Gospel's message of compassion, and distorting the truth. "The gulf between modern society and Christianity rests solely on a misunderstanding brought about by falsification and brazen deception on the part of the Catholic Church. It is imperative that we put an end to it, especially as the real teachings of Christ have so much in common and coincide so thoroughly with the principles and aspirations of modern society, and are therefore destined to join together to form an indissoluble, transcendent whole."

The first days of December did not bring the money he had been expecting from Chaudet, but he did receive the October issue of the *Revue Blanche,* which had published part of *Noa Noa.* Included with it were poems by Charles Morice, who suggested that Gauguin and Molard, a musician, work with him on what he referred to as a *ballet doré,* a lyric pantomime about Tahiti and the last of its Maori kings. Not only was the idea ridiculous, but it also proved to Gauguin how flighty and unconcerned his friend really was: it had not even occurred to Morice to send the painter his royalties!

With Christmas approaching, the loneliness became overwhelming. "May your conscience sleep," he wrote to Mette after his forty-ninth birthday had come and gone, "so that you won't welcome death as a deliverance." He also broke his silence with respect to the loss of his daughter. "Like my mother, her name was Aline.... Her grave is over there with its flowers; all that is just an illusion. Her grave is here, right by me; my tears are its living flowers." In previous paintings he had identified himself with the Christ of Gesthemane and Golgotha. Now he was convinced that, as he wrote to de Monfreid upon learning of Mallarmé's death, an artist must die "a martyr to his art."

He had failed to regain his Paradise Lost and knew that he never would, at least in this life. Death itself had teased him only to give him the slip; he would have to court him. The powdered arsenic he was rubbing into his ulcerous legs was going to waste. He would put it to better use, up there in the mountains. First, however, he would at least make an attempt to answer the three questions that sum up the whole of human destiny: Where do we come from? What are we? Where are we going? "Before I die, " he later wrote to de Monfreid, "I wish to paint a large picture I had in mind, and I worked night and day that whole month in an incredible fever." The result was the great testamentary painting in which Gauguin surpassed himself.

A Suicide Attempt with Arsenic

Gauguin spent the entire month of December in front of a coarse jute canvas, painting what he assumed would be his last picture. Convinced that it "not only surpasses all my previous ones, but that I shall never do anything better," he waited until the 30th, when the schooner *Galilee* would bring his mail—and perhaps some money. There wasn't any. Bottle of arsenic in hand, he walked across the upland plantations, lay back amid the ferns, and swallowed the poison as he gazed at the sea and island of Moorea. But he took too much and began to vomit. "Finally, after a night of terrible suffering, I returned home. For an entire month I have been plagued by pressure at my temples, then by fits of dizziness, and I am nauseated by what little I eat."

Now he was, as he put it, "condemned to live" off occasional sums of money so paltry that he could not meet his obligations to the Caisse Agricole. It so happened that this firm had an opening for secretary-treasurer, so Gauguin decided to see the new governor, Gustave Gallet, and apply for the position. Moved by the painter's plight, Gallet suggested instead that he sign on as a draftsman in the Public Works Department. Although the job did not

pay well, he had no choice but to accept. He closed up his hut in Punaauia and rented a small house in Papeete, but Pahura did not find the capital to her liking and moved back to the country. "As I wrote you earlier," he admitted to de Monfreid, "I don't do any more painting. I work in the Public Works Department, plodding along in my stupid, mindless existence and still suffering with my foot." Time and again, he pressed de Monfreid for news of his art dealers and prospective buyers. Gauguin took to loitering in taverns, mingling with soldiers and sailors, quenching his thirst for absinthe or beer with low-level government officials. It was August, 1898. Bored at work and at home, he tried to coax Pahura into coming back and living with him. She turned him down, as another child was on the way.

Some money orders arrived just in the nick of time. He resumed payments to the Caisse Agricole, and on September 2 was admitted to the hospital ward for noncommissioned officers as a "writer with the Public Works Department." For the next twenty-one days he was kept on a diet of Vichy water and subjected to a drastic, aggressive therapy for his ulcerous legs and buttocks.

By January, 1899, he realized that his health was not improving and that it would be "far better to die." "My heart is empty," he wrote to de Monfreid. "The only true satisfaction is *in oneself,*" but now he was filled with self-loathing. A thousand francs from de Monfreid brightened his outlook considerably. He quit his job with the "Public Works Department and Land Registry," moved back to Punaauia, and resumed his life with Pahura, whose pregnancy he looked upon as "a happy thing in that perhaps the child will give me something to live for." On April 19, she gave birth to a son; Gauguin named him Emile. De Monfreid sent him some flower seeds, and soon Gauguin's hut was surrounded by irises, gladiolus, and dahlias. "All this, together with the many flowering Tahitian shrubs, will make for a veritable Garden of Eden. When I am able to paint again, if my imagination is played out, I shall do some studies of flowers." And so he did, resulting in the many beautiful still lifes from the second Tahitian period.

But illness made him testy; he was in a mood to pick a fight. His deep-seated need to be revenged for his frustrations won out over any desire he may have had to assimilate *fiu,* the Tahitian outlook of fatalism and indifference. When his house was repeatedly burglarized and the guilty parties went off scot-free, an exasperated Gauguin felt he had fallen victim to the apathy of the authorities. He filed a complaint with Charlier, the public prosecutor. But the wheels of justice moved too slowly for the painter, so he published an insulting open letter in *Les Guêpes* and threatened him with a duel. When Charlier did not reply, Gauguin followed up with more articles against the administration. Heartened by the success of his diatribes, he founded his own satirical journal, *Le Sourire,* a four-page monthly which he called "serious," then "spiteful." There were occasional woodcuts and humorous drawings by Gauguin himself. Sales were disappointing as it was "passed from hand to hand." In the first issue (August 21, 1899), Gauguin pitted himself against Goupil and the Papeete-Mataiea railway he was planning to build for his own business needs. His gift for polemical writing caught the eye of Cardella, owner of the pro-Catholic *Les Guêpes* and nemesis of Goupil's pro-Protestant *Océanie Française.* In February, 1900, Cardella—who happened to be the mayor of Papeete—put Gauguin in charge of *Les Guêpes.* A relentless campaign against Governor Gallet ensued; he was characterized as a "ferocious despot," a "Mr. Busybody" who continues to flaunt that fine pudginess and stupid face of his in the streets. Gauguin stopped publishing *Le Sourire* in April, as it was duplicating material being printed in *Les Guêpes.* He threw himself into politics with a passion, hosted lavish banquets followed by erotic "sprees" come evening. He did practically no painting.

On September 23, at a meeting of the Catholic Party in the Papeete town hall, Paul Gauguin delivered a speech against the influx of Chinese immigrants that he felt jeopardized

"the vitality of Tahiti: this yellow blot on our country's flag makes me blush with shame," he declared, after which he circulated a petition signed "P. G., publiciste." However, during his two years as a polemical journalist and political activist—artistically, a lackluster period except for a few original illustrations—the interests of the natives were not his primary concern. Through articles and speeches he aired his personal grievances against the authorities, devoted himself to the "just cause of the working colonist," and, as one reader reprovingly noted, in the long run neglected his art to do the bidding of his employers, the owners of *Les Guêpes*. On February 24, 1901, Edouard Petit replaced Gallet as governor; the change in personnel met with the approval of the Catholic Party. In August, Cardella announced that *Les Guêpes* would no longer be published on a regular basis.

"My Imagination Is Waning"

Gauguin's health was taking an obvious turn for the worse. He could hardly walk any more, even with the help of his carved cane. On December 19, 1900, he was admitted to the hospital with a fever. He asked to be discharged on February 2 but was readmitted on the 4th because the eczema had spread to his hands. He remained there until the 21st, only to be admitted again on March 18 for pains in his left shoulder blade. Dr. Alquier did what he could to alleviate the excruciating neuralgia with morphine injections, but the eczema showed no signs of significant improvement.

Gauguin was more anxious than ever to be rid of his ailments. His hope of going off to the Marquesas had become an all-consuming desire, even if there was no hospital on those remote islands! Now that his pain had subsided somewhat and de Monfreid had sent him some homeopathic medicines, he gave serious thought to the next major relocation. (At this time he also asked de Monfreid to send him a "sturdy Spanish mandolin.") With collectors like Emmanuel Bibesco and Fayet purchasing his work, he felt he had built up a reliable clientele, Chaudet's death notwithstanding. He gave de Monfreid power of attorney—"Ah, my dear Daniel, I must pester you with all my business," he admitted objectively—and through the kind offices of his friend worked out a nonexclusive contract with Ambroise Vollard: twenty-five paintings a year for a monthly payment of 350 francs. After endless equivocating and chicanery, endless delays in getting pictures dispatched and remittances disbursed, Gauguin finally conceded in April, 1901, that the Vollard deal would "more than cover expenses" and that he could now settle in the Marquesas, "where living is very easy and very cheap," and where he would find "fresh subject matter for painting." "Here," he confessed, "my imagination has begun to cool."

He put his land and hut in Punaauia up for sale. Pahura made it clear that she would rather stay in Tahiti with her family. Moreover, rumor had it that in the Marquesas a girl could be had "for a handful of chocolates." Before long, Gauguin got used to the idea that he would have to leave Pahura and Emile behind.

A former Swedish sailor offered 5,000 francs for his property. The transaction completed, Gauguin paid off his outstanding balance at the Caisse Agricole and started packing his many belongings. In a detailed letter to de Monfreid, he complained again about Vollard: he was a "shrewd character" and had to be kept in suspense. He also asked for canvas, size, and gold dust ("yellow gold, green gold, red gold") for his future "incantations" and "invocations." After some instructions about money matters, he closed with, "When will the time come when we shall be able to speak of nothing but Art?"

On September 10, 1901, the steamer *La Croix du Sud* left Papeete for the Marquesas, an archipelago some 1,500 kilometers northeast of Tahiti. Gauguin's destination was the southernmost island of Fatu-Iva, where some splendid archaeological remains still bear witness to the golden age of the Maoris.

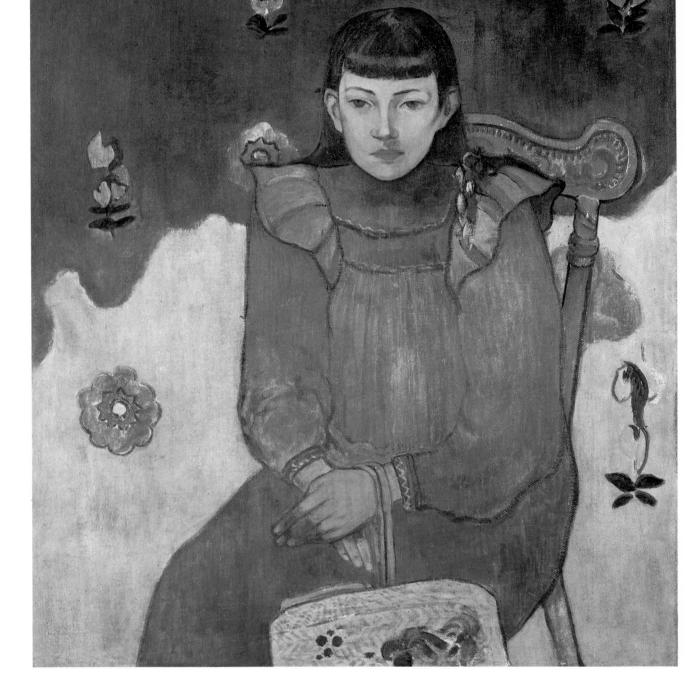

385. Jeanne ("Vaïté") Goupil as a child

386. Gauguin. *Vaïté Goupil*. 1896

387. The Goupil family in Tahiti

G auguin was short of money when he dropped in on Auguste Goupil, an attorney he had met during his first stay in Tahiti. Goupil had since served as consul of Sweden and Norway and had become a wealthy businessman. He now boasted a sumptuous residence and sprawling, parklike grounds at Outumaoro, only four kilometers from the painter's hut. Goupil broke bread with Gauguin and suggested he give his elder daughter painting lessons. The younger daughter, Jeanne, sat for the painter, who went out of his way not to offend the pedantic tastes of his host and benefactor. Before long, associating with a man so conceited and so insensitive to his art proved tiresome. Fortunately, his friend and only faithful correspondent, de Monfreid,

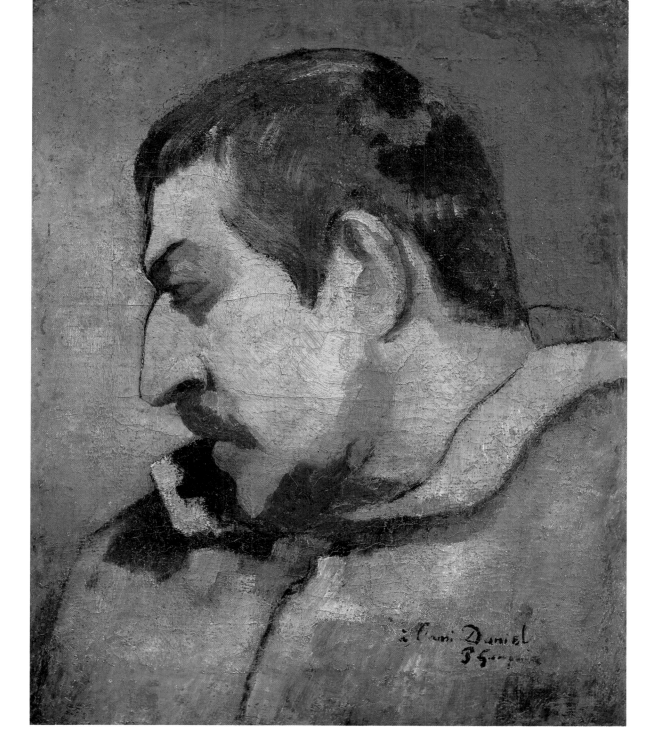

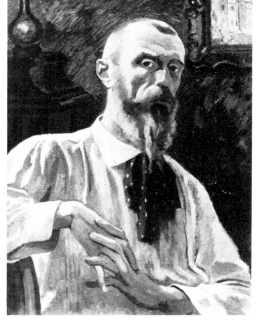

388. Georges-Daniel de Monfreid. *Self-Portrait*

389. Gauguin. *Self-Portrait: "à l'ami Daniel."* 1897

did everything in his power to get his paintings sold in France.
"You shall be receiving some of my pictures in the near future," he
informed him on February 14, 1897. "My physical and mental
suffering is such that I am not even up to forming an opinion of
them." Included in the parcel was a profile of a head bowed in
sadness: a "self-study, story of painting . . . which I present to you as
a very small token of my friendship." In April, his wife informed him
of Aline's death. At first, he turned off his emotions, but later
unburdened himself to de Monfreid. "The news did not move me in
the least. I have grown so inured to suffering. Then, each day . . .
the wound opens more deeply. . . ."

390. Gauguin. *Self-Portrait*

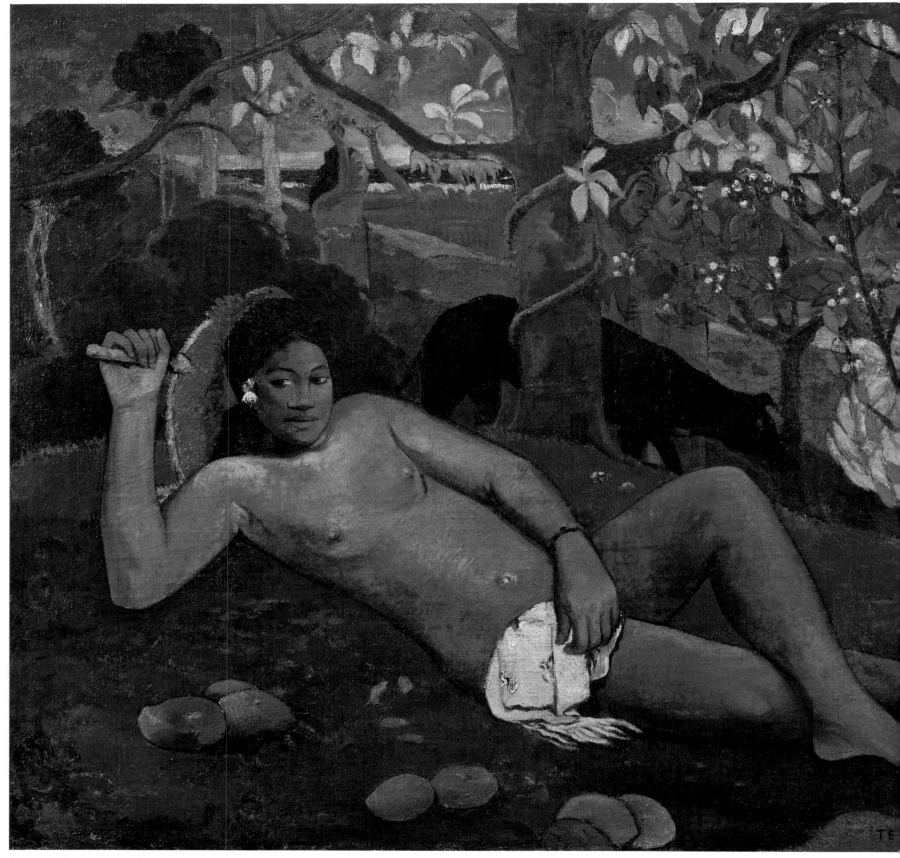

391. Gauguin. *The King's Wife (Te Arii Vahine)*. 1896

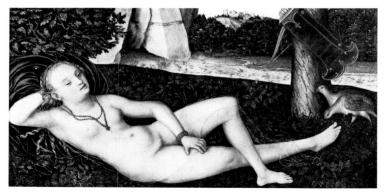

392. Lucas Cranach. *Diana Reclining*. c. 1537

393. Schoolgirls resting on their way back from an outing, Tahiti

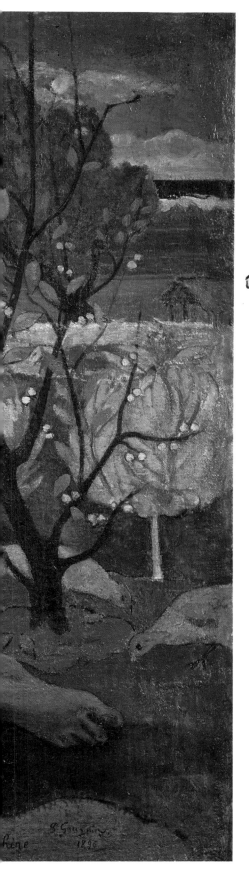

394. Gauguin. *Maori Woman as an Idol*

395. Gauguin. *Le Père Paillard.* 1892

396. Gauguin. *Decorative Figure*

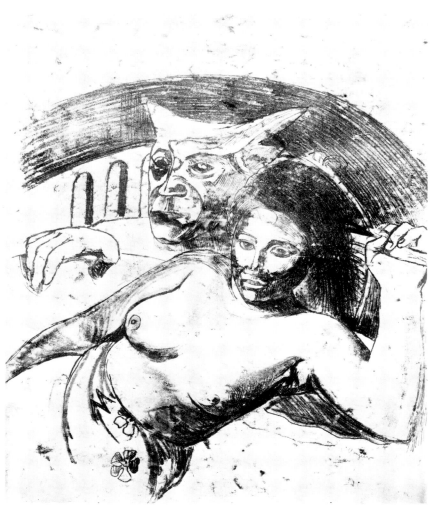

397. Gauguin. *Study for "The King's Wife"*

“I have just finished a painting 1.30 meters by 1 meter which I think is better than anything I have done thus far. A nude queen lying on a green carpet, a servant picking fruit, two old men near a large tree and discussing the Tree of Knowledge. A seashore in the background.... As far as color is concerned, I don't think I have ever struck a tone of such depth and fullness. The trees are in blossom; a dog stands guard; on the right, two doves are cooing. What is the use of sending this picture on, when there are so many others that do not sell and create such an uproar? This one will only create a bigger one...." Such was Gauguin's opinion of Te Arii Vahine *in a letter to Georges-Daniel de Monfreid. The pose of his* vahine *derives from Lucas Cranach's* Diana. *Centuries after her slumber began, Gauguin transformed her into a tropical queen and gave her the features of a Tonga woman copied from a photograph he had purchased in Australia or New Zealand. (See pages 188-189 on* Noa Noa.) *Although Cranach's setting has been transplanted to the South Seas, certain details, such as the two partridges at the foot of a tree, were carried over into* Te Arii Vahine. *But a sinister presence lurks nearby: not just the snake coiled about the tree (instead of Cranach's bow and quiver), but the horned devil keeping an eye on Gauguin's* décorative personne. *Its features recall those of* Père Paillard *(Father Lechery), a derisive statue of Monsignor Joseph Martin which the painter placed in front of his hut. Like the effigy in* Te Arii Vahine, *this bishop of the Marquesas kept watch over the girls attending convent school, safeguarding them from the unholy desires of the painter and sculptor who was out to lead them astray.*

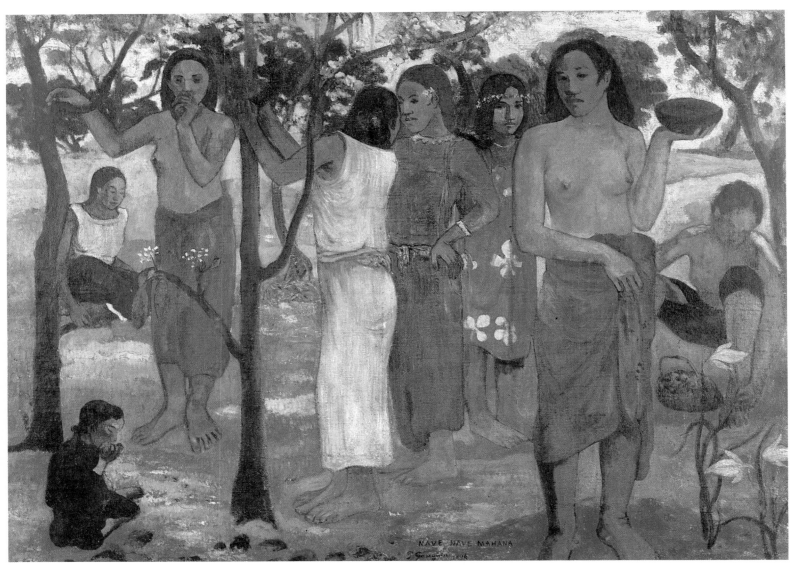

398. Gauguin. *Delicious Days (Nave Nave Mahana)*. 1896

399. Pierre-Paul Prud'hon. *Joseph and Potiphar's Wife*. c. 1793

400. Gauguin. *Joseph and Potiphar's Wife*. 1896

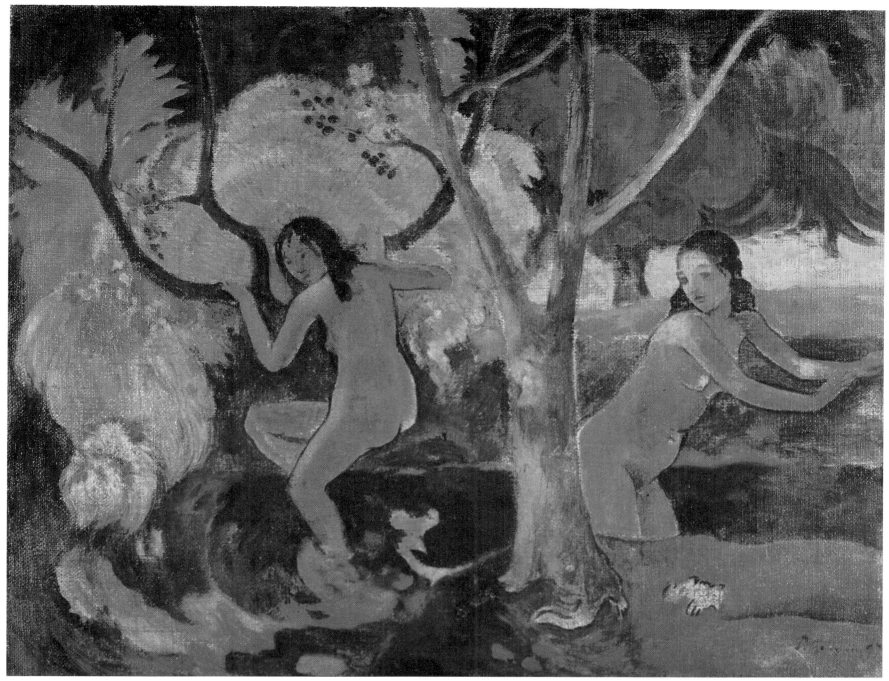

401. Gauguin. *Tahitian Women Bathing*. 1897

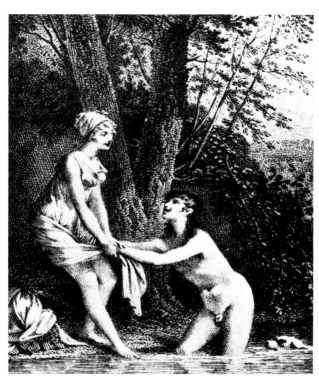

402. Pierre-Paul Prud'hon. *The Bath*

R ender unto Prud'hon that which is Prud'hon's and unto Gauguin that which is
Gauguin's. From him he occasionally borrowed stately, graceful poses,
usually inverting them to throw us off the track (just as Henri Rousseau did
with his photographic sources). Once transmuted, however, the results are his and his
alone. In this respect, Gauguin can be compared to Nicolas Poussin, who transformed
Greek and Roman myths into lush, elegiac allegories of the mysterious forces of
nature. (Furthermore, he may have helped to inspire Gauguin's bold, yet beautifully
balanced, chromatic effects.) Had not Gauguin taken the Impressionists to task for
"heeding only the eye," for neglecting "the mysterious centers of thought," for losing
sight of the fact that "there is metaphysical as well as physical," and for falling into
"purely scientific justifications"? To be sure, his models are part-imitation; they seem
out of place in their imaginary settings. But they are not slavish imitations.
Paradoxically, pictorial quotation was, for Gauguin, simply a way to free himself from
the stranglehold of culture, from the store of visual images we call memory, just as
Joseph left his garment in the arms of Potiphar and fled naked, but unsullied. "To
have a style," wrote Rémy de Gourmont in February, 1899, "means to speak a distinctive
dialect amid common parlance."

403. Bas-relief, Temple of Borobudur, Java

404. Gauguin. *Te Faruru (Here We Make Love)*

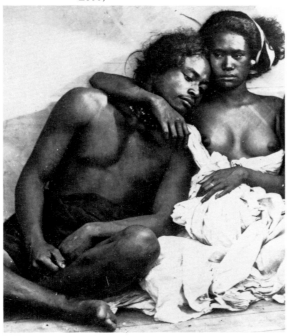

405. King Vaitahu and his wife, Marquesas Islands, c. 1880

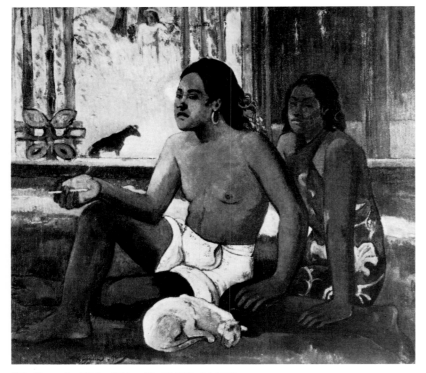

406. Gauguin. *Eiaha Ohipa (Do Not Work).* 1896

"Everything in this painting is a dream," Gauguin pointed out to de Monfreid in a letter dated March 12, 1897. "Is the child really there, or the mother, or the rider in the path? Or is it all just a dream of the painter's?" He failed to mention the lovers he carved into panels in his hut, locked in an embrace as though terrified by the prospect of separation. Everything is nostalgia! The longing for love, as depicted in a

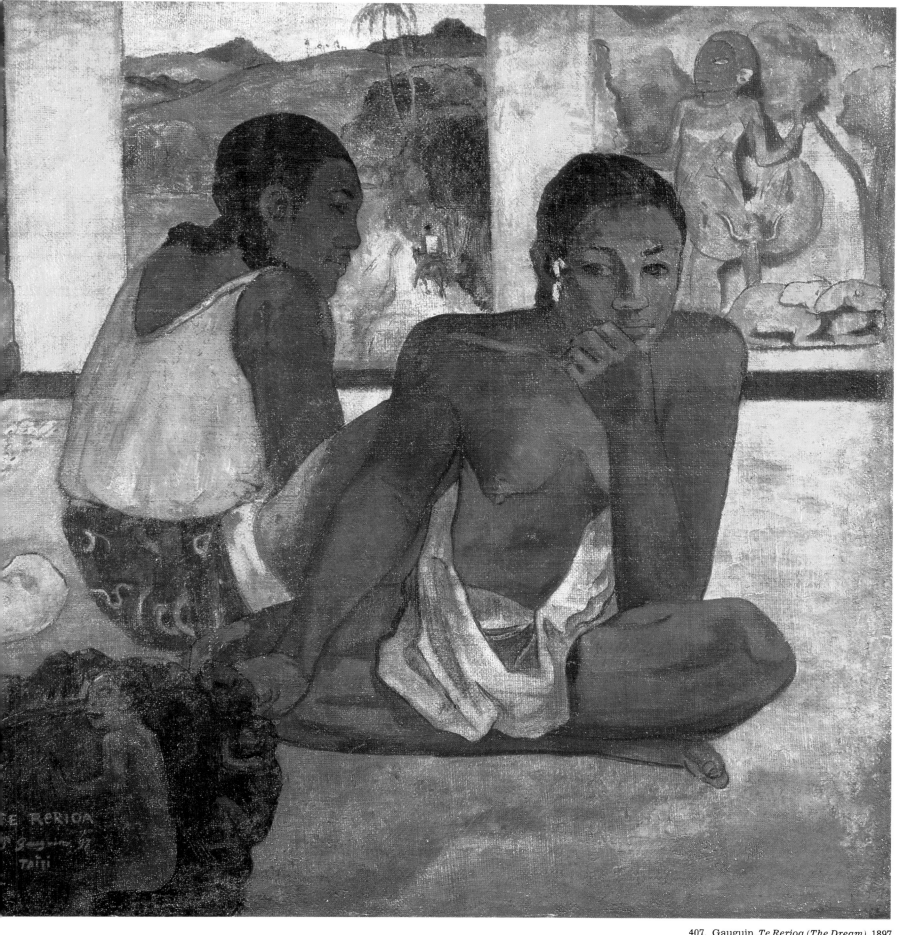

407. Gauguin. *Te Rerioa (The Dream)*. 1897

relief carving from Borobudur, where a woman is leaning against her man-god. The yearning for nature, glimpsed through a picture within a picture, or a dog growing impatient at a window. Or work calling you back to the fields, but which an opiated cigarette keeps you from finishing. "Regarding, then, Beauty as my province," Poe declared in The Philosophy of Composition, "*my next question referred to the* tone *of its highest manifestation—and* all experience has shown that . . . melancholy is the most legitimate of all the poetical tones." No doubt Gauguin was familiar with what Baudelaire had to say about this American poet, who was given to placing his figures "against purplish and greenish backgrounds that bring out the phosphorescence of decay and the smell of the storm."

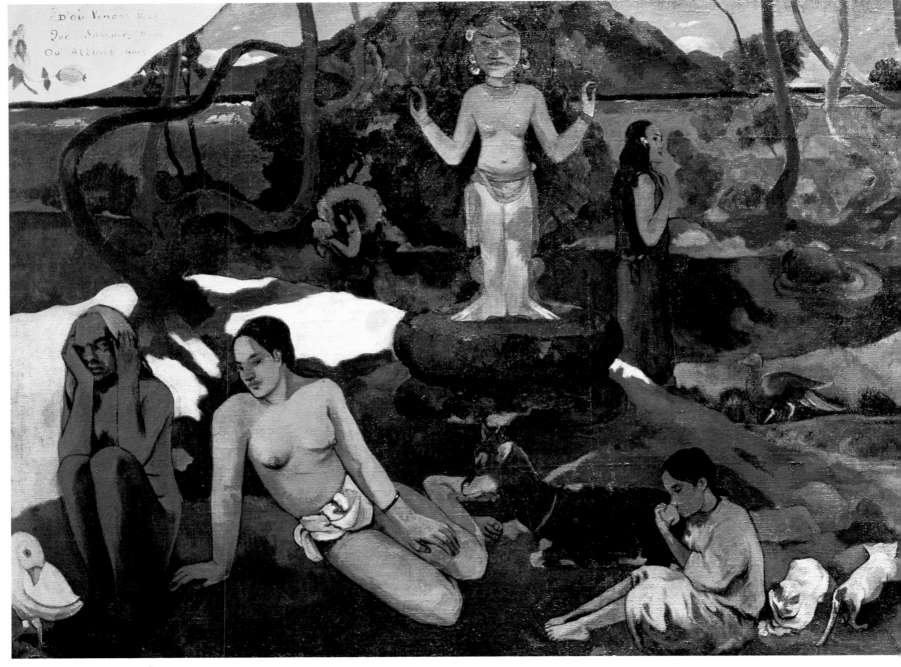

408. Gauguin. *Where Do We Come From? What Are We? Where Are We Going?* 1897

409. Gauguin. *Breton Eve.* 1889

410. Vase in shape of a seated figure

Gauguin was seriously ill. He was coughing up blood, and his legs were covered with ulcers which neighbors ascribed to leprosy. But syphilis was not the only thing taking a toll on him; he never really recovered from the news that his daughter had died. To William Molard he admitted, "I cry out, 'God Almighty, if you exist, I accuse you of injustice and spitefulness.' Yes, on learning of my poor Aline's death, I doubted everything." That December, he resolved to take arsenic and do away with himself. First, however, he would "bequeath" to posterity his spiritual and artistic testament, a painting that attempts to answer the questions Balzac had asked in Seraphita: "Do you understand by this idea made manifest the destiny of humankind? Where it comes from? Where it is going?" Painted on a piece of coarse jute canvas measuring 1.39 meters by 3.75 meters, the general composition recalls The Sacred Woods by Puvis de Chavannes, even more, the Pont-Aven Triptych by his friend Paul Sérusier—except that the island of Moorea looms in the distance. It took Gauguin nearly a month to piece together these images—some sources of which are shown here—into the beautifully orchestrated puzzle that is Where Do We Come From? He described the painting in a letter to de Monfreid; some key excerpts appear on the next page.

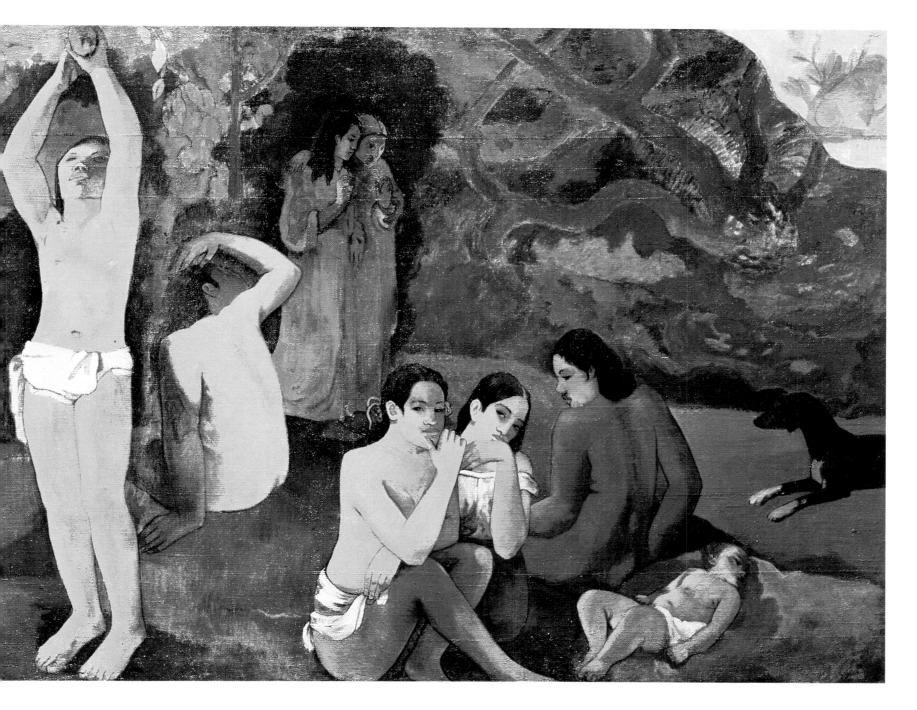

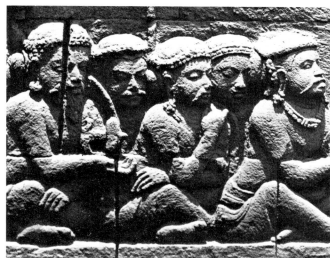

412. Bas-relief, Temple of Borobudur, Java

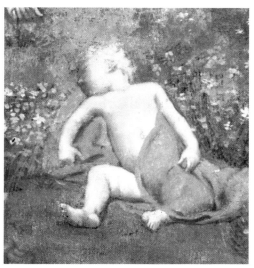

413. Pierre Puvis de Chavannes. *The Poor Fisherman* (detail). 1881

411. Attributed to School of Rembrandt. *Study of Nude*

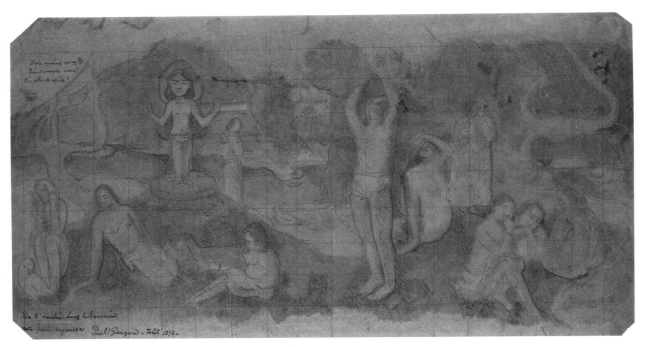

414. Gauguin. *Sketch for "Where Do We Come From? What Are We? Where Are We Going?"* 1898

415. Paul Sérusier. *Pont-Aven Triptych.* c. 1891

416. Pierre Puvis de Chavannes. *The Sacred Grove (Arts and Sciences).* 1888–89

"February 1898. *My dear Daniel.... Before dying, I put into it all my energy, such aching passion ... and vision so clear, needing no correction, that all sense of hurried execution vanishes, and it surges with life.... At the lower right, a sleeping baby and three crouching women. Two figures dressed in purple confide their thoughts to each other; a crouching figure, intentionally huge and disproportionate, raises her arms and looks in astonishment at these two who dare to think about their destiny. A figure in the center is picking fruit. Two cats near a child. A white she-goat. An idol, its arms mysteriously and rhythmically uplifted, seems to be pointing to the Beyond. The crouched figure seems to be listening to the idol. Lastly, an old woman nearing death appears to accept and resign herself to her thoughts. She completes the story. At her feet, a strange white bird with a lizard in its claws represents the futility of words...."*

216

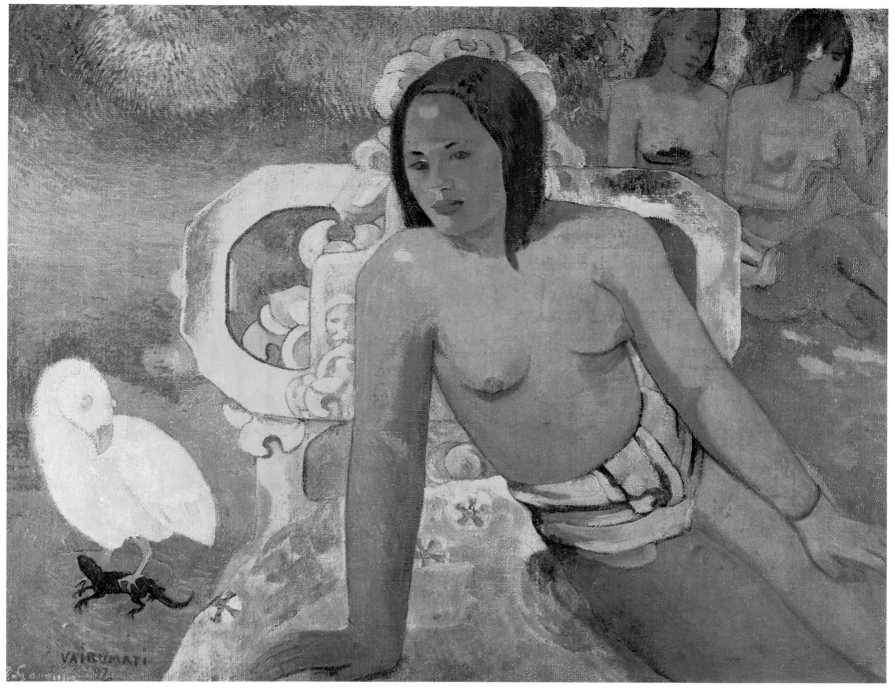

417. Gauguin. *Vairumati*. 1897

418. Gauguin. *Goose*. 1889

A woman heeding an idol and a white bird clutching a lizard reappear in Vairumati, *whom Gauguin describes in* Noa Noa. *"She was tall, and the fire of the sun shone in the gold of her flesh, while all the mysteries of love slumbered in the night of her hair."*

He later (1901) expounded on the meaning of his great frescolike painting in a letter to Charles Morice. "Near a dying old woman, a strange, stupid bird brings the poem to a close by comparing the inferior being with the intelligent being in this great, all-embracing question posed by the title: What are we? Day-to-day existence. The man of instinct wonders what all of it means: Where do we come from? Spring. Child. Life begins. Behind a tree, two sinister figures shrouded in somber garb add near the Tree of Knowledge their note of anguish caused by that knowledge, in contrast with simple beings in pristine surroundings that could be the human concept of Paradise, beings who surrender themselves to the joy of living." What more need be said of Gauguin's inspiration?

419. Kitao Masayoshi. Sketch of geese

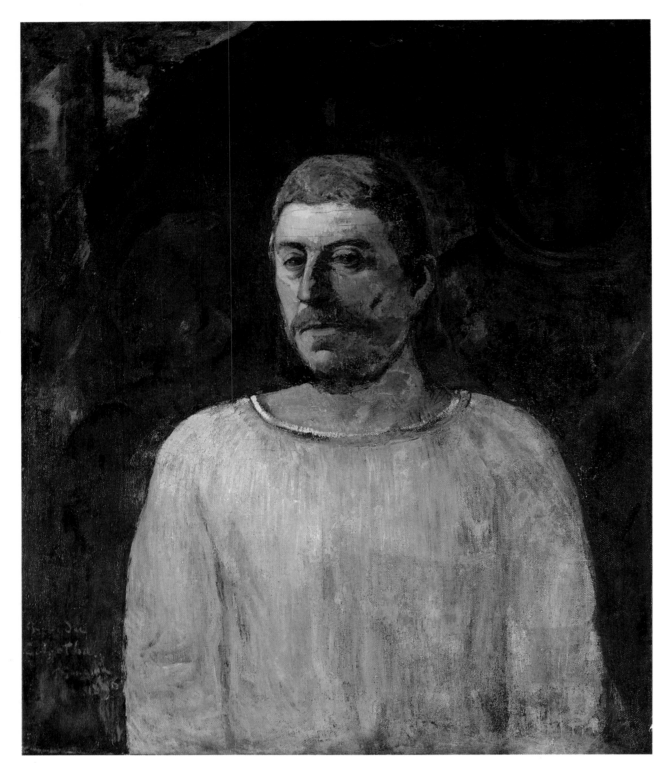

420. Gauguin. *Self-Portrait near Golgotha*. 1896

421. Gauguin. *Head of a Tahitian Man*. 1891–93

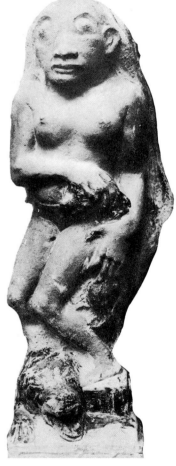

422. Gauguin. *Oviri (Savage)*. c. 1893

I n his Self-Portrait near Golgotha *we see not only the painter as a Christ figure, but profile and full-face representations of his earlier statue,* Oviri, *which Gauguin also dubbed "The Murderess." His inspiration for the monster can be traced to Balzac's* Séraphita, *for a notation alongside the pen-and-ink drawing of Oviri in the first issue of* Le Sourire, *journal méchant reads: "And the monster, clutching its creature, fertilizes with its seed a bountiful womb to beget Séraphitus-Séraphina. Transposed into sculpture, Oviri squeezes the lower abdomen of a lizardlike monster to her own; its head and right paw lie at her feet as she draws out its sperm. This probably ties in with a myth Gauguin recounts in* Ancien Culte Mahorie. *"The first seed," we learn, "came from the union of Taaora and the goddess of the bosom of the Earth" and that "from this was born all that grows on*

the face of the earth." "Soon I shall be a father," Gauguin wrote to de Monfreid in November, 1896. "My charming Dulcinea has decided to lay.... My studio is quite beautiful, and I assure you that time goes by quickly.... Ah, my dear Daniel, if only you knew this Tahitian life, you would not wish to live any other way." Pahura, who was scarcely fifteen herself, gave birth a few weeks before Christmas; the baby girl died shortly thereafter. Even as Father Michel, the resident missionary in Punaauia, held him up to ridicule, Gauguin made this blessed event-turned-tragedy the subject of two nativity scenes: Baby *and* Te Tamari No Atua *(literally, The Children of God). The setting is the painter's hut, to which has been added a cattle stall copied from a painting by Tassaert. Now sanctified, Pahura, like her infant deity, has been crowned with a halo.*

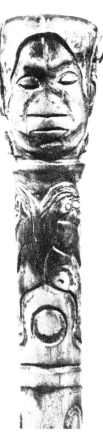

423. Gauguin. Cane with carved decoration

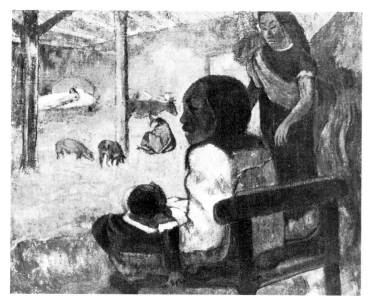

424. Gauguin. *Tahitian Nativity*. 1896

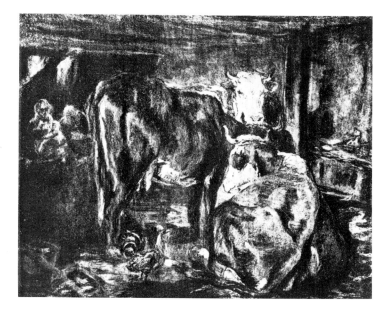

425. Tassaert. *Stable Interior*. 1837

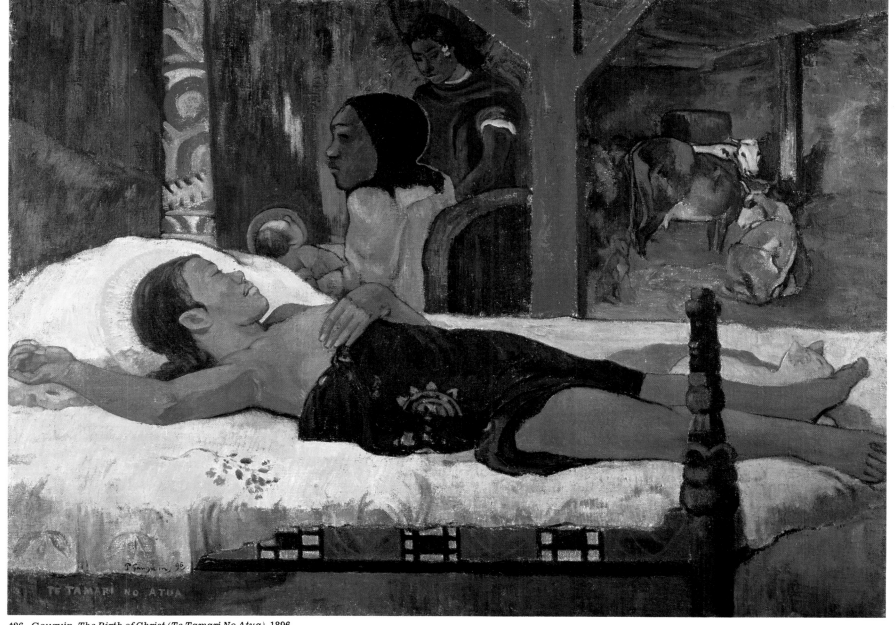

426. Gauguin. *The Birth of Christ (Te Tamari No Atua)*. 1896

427. Gauguin. *Nevermore (Otaïti)*. 1897

For Edgar Allan Poe, the world is but "*the dream of a dream,*" because everything must die: "*Quoth the Raven, Nevermore.*" The incessant refrain of Poe's bird of misfortune had already inspired a poem by Baudelaire; now it became the title of a mysterious painting by Paul Gauguin. "*My aim was to suggest with a simple nude a certain barbarian luxury of bygone days,*" he explained. "*It is all bathed in sad and somber colors, and deliberately so.... As a title,* Nevermore; *not at all the Raven of Edgar Poe, but the bird of the devil on the lookout.*" But the eternal bird of ill omen is not the only disquieting presence; some unknown Iago and Othello—an illusion to Delacroix's sketches for Othello and Desdemona (1849)—are huddled in the doorway. "*Of all melancholy topics, what ... is the most melancholy?*" Poe asks in The Philosophy of Composition. "*Death—was the obvious*

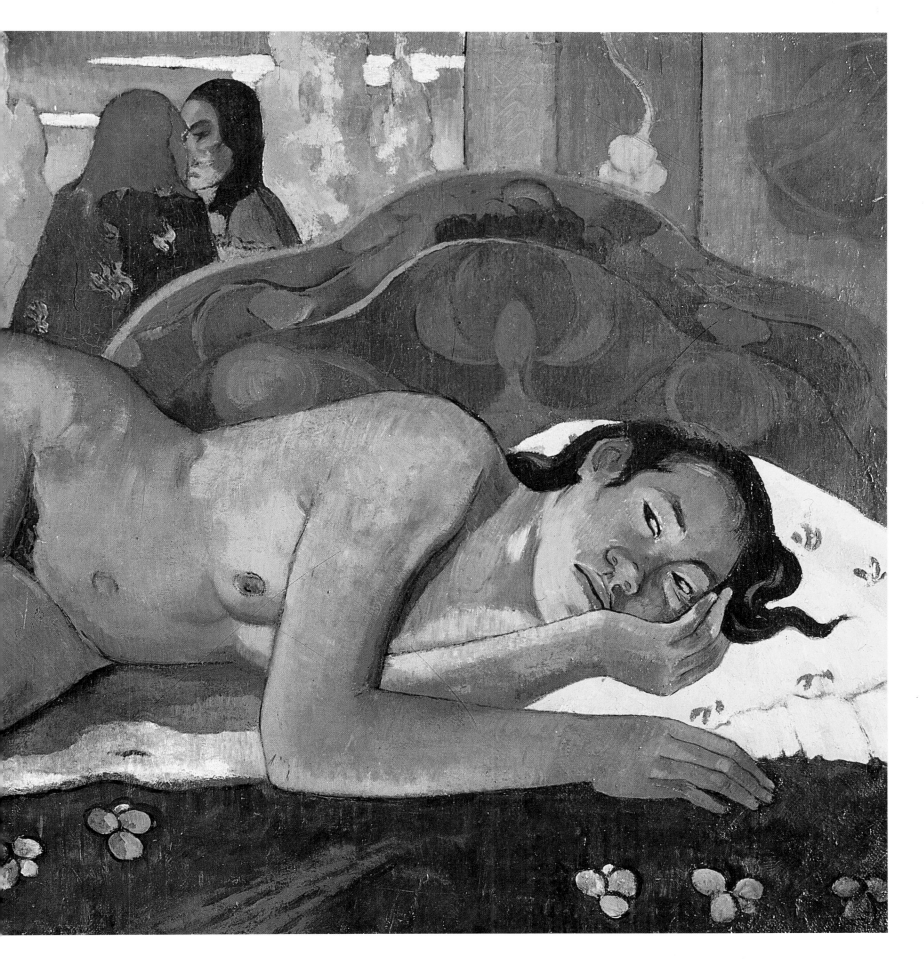

reply. 'And when,' I said, 'is this most melancholy of topics most poetical?'... When it most closely allies itself to Beauty: the death, then, of a beautiful woman is unquestionably the most poetical topic in the world." The young vahine in this painting, Pahura, is all the more listless and unsmiling because the baby she had borne Gauguin, the flesh of her flesh, has just died, hence the mournful title, Nevermore.

428. Eugène Delacroix. *Study for "Othello and Desdemona"* (detail)

429. Gauguin. *Faa Iheihe (Decorated with Ornaments).* 1898

430. Gauguin. *War and Peace* (reproduced in part)

431. Gustave Courbet. *Hunting Dog*

After his attempted suicide, Gauguin tried to reawaken his zest for living. In this huge, sun-drenched painting (Faa Iheihe), a number of figures are making preparations for a celebration. "At that very moment, when the most intense emotions fuse in the depths of one's being, when they burst forth, when the whole concept wells up like lava from a volcano, is there not something like a blossoming? The work of art is created suddenly, brutally, if you wish, but great and superhuman in appearance" (letter to de Monfreid, March, 1898). Not a single figure is seated or crouching; every one of them is upright. The sources for Faa Iheihe include the robust Courbet, from whom Gauguin borrowed the dog and the nude woman with her back to us. He even transformed a bare-breasted apple seller on a cover of Le Courrier Français into the woman at left picking flowers (later reprised in Two Tahitian Women, 1899). The painter thus sought to brighten his mood by inundating himself with his paradisiac vision.

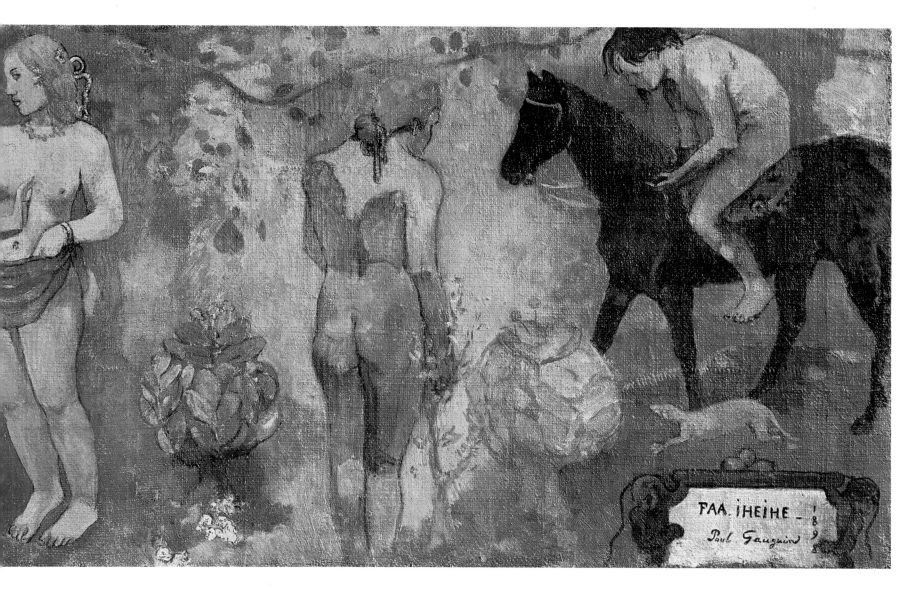

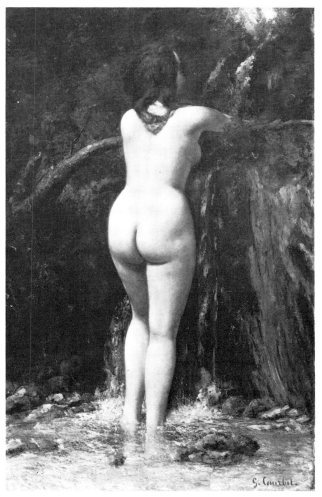

432. Gustave Courbet. *The Source*. c. 1862

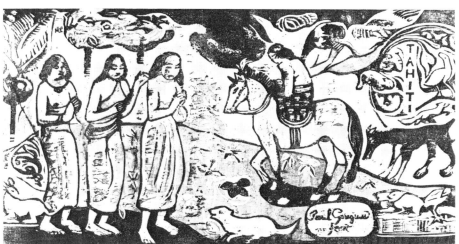

433. Gauguin. *Changing Residence*

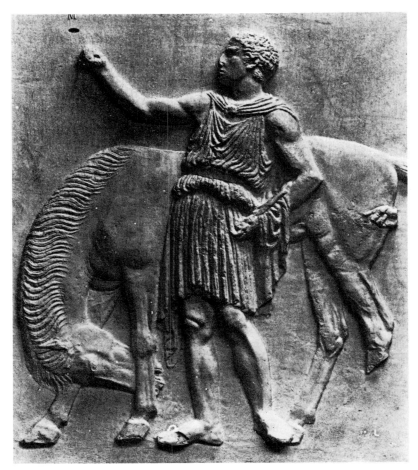

434. Panathenian procession, from the Parthenon frieze

435. Edgar Degas. *Mlle Fiocre in the Ballet "La Source."* 1866–68

436. Young native on horseback, Tahiti

437. Gauguin. *Study of a Horse*

Blessed with unerring visual recall, did Gauguin remember the Orientalizing picture his friend Degas had painted of Eugénie Fiocre dancing in the ballet "The Source" at the Opera? Or his fascination with those artificial, but spellbinding spectacles which had opened his eyes again to "the contrived movements of the Greeks"? Be that as it may, the pose struck by the rider, whose mount is quenching its thirst, derives from a counterpart on the Parthenon; the other two bring to mind the later jockeys of Degas. This now-famous painting was commissioned by Ambroise Millaud, a pharmacist, in exchange for services rendered, but with the following stipulation: the subject had to be "true-to-life and from nature." Millaud's daughter later recalled that her father was very disappointed with the outcome. "But this horse is green!" he exclaimed. "Monsieur Millaud," Gauguin replied, "haven't you ever noticed that everything here is green? Sit down in an armchair and close your eyes halfway, and you will see that green predominates over all other colors!" "Just the same," retorted Millaud, "I can't sit down and close my eyes halfway each time I want to look at a painting." Gauguin's inaccurate doses of color were not to the pharmacist's liking, and Millaud adamantly refused to go through with the barter. It is now one of the masterpieces in the Musée d'Orsay in Paris.

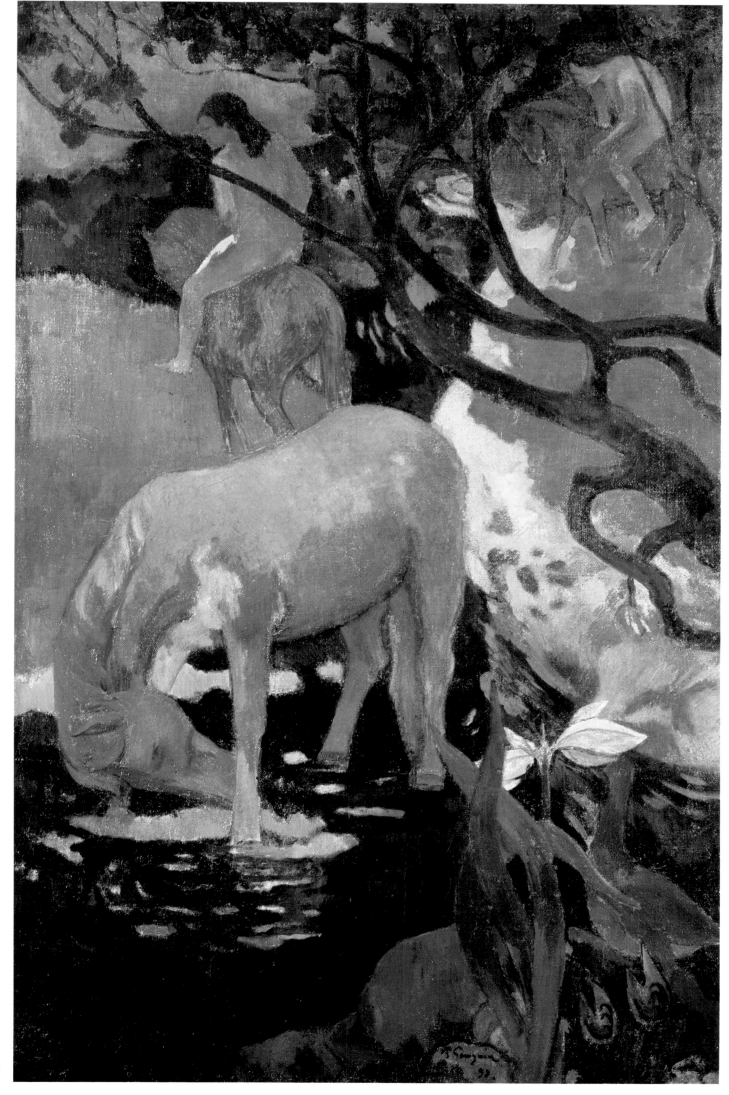

438. Gauguin. *The White
Horse.* 1898

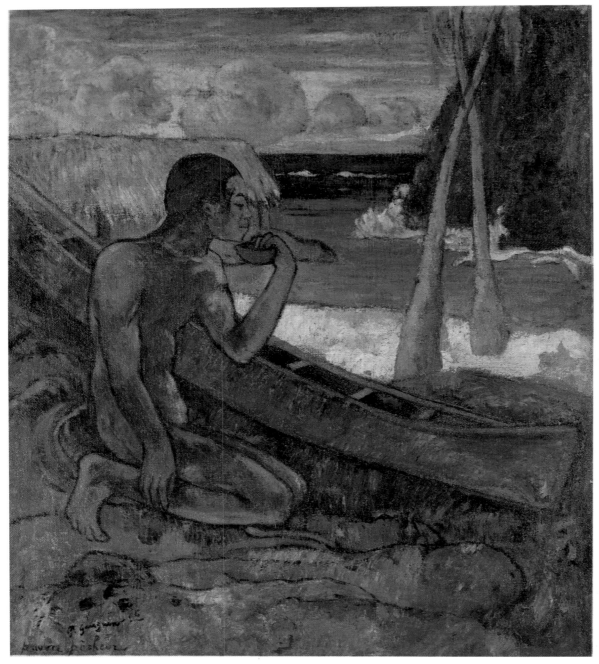

439. Gauguin. *The Poor Fisherman.* 1896

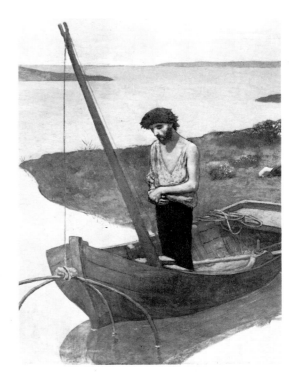

440. Pierre Puvis de Chavannes. *The Poor Fisherman* (detail). 1881

441. Fisherman and dugout canoes, Tahiti, c. 1896

T he collection of Gustave Arosa included a painting of a sailboat by Jongkind, which so impressed Gauguin that he took a photograph of it with him to the South Seas. And so, our seafaring painter climbed aboard his imaginary ship and set sail for Hiva Oa, a primitive Cythera whose temples were nothing more than straw huts on ground as red as passion, where vahines yearning for men mill about beneath entwined coconut palms. In Ancien Culte Mahorie, Gauguin recounts the Oceanic version of how the stars came into being. "The King of the Golden Heavens, the only king, slept with his wife Fanoui. She begat the star Tauroua (Venus, the Morning Star).... He set sail toward the left, northward, and there slept with his wife, who guides sailors and gave birth to the red star that shines in the evening.... The red star, the god who steers for the west, readied his dugout canoe, the pirogue of daylight, scudding heavenward. He sailed toward the sunrise." Always on the lookout for his lucky star, Gauguin paused to study a humble fisherman who asks for nothing more than beautiful surroundings and some coconuts to quench his thirst—a far cry from The Poor Fisherman by Puvis de Chavannes.

442. Johan Barthold Jongkind. *Sailboats*. 1861

443. Sailboat, Tahiti

444. Gauguin. *Tahitian Idyll*. 1901

445. Michelangelo. *Ignudo,* Sistine Chapel, Rome. 1509–10

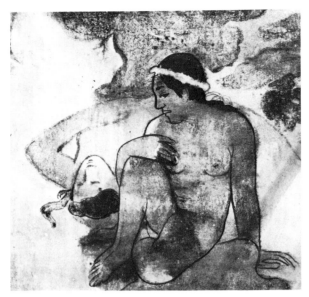

446. Gauguin. *Aha Oe Feii? (Are You Jealous?).* 1894

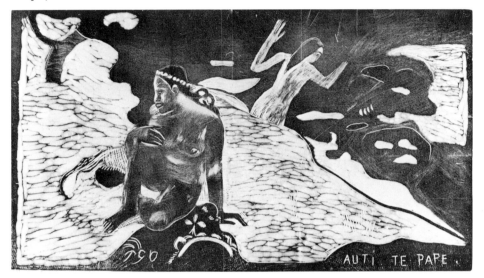

447. Gauguin. *Auti Te Pape (Women at the River).* 1891–93

448. Gauguin. *And the Gold of Their Bodies.* 1901

When critics pointed out that his paintings did not create the illusion of depth, Gauguin replied that "any sense of receding space would be meaningless. My aim being to suggest a tangle of lush natural growth, a tropical sun that sets everything around it aglow, I had no choice but to place these figures in a compatible setting. Life out-of-doors, to be sure, yet intimate." Gauguin may have looked to the hieratic relief carvings of Borobudur for inspiration; in point of fact, the Tahitians in And the Gold of Their Bodies (as well as other paintings with similar models) have more in common with the ignudi on the ceiling of the Sistine Chapel. It is to Michelangelo they owe both their luminosity and intimacy, the compelling twists of their bodies, the sculptural quality of their severely delineated contours, the terracotta tones which add to the mood of unabashed sensuality. "They tell me I am not Rembrandt, Michelangelo, or Puvis de Chavannes. I am fully aware of that!" he wrote in Racontars de Rapin (1902). "You can tell an artist by the nature of the transposition," he adds. "I do a portrait of a woman. I like her dress, but not her head; so I use another one instead. Incensed, the first model accuses me of giving to some other woman the dress that belonged to her. Which is to say that there are several ways to construe theft." In this case, however, it would be more correct to speak in terms of "personal loans" which Gauguin paid back, with interest.

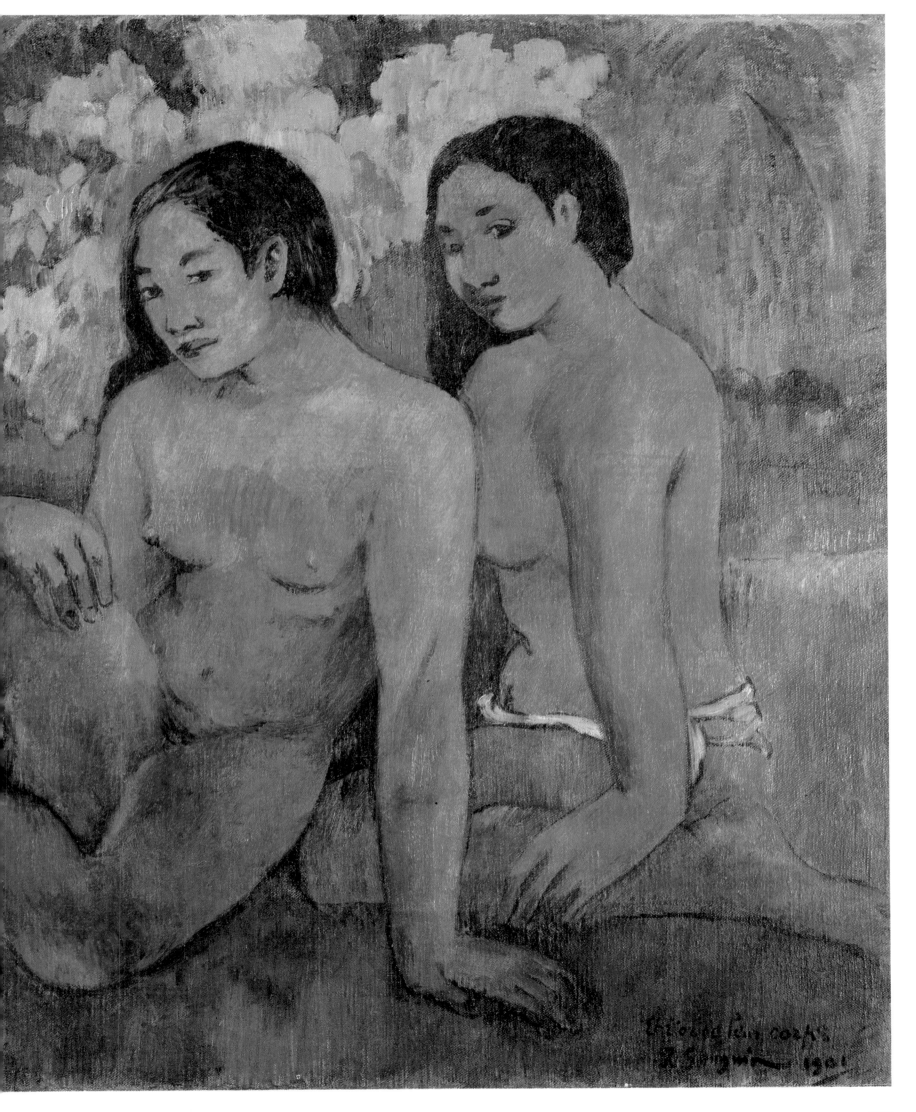

229

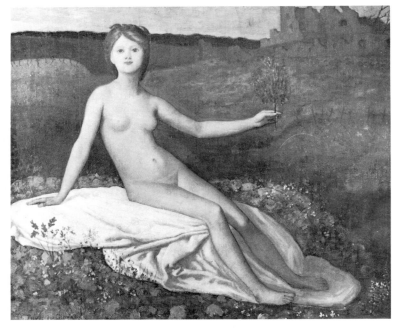

449. Pierre Puvis de Chavannes. *Hope.* c. 1872

450. Vincent van Gogh. *Sunflowers.*
1888

451. Gauguin. *Sunflowers on a Chair.* 1901

452. Gauguin. *Still Life with "Hope."* 1901

"**P**erhaps sight had its origin in flowers," Odilon Redon noted, referring to one of the eight lithographs that comprise Les Origines. *The plant kingdom is of doubtful classification: spirits may lurk therein, as symbolized by the peacock feather with petal-like lashes. Above and behind his bouquets of wild, sunlike flowers, Gauguin winks knowingly at those painters he continued to admire, even though he was on the other side of the world from Paris: Van Gogh, whose sunflowers so strongly influenced his own; Redon, whose illuminated eye reappears in several of Gauguin's still lifes; Puvis de Chavannes, whose allegory of Hope moved him still; Degas, whose little painting of a young woman stepping into a bathtub peeks out at us at the far left. They are windows looking out to the past, or mirrors which, like the flowers, speak of his gratitude.*

Vincent van Gogh had, in Gauguin's opinion, given of his best in his still lifes of sunflowers; in a guilt-ridden letter he asked the painter he had left behind in Arles to send him one of those bouquets. Suns, flowers, eyes—Gauguin was to recount again their unseen birth . . . and evanescent death.

230

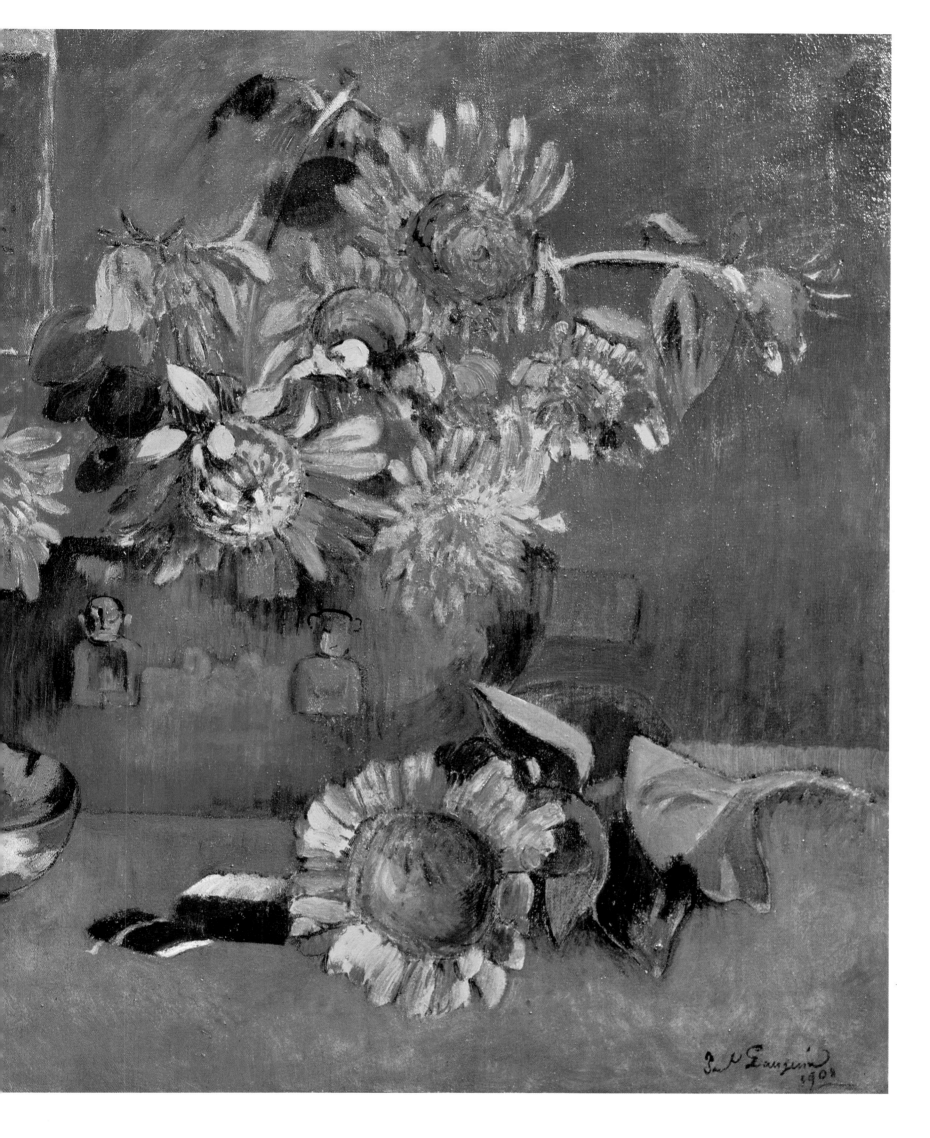

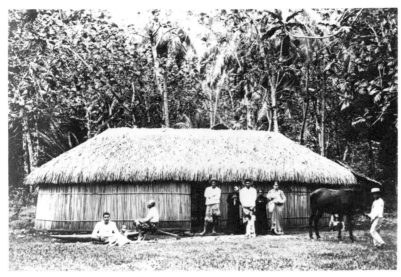

453. Native hut, Tahiti, c. 1895

454. Gauguin. *Noa Noa*, folio 71

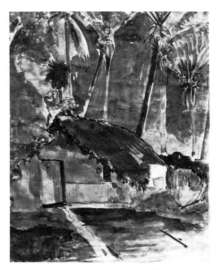

455. Gauguin. *Noa Noa*, folio 181

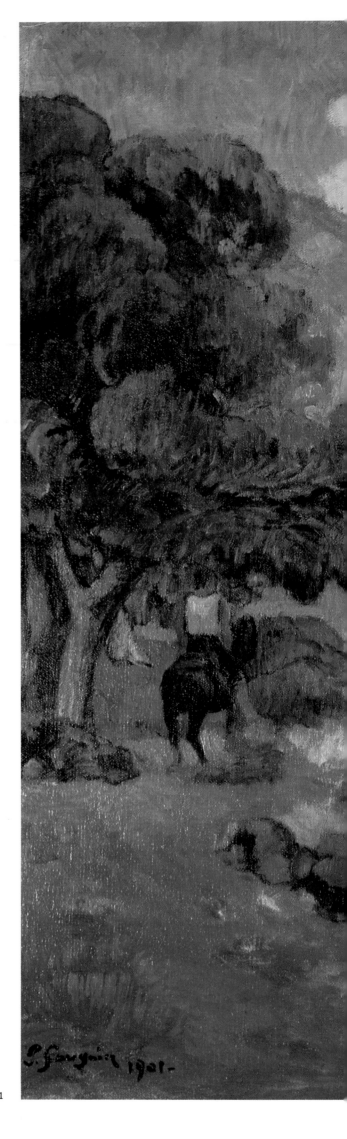

T his is without doubt the most beautiful landscape the solitary master of the Studio of the Tropics ever painted. He had already put his hut in Punaauia up for sale, and in September, 1901, he would leave Tahiti for the Marquesas Islands. On the verge of physical collapse and, as he wrote to Charles Morice, "defeated by poverty and most of all by the infirmity of a quite premature old age," Gauguin wondered if he would ever enjoy "some respite to finish my work." Now that his sole aim was to pursue that calling under the best possible conditions, he came to believe that his painting would benefit from an even more isolated setting closer to "primitive life." However, he had given up all hope of ever gaining recognition. "People are so thick-headed," he wrote to Georges-Daniel de Monfreid. "By the time they are shown paintings with new and terrible things in them, Tahiti will have become comprehensible and charming. My paintings from Brittany have become so much Cologne water on account of the Marquesas." Without fanfare, a man on horseback wends his way through this untroubled little valley toward two simple huts and two women who have just emerged from them; greenery and mountains surround them, while swollen tropical clouds scud overhead. The scene is all the more touching because we know that Gauguin was bidding it farewell.

456. Gauguin. *Landscape with Three Figures*. 1901

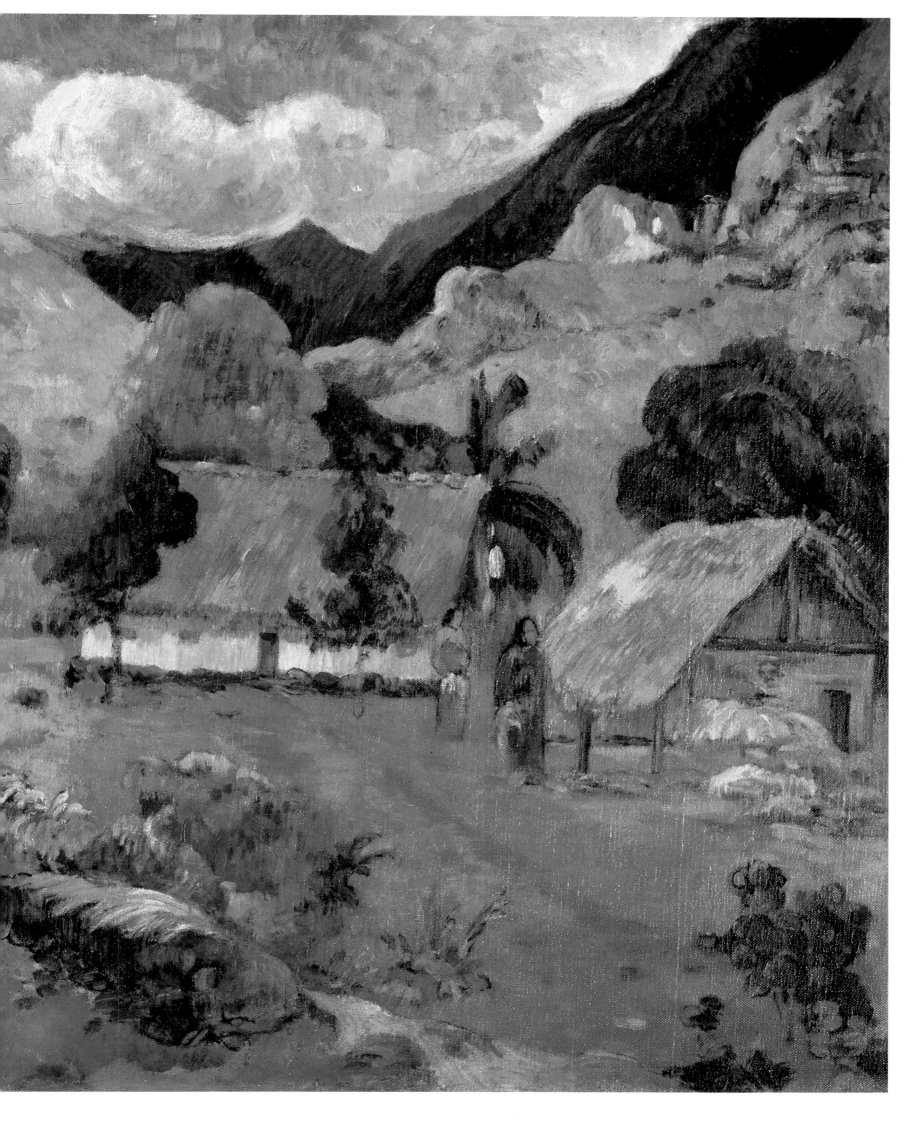

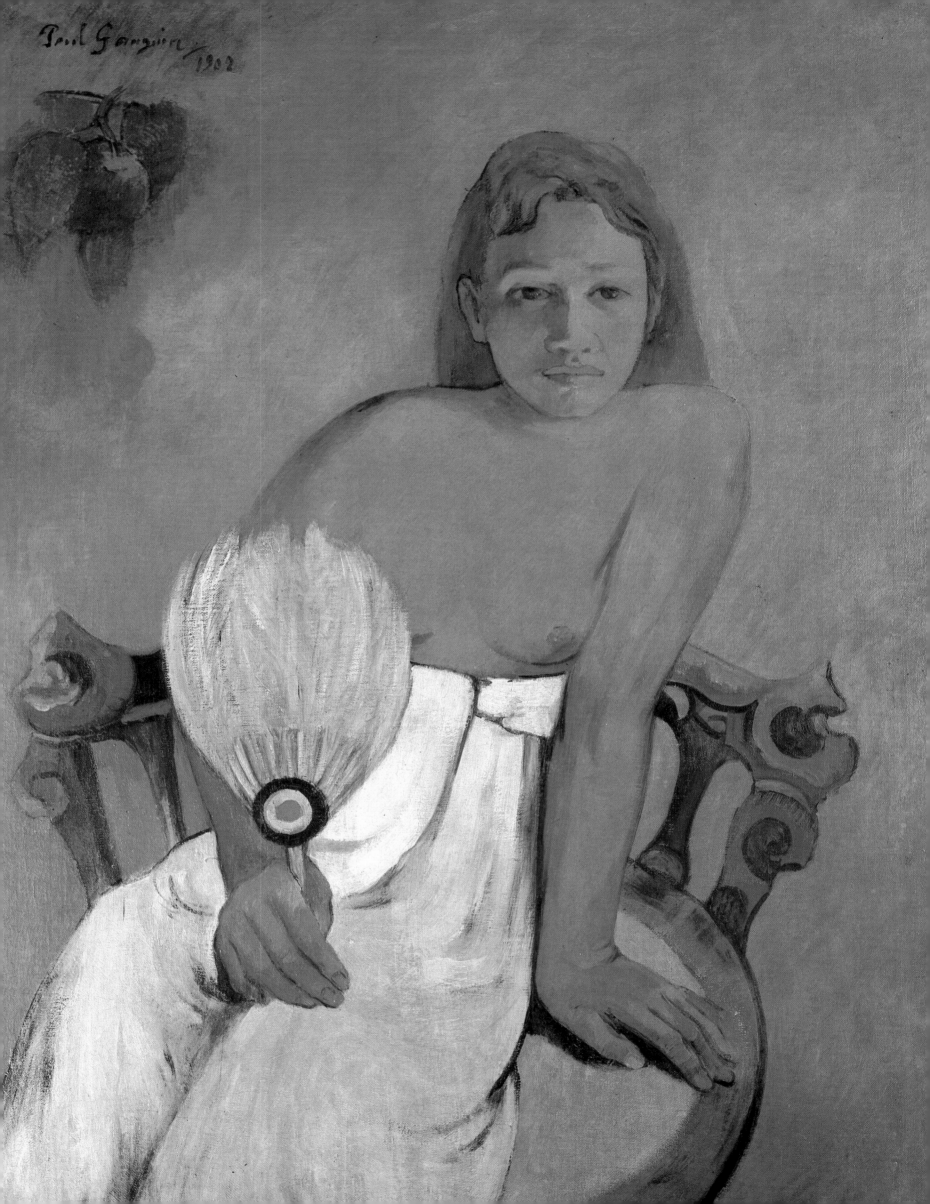

10

The Marquesas: Gauguin's "House of Pleasure"

September 1901–May 1903

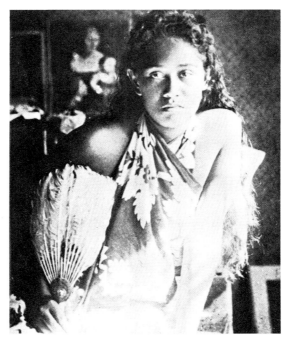

458. Model for *Young Woman with Fan*

Gauguin could not bring himself to believe that the Maori civilization had vanished without a trace, that "this handsome race had found no haven whatever for its noble splendor." Would he find it in the Marquesas Islands?

Early on the morning of September 16, 1901, the *Croix du Sud* reached its destination: Atuona, on the southern coast of Hiva Oa (Dominique). Gauguin would have to take a cutter if he intended to proceed to the island of Fatu Hiva, where there was no doctor to tend the needs of a sick man like himself. Would it be wise to settle in so remote a place? Jointly ruled by a thriving Catholic mission (Monsignor Martin, Director) and an overbearing police sergeant by the name of Charpillet, the village of Atuona had one nurse for its 500 inhabitants, a prepossessing Annamese who had been deported from his native Indochina for political reasons. The painter was immediately placed in the care of this man commonly known as Ky Dong.

Ky Dong escorted him to the house of a "half-Chinese," who provided him with a room. But Gauguin was longing for female companionship. "It so happened," his go-between later recalled, "we chanced upon five or six young and accommodating Marquesan women. They were invited to join him for tea and cakes. Since the painter seemed quite openhanded, they all agreed to set up housekeeping with him. Our wayfarer found himself in a quandary: which one should he choose? Fetuhonu carried the day. She was a tall, twenty-year-old beauty whose only defect was that she had club feet. The ones

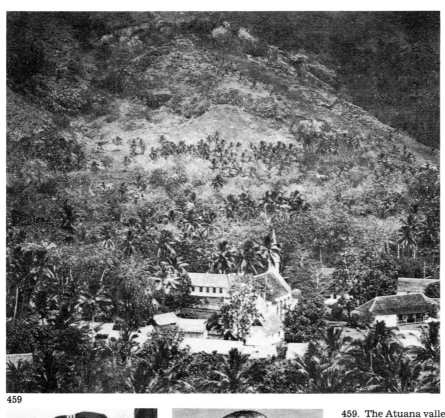

459

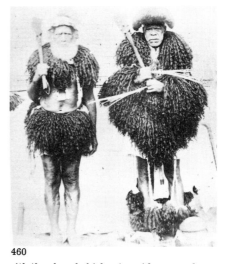

460

461

462

463

The Atuana valley with the church, bishop's residence, and school for girls. Gauguin's "House of Pleasure" amid the palms at left

459. The Atuana valley with the church, bishop's residence, and school for girls. Gauguin's "House of Pleasure" amid the palms at left
460. Marquesans, Atuana, 1900
461. Edouard Petit, Governor of Tahiti from 1901 to 1904
462. Monsignor Joseph Martin, apostolic vicar of the Marquesas Islands
463. Pastor Paul Vernier who comforted Gauguin as he neared death
464. Death certificate filled out by Officer Claverie at Atuana and cosigned by Tioka, "at one in the evening," May 8, 1903
465. The tomb of Paul Gauguin shortly after the artist's death, Hiva Oa (Dominique), Marquesas Islands

464

465

he had rejected vented their spite by jeering at the new couple in the Marquesan language, which Gauguin could not understand."

His plan was to live in a spacious hut, but first he had to purchase some land on which to have it built. The 500-square-meter parcel he had his eye on was located in the heart of the village, opposite the store run by Ben Varney, an American. As it belonged to the missionaries, Charpillet spoke to Monsignor Martin on his behalf and secured the land for the painter for 650 francs.

"Be in Love"

Gauguin drew up the plans himself and instructed two carpenters, Tioka and Kekela, to build the hut as quickly as possible. Perched atop pilings, it measured six meters wide and thirteen meters long; the outer walls were of bamboo slats, the roof of thatched palm fronds. The ground floor consisted of a sculpture workshop and a kitchen; between them was a dining room to which he later added a shed for his cart. An outer stairway led up to the second floor. On one side of a thin partition was the painter's bedroom, taken up almost entirely by his bed; on the other, a huge, bright studio with a wide window. All around the bedroom door the lord of the manor placed wooden panels carved with archaic designs of the kind he had admired in the museum in Auckland. To the left, *Soyez Mystérieuses;* to the right, *Soyez Amoureuses et Vous Serez Heureuses;* above, MAISON DU JOUIR. How provocative that sign was for the parish church nearby! Gauguin decorated the walls with fifty erotic photographs and drawings; wine and rum flowed freely. His trunks, easel, mandolin, guitar, and harmonium held the natives spellbound. They would linger in his studio for evenings at a time.

The House of Pleasure was only a stone's throw from the convent school of Saint-Joseph de Cluny. But the frolicking girls passing before his aroused eyes were warned against the perils of the flesh and prohibited from associating with the oddball who concealed his yearning and disease under a suspicious loincloth all daubed with paint. Gauguin retaliated by launching a relentless campaign aimed at persuading the natives that, contrary to what the missionaries had led them to believe, the law did not require them to send their children to school if they lived more than four kilometers away. Case in point: the parents of Marie-Rose Vaeoho, a beguiling girl of fifteen, lived in the Hekeani valley. Gauguin won them over with magnificent gifts from Ben Varney's store—cotton goods, lace, and ribbons—and on November 18, 1901, he was given their daughter's hand in marriage.

He gave his child-bride a sewing machine but relieved her of household chores by taking on a gardener, Matahava, and a cook, Kahui. "I have everything any humble artist could dream of," he declared to de Monfreid. "What models! Wonderful! I have already started working."

His favorite model was a sensuous and obliging redhead, Tuhotua, whose husband was a *taua* (sorcerer) by the name of Haapuani. An unsurpassed storyteller and devotee of rum, Haapuani fired Gauguin's interest in age-old Marquesan customs and superstitions, which, despite the inroads Christianity had made, lived on in the remote valleys of these far-off islands. Through him he came to understand the meaning of the tattoos that still decorated the skin of elderly islanders. He also sought out carved objects—bowls, plates, clubs, pendants, fallen *tikis*—which inspired him to stylize his own sculpture. Gradually, he became popular among the natives, winning over even the most savage among them. Ac-

cording to several eyewitnesses, Gauguin delighted in entertaining women at home. He would sit among them and fondle them; and when they pointed to his "obscene paintings" and said *Ko-Ki mea faufau* (Gauguin, that's dirty), he would burst out laughing.

Now and again, Europeans would drop by for a meal with him and Marie-Rose, who always had his cat and his dog, Pego, by her side. Their guests included Ben Varney and the store-owner's competitor, Frébault; Reiner, a gendarme from Alsace, who had settled in Polynesia; Guilletoue, a Basque, who was famous for hunting wild oxen; and their faithful friend Ky Dong. They would exchange the latest island gossip and complain about the authorities.

"I have got down to pretty serious work again, though I am still ill," Gauguin wrote to his "dear Daniel" in March, 1902. "You have no idea of the peace and quiet I have here in my solitude...."

Père Paillard and Coquin

The peace and quiet did not last very long. On March 18, Governor Petit arrived aboard the dispatch boat *La Durance* to inspect the Marquesas Islands. The inhabitants were fed up with having to pay taxes for roads that did not exist. Acting as their self-appointed spokesman, Gauguin requested a meeting with him, only to be turned down. The letter of petition that followed marked the first time the painter pitted himself actively and openly against the French authorities. The sudden deterioration of his health only intensified his aggressiveness.

Concerned about his palpitations and practically unable to walk, Gauguin asked Ben Varney to order a cart from Papeete. He also sent for Paul-Louis Vernier, a Protestant minister who had some knowledge of medicine (Tioka was his deacon), who treated an ulcer on his lower back.

Bastille Day was at hand, and the upcoming festivities included a prize for the best group of dancers and singers. Charpillet asked Gauguin to preside over the panel that would judge the many native groups flocking to the competition from villages or neighboring islands. Gauguin awarded two prizes for singing: one to the Protestant choral society for its rendition of the Marseillaise, the other to its Catholic counterpart for the Hymn to Joan of Arc. The "good sisters" and "dear brothers" of Ploërmel were beside themselves with indignation and henceforth made a point of mispronouncing the painter's name Coquin (scoundrel). Even more offensive in the eyes of Monsignor Martin was a carved wooden effigy of him, complete with horns, which "Coquin" had put in his garden for all to see. Marie-Rose had joined her family to give birth to a daughter (Tahiatikaomata, on September 14); in the interim, Gauguin needed a *vahine*. This prompted Monsignor Martin to issue stern warnings to native girls, whereupon the painter produced his bust of *Père Paillard* (Father Lechery) as an act of revenge; next to it stood a statue of his servant (and reputed mistress) Thérèse and an apelike figure of Father Orens, rechristened *Saint Orang*. One can almost see the tittering pupils—and the sickly smiles of the local clergy—as they passed by his hut every day on their way to school.

Poor Gauguin! What paltry consolation for his blighted yearnings! He did not feel up to finding a new companion anyway and decided instead to rework the manuscript on "The Catholic Church and Modern Times." After changing the title to "The Modern Spirit and Catholicism," he added some twenty scathing pages on the subject of marriage and how it had degenerated into a haggling match. Gauguin points an accusing finger at the clergy, for they do the bidding of what he characterizes as an "encroaching power."

A copy of the civil code in hand, the painter would patrol the beach, accost Marquesan natives as they arrived from other islands, and again attempt to show them that they were not required to send their children to school.

In a lengthy report filed on August 28, Charpillet reprimanded this irksome "sieur Gauguin" for being an instigator. Because of him, natives were refusing to pay their taxes and were keeping their sons and daughters out of school. "Along with these dangers," adds the police sergeant, "there are those which stem from his being a disciple of Epicurus, something Marquesans scarcely need know about."

The shipwreck of the *Croix du Sud* interrupted all mail delivery for three months, and at this time Gauguin wondered in a letter to de Monfreid whether he ought to call it quits. "If I must remain uncured of this chronic eczema on both feet, which causes me so much suffering, it would be better for me to come back for a change of climate. I then might settle near you in the south of France, perhaps even go to Spain to look for new subjects." But he admitted: "What a shame it would be to leave a land as beautiful as the Marquesas!" Once his pain was alleviated by morphine injections or laudanum, he would sit at his harmonium and play plaintive tunes. One day, he turned over his syringe to Ben Varney for fear that he might take too much; but he also urged him to hold on to it, just in case. "Now you are that phenomenal, legendary artist," de Monfreid replied, "who from out of the depths of Polynesia sends forth his disconcerting and inimitable work—the definitive work of a great man who has, as it were, vanished from the world.... You are so far away! You must not return! In short, you enjoy the same immunity as the great dead; you have passed into the *history of art*."

The March of Art to the Twentieth Century

Since Gauguin hardly painted any more, he decided the time had come to vindicate himself and his art for posterity. He set down his thoughts about art, about painters he had liked and who, in his opinion, deserved a permanent place in history. There were barbs for critics who "learn only from the past," because what really mattered were those forces destined to "lead the way for art in the twentieth century." In September, 1902, he sent these so-called *Racontars de Rapin* to Fontainas for publication in the *Mercure de France*. They were turned down.

A few months later, Gauguin sent another text entitled *Avant et Après*. "I absolutely want it published," he wrote, even if raising the money meant having to sell some of the paintings he had left with de Monfreid. "It is not in the least a literary work . . . but something quite different: civilized man and the barbarian face to face." He presented this miscellany of childhood memories, thoughts, anecdotes, and views on painting, together with accompanying sketches, to Fontainas.

This book is also a source of information about events that took place during his stay on Hiva Oa. On January 7, 1903, the Tuamotu archipelago was ravaged by a catastrophic typhoon. The Makemake River overflowed its banks; Gauguin's hut, which stood nearby, was nearly swept away.

From now on, Gauguin became deeply involved in helping to mediate disputes between Marquesans and Charpillet's replacement, Claverie. First, he accused the gendarme of improperly handling an investigation into a crime of passion that had left an Atuana woman dead. Then, egged on by shopkeepers as well as by friends like Guilletoue and Reiner, he accused another police officer, Guichenay, of allowing contraband goods to enter the country in exchange for a jug of wine. Lastly, he acted as counsel for twenty-nine

Protestant natives from the Hanaiapa-Hanapaoa valley, who (Gauguin concluded after looking into the matter on his own) had been wrongfully charged with drunkenness. He pleaded in court on their behalf, but it was no use: they were sentenced to five years' imprisonment and a fine of 100 francs. A few days later, the incensed painter got into so violent an argument with Claverie that he began to spit blood on his way home. The memoranda he then wrote were sent directly to the judge and to the inspectors who were in the Marquesas at the time. "The native," he pointed out, "very timorous by nature in front of the European, who appears to him so much wiser and his better, remembering also the canonfire of bygone days, would rather confess even when he is innocent, knowing that a denial of the charge will make him liable to a much harsher punishment."

When Inspector Salles got back from his tour of duty, he filed an incriminating report on Gauguin with the Colonial Office. This painter of the Impressionist school, in poor health, lived in a place he called the House of Pleasures, stood up for all the moral failings of the natives, and, worst of all, had managed to reduce the number of pupils attending Catholic schools in Atuana from three hundred to seventy. Governor Petit went the inspector one better: he characterized him as a "low, disreputable Frenchman" and authorized the police to sue him for libeling Guichenay.

"All These Worries Are Killing Me"

On March 27, 1903, Police Officer Pambrun served Paul Gauguin with a summons ordering him to appear before Judge Horville only four days later. On the 31st, Horville turned down his request for a change of venue as well as for a court of inquiry, and summoned the gendarme Claverie. The defendant "sieur Gauguin" was sentenced to three months' imprisonment and a fine of 500 francs. This travesty of justice was a blow from which he never recovered.

Panic-stricken, Gauguin filed an appeal with the court in Papeete on April 2 and wrote to Charles Morice urging him to rally public opinion in Paris to his cause. "I have been caught in a trap set by the police. . . . It's all over for me and perhaps appealing the decision will make no difference. . . . Act quickly and energetically. If we win, the struggle will have been glorious and I shall have done a great thing in the Marquesas. Many iniquities shall have been done away with and that will have made all the suffering worthwhile." Then, changing the subject to art, he declared himself a "savage," indeed, a "savage in spite of myself;" and it was this quality, so lacking in contemporary painting, that made him "inimitable." "It is true that I know very little! . . . But who can say if even this little, worked on by others, will not become something great? How many centuries it takes to create even a *semblance* of movement!"

Already in debt to the Société Commerciale de l'Océanie to the tune of 1,400 francs, he now had to incur the expense of traveling to Papeete and retaining an attorney. To raise some quick cash, he sent three paintings to de Monfreid in hopes of getting 1,500 francs from Fayet. "I am done for; it spells the complete destruction of my health. . . . Attend to everything as quickly as possible and tell Monsieur Fayet that I shall be eternally grateful." His last letter to de Monfreid (April, 1903) ends as follows: "All these worries are killing me."

Gauguin was in fact dying—among other things of advanced heart disease—but still putting up a fight. Unable to sleep, he begged Ben Varney to give him back his syringe. Once the morphine had quieted him down, he filed a lengthy statement with the chief of police in Tahiti on April 28. "If this happens again, I shall ask you to *force* the

insolent man to give me satisfaction in a duel." He cooped himself up at home for an entire week. Even Kahui, the cook, spent hardly any time in what had become a house of suffering; but old Tioka informed Pastor Vernier that "the white man is bad off, he is very sick!"

Early in the morning of May 8, Gauguin asked Tioka to fetch the pastor. "Still in bed," Vernier later recalled, "Gauguin complained of sharp pain in his body. He asked me whether it was morning or evening, day or night. He told me that he had had two fainting spells. Then he spoke of Salammbô [Flaubert]. I left him lying on his back, calm and rested after this brief chat."

Around eleven o'clock that morning, Kahui summoned Vernier again. "Come quickly, the white man is dead." "I found Gauguin lifeless," Vernier tells us, "one leg hanging from the bed, but still warm to the touch." Old Tioka told him what had happened: "'I came to see how he was,' he said. 'I called from below, Ko-Ki, Ko-Ki! Hearing nothing, I went up to see: Ai, ai!' As he spoke he nibbled at his scalp, a Marquesan way of calling the dead back to life." Tioka then began to sing a dirge. "I myself tried artificial respiration by rhythmic moving of the tongue, but it was no use. Apparently, Gauguin had died of acute heart failure." Tioka and the servants called in friends, and soon the house of the deceased painter was full of wailing people.

Victor Segalen, a young medical officer who arrived on the *Durance* four months after Gauguin's death, reported as follows: "Cause of death, broken blood vessel, an opinion shared by a colleague of mine from another Pacific warship, who saw him three months before the end."

Police Officer Claverie filled out the death certificate, adding spitefully: "It is known that he is survived by a wife and children, but the name of the former is not known." Vernier was incensed to learn that the bishop and several priests had taken it upon themselves to give Gauguin a Christian burial and removed his remains to the church. Overlooking the village of Atuana was the white cross of the Catholic cemetery on Hueakihi hill; here, on Saturday, May 9, 1903, Paul Gauguin was laid to rest. Father Saltel gave absolution while a handful of witnesses looked on. "Nothing of note happened here," Monsignor Martin wrote to his congregation, "except that death came suddenly to a sorry figure by the name of Gauguin, a well-known artist and an enemy of God and all that is upright."

Gauguin—the Stuff of Legend

The first sale of the painter's land and furnishings took place in Atuona on July 20. Ben Varney purchased the "Maison du Jouir" and the land it stood on for about 1,000 francs. Mr. Vermeersch, the receiver of registry fees and stamp duties, asked a painter by the name of Le Moine to help him compile a list of Gauguin's remaining effects for the auction that was subsequently held in Papeete (September 2, 1903). In the process they discarded a great many "drawings, rough sketches, loose papers with vague markings, obscenities, and roughed-out pieces of sculpture" which, in Le Moine's estimation, showed not an "inspired mentality," but an "unhealthy imagination."

Georges-Daniel de Monfreid became concerned when he stopped getting letters from his usually faithful correspondent. "My dear Gauguin," he wrote from Saint-Clément in the Pyrenees on June 9, 1903, "while it is on my mind, let me ask you something . . . if you should happen to depart this life before I do and before you have put your affairs in order, what should I do?"

The "mysterious" and "amorous" figures we see here—a statuelike Mother and Daughter copied from a photograph, and The Lovers seeking refuge in the heat of voluptuous passion—illustrate well the mottos Gauguin carved into the wooden panels framing the entrance of his "House of Pleasure" in Atuona, on the island of Hiva Oa. He greatly admired the Marquesans for their "highly developed decorative art." "Give him any geometrically shaped object whatever . . . he will find a way to leave no empty spaces that might jar or displease, and will do so consistently over the entire surface. The basic component is the human body or the face. Especially the face." Like them, Gauguin enveloped the pairs of streamlined figures carved into his wood panels with snakes, flowers, leaves, and branches, or with stylized dogs and peacocks—all bidding visitors enter his tropical Abbey of Thélème—his final abode, dedicated to the bodily pleasures and to love.

466. Mother and daughter, Tahiti, c. 1895

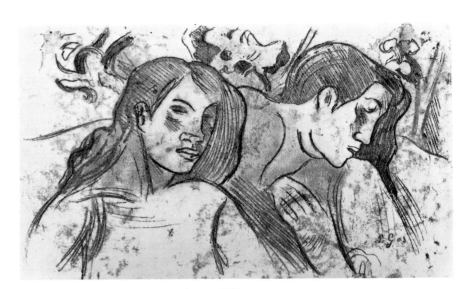

467. Gauguin. *Two Marquesan Natives*. c. 1902

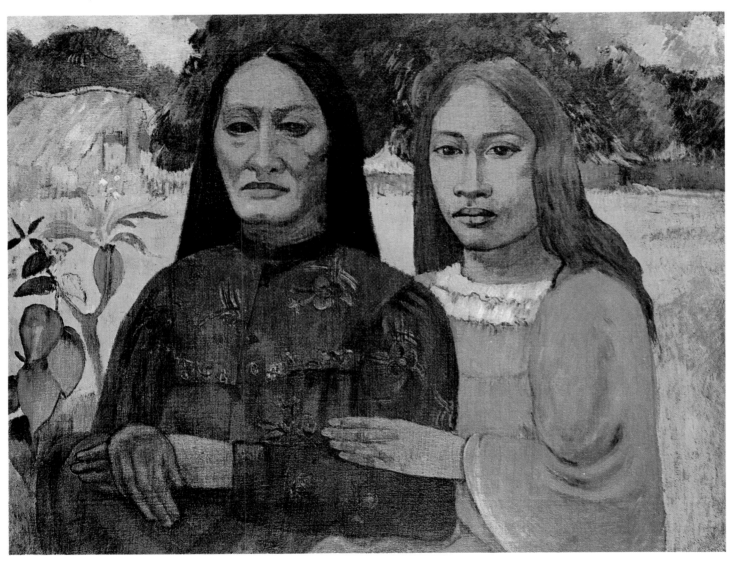

468. Gauguin. *Mother and Daughter*. 1902

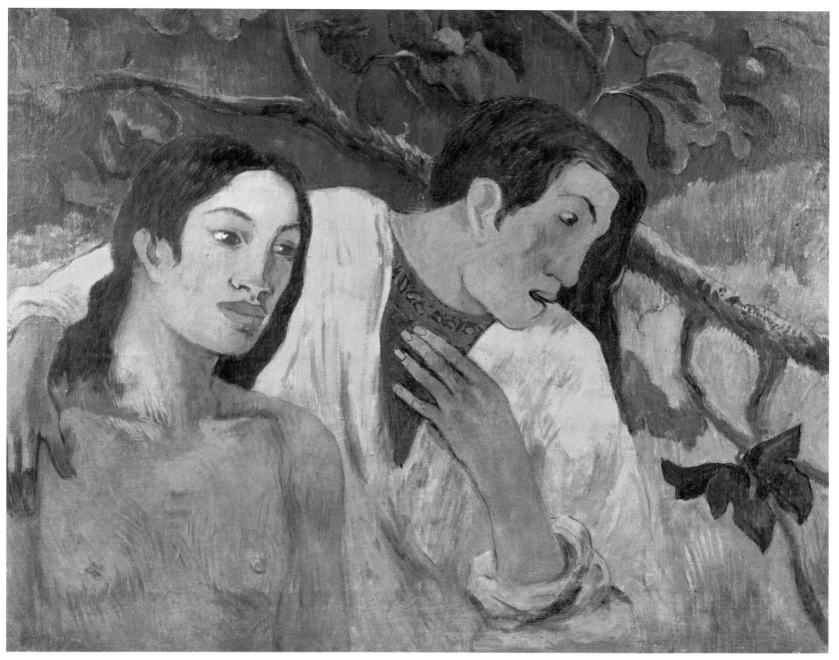

469. Gauguin. *Tahitian Lovers.* 1902

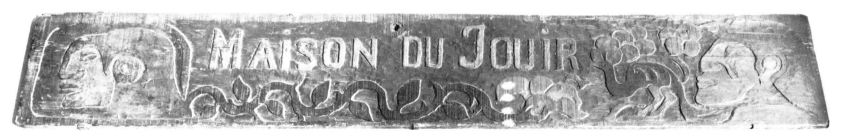

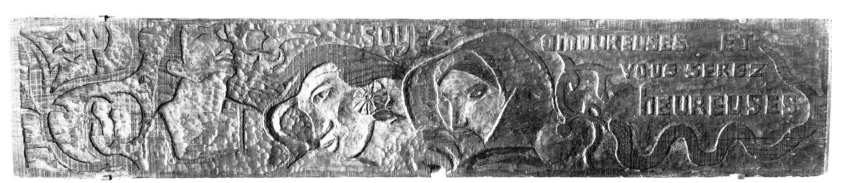

470. Gauguin. Lintel and panel from the door of Gauguin's
"House of Pleasure," Hiva Oa (Dominique), Marquesas Islands

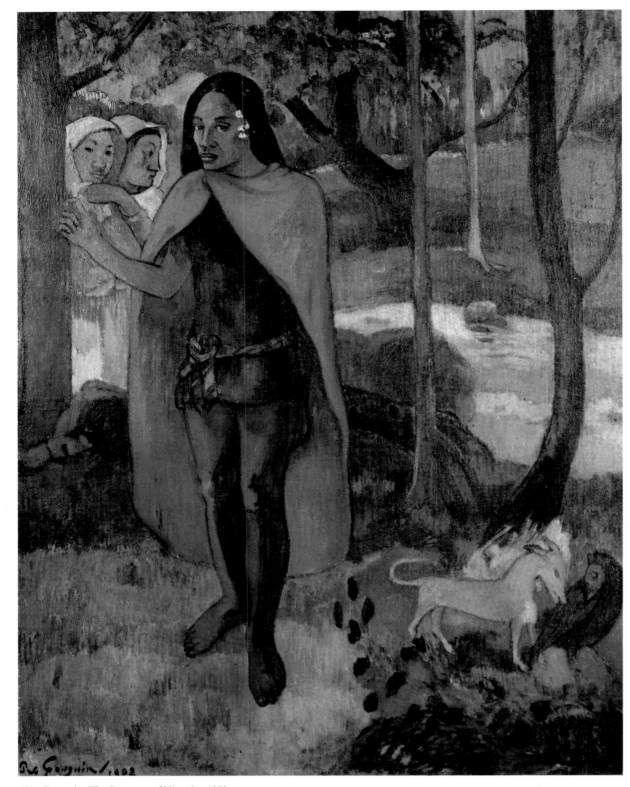

471. Gauguin. *The Sorcerer of Hiva Oa*. 1902

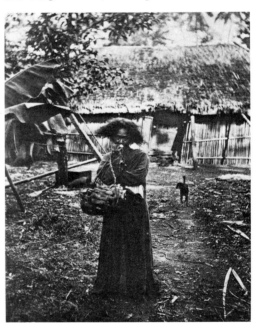

472. Gauguin. *Tahitian Family*. c. 1902

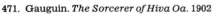

473. Sorceress, Tahiti

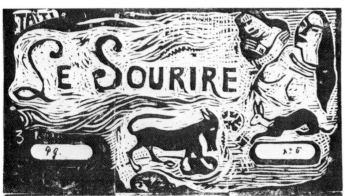

474. Gauguin. Woodcut from *Le Sourire*. 1899–1900

In each of these pictures of equal size we see a man with two retiring female figures watching from a distance. That is where the similarity ends. On the right, a half-naked "noble savage," his son, and his goat are part of an idyllic scene on a pink beach, the color of happiness. On the left, the proud sorcerer of Hiva Oa, Haapuani, emerges from the shadows wearing a red cape; his companions are the same fiendish fox Gauguin carved for Le Sourire and the mysterious bird that had already appeared in several of his paintings. Not only was Haapuani considered the most influential sorcerer and most accomplished dancer in Atuona, but, as Gauguin found out, worth knowing because he "loaned out" his pretty wife, Tuhotua, when the need arose. With a photograph as his guide, he painted a portrait of the redhead, fan in hand, seated in a carved armchair. "There is no doubt about it," he wrote to Charles Morice, "the savage is better than we are. You were mistaken that time when you said that I was wrong to call myself a savage.... A man's work is the explanation of the man."

244

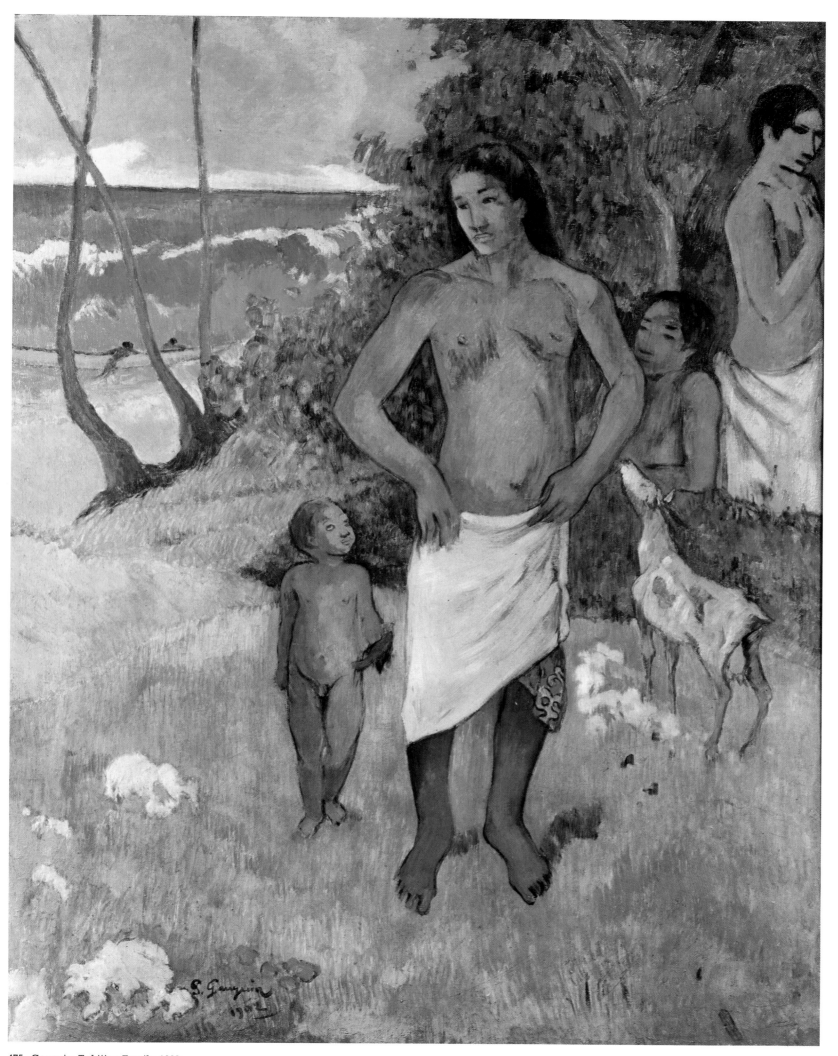

475. Gauguin. *Tahitian Family*. 1902

476. Gauguin. Study for *Contes Barbares*

477. Gauguin. *Meyer de Haan*, from *Noa Noa*, folio 174

478-479. Bas-relief, Temple of Borobudur, Java

So multiform was the talent of Gauguin that he could reconcile the irreconcilable: on the one hand, the "animal nature that is within us" and which, like the Greek giant Antaeus (a favorite myth of the author of Les Contes Barbares), *lasts only as long as there is contact with the earth; on the other, the mind, which "shall always find nourishment in the primitive arts."* Like Buddhas from the friezes of Borobudur, these *vahines, one seen full face, one in profile, sit directly on the ground amid mangos and flowers. Lurking in the background, the watchful* Mind—here embodied in the pensive and devilish-looking Meyer de Haan, Gauguin's friend from Le Pouldu—looks on. *"In painting one must search rather for suggestion than for description,"* the master of exotic symbolism explained to de Monfreid. He quoted the following prayer in his Ancien Culte Mahorie: *"Keep watch near me, oh God! Stay close by, oh my Lord! Protect me from the spells of sudden death and misconduct; from wishing anyone harm; from the curse of furtive plotting; from disputes over boundaries."*

480. Gauguin. *Contes Barbares*. 1902

481. Gauguin. *Riders on the Beach*. 1902

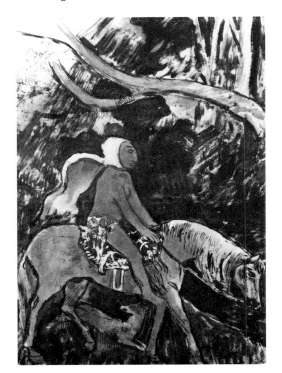

482. Gauguin. *Rider*

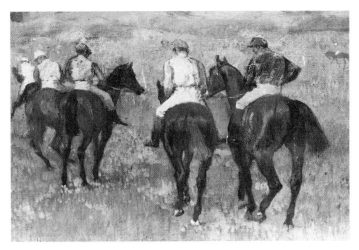

483. Edgar Degas. *Racehorses* (reproduced in part). c. 1884

484. Ignacio Merino. *Riders on the Beach*

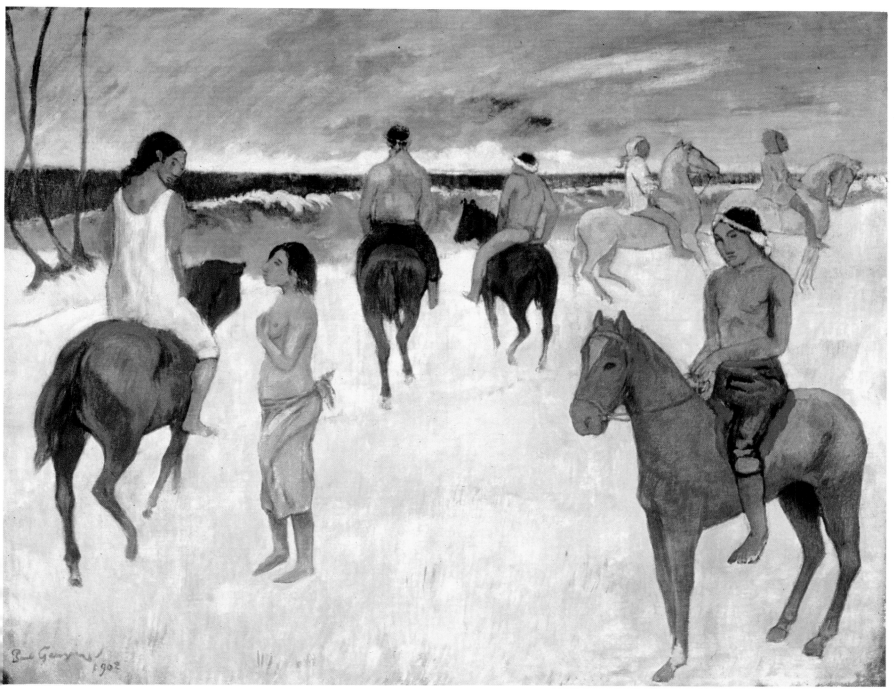

485. Gauguin. *Riders on the Beach*. 1902

A few months before his death in the Marquesas, certain images that had long lain dormant in Gauguin's mind merged with an irresistible wish to escape death. The result was the kind of receding space we see in these symmetrical paintings, both of which bring us to the edge of the Pacific Ocean. With an energy born of despair, he tried to make a getaway, like these Marquesan youths on horseback; they are transpositions of their counterparts on the Parthenon, the Peruvian riders of the painter Merino, and the high-spirited jockeys of Degas. But two women—one yellow, one red, their hair done up like witches—soon cut off the cavalcade of strapping men; they have reached the Japanese-inspired billows breaking against the shore and must turn aside. A mounted Marquesan at rest and a bewildered beggar woman seem to be asking each other: What is to be done? Press on or pull back? Gauguin himself could no longer answer that question. Already he was looking back on bygone days as he reluctantly, resignedly, scanned the horizon. He was just a castaway now exiled to the edge of infinity.

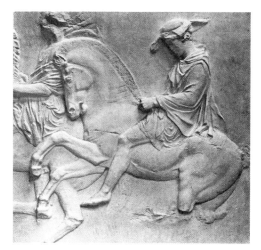

486. Rider, from the Parthenon frieze

487. Tahitian on horseback

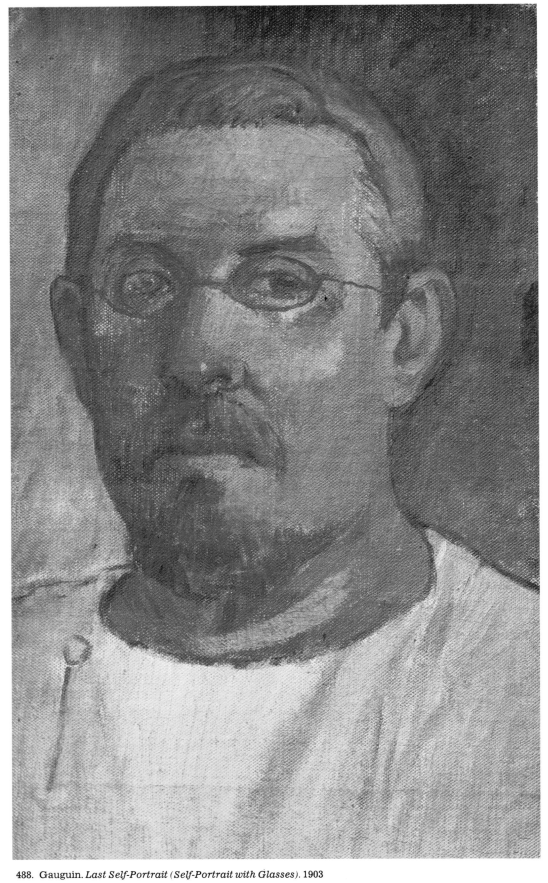

488. Gauguin. *Last Self-Portrait (Self-Portrait with Glasses)*. 1903

"They heed only the eye and neglect the mysterious center of thought."

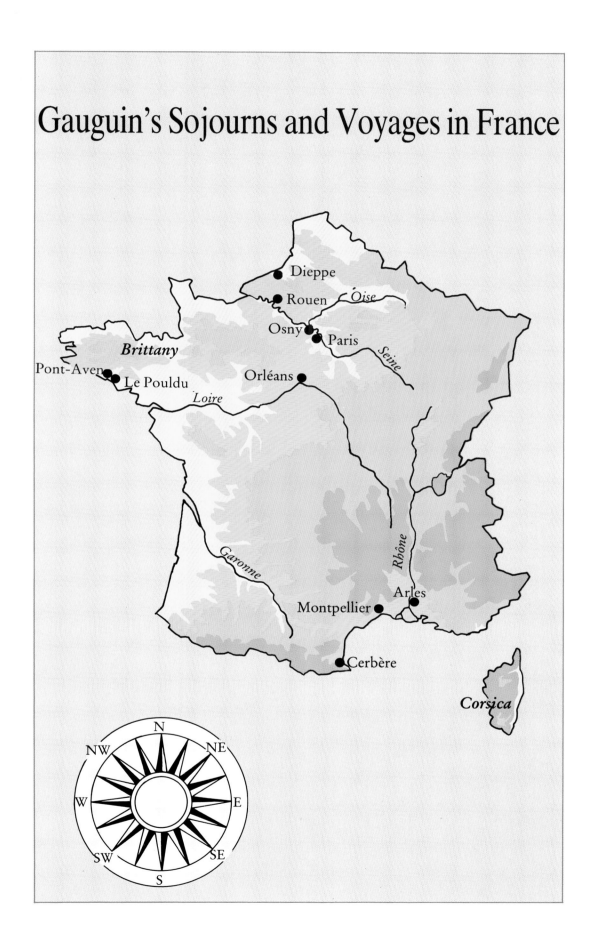

Gauguin's Sojourns and Voyages in France

Dieppe

Rouen

Oise

Osny

Paris

Seine

Brittany

Pont-Aven

Le Pouldu

Orléans

Loire

Garonne

Rhône

Arles

Montpellier

Cerbère

Corsica

N

NW NE

W E

SW SE

S

North America

Pacific Ocean

Atlantic Ocean

Africa

South America

Arc

North Ca

Norway

Bergen

Aberdeen

London
Cardiff

Denmark
Copenhagen

Gdansk
Trieste

Pont-Aven
France

Cherbourg

Genoa

Kotor

Va

Marseille

Salon

Bastia

Corfu

Gibraltar

Algiers

Ac

Guadeloupe

Saint-Pierre
(Le Carbet)
Martinique

Panama

Taboga

Callao Lima
Peru

Rio de Janeiro

Iquique

Valparaiso

Port Famine

Sojourns and Travels

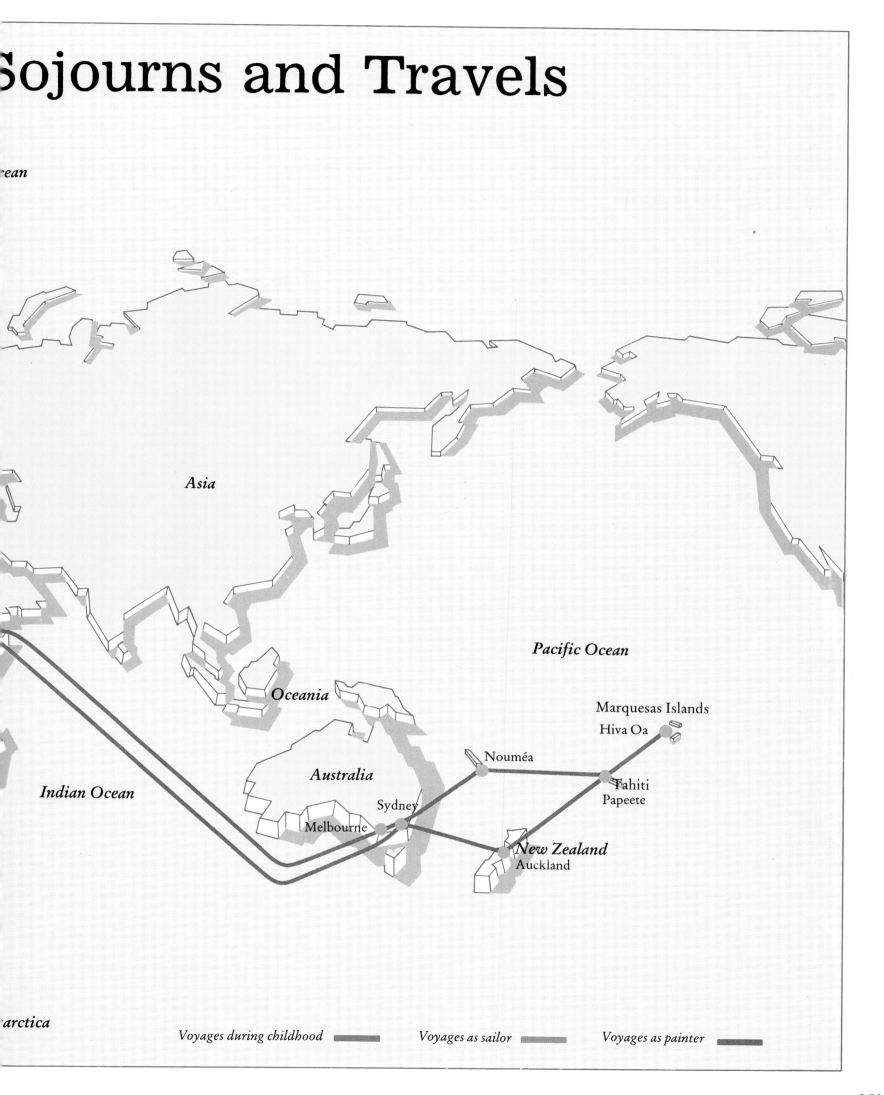

Asia

Pacific Ocean

Oceania

Marquesas Islands
Hiva Oa

Indian Ocean

Australia

Nouméa

Tahiti
Papeete

Sydney

Melbourne

New Zealand
Auckland

Antarctica

Voyages during childhood ——— *Voyages as sailor* ——— *Voyages as painter* ———

Acknowledgments

In addition to museum curators in France and abroad, gallery directors and directors of photo archives, local officials as well as mayors and clergy of communities and their assistants, authors of writings on Gauguin, and collectors who have extended their confidence to him, this author wishes to thank the following who have been particularly helpful:

M. and Mme Clément Altarriba
Marie-Amélie Anquetil
Gilles Artur
Marianne Barbey
Huguette Bérès
Françoise Cachin
M. and Mme Alain Carrière
René-Marc Chaffardon
M. and Mme Pierre Chapelot
M. and Mme Maurice Chapuis
Bernard Clavel
Serge Clin
Jean-Marie Dallet
Bengt Danielsson
Maïotte Dauphite
Pierre Debray-Ritzen
Paule Dedeban
M. and Mme Yvon Deguinguand
M. and Mme Christian Demolliens
Claire Denis
Dominique Denis
Jean-Paul Deudon

Amandine Doré
Bernard Dorival
M. and Mme Jean-Pierre Ducrest
Catherine Dufayet
Jean Dupont-Nivet
M. Eberhart
François d'Esneval
Madeleine Faucher
Jean-Louis Ferrier
Georges Gomez y Càceres
Jean-François Gonthier
Paul Gottlieb
Dr and Mme René Guyot
Viviane Hendrick
Marie-Lise Hieaux
Michel Hoog
René Huyghe
Shigemi Inaga
Claude Jean
Henriette Joël
Paul and Samuel Josefowitz
Jack S. Josey

Margaret Kaplan
Lambert Kaus
Vianey de La Boulaye
Geneviève Lacambre
Michel Laclotte
Laurent Laffont
Robert Laffont
M. and Mme J.-P. Laly
Hubert Landais
Jacques Legrand
M. and Mme Jean le Pichon
Josiane le Pichon
Alain Le Thoer
Jean-Pierre Liegibel
Robert Maillard
Daniel Malingue
Maurice Malingue
Yves Maufra
Mathieu-Georges May
Francis Mazière
Victor Merlhès
Paul Morgaat

M. Niarchos
Jean-Paul Oberthur
R. P. Patrick O'Reilly
Michel Péricard
Jacques Peuchmaurd
Véra Pokorny
Edouard Pommier
Maryse Pouzoullic
Véronique Prat
Josette Pratte
Michèle Psalty
Catherine Puget
Daniel Radford
Françoise Radux
Rémy Ravon
Maître Maurice Rheims
François Szymanski
Patrick Thumerelle
Joanne Toor Cummings
Jean-Baptiste Trouplin
Daniel Wildenstein
Pierre Wildenstein

489. Gauguin. *Landscape with Pig and Horse*. 1903

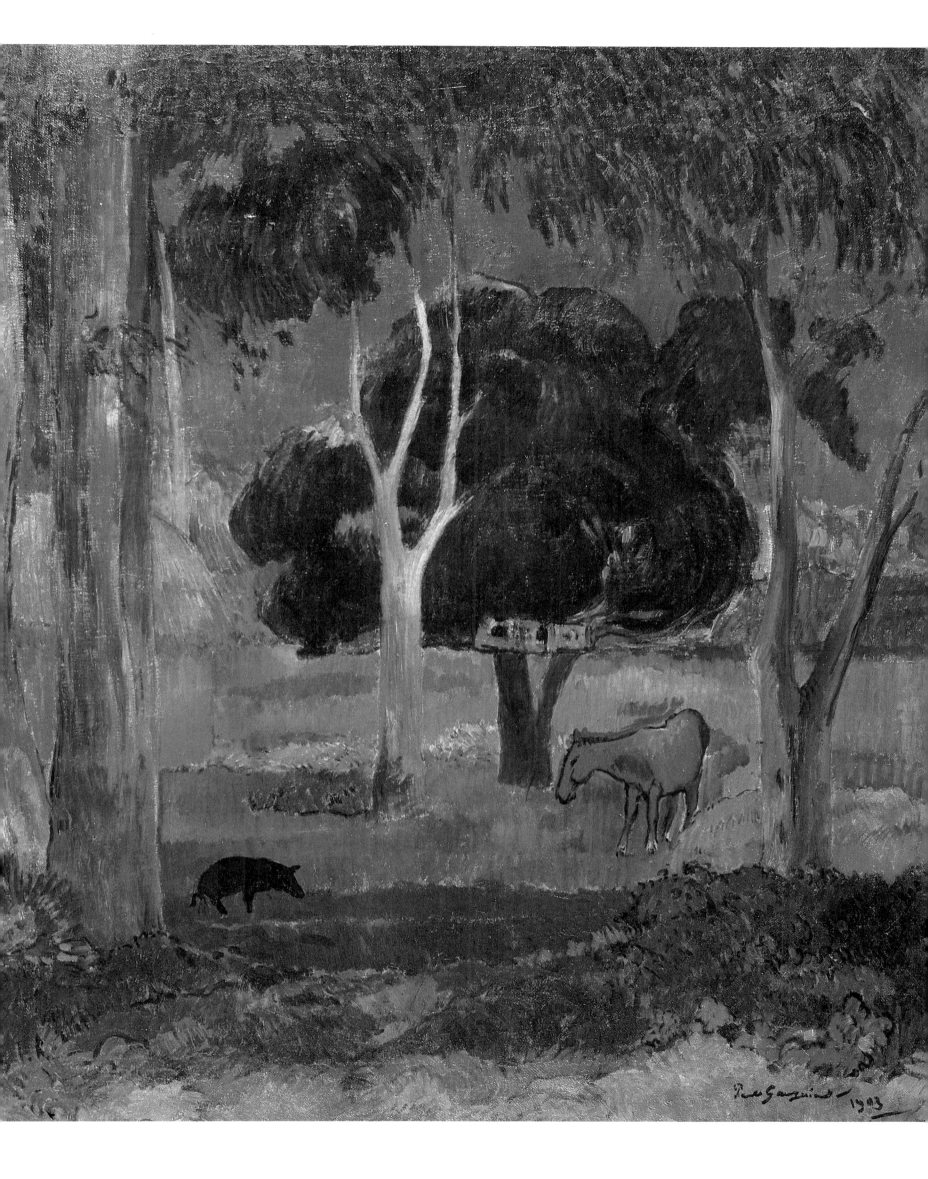

Selected Bibliography

By Gauguin: Writings and Notebooks

Ancien Culte Mahorie (Tahiti, 1892–93)
Facsimile. René Huyghe, ed.
Paris: La Palme, 1951

Avant et Après (Marquesas Islands, Atuana, 1903)
Paris: G. Crès, 1923
Condensed English version:
The Intimate Journals of Paul Gauguin
Van Wyck Brooks, ed.
Boston: Routledge & Kegan, 1985

Cahier pour Aline (Tahiti, 1893)
Facsimile. Suzanne Damiron, ed.
Paris: Société des Amis de la Bibliothèque d'Art et d'Archéologie de l'Université de Paris, 1963

Le Carnet de Paul Gauguin
Facsimile. René Huyghe, ed.
Paris: Quatre chemins, 1952

Carnet de Tahiti
Facsimile. Bernard Dorival, ed.
Paris: Quatre chemins, 1954

Correspondance de Paul Gauguin: Documents témoignages
Victor Merlhes, ed. Volume I: 1873–88
Paris: Fondation Singer-Polignac, 1984

Gauguin Sketchbook
René Huyghe, ed.
New York: Crown, 1978

Les Guêpes (periodical published by Gauguin at Papeete, 1899–1900)
Facsimile
Paris: Maisonneuve, 1952

45 lettres à Vincent, Théo et Jo van Gogh
Lausanne: Bibliothèque des Arts, 1983

Lettres de Gauguin
Maurice Malingue, ed.
Paris: Grasset, 1946

Lettres de Gauguin à Georges Daniel de Monfreid
A. Joly-Segalen, ed.
Paris: Falaise, 1950

Lettres de Paul Gauguin à Émile Bernard (1888–91).
Preface M. A. Bernard-Fort
Geneva: Cailler, 1954

Letters of Paul Gauguin to Georges-Daniel de Monfried (sic)
R. Pielkovo, transl.
London: Heinemann, 1923

Letters to Ambroise Vollard and André Fontainas
John Rewald, ed.
San Francisco: Grabhorn Press, 1943

Letters to His Wife and Friends
Maurice Malingue, ed.
Cleveland: World Publ., 1949

Noa Noa: Gauguin's Tahiti
Nicholas Wadley, ed.
Salem, NH: Salem House, 1985

Noa Noa: The Tahitian Journal
O. F. Theis, transl.
Mineola, New York: Dover, 1985

Racontars de Rapin (Marquesas Islands, Atuana, September 1902)
Paris: Falaise, 1951

Le Sourire (periodical published by Gauguin at Papeete, 1899–1900)
Facsimile. L. J. Bouge, ed.
Paris: Maisonneuve, 1952

The Writings of a Savage, Paul Gauguin
Daniel Guérin, ed.
New York: Viking, 1978

Exhibition and Œuvre Catalogs

(in chronological order)

The Museum of Modern Art, New York
First Loan Exhibition: Cézanne, Gauguin, Seurat, van Gogh
November 1929
Reprint edition
New York: Arno for the Museum of Modern Art, 1972

Leymarie, Jean
Gauguin: Exposition du centenaire
Paris: Éditions de musées nationaux, 1949

Museum of Fine Arts, Houston
Paul Gauguin: His Place in the Meeting of East and West
Introduction and catalog H. Dorra
March–April 1954

The Arts Council of Great Britain, London and Edinburgh
Paul Gauguin: An Exhibition of Paintings, Engravings, and Sculpture
Introduction and catalog Douglas Cooper
1955

Wildenstein & Co., New York
Gauguin
Text Robert Goldwater and C. O. Schniewind
April–May 1956

The Art Institute of Chicago
Gauguin: Paintings, Drawings, Prints, Sculpture
Introductions Theodore Rousseau and Harold Joachim
Feb.–March, 1959

This exhibition was also shown at the Metropolitan Museum of Art
New York (April–May 1959)

Wildenstein, Georges, and Raymond Cogniat, editors
Paul Gauguin. Œuvre catalog, 2 vols.
Paris: Les Beaux-Arts, 1964

Longstreet, Stephen, ed.
Drawings of Gauguin. Master Draughtsman Series
Alhambra, CA.: Borden, 1965

Musée Gauguin, Papeari Tahiti
Le musée Gauguin
Text Roger Heim
Paris: Fondation Singer-Polignac, 1965

Solomon R. Guggenheim Museum
Gauguin and the Decorative Style
1966

The Arts Council of Britain/Tate Gallery
Gauguin and the Pont-Aven Group
Preface Denys Sutton; catalog Ronald Pickvance
London: Curwen Press, 1966

Cincinnati Art Museum
The Early Works of Paul Gauguin: Genesis of an Artist
Text Richard J. Boyle
Mar.–April, 1971

The Metropolitan Museum of Art
Prints by Gauguin
1971

Philadelphia Museum of Art
Paul Gauguin: Monotypes
Text Richard S. Field
1973

Musée National Vincent van Gogh, Amsterdam
Œuvres écrites de Gauguin et van Gogh
May–June, 1975
Paris: Institut neerlandais, 1975

Guérin, Marcel
Gauguin's Graphic Work (reprint of 1927 edition)
San Francisco: Wofsy Fine Arts, 1980

Sugana, G. M.
Tout l'œuvre peint de Gauguin
Paris: Flammarion, 1981

Art Gallery of Toronto
Vincent van Gogh and the Birth of Cloisonism
Catalog Bogomila Welsh-Ovcharov
Apr.–June, 1981

The Metropolitan Museum of Art
Van Gogh in Arles
Ronald Pickvance, ed.
New York: Abrams, 1984

Musée Départemental du Prieuré
Chemin de Gauguin
Gille Artur et al.
1985

On Gauguin

Andersen, Wayne V.
Gauguin's Paradise Lost
New York: Viking, 1971

Bernard, Émile
Souvenirs inédits sur l'artiste peintre Paul Gauguin et ses compagnons lors de leur séjour à Pont-Aven et au Pouldu
Lorient: Nouvelliste du Morbihan, 1941

Bodelson, Merete
Gauguin's Ceramics
London: Faber & Faber, 1964

Bompard, Pierre
Ma mission aux Marquises
Paris: Éditions des Deux Miroirs, 1962

Boudaille, Georges
Gauguin. Alisa Jaffa, transl.
New York: Tudor, 1964

Burnett, Robert
The Life of Paul Gauguin
New York: Oxford University Press, 1937

Cachin, Françoise
Gauguin
Paris: Librairie Générale Française, 1968

Chassé, Charles
Gauguin et le groupe de Pont-Aven
Paris: H. Floury, 1921

Chassé, Charles
Le mouvement symboliste dans l'art du XIXᵉ siècle
Paris: H. Floury, 1947

Chassé, Charles
Gauguin et son temps
Paris: Bibliothèque des Arts, 1955

Chassé, Charles
Les Nabis et leur temps
Paris: Bibliothèque des Arts, 1960

Cogniat, Raymond
Gauguin
New York: Abrams, 1936

Dallet, Jean-Marie
Je, Gauguin
Paris: R. Laffont, 1981

Danielsson, Bengt
Forgotten Islands of the South Seas
London: Allen and Unwin, 1965

Danielsson, Bengt
Gauguin in the South Seas
Reginald Spink, transl.
Garden City, NY: Doubleday, 1966

Danielsson, Bengt, and P. O'Reilly
Gauguin: Journaliste à Tahiti et ses articles des "Guêpes"
Paris: Société des Océanistes, 1966

Davenport, W., B. Danielsson, R. Field
Gauguin and Exotic Art
Pennsylvania, 1969

Denis, Maurice
Théories 1890–1910 du symbolisme et de Gauguin vers un nouvel ordre classique
Paris: Rouart et Watelin, 1920

Estienne, Charles
Gauguin.
James Emmons, transl.
Geneva: Skira, 1953

Field, Richard
Paul Gauguin: The Paintings of the First Voyage to Tahiti
New York: Garland, 1977

Fletcher, John Gould
Paul Gauguin, His Life and Art
New York: Brown, 1921

Fouchet, Max-Pol
Gauguin: Le peintre et l'homme
Woodbury, NY: Barron's, 1975

Gauguin, Pola
My Father Paul Gauguin
Arthur G. Chater, transl.
New York: Knopf, 1937

Goldwater, Robert
Paul Gauguin
New York: Abrams, 1958

Goldwater, Robert
Primitivism in Modern Painting
New York: Vintage, 1967

Goldwater, Robert
Gauguin
New York: Abrams, 1984

Gray, Christopher
Sculpture and Ceramics of Paul Gauguin
New York: Hacker, 1980

Hanson, Lawrence and Elisabeth
Noble Savage: The Life of Paul Gauguin
New York: Random House, 1955

Hanson, L. and E.
Gauguin
New York: Rizzoli, 1958

Hanson, L. and E.
The Seekers: Gauguin, van Gogh, Cezanne
New York: Random House, 1963

Hautecœur, Louis
Paul Gauguin
Paris: Skira, 1938

Hind, Charles Lewis
The Post-Impressionists
London: Methuen, 1911

Huyghe, René
Gauguin. QLP Art Series
New York: Crown, 1978

Huyghe, René, et al.
Gauguin. Collection Génies et Réalités
Paris: Hachette, 1986

Jaworska, Wladyslawa
Gauguin and the Pont-Aven School.
Patrick Evans, transl.
Greenwich, CT: New York Graphic Society, 1972

Jirat-Wasintynski, Vojtech
Paul Gauguin in the Context of Symbolism
New York: Garland, 1978

Kunstler, Charles
Gauguin, peintre maudit
Paris: Floury, 1934

Le Paul, Guy
L'impressionisme dans l'école de Pont-Aven: Monet, Renoir, Gauguin et leurs disciples
Lausanne: Bibliothèque des Arts, 1983

Le Pichon, Yann
Le Monde du Douanier Rousseau
Paris: R. Laffont, 1981

Le Pichon, Yann
Les Peintres du Bonheur
Paris: R. Laffont, 1983

Le Prohon, Pierre
Paul Gauguin
Paris: Grund, 1975

Leymarie, Jean
Paul Gauguin: Watercolors, Pastels and Drawings in Colour
London: Faber & Faber, 1961

Loize, Jean
Gauguin écrivain: ou les sept visages de "Noa Noa"
Paris: Musée de l'homme, Société des océanistes, 1949

Lövgren, S.
The Genesis of Modernism: Seurat, Gauguin, van Gogh and French Symbolism in the 1880s
Stockholm: Almquist & Wiksell, 1959

Malingue, Maurice
Gauguin, le peintre et son œuvre
Foreword Pola Gauguin
New York: Crown, 1948

Maugham, Somerset
The Moon and Sixpence
New York: Penguin, 1977

Mittelstädt, Kuno
Paul Gauguin: Self-Portraits
Oxford: Cassirer, 1968

Morice, Charles
Gauguin
Paris: Floury, 1919

Muller, Joseph-Émile
Gauguin
London: Eyre Methuen, 1982

Perruchot, Henri
Gauguin
Jean Ellsmore, ed.
London: Perpetus Books, 1963

Pickvance, Ronald
The Drawings of Gauguin
New York: P. Hamlyn, 1970

Pissarro, Camille
Letters to His Son Lucien
John Rewald, éd.
Mamaroneck, NY: P. P. Appel, 1972

Puig, René
Paul Gauguin, D. de Monfreid et leurs amis
Perpignan: La Tramontane, 1958

Read, Herbert
"Gauguin: Return to Symbolism"
Art News Annual, no. 25 (1956), pp. 122–56

Rechnitzer-Pope, Karen Kristine
Gauguin and Martinique
Austin: University of Texas, 1981

Rewald, John
Gauguin
Paris: Hyperion, 1938

Rewald, John
Paul Gauguin
New York: Abrams, 1954

Rewald, John
Post-Impressionism from van Gogh to Gauguin. 3rd rev. ed.
New York: The Museum of Modern Art, 1978

Rewald, John
Gauguin Drawings
New York: T. Yoseloff, 1958

Rewald, John
The History of Impressionism
London: Secker & Warburg, 1980

Rewald, John
Studies in Post-Impressionism
Irene Gordon and Frances Weitzenhoffer, eds.
New York: Abrams, 1986

Rey, Robert
Gauguin
New York: Dodd, Mead, 1924

Rookmaker, H. R.
Synthetist Art Theories: Genesis and Nature of the Ideas on the Art of Gauguin and His Circle
Amsterdam: Swets & Zeitlinger, 1959

Rookmaker, H. R.
Gauguin and Nineteenth Century Art Theory
Amsterdam: Swets & Zeitlinger, 1972

Roskill, Mark
Van Gogh, Gauguin and the Impressionist Circle
Greenwich, CT: New York Graphic Society, 1970

Rotonchamp, Jean de
Paul Gauguin
Paris: Crès, 1925

Rubin, William, ed.
"Primitivism" in 20th Century Art. 2 vols.
New York: The Museum of Modern Art, 1984

Russel, John
Gauguin
New York: New American Library, 1968

Schneeberger, Pierre Francis
Gauguin: Tahiti
New York: French and European Publications, 1963

Segalen, Victor
Journal des îles
Papeete: Éditions du Pacifique, 1978

Segalen, Victor
Gauguin dans son dernier décor et autres textes de Tahiti
Montpellier: Fata Morgana, 1975

Teilhet-Fisk, Jehanne
Paradise Reviewed: An Interpretation of Gauguin's Polynesian Symbolism
Ann Arbor: University of Michigan Press, 1983

Van Gogh, Vincent
The Complete Letters of Vincent van Gogh
Greenwich, CT: New York Graphic Society, 1958

Venturi, Lionello
Impressionists and Symbolists
New York: Scribner's, 1950

Vollard, Ambroise
Recollections of a Picture Dealer
Foreword Una E. Johnson
New York: Hacker, 1978

Wallis, A. A.
The Symbolist Painters of 1890
New York: New York University Press, 1941

Wichmann, Siegfried
Japonisme: The Japanese Influence on Western Art in the 19th and 20th Centuries
New York: Park Lane, 1985

Wildenstein, Georges, et al.
"Gauguin, sa vie, son œuvre"
Gazette des Beaux-Arts (Paris), Jan.–April 1958 (special number)

Wise, Susan
Paul Gauguin: His Life and His Paintings
Mount Vernon, NY: Artists' Limited Editions, 1980

List of Illustrations

The Archives Maurice Malingue have recently been given to the Musée départemental du Prieuré, Saint-Germain-en-Laye.

1. Gauguin. **Bonjour, Monsieur Gauguin.** 1889. Oil, 113 × 92 cm (reproduced in part). Národní Galerie, Prague (Archives Smeets)

2. Gauguin. **L'Appel.** 1902. Oil, 130 × 90 cm (reproduced in part). The Cleveland Museum of Art, Gift of Leonhard C. Hanna Jr. Fund (Museum photo)

3. Paul Gauguin in front of his painting **Te Faaturuma (Sullen Woman)** 1893–94. Photograph, reproduced in part (Archives Larousse)

4. Gauguin. **Mette Gauguin in an Evening Gown.** 1884. Oil, 65 × 54 cm (reproduced in part). Nasjonalgalleriet, Oslo (Jacques Lathion)

5. Mette Gauguin leaning on a railing, photograph (Archives Maurice Malingue), Musée départemental du Prieuré, Saint-Germain-en-Laye

6. Flora Tristan, the painter's grandmother

7. Aline Gauguin, the painter's mother. Detail of a portrait by Jules Laure (Archives M. Malingue)

8. Commemorative plaque at 52 Rue Notre-Dame-de-Lorette, Paris, noting that Gauguin was born here on June 7, 1848 (Patrick Thumerelle, Paris)

9. Paul Gauguin, two years old. Detail of a portrait by Jules Laure (Archives M. Malingue)

10. The Loire at Orléans, where Gauguin spent part of his childhood after four years in Peru (Photograph P. Thumerelle)

11. The corvette **Desaix** (formerly the **Jérôme-Napoléon**), where Gauguin was a sailor from March 3, 1868, to April 23, 1871 (Musée de la Marine, Paris)

12. Gustave Arosa, his wife Zoé, Irène and her husband, and Marguerite. Gauguin stayed with the Arosas after having been discharged from the Navy. Photograph (Archives M. Malingue)

13. The Stock Exchange, Paris, where Gauguin worked as a bookkeeper for stockbrokers and a banker (Photograph Roger-Viollet)

14. Paul Gauguin in 1873 (Archives M. Malingue)

15. Mette Gad at the time of her marriage to Paul Gauguin, 1873 (Archives M. Malingue)

16. Sketch of Emil Gauguin by his father. Charcoal, 10 × 8 cm. The Cleveland Museum of Art (Museum photo)

17. Mette Gauguin with two of her children in Paris. Photograph (Archives M. Malingue)

18. Marie Uribe, Gauguin's sister (Archives M. Malingue)

19. Faun at the Rue Carcel, Paris (P. Thumerelle)

20. Paul Gauguin, c. 1873 (Photograph Roger-Viollet)

21. Gauguin. **The Seine between the Pont d'Iéna and the Pont de Grenelle.** 1875. Oil, 81 × 116 cm. Private collection

22. Bridge over the Seine, Paris (Photograph P. Thumerelle)

23. Johan Barthold Jongkind. **View of the Pont-Royal in Paris.** 1852. Musée de Bagnères-de-Bigorre (Lauros-Giraudon)

24. Camille Pissarro. **Madame Pissarro Sewing near a Window.** 1878–79. Oil, 54 × 45 cm. Ashmolean Museum, Oxford

25. Gauguin. **Mette Gauguin Sewing near a Window.** 1878. Oil, 116 × 81 cm. Collection E. G. Bührle, Zurich (W. Dräyer, Zurich)

26. Gustave Courbet. **Bather Sleeping near a Brook.** 1845. Oil, 81 × 65 cm. The Detroit Institute of Arts, Founders Society Purchase (Bulloz, Paris)

27. Eugène Delacroix. **Aline the Mulatto.** 1824–26. Oil, 80 × 65 cm. Musée Fabre, Montpellier (Giraudon)

28. Gauguin. **"The Mulatto" after Delacroix.** 1878. Oil, 45 × 37 cm. Private collection, Zurich

29. Gauguin. **Study of a Nude: Suzanne Sewing.** 1880. Oil, 115 × 80 cm. Ny Carlsberg Glyptotek, Copenhagen (Museum photo)

30. Mette Gauguin, c. 1873. Photograph (Archives M. Malingue)

31. Gauguin. **Bust of Mette Gauguin.** c. 1879. White marble, height 60 cm. Courtauld Institute, London

32. Emil Gauguin and his nanny Justine, 1875. Photograph (Archives M. Malingue)

33. Gauguin. **Bust of Emil Gauguin.** c. 1878. White marble, height 41 cm. The Metropolitan Museum of Art, Gift of Joseph M. May Memorial Association, New York (Museum photo)

34. Gauguin. **Clovis Sleeping.** c. 1883. Oil. Private collection.

35. Gauguin. **The Painter's Family in the Garden of Rue Carcel in Paris.** c. 1882. Oil, 87 × 114 cm. Ny Carlsberg Glyptotek, Copenhagen (Museum photo)

36. Gauguin. **Snow, Rue Carcel.** 1882. Oil, 60 × 50 cm. Ny Carlsberg Glyptotek, Copenhagen (Museum photo)

37. The garden of Rue Carcel today (Photograph P. Thumerelle)

38. Camille Pissarro. **A Corner of the Garden in the Hermitage District.** 1877. Oil. Musée d'Orsay, Paris (Lauros-Giraudon)

39. Camille Pissarro. **Portrait of Gauguin.** Paul Gauguin. **Portrait of Pissarro.** 1883. Pencil drawings. Musée du Louvre, Paris (Giraudon)

40. Gauguin. **Mother and Child under the Trees.** 1886. Oil, 93 × 73 cm. Private collection

41. Gauguin. **Rouen, Church of Saint-Ouen.** 1884. Oil, 90 × 73 cm. Private collection (Archives Wildenstein)

42. The church of Saint-Ouen as seen from the outskirts of Rouen (Photograph P. Thumerelle)

43. The spires of Rouen Cathedral and the Church of Saint-Ouen as seen from the outskirts of the city (Photograph P. Thumerelle)

44. Gauguin. **View of Rouen, with the Spires of the Cathedral and the Church of Saint-Ouen.** 1884. Oil, 57 × 87 cm. The Paul Getty Museum, Malibu (Museum photo)

45. Mill at Osny (Photograph P. Thumerelle)

46. Gauguin. **The Sluice Gate at Osny, Normandy.** 1883. Oil, 65 × 54 cm. Private collection

47. Gauguin. **Self-Portrait before an Easel.** 1885. Oil, 65 × 54 cm. Collection Jacques Körfer, Bern (Hinz, Basel)

48. Paul Gauguin, c. 1885 in Copenhagen (Archives M. Malingue)

49. Gauguin. **Glazed Stoneware Vase with Mask.** Height 20 cm. Private collection (Droits réservés)

50. Gauguin. **Still Life with Mandolin.** 1885. Oil, 65 × 53 cm. Musée d'Orsay, Paris (RMN)

51. Odilon Redon. **Madame Odilon Redon.** 1885. Musée d'Orsay, Paris (RMN)

52. Gauguin. **La Fille du Patron.** 1886. Oil, 53 × 54 cm. Musée départemental du Prieuré, Saint-Germain-en-Laye (Museum photo)

53. Clovis Gauguin as a child in Copenhagen. Photograph (Archives M. Malingue)

54. Paul Cézanne. **The Artist's Son.** 1880–85. Oil, 35 × 38 cm. Musée d'Orsay, Paris (RMN)

55. Gauguin. **Portrait of Clovis.** 1886. Oil, 56 × 40 cm. The Newark Museum, Gift of Mrs. L.B. Wescott (Museum photo)

56. Gauguin. **Breton Shepherdess.** 1886. Oil, 60 × 73 cm reproduced in part. Laing Art Gallery, Newcastle-upon-Tyne (Museum photo)

57. Breton girl sitting on a rock in the Bois d'Amour, photograph

58. Gauguin. Sketch of the vase in **Still Life with Profile of Charles Laval.** From a letter to his wife, December 6, 1887. Bibliothèque Doucet, Paris

59. Gauguin. **Still Life with Profile of Charles Laval.** 1886. Oil, 46 × 38 cm. Private collection

60. Charles Laval. **Self-Portrait** dedicated to Vincent van Gogh. 1888. Oil, 50 × 60 cm (W. Dräyer, Zurich)

61. Costumes for the Pardon (Breton processional pilgrimage) at Pont-Aven, photograph (Collection Sirot-Angel)

62. Camille Pissarro. **Roundelay.** c. 1884. Tempera

63. Emile Bernard. **Breton Roundelay.** 1888. Etching. Private collection © Spadem 1986

64. Gauguin. **Breton Peasant Women.** c. 1886. Oil, 72 × 91 cm. Neue Pinakothek, Munich (Held)

65. Women washing clothes in the Aven, Pont-Aven, photograph (Centre de Documentation, Musée du Pont-Aven)

66. Gauguin. **Washerwomen at Pont-Aven.** 1886. Oil, 71 × 90 cm. Musée d'Orsay, Paris (RMN)

67. Gauguin. **Breton Shepherdess.** 1886. Oil, 60 × 73 cm. Laing Art Gallery, Newcastle-upon-Tyne (Museum photo)

68. Gauguin. **Little Breton Girl Seated.** 1886. Pastel and watercolor, 30 × 40 cm. Musée National des Arts Africains et Océaniens, Paris (RMN)

69. Gauguin. **The Beach at Dieppe.** 1885. Oil, 72 × 72 cm. Ny Carlsberg Glyptotek, Copenhagen

70. Claude Monet. **Rocks at Belle-Ile, Port-Domois.** 1886. Oil, 73 × 60 cm. Musée du Louvre, Paris (Giraudon) © Spadem 1986

71. Gauguin. **Rocks by the Sea.** 1886. Oil, 71 × 92 cm. Konstmuseum, Göteborg (Sixten Sandell)

72. Gauguin. **Seashore at Martinique.** 1887. Oil, 46 × 61 cm (reproduced in part). Private collection, Paris (Garanger-Giraudon)

73. Coastline at Le Carbet, Martinique, photograph

74. Paul Gauguin, c. 1886, photograph (Archives M. Malingue)

75. Charles Laval. **Self-Portrait** detail. 1889 (Archives M. Malingue)

76. Panama Canal during construction (Photograph Boyer-Viollet)

77. Port of St. Pierre, Martinique, with Mont

Pelée in the distance, photograph (Collection Sirot-Angel)

78. Mette Gauguin and her five children, Copenhagen, 1885, photograph (Archives M. Malingue)

79. Martinique women as drawn by the illustrator Riou

80. Gauguin. **The Pond.** 1887. Oil, 90 × 116 cm. Neue Pinakothek, Munich (J. Blauel-Artothek)

81. Farmers' huts Martinique, photograph. (Archives Nationales), Section Outre-mer, Paris (Th. Célestins, Archives ERL)

82. Katsushika Hokusai. **Hodogaya on the Tō-kaidō,** from **The Thirty-Six Views of Mt. Fuji.** 1825.-32. Woodcut. Collection Bérès, Paris (P. Thumerelle)

83. Gauguin. **Seashore at Martinique.** 1887. Oil, 46 × 61 cm. Private collection, Paris (Garanger-Giraudon)

84. Gauguin. **Seashore at Martinique.** 1887. Oil, 54 × 90 cm. Ny Carlsberg Glyptotek, Copenhagen (Museum photo)

85. Camille Pissarro. **Coconut Palms by the Sea, St. Thomas.** 1856. Oil, 27 × 35 cm. Virginia Museum of Fine Arts, Mr. and Mrs. Paul Mellon Collection, Richmond (Museum photo)

86. Camille Pissarro. **Chestnut Trees at Louveciennes.** 1872. Oil, 41 × 54 cm. Private collection (Droits réservés)

87. River in Martinique, photograph. Archives Nationales, Section Outre-mer, Paris (Th. Célestins, Archives ERL)

88. Gauguin. **By the Pond.** 1887. Oil, 54 × 65 cm. Rijksmuseum Vincent van Gogh, Amsterdam

89. Gauguin. **Tropical Landscape.** 1887. Oil, 116 × 89 cm. National Galleries of Scotland, Maitland Collection, Edinburgh (Museum photo)

90. Charles Laval. **Landscape, Martinique.** 1887. Oil. Private collection (Lauros-Giraudon)

91. Gauguin. Pot in the shape of a Martinique head. Stoneware, height 18 cm. Private collection

92. Gauguin. Paintbrush stand. Bamboo, with pyrographic inscription "A l'ami Schuff. Martinique 1887." Height 20 cm (Courtesy Galerie St.-Etienne, New York)

93. Camille Pissarro. **Negress.** 1867. Etching, 31 × 22 cm. Private collection (Droits réservés)

94. Gauguin. **Picking Mangos.** 1887. Oil, 89 × 116 cm. Rijksmuseum Vincent van Gogh, Amsterdam

95. Gauguin. **Martinique Pastoral ("The Cricket and the Ant").** Zincograph. Bibliothèque Nationale, Cabinet des Estampes, Paris (Archives ERL)

96. Jean-François Millet. **Peasant Girl Seated by a Haystack.** c. 1853. Pencil drawing. Musée du Louvre, Cabinet des Dessins, Paris

97. Toyokuni. **Sawamura Sōjurō III.** c. 1798. Woodcut. Collection Huguette Bérès, Paris

98. Gauguin. **Self-Portrait with Halo.** 1889. Oil on wood, 79 × 51 cm. National Gallery of Art, Chester Dale Collection, Washington, D.C. (Museum photo)

99. Gauguin. **Martinique.** Polychrome wood relief, 30 × 49 cm. Ny Carlsberg Glyptotek, Copenhagen (Museum photo)

100. Peruvian mummy, photograph. Musée de l'Homme, Paris

101. Gauguin. Drawing of a fox from his sketchbook

102. Gauguin. **Soyez amoureuses, vous serez heureuses (Be in Love, and You Will Be Happy).** c. 1889. Polychrome wood relief, 120 × 97 cm. Museum of Fine Arts, Arthur Tracy Cabot Fund, Boston (Museum photo)

103. Gauguin. **Breton Girls Dancing.** 1888. Oil, 73 × 92 cm (reproduced in part). The National Gallery of Art, Mellon Collection, Washington, D.C. (Bibliothèque des Arts, Lausanne)

104. Breton girl in traditional headdress of Pont-Aven (Photograph Explorer)

105. Pont-Aven as seen from the uplands near Lezaven, photograph. Collection Sirot-Angel (Archives ERL)

106. Guests and staff in front of the Pension Gloanec in Pont-Aven, photograph

107. Marie-Jeanne Gloanec and staff in the courtyard of the inn, photograph (Archives D. Sellin, Washington, D.C.)

108. One of the staff, Marie Derrien, in the dining room of the Pension Gloanec, 1888, photograph

109. Madeleine Bernard in traditional Pont-Aven attire, 1888, photograph (Archives S. Clin, Paris)

110. Emile Bernard, photograph (Archives S. Clin)

111. Breton peasant girl, photograph (Collection Sirot-Angel)

112. The village of Pont-Aven, photograph (Archives ERL)

113. Louis Le Nain. **Back from Haying** (detail) 1641. Musée du Louvre, Paris.

114. Gauguin. **Winter, or Breton Boy Adjusting His Wooden Shoe.** 1888. Oil, 90 × 71 cm. Ny Carlsberg Glyptotek, Copenhagen (Museum photo)

115. Gauguin. **Breton Shepherd Boy.** 1888. Oil, 89 × 116 cm. National Museum of Western Art, Tokyo (Museum photo)

116. Breton boy at Pont-Aven. Postcard

117. Gauguin. **Breton Woman Bending Over.** Charcoal. Bibliothèque Nationale, Cabinet des Estampes, Paris (Archives ERL)

118. Frédéric Bazille. **Summer Scene** (detail). 1869. Oil, 158 × 158 cm. Harvard University Museums, Fogg Art Museum, Gift of Mr. and Mrs. F. Meynier de Salinelles, Cambridge (Museum photo)

119. Pierre Puvis de Chavannes. **The Gentle Land** (detail). 1882. Musée Bonnat, Bayonne

120. Gauguin. **Children Wrestling.** From letter 46 to Van Gogh, Pont-Aven, August 1888. Rijksmuseum Vincent van Gogh, Amsterdam (Museum photo)

121. Gauguin. **Children Wrestling.** 1888. Oil, 93 × 73 cm. Private collection, Lausanne

122. Gauguin. **Breton Boys Bathing.** 1888. Oil, 92 × 73 cm. Kunsthalle, Hamburg (R. Kleinhempel, Hamburg)

123. Edgar Degas. **Young Spartans Exercising.** 1860. Oil, 109 × 155 cm (reproduced in part). National Gallery, London

124. Gauguin. **Nude Breton Boy.** 1889. Oil, 93 × 74 cm. Wallraf-Richartz Museum, Cologne (Rheinisches Bildarchiv, Cologne)

125. Spire of the church at Pont-Aven as seen from the Derout-Lollichon fields, photograph (Archives ERL)

126. Gustave Courbet. **The Painter's Studio** (detail). 1855. Musée d'Orsay, Paris

127. Gauguin. **Hay Harvest.** 1888. Oil, 73 × 92 cm. Musée d'Orsay, Paris (RMN)

128. Gauguin. **Breton Girls Dancing, Pont-Aven.** 1888. Oil, 73 × 92 cm. National Gallery of Art, Mellon Collection, Washington, D.C

129. Emile Bernard. **Breton Women Seated in a Meadow.** 1886. Watercolor and gouache, 45 × 52 cm. Kunsthalle, Bremen © Spadem 1986

130. Pascal Dagnan-Bouveret. **Breton Women during a Pardon.** 1887. Oil, 125 × 141 cm. Calouste Gulbenkian Foundation, Lisbon (Droits réservés)

131. Gauguin. **Breton Scene** (on cylindrical vase by Ernest Chaplet). 1886–87. Glazed stoneware, height 30 cm. Musées royaux d'Art et d'Histoire, Brussels

132. Utagawa Hiroshige. **Blossoming Plum Tree.** 1857. Private collection (Droits réservés)

133. Elderly Breton woman in mourning clothes, photograph. Bibliothèque Nationale, Paris (Archives ERL)

134. Gauguin. **The Vision after the Sermon—Jacob Wrestling with the Angel.** 1888. Oil, 73 × 92 cm. National Gallery of Scotland, Edinburgh (Archives Smeets)

135. Katsushika Hokusai. **Wrestlers,** from the **Hokusai Sketchbooks** 1814–49. Bibliothèque Nationale, Paris (Archives ERL)

136. Eugène Delacroix. **Jacob Wrestling with the Angel** (detail) 1827. Chapelle des Anges, Saint-Sulpice, Paris (Bulloz)

137. Gauguin. Sketch from a letter to Van Gogh, 1888. Rijksmuseum Vincent van Gogh, Amsterdam (Museum photo)

138. Emile Bernard. **Breton Women in the Meadow.** 1888. Oil, 74 × 92 cm. Private collection © Spadem 1986

139. Katsushika Hokusai. **Animals,** from the **Hokusai Sketchbooks** 1814–49. Private collection

140. Gauguin. **Still Life: Fête Gloanec.** 1888. Oil, 38 × 53 cm. Musée des Beaux-Arts, Orléans

141. Gauguin. **Still Life with Three Puppies.** 1888. Oil, 92 × 63 cm. The Museum of Modern Art, Mrs. Simon Guggenheim Fund, New York (P. Willi—Top, Paris)

142. Hiroshige II 1829–69. **Snow in the Kiso Mountains,** from **One Hundred Remarkable Views of the Provinces.** Woodcut. Collection Huguette Bérès, Paris

143. Bois d'Amour, Pont-Aven, photograph

144. Breton women in the Bois d'Amour, Pont-Aven. Postcard Luc Robin, Pont-Aven

145. Gauguin. **Above the Abyss.** 1888. Oil, 73 × 60 cm. Musée d'Orsay, Paris (P. Willi—Top)

146. Paul Sérusier. **Landscape of the Bois d'Amour—The Talisman.** 1888. Oil on wood, 27 × 22 cm. Musée d'Orsay, Paris (RMN) © Spadem 1986

147. Gauguin. **The Blanche River.** 1888. Oil, 58 × 72 cm. Musée de Peinture et de Sculpture, Grenoble (Ifot, Grenoble)

148. Breton boys swimming in the Aven. Photograph from the collection of Granchy Taylor (Archives M. Malingue)

149. Gauguin. **Captain Jacob.** 1888. Oil, 31 × 44 cm. Private collection (Musée départemental du Prieuré, Saint-Germain-en-Laye)

150. Emile Bernard. **My Sister Madeleine.** 1888. Oil, 61 × 50 cm. Musée Toulouse-Lautrec, Albi (Museum photo) © Spadem 1986.

151. Emile Bernard and his sister Madeleine, photograph (Archives S. Clin)

152. Gauguin. **Madeleine Bernard.** 1888. Oil, 72 × 58 cm. Musée de Peinture et de Sculpture, Grenoble (Ifot)

153. Gauguin. **The Alyscamps.** 1888. Oil, 92 × 73 cm (reproduced in part) Musée d'Orsay, Paris (Giraudon)

154. The Alyscamps at Arles, photograph (Dieuzaide, Toulouse)

155. Place Lamartine, Arles, as seen from the Porte de la Cavalerie. Postcard

156. Avenue de Montmajour, Arles. Postcard

157. Vincent van Gogh. **Self-Portrait with Bandaged Ear.** 1889. Collection Leigh B. Block, Chicago (Roger-Viollet)

158. Theo van Gogh, c. 1888, photograph (Archives Rijksmuseum Vincent van Gogh, Amsterdam)

159. Vincent van Gogh. **Van Gogh's Chair.** 1888–89. Oil, 92 × 73 cm. National Gallery, London (Museum photo)

160. Vincent van Gogh. **Gauguin's Armchair.** 1888–89. Oil, 91 × 72 cm. Rijksmuseum Vincent van Gogh, Amsterdam (Museum photo)

161. Mette Gauguin in Copenhagen, photograph (Archives M. Malingue)

162. Gauguin's five children in Copenhagen, photograph (Archives M. Malingue)

163. Gauguin. **Old Women of Arles.** 1888. Oil, 73 × 92 cm. The Art Institute of Chicago, Mr. and Mrs. Lewis L. Coburn Memorial Collection (Museum photo)

164–165. Gauguin. Studies for **Old Women of Arles.** From Gauguin's sketchbook

166. Vincent van Gogh. **Memory of the Garden at Etten.** 1888. Oil, 74 × 93 cm. The Hermitage Museum, Leningrad

167. Emile Bernard. **Self-Portrait: "à son Copaing Vincent."** 1888. Oil, 46 × 55 cm. Stedelijkmuseum, Amsterdam (W. Dräyer) © Spadem 1986.

168. Gauguin. **Self-Portrait: "Les Misérables."** 1888. Oil, 45 × 55 cm. Rijksmuseum Vincent van Gogh, Amsterdam (Held)

169. Gauguin. **Van Gogh Painting Sunflowers.** 1888. Oil, 73 × 92 cm. Rijksmuseum Vincent van Gogh, Amsterdam

170. Gauguin. **Landscape with Blue Trees.** 1888. Oil, 92 × 73 cm. Ordrupgaardsamlingen, Copenhagen

171. Gauguin. **Madame Roulin.** 1888. Oil, 50 × 63 cm. Saint Louis Art Museum (Museum photo)

172. Emile Bernard. **Portrait of the Artist's Grandmother.** 1887. Oil, 53 × 64 cm. Rijksmuseum Vincent van Gogh, Amsterdam © Spadem 1986

173. Vincent van Gogh. **Portrait of Madame Augustine Roulin.** 1888. Oil, 55 × 65 cm. Collection Oskar Reinhart, Winterthur (Held)

174. Camille Pissarro. **Washerwoman.** 1878–81. Sketch. Private collection (Droits réservés)

175. Gauguin. **Washerwoman.** Sketch from the artist's sketchbook

176. Jean-François Millet. **The Gleaners** (detail) 1857. Oil, 84 × 111 cm. Musée du Louvre, Paris (Bulloz)

177. Gauguin. **Washerwomen.** 1888. Oil, 73 × 92 cm. Museo de Bellas Artes y de Arte Moderno, Bilbao

178. Gauguin. **Grape Gathering: Human Misery.** 1888. Oil, 73 × 92 cm. Ordrupgaardsamlingen, Copenhagen (Ole Woldbye, Copenhagen)

179. Jean Benner. **Young Women in a Ravine near Caprile.** Salon of 1881

180. Vincent van Gogh. **The Night Café.** September, 1888. Pencil, watercolor, and gouache, 44 × 63 cm. Collection Hahnloser, Bern (Hinz)

181. Gauguin. **Café at Arles (Madame Ginoux).** 1888. Oil, 73 × 92 cm. Pushkin State Museum of Fine Arts, Moscow (Archives Smeets)

182. Gauguin. **L'Arlésienne: Madame Ginoux.** 1888. Charcoal, black conté crayon, red crayon heightened with white chalk, 56 × 49 cm. Fine Arts Museum of San Francisco, Achenbach Foundation for Graphic Arts, Dr. T. Edward and Tullah Hanley Collection (Museum photo)

183. Vincent van Gogh. **L'Arlésienne: Madame Ginoux.** Jan.–Feb. 1890. Oil, 65 × 54 cm. Museu de Arte, São Paulo (Bulloz)

184. Vincent van Gogh's house (the "Yellow House") in Arles (since demolished) photograph. Archives Rijksmuseum Vincent van Gogh, Amsterdam (Museum photo)

185. Vincent van Gogh. **The Yellow House.** September 1888. Oil, 76 × 94 cm. Rijksmuseum Vincent van Gogh, Amsterdam (Museum photo)

186. Gauguin. **The Yellow Haystacks.** 1889. Oil, 73 × 92 cm. Musée d'Orsay, Paris

187. Jean-François Millet. **The Haybinders.** 1850. Musée du Louvre, Paris (RMN)

188. Gauguin. **Woman in the Hay.** 1888. Oil, 73 × 92 cm. Collection Stavros Niarchos (P. Willi–Top)

189. Eugène Delacroix. **Death of Sardanapalus** (detail). 1827–28. Musée du Louvre, Paris (RMN)

190. Jean-François Millet. **Nude** (Study for **Les Regrets**). c. 1846. Crayon, 27 × 20 cm. The Art Institute of Chicago, The Edward E. Ayer Fund

191. Gauguin. **Study for "Woman in the Hay."** December 1888. Charcoal and watercolor. Rijksmuseum Vincent van Gogh, Amsterdam (Museum photo)

192. Gauguin. **Self-Portrait with the Yellow Christ.** 1889. Oil, 38 × 46 cm (reproduced in part). Private collection, Saint-Germain-en-Laye (Lauros-Giraudon)

193. Paul Gauguin, c. 1889, photograph from a plate belonging to Mme. Huc de Monfreid. Collection O'Reilly (Archives ERL)

194. Poster announcing the exhibition at the Café Volpini during the Paris World's Fair, 1889

195. Catalogue cover for the Volpini exhibition

196. Gauguin. **Portrait of Mallarmé with a Raven.** 1891. Etching

197. Grands Sables beach at Le Pouldu and the house called "Le Pendu," motif of a Gauguin painting. Photograph (Collection Gourrier)

198. Gauguin. Sketched self-portrait as an Indian

199. The Saint-Maudet Chapel overlooking Le Pouldu, postcard

200. Polychrome Breton statue in the chapel (Archives ERL)

201. "La Buvette de la Plage," Marie Henry's inn at Le Pouldu, photograph (Collection Le Thoer)

202. The dining room of La Buvette de la Plage, Le Pouldu, 1924, photograph (Collection Gourrier)

203. Gauguin. **Woman in the Waves (Ondine).** 1889. Oil, 92 × 72 cm. Cleveland Museum of Art, Gift of Mr. and Mrs. William Powell Jones (Museum photo)

204. The Schuffenecker family, photograph (Archives du Musée départemental du Prieuré, Saint-Germain-en-Laye)

205. Gauguin. **Madame Schuffenecker.** Bronze, height 47 cm. Collection Maurice Malingue, Musée départemental du Prieuré, Saint-Germain-en-Laye

206. Jeanne Schuffenecker, age 12. Photograph taken by Gauguin, Rue Paturle (Archives du Musée départemental du Prieuré, Saint-Germain-en-Laye)

207. Emile Schuffenecker. Sketch of his daughter (Archives du Musée départemental du Prieuré, Saint-Germain-en-Laye)

208. Gauguin. **The Schuffenecker Family.** 1889. Oil, 73 × 92 cm. Musée d'Orsay, Paris (RMN)

209. Gauguin. **Breton Calvary: The Green Christ.** 1889. Oil, 92 × 73 cm. Musées royaux des Beaux-Arts, Brussels (Giraudon)

210. Gauguin. **Holy Images.** Engraving from **Le Journal Intime de Paul Gauguin,** preface by Emil Gauguin, 1923. Musée départemental du Prieuré, Saint-Germain-en-Laye (P. Thumerelle)

211. Breton Calvary at Nizon, photograph (P. Thumerelle)

212. Gauguin. **Agony in the Garden.** 1889. Oil, 73 × 92 cm. Norton Gallery of Art, West Palm Beach (Museum photo)

213. Gauguin. **Christ in Gethsemane.** Sketch from a letter to Vincent van Gogh, November 1889. Rijksmuseum Vincent van Gogh, Amsterdam (Museum photo)

214. Emile Bernard. **Christ in Gethsemane.** 1889. Private collection © Spadem 1986

215. Gauguin. **Self-Portrait with the Yellow Christ.** 1889. Oil, 38 × 46 cm. Private collection, Saint-Germain-en-Laye (Lauros-Giraudon)

216. The polychrome wooden crucifix in the Chapel of Trémalo, Finistère. 17th century. Collection Comte de la Villemarqué de Cornouailles

217. Charles Filiger. **Crucifixion.** Private collection (Droits réservés) (J. Hyde)

218. Gauguin. Tobacco jar with self-portrait. 1889. Glazed stoneware, height 28 cm. Musée du Jeu de Paume, Paris (Giraudon)

219. Gauguin. **The Yellow Christ.** 1889. Oil, 92 × 73 cm. Albright-Knox Art Gallery, Buffalo (P. Willi–Top)

220. Gauguin. **Self-Portrait with Palette.** c. 1891. Oil, 55 × 46 cm. Private collection (Droits réservés)

221. Gauguin with a palette, photograph (Harlingue-Viollet, Paris)

222. Angèle Satre, photograph (Archives Musée de Pont-Aven)

223. Ando Hiroshige. **Sekiya Hills from Masaki,** from **One Hundred Famous Views of Edo.** 1857. Woodcut. Österreichisches Museum für angewandte Kunst, Vienna.

224. Gauguin. **La Belle Angèle (Portrait of Madame Satre).** 1889. Oil, 92 × 72 cm. Musée d'Orsay, Paris (P. Willi–Top)

225. Gauguin. **Breton Haymakers.** 1889. Oil, 76 × 95 cm. Private collection (Hinz)

226. Emile Bernard. **Breton Woman on Her Farm at Pont-Aven.** 1886. Zincograph heightened with watercolor. Private collection (S. Clin) © Spadem 1986

227. Gauguin. **Breton Haymakers.** Illustration from the catalogue of the Volpini exhibition

228. Emile Bernard. **Breton Landscape: The Harvest.** 1888. Oil, 56 × 45 cm. Musée d'Orsay, Paris (RMN) © Spadem 1986

229. Gauguin. **Harvest in Brittany.** 1889. Oil, 92 × 73 cm. Courtauld Institute, London (Museum photo)

230. Well at the Kersellec farm (Photograph P. Thumerelle)

231. The Kersellec farm today (Photograph P. Thumerelle)

232. Jacob Meyer de Haan. **Farmyard and Well at Le Pouldu.** 1889. Oil, 74 × 93 cm. Kröller-Müller Museum, Otterlo (Museum photo)

233. Gauguin. **The Blue Roof: Farm at Le Pouldu.** 1890. Oil, 73 × 92 cm. Private collection (Giraudon)

234. Gauguin. **Two Little Breton Girls by the Sea.** 1889. Oil, 92 × 73 cm. National Museum of Western Art, Tokyo (Held)

235. Paul Sérusier. **Three Little Girls at Le Pouldu.** c. 1890. Oil, 97 × 74 cm. Private collection, France © Spadem 1986.

236. Gauguin. **Head of a Peasant Girl.** Pencil and ink wash, 23 × 20 cm. Harvard University, Fogg Art Museum, Meta and Paul J. Sachs Collection, Cambridge (Museum photo)

237. Gustave Courbet. **The Burial at Ornans** detail. 1849. Oil, 315 × 668 cm. Musée du Louvre, Paris (Giraudon)

238. Gauguin. **Among the Lilies: Breton Landscape with Children and Dog.** 1889. Oil, 93 × 74 cm. Collection Rudolf Staechelin, Basel (Hinz)

239. Camille Pissarro. **Portrait of Cézanne.** 1874. Etching, 27 × 21 cm. Musée Bonnat, Bayonne (Lauros-Giraudon)

240. Gauguin. **The Painter Roy** detail. 1889. Oil, 41 × 33 cm. Private collection, USA (Musée départemental du Prieuré, Saint-Germain-en-Laye)

241. Gauguin. **Old Man with a Stick.** 1889. Oil, 70 × 45 cm. Petit Palais, Musée de la Ville de Paris (H. Josse)

242. Gauguin. **"Nirvana"—Portrait of Meyer de Haan.** 1889. Oil, 20 × 29 cm. Wadsworth Atheneum, The Ella Gallup Sumner and Mary Catlin Sumner Collection, Hartford (Joseph Szaszfai)

243. Jacob Meyer de Haan. **Self-Portrait in Breton Costume.** c. 1889. Oil, 74 × 54 cm. Private collection (Giraudon)

244. Gauguin. **Jacob Meyer de Haan.** 1889. Watercolor, 16 × 12 cm. The Museum of Modern Art, Gift of Arthur G. Altschul, New York (Museum photo)

245. Gauguin. **Bust of Meyer de Haan.** Polychrome wood, height 70 cm. Private collection (Archives Ides et Calendes)

246. Gauguin. **Bonjour, Monsieur Gauguin.** 1889. Oil, 113 × 92 cm. Národni Galerie, Prague (W. Dräyer)

247. Breton women at a gate, from the postcard series **La Bretagne pittoresque**

248. Jean-François Millet. **Shepherdess Seated on a Rock.** Black crayon, heightened with white, 37 × 28 cm. Collection Alan Clark (J. Hyde)

249. Gauguin. **Breton Women at a Gate.** 1889. Zincograph, 17 × 22 cm. Bibliothèque Nationale, Paris

250. Camille Pissarro. **Peasant Women at Rest.**

1881. Toledo Museum of Art, Gift of Edward Drummond Libbey

251. Gauguin. **The Gate.** 1889. Oil, 92 × 73 cm. Kunstmuseum, Zurich

252. Edouard Manet. **Olympia.** 1863. Oil, 130 × 190 cm. Musée d'Orsay, Paris (RMN)

253. Gauguin. **Olympia after Manet.** 1891. Oil, 89 × 130 cm. Private collection

254. Breton wedding party strolling through the Bois d'Amour, Pont-Aven, Collection Sirot-Angel (Meurisse)

255. Gauguin. Study for **The Loss of Virginity.** Early 1891. Private collection (Droits réservés)

256. Gauguin. **The Loss of Virginity (Spring Awakening).** 1891. Oil, 90 × 130 cm. Chrysler Art Museum, Norfolk (Archives Smeets)

257. Hans Holbein. **Christ in the Tomb.** 1521. Tempera, 31 × 200 cm. Kunstmuseum, Basel

258. Emile Bernard. **Madeleine in the Bois d'Amour.** 1888. Oil, 138 × 163 cm reproduced in part. Musée d'Orsay, Paris (Lauros-Giraudon) © Spadem 1986

259. Paul Cézanne. **Fruit Bowl, Cloth, Glass, and Apples.** 1879–82. Oil, 46 × 55 cm. Bibliothèque Nationale, Paris (Druet Archives ERL)

260. Paul Cézanne. **Lady with a Fan (Madame Cézanne).** 1879–82. Oil, 93 × 73 cm. Collection E.G. Bührle Foundation, Zurich (Hinz)

261. Gauguin. **Roses and Statuette.** 1890. Oil, 73 × 54 cm. Musée Saint-Denis, Reims (J. Babinot)

262. Gauguin. **Statuette of a Martinique Woman.** 1889. Wax, height 20 cm. Private collection (Droits réservés)

263. Gauguin. **Portrait of a Seated Woman** (also known as **Portrait of Marie Derrien**). 1890. Oil, 65 × 55 cm. The Art Institute of Chicago, Joseph Winterbotham Collection (Museum photo)

264. Paul Cézanne. **Fruit Bowl, Cloth, and Dish of Apples.** 1879–82. Oil, 36 × 45 cm. Bibliothèque Nationale, Paris (Druet, Archives ERL)

265. Gauguin. **Fruit Dish on a Garden Chair.** c. 1890. Oil, 28 × 37 cm. Los Angeles County Museum of Art, Gift of Miss Merle Oberon.

266. Portrait of Gauguin's mother. Private collection (Droits réservés)

267. Gauguin. **Exotic Eve.** 1890. Oil on board, 43 × 25 cm. Private collection (Droits réservés)

268. Gauguin. **The Artist's Mother (Aline Marie Chazal).** 1890. Oil, 41 × 33 cm. Staatsgalerie, Stuttgart (Museum photo)

269. Kunichika. **Portrait of a Japanese Kabuki Actor as Hige no Ikyu.** c. 1880. Woodcut. Museum of Fine Arts, Boston

270. Vessel in the shape of a head. Pre-Columbian, Peru. Height 32 cm. Metropolitan Museum of Art, Gift of Nathan Cummings, New York (Museum photo)

271. Gauguin. Cup as self-portrait. 1889. Glazed stoneware, height 19 cm, width 18 cm. Det Danske Kunstindustrimuseet, Copenhagen (Ole Woldbye)

272. Gauguin. **Still Life with a Japanese Print.** 1889. Oil, 73 × 92 cm. Collection Thyssen-Bornemisza, Lugano (Lauros-Giraudon)

273. Gauguin. **The Market (Ta Matete).** 1892. Gouache, 73 × 92 cm (reproduced in part). Kunstmuseum, Basel (Hinz)

274. Tahitian women performing an **aparima**, or

song with pantomime, photograph (Archives M. Bengt Danielsson, Papeete)

275. Papeete Bay as sketched by Gustave Arosa's brother, Achille Arosa, during his trip to Tahiti (Archives M. Malingue)

276. Tahitian landscape, photograph (Archives M. Malingue)

277. The port of Papeete, photograph (Collection O'Reilly)

278. The palace of Pomaré V at Papeete, photograph (Archives Nationales, Section Outre-mer)

279. River in Tahiti. Photograph from **Album Océanie** (Collection Sirot-Angel)

280. Tahitian half-caste, c. 1895. Photograph by Lemasson (Collection O'Reilly)

281. Young Tahitian women, in the background their huts, photograph (Collection O'Reilly)

282. Gauguin. Sketch of himself and profile of a **vahine**

283. Gauguin. **Tahitian Woman.** c. 1892. Watercolor, 40 × 32 cm. Musée de Peinture et de Sculpture, Grenoble (P. Willi–Top)

284. Gauguin. **Tahitian Women (On the Beach).** 1891. Oil, 69 × 91 cm. Musée d'Orsay, Paris (Archives ERL)

285. Charles Chaplin. **Little Harvester Sleeping by a Wall.** Photogravure, from the Arosa auction, 1878. Bibliothèque Nationale, Cabinet des Estampes, Paris (Archives ERL)

286. Tahitian woman, c. 1890. Photograph by Lemasson (Collection O'Reilly)

287. Gauguin. **Head of a Tahitian Woman.** Crayon, 40 × 31 cm. The Art Institute of Chicago, Gift of David Adler and friends (Museum photo)

288. Gauguin. **Head of a Tahitian Woman.** Crayon. Private collection, Paris (Giraudon)

289. Gauguin. **Revery (Woman in Red Dress).** 1891. Oil, 92 × 73 cm. Nelson Atkins Museum of Art, Nelson Fund, Kansas City (Museum photo)

290. Bas-relief. Temple of Borobudur, Java. Detail of a plate from Van Kinsbergen, **Antiquités javanaises,** 1910. Bibliothèque Nationale, Cabinet des Estampes, Paris (Archives ERL)

291. Sandro Botticelli. **Primavera** (detail). c. 1478. Uffizi Gallery, Florence (Anderson-Viollet)

292. Gauguin. **Tahitian Repast (The Bananas).** 1891. Oil, 73 × 92 cm. Musée d'Orsay, Paris (H. Josse)

293. Gauguin. **Ia Orana Maria (We Greet Thee, Mary).** 1891. Oil, 114 × 88 cm. The Metropolitan Museum of Art, Bequest of Sam A. Lewisohn, New York (Museum photo)

294. Gauguin. **The Dead Tree (Matamoe)** or **Landscape with Peacocks.** 1892. Oil, 115 × 86 cm. Pushkin State Museum of Fine Arts, Moscow (Archives Smeets)

295–296. Parthenon frieze detail. From Charles Yriarte, **Les Frises du Parthénon,** 1868. Collotype plates by Gustave Arosa. Cabinet des Estampes, Bibliothèque Nationale, Paris (Archives ERL)

297. Gauguin. **Man with an Ax (The Servant of Pia).** 1891. Oil, 92 × 70 cm. Private collection (Top)

298. Gauguin. **In the Vanilla Grove, Man and Horse.** 1891. Oil, 73 × 92 cm. Solomon R. Guggenheim Museum, Gift of Justin K. Thannhauser, New York (Carmelo Guadagno)

299. Gauguin. **Delicious Earth (Te Nave Nave Fenua).** 1892. Oil, 92 × 74 cm. Ohara Museum of Art, Kurashiki, Japan (Museum photo)

300. Bas-relief, Temple of Borobudur, Java. Detail of a plate from Van Kinsbergen, **Antiquités javanaises**, 1910. Bibliothèque Nationale, Cabinet des Estampes, Paris (Archives ERL)

301. Sandro Botticelli. **The Birth of Venus** detail. c. 1485. Uffizi Gallery, Florence (Giraudon)

302. Gauguin. **Delicious Earth (Nave Nave Fenua).** c. 1891–93. Woodcut, 36 × 20 cm

303. Gauguin. **Vahine No Te Vi (Woman with Mango).** 1892. Oil, 70 × 45 cm. Baltimore Museum of Art, Cone Collection (Museum photo)

304. Gauguin. **At the Black Rocks.** Engraving from the catalogue of the Volpini exhibition, 1889 (Archives Ides et Calendes)

305. Ando Hiroshige. **Pine Like a Full Moon in Ueno Park,** from **One Hundred Famous Views of Edo.** 1857. Woodcut. Collection Huguette Bérès, Paris.

306. Gauguin. **Fatata Te Miti (By the Sea).** 1892. Oil, 68 × 92 cm. National Gallery of Art, Chester Dale Collection, Washington, D.C. (Museum photo)

307. Gauguin. **Self-Portrait with Idol.** 1891. Oil, 44 × 33 cm. Marion Koogler McNay Art Museum, Bequest of Marion Koogler McNay, San Antonio (Museum photo)

308. Gauguin. **Hina,** statuette of the goddess. Wood, height 40 cm. Private collection (Droits réservés)

309. Paul Gauguin in an armchair, 1891, photograph (reproduced in part, Archives M. Malingue)

310. Gauguin. **Self-Portrait with Hat** detail. 1893. Oil, 46 × 38 cm. Musée d'Orsay, Paris (RMN)

311. Gauguin. **Spirit of the Dead Watching (Manao Tupapau).** 1892. Oil, 73 × 92 cm. Albright-Knox Art Gallery, A. Conger Goodyear Collection, Buffalo (Museum photo)

312. Gauguin. **Maruru.** Woodcut. Musée National des Arts Africains et Océaniens, Paris (RMN)

313. Gauguin. Drawing of a Marquesan earplug. c. 1895. The Art Institute of Chicago, David Adler Memorial Fund (Museum photo)

314. Tiki, stone statue from the Marquesas Islands. Musée Barbier-Müller, Geneva (Museum photo)

315. Gauguin. Study of a Tiki. 1895–97. Pen and India ink, 20 × 15 cm. Private collection (Droits réservés)

316. Gauguin. **Parahi Te Marae (There Is the Temple).** 1892. Oil, 68 × 91 cm. Philadelphia Museum of Art, Gift of Mrs. Rodolphe Meyer de Schauensee (Museum photo)

317. Gauguin. **Arearea (Joyousness).** 1892. Oil, 75 × 94 cm. Musée d'Orsay, Paris (RMN)

318. **The Rest.** Photographic composition by L. Gauthier, c. 1910 (Collection O'Reilly)

319. Tahitian meal. c. 1895. Photograph from **Album Lemasson** (Collection O'Reilly)

320. Gauguin. **Te Fare Hymenee (House of Song).** 1892. Oil, 50 × 90 cm. Private collection, Lausanne

321. Gauguin. **Noa Noa,** folio 63. Musée du Louvre, Cabinet des Dessins, Paris (RMN)

322. Gauguin. **The Valley.** 1892. Oil, 42 × 67 cm. Collection Mrs. Jaeggli, Winterthur (Hinz)

323. Native hut. c. 1891, photograph (Musée de l'Homme, Paris)

324. Gauguin. **The Moon and the Earth (Hina Te Fatou).** 1893. Oil, 114 × 62 cm. The Museum of Modern Art, Lillie P. Bliss Collection, New York (Museum photo)

325. Tahitian man at a mountain spring, Gauguin's model for **Pape Moe,** photograph (Roger-Viollet)

326. Gauguin. **The Source.** Wood relief. Cabinet des Estampes, Bibliothèque Nationale, Collection Druet, Paris (Archives ERL)

327. Gauguin. **Mysterious Water (Pape Moe).** c. 1893. Watercolor over monotype, 36 × 26 cm. The Art Institute of Chicago, Gift of Mrs. Emily Crane Chadbourne (Museum photo)

328. Gustave Courbet. **The Source.** 1868. 128 × 97 cm. Musée du Louvre, Paris (Bulloz)

329. Gauguin. **Mysterious Water (Pape Moe).** 1893. Oil, 99 × 75 cm. Collection Mme. H. Anda-Bührle, Zurich (W. Dräyer)

330. Gauguin. **Under the Pandanus Tree (I Raro te Oviri).** Frontispiece of **Noa Noa.** Monotype heightened with watercolor. Musée du Louvre, Cabinet des Dessins, Paris (RMN)

331. Tahitian bearer, c. 1886, photograph. Musée de l'Homme, Paris (Dormoy)

332. Dinner in the city. From an Egyptian tomb in the vicinity of Thebes. c. 1500 B.C. (Boudot-Lamotte)

333. Gauguin. **The Seed of the Areois (Te Aa No Areois).** 1892. Oil, 92 × 73 cm. Private collection, New York (Droits réservés)

334. Gauguin. **The Market (Ta Matete).** 1892. Gouache, 73 × 92 cm. Kunstmuseum, Basel (Hinz)

335. Gauguin. **Alone (Otahi).** 1893. Oil, 50 × 73 cm. Private collection (Archives Smeets)

336. Gauguin. **Crouched Figure.** From Le **Sourire,** plate III. Musée départemental du Prieuré, Saint-Germain-en-Laye (P. Thumerelle)

337. Gauguin. **Alone (Otahi).** 1893. Oil, 50 × 73 cm. Private collection (Archives Smeets)

338. Katsushika Hokusai. **Crouched Figure,** from the **Hokusai Sketchbooks** 1814–49. Woodcut. Private collection (Droits réservés)

339. Edgar Degas. **Crouched Female Nude.** Charcoal and pastel

340. **Prince Sudhana Bowing.** Relief no. 56, Temple of Borobudur, Java (Roger-Viollet)

341. Gauguin. **Mary Magdalene at the Foot of the Cross.** Woodcut from **L'Ymagier,** no. 3 (April 1895), after a monotype from 1894. Bibliothèque du Musée départemental du Prieuré, Saint-Germain-en-Laye.

342. Gauguin. **Nafea Faa Ipoipo? (When Will You Marry?)** 1892. Oil, 102 × 78 cm. Rudolf Staechelin Foundation, Kunstmuseum, Basel (Hinz)

343. Gauguin. **Annah la Javanaise (Aita Parari).** 1893. Oil, 116 × 81 cm. Collection Stavros Niarchos (Hinz)

344. Annah la Javanaise. Photograph by Alphonse Mucha, 1898 (Archives M. Bengt Danielsson)

345. Gauguin in front of his painting **Te Faaturuma (Sullen Woman),** Paris, Winter 1893–94, photograph (Archives Larousse)

346. Gauguin's studio, 6 Rue Vercingétorix, Paris: Annah la Javanaise behind the cellist Schneklud, photograph (Archives M. Malingue)

347. Exterior of Gauguin's studio in Paris, 6 Rue Vercingétorix, photograph (Archives M. Bengt Danielsson)

348. Gauguin. Catalogue frontispiece for his exhibition at the Durand-Ruel Gallery, November 1893 (Archives M. Malingue)

349. The Swedish playwright August Strindberg photograph (Roger-Viollet)

350. Edgar Degas, photograph (Roger-Viollet)

351. Gauguin. **Tahitian Woman in a Landscape.** 1893. Oil on glass from Gauguin's studio on Rue Vercingétorix, 116 × 75 cm. Musée d'Orsay, Paris (RMN)

352. Gauguin. Cover originally planned for **Noa Noa.** 1891–93. Woodcut.

353. Gauguin. Cover of **Noa Noa,** Charles Morice edition (P. Thumerelle)

354. Gauguin. **Noa Noa,** folios 55, 63, 67, 75, 172, 173. Cabinet des Dessins, Musée du Louvre, Paris (RMN)

355. Bearers with offerings. Bas-relief from the Mastaba of Akhontotep detail. Old Kingdom, 2475–2180 B.C. Musée du Louvre, Paris

356. Gauguin. **Maori Woman as an Idol.** Ink drawing. Private collection (Droits réservés)

357. Gauguin. **The Day of the God (Mahana No Atua).** 1894. Oil, 70 × 90 cm. The Art Institute of Chicago, Helen Birch Bartlett Memorial Collection (Museum photo)

358. Gauguin. **Shell Idol.** c. 1893. Wood, height 27 cm. Musée d'Orsay, Paris (RMN)

359. Pierre Puvis de Chavannes. **Girls by the Seashore** (detail). c. 1879. Musée du Louvre, Paris (Giraudon)

360. Gauguin. **Spirit of the Dead Watching (Manao Tupapau).** c. 1891. Woodcut. Musée National des Arts Africains et Océaniens, Paris

361. Plowing fields. Bas-relief, Temple of Ti, Saqqara. Old Kingdom, c. 2400 B.C. (Giraudon)

362. Gauguin. **Noa Noa,** folio 182. Musée du Louvre, Cabinet des Dessins, Paris (RMN)

363. Gauguin. **Christmas Eve.** 1894. Oil, 72 × 83 cm. Private collection, Lausanne

364. Gauguin. **Village in the Snow.** 1894. Oil, 65 × 90 cm. Musée d'Orsay, Paris (RMN)

365. Utagawa Hiroshige. **Kambara: Snow in the Evening,** from **The Fifty-Three Stages of the Tōkaidō Highway.** Woodcut. Collection Huguette Bérès, Paris.

366. Gauguin. **Paris in the Snow.** 1894. Oil, 72 × 88 cm. Rijksmuseum Vincent van Gogh, Amsterdam (Museum photo)

367. Gauguin. **The Angelus in Brittany** (inscribed in English "For my friend O'Conor, one man of Samoa, 1894"). Monotype heightened with watercolor, 27 × 31 cm. Private collection, Lausanne

368. Gauguin. **Breton Girl Praying.** 1894. Oil, 65 × 46 cm. Private collection (Droits réservés)

369. Charles Filiger. **Praying Saint.** 1892. Gouache, 25 × 24 cm (reproduced in part). Private collection (Droits réservés)

370. The cellist Fritz ("Upaupa") Schneklud, photograph (Archives M. Malingue)

371. Gauguin. **Upaupa Schneklud (The Cellist).** 1894. Oil, 92 × 73 cm. Baltimore Museum of Art, Gift of Hilda K. Blaustein in memory of Jacob Blaustein (Museum photo)

372. Mill at Pont-Aven, postcard

373. Stepping stones near the Mill at Plessis, from the postcard series **La Bretagne pittoresque** (Collection Sirot-Angel)

374. Gauguin. **The David Mill.** 1894. Oil, 73 × 92 cm. Musée d'Orsay, Paris (RMN)

375. Gauguin. **Two Tahitian Women.** 1899. Oil, 94 × 72 cm. The Metropolitan Museum of Art, Gift of William Church Osborn, New York (Museum photo)

376. Two Tahitian women (Ruru and Terii striking the pose of **Two Tahitian Women**). Photograph by Potentier, 1937 (Collection O'Reilly)

377. Tahitian **vahines,** c. 1890, photograph (Musée de l'Homme, Paris)

378. Gauguin. **Tehura.** 1891–93. Wood, height 25 cm. Musée du Louvre, Paris (RMN)

379. Gauguin's carved wooden cane. Musée du Louvre, Paris (Giraudon)

380. Museum in Auckland, New Zealand, where Gauguin examined Oceanic sculpture on August 26, 1895. Photograph (Museum photo)

381. Chart for "Paul Gauguin, pauper" during the artist's hospitalization in Papeete, July 6–14, 1896 (Archives M. Malingue)

382. Gauguin's hut in Punaauia, 1897 (Archives M. Bengt Danielsson)

383. Gauguin's beloved daughter, Aline, in Copenhagen shortly before her death. Photograph (Archives M. Malingue)

384. Page one of **Les Guêpes,** no. 25 (Feb., 1901) with an editorial by Gauguin entitled "Les Pédants"

385. Jeanne ("Vaïté") Goupil as a child. Photograph by Cl. E. Spitz (Collection O'Reilly)

386. Gauguin. **Vaïté Goupil.** 1896. Oil, 75 × 65 cm. Ordrupgaardsamlingen, Copenhagen (Ole Woldbye)

387. The Goupil family in Tahiti, photograph (Collection O'Reilly)

388. Georges-Daniel de Monfreid. **Self-Portrait.** Private collection (Droits réservés)

389. Gauguin. **Self-Portrait: "à l'ami Daniel."** 1897. Oil, 39 × 35 cm. Musée d'Orsay, Paris

390. Gauguin. **Self-Portrait.** Crayon. Private collection (Droits réservés)

391. Gauguin. **The King's Wife (Te Arii Vahine).** 1896. Oil, 97 × 130 cm. The Hermitage Museum, Leningrad (Hinz)

392. Lucas Cranach. **Diana Reclining.** c. 1537. Musée des Beaux-Arts, Besançon (Lauros-Giraudon)

393. Schoolgirls resting on the way back from an outing, Tahiti, photograph. Musée des Colonies, Archives Nationales, Section Outre-mer (Archives ERL)

394. Gauguin. **Maori Woman as an Idol.** Ink drawing. Private collection

395. Gauguin. **Le Père Paillard.** 1892. Wood, carved at Hiva Oa, height 27 cm. Private collection (Droits réservés)

396. Gauguin. **Decorative Figure.** Woodcut from **Le Journal Intime de Paul Gauguin** (1923), with preface by the artist's son, Emil Gauguin. Bibliothèque du Musée départemental du Prieuré, Saint-Germain-en-Laye (P. Thumerelle)

397. Gauguin. **Study for "The King's Wife."** Bibliothèque Nationale, Cabinet des Estampes, Paris (Archives ERL)

398. Gauguin. **Delicious Days (Nave Nave Mahana).** 1896. Oil, 94 × 130 cm. Musée des Beaux-Arts, Lyon (Bernard Lontin, Lyon)

399. Pierre-Paul Prud'hon. **Joseph and Poti-**

phar's Wife. c. 1793. Engraving (Archives ERL)

400. Gauguin. **Joseph and Potiphar's Wife.** 1896. Oil, 89 × 116 cm. Private collection (Droits réservés)

401. **Tahitian Women Bathing.** 1897. Oil, 73 × 92 cm. Barber Institute of Fine Arts, University of Birmingham, Birmingham, England (Museum photo)

402. Pierre-Paul Prud'hon. **The Bath.** Plate XV from Charles Clément, **Prud'hon,** with collotypes by G. Arosa. Bibliothèque Nationale, Cabinet des Estampes, Paris (Archives ERL)

403. Bas-relief, Temple of Borobudur, Java. Detail of a plate from Van Kinsbergen, **Antiquités javanaises,** 1910. Bibliothèque Nationale, Cabinet des Estampes, Paris (Archives ERL)

404. Gauguin. **Te Faruru (Here We Make Love).** From **Noa Noa,** folio 127. Musée du Louvre, Cabinet des Dessins, Paris (RMN)

405. King Vaitahu and his wife, Marquesas Islands, c. 1880. Photograph by Admiral Miot. Musée de l'Homme, Paris

406. Gauguin. **Eiaha Ohipa (Do Not Work).** 1896. Oil, 65 × 75 cm. The Hermitage Museum, Leningrad

407. Gauguin. **Te Rerioa (The Dream).** 1897. Oil, 95 × 132 cm. Courtauld Institute, London (Museum photo)

408. Gauguin. **Where Do We Come From? What Are We? Where Are We Going?** 1897. Oil, 139 × 375 cm. Museum of Fine Arts, Tompkins Collection, Boston (Museum photo)

409. Gauguin. **Breton Eve.** 1889. Pastel and watercolor, 33 × 31 cm. Marion Koogler McNay Art Institute, Gift of Marion Koogler McNay, San Antonio (Museum photo)

410. Vase in shape of a seated figure. Kyoto stoneware. Bibliothèque du Musée du Prieuré, Saint-Germain-en-Laye (P. Thumerelle)

411. Attributed to Rembrandt School. **Study of Nude.** Pen and ink wash. Musée du Louvre, Cabinet des Dessins, Paris (Giraudon)

412. Bas-relief, Temple of Borobudur, Java. Detail of a plate from Van Kinsbergen, **Antiquités javanaises,** 1910. Bibliothèque Nationale, Cabinet des Estampes, Paris (Archives ERL)

413. Pierre Puvis de Chavannes. **The Poor Fisherman** detail. 1881. Oil, 155 × 192 cm. Musée du Louvre, Paris (RMN)

414. Gauguin. **Sketch for "Where Do We Come From? What Are We? Where Are We Going?"** 1898. Watercolor, 21 × 38 cm. Musée National des Arts Africains et Océaniens, Paris (RMN)

415. Paul Sérusier. **Pont-Aven Triptych.** c. 1891. Oil, 73 × 133 cm. Private collection, Paris © Spadem 1986

416. Pierre Puvis de Chavannes. **The Sacred Grove (Arts and Sciences).** Frescoes in the Hemicycle, Grand Amphitheater of the Sorbonne, Paris, 1888–89 (Bulloz)

417. Gauguin. **Vairumati.** 1897. Oil, 73 × 84 cm. Musée d'Orsay, Paris (Archives ERL)

418. Gauguin. **Goose.** 1889. Oil on plaster above door of Marie Henry's dining room, Le Pouldu, 53 × 72 cm. Collection Lévy (Gourrier)

419. Kitao Masayoshi. Sketch of geese

420. Gauguin. **Self-Portrait near Golgotha.** 1896. Oil, 76 × 64 cm. Museu de Arte, São Paulo (Museum photo)

421. Gauguin. **Head of a Tahitian Man.** 1891–93. Crayon. The Art Institute of Chicago, Gift of Mrs. Emily Crane Chadbourne (Museum photo)

422. Gauguin. **Oviri (Savage).** c. 1893. Terracotta, height 74 cm. Collection Galerie Spiess, Paris

423. Gauguin. Cane with carved decoration. Wood, height 88 cm. Private collection (Droits réservés)

424. Gauguin. **Tahitian Nativity.** 1896. Oil, 66 × 75 cm. The Hermitage Museum, Leningrad

425. Tassaert. **Stable Interior.** 1837. Formerly Collection Arosa. Cabinet des Estampes, Bibliothèque Nationale, Paris (Archives ERL)

426. Gauguin. **The Birth of Christ (Te Tamari No Atua).** 1896. Oil, 96 × 128 cm. Neue Pinakothek, Munich (Held)

427. Gauguin. **Nevermore (Otaïti).** 1897. Oil, 60 × 116 cm. Courtauld Institute, London (Museum photo)

428. Eugène Delacroix. **Study for "Othello and Desdemona"** (détail). Facsimile by A. Robaut, formerly Collection Arosa, Bibliothèque Nationale, Cabinet des Estampes, Paris (Archives ERL)

429. Gauguin. **Faa Iheihe (Decorated with Ornaments).** 1898. Oil, 54 × 169 cm. Tate Gallery, London (Museum photo)

430. Gauguin. **War and Peace.** Wood relief (reproduced in part). Bibliothèque Nationale, Cabinet des Estampes, Collection Druet, Paris (Archives ERL)

431. Gustave Courbet. **Hunting Dog.** Engraving, part of Arosa auction, 1878. Bibliothèque Nationale, Cabinet des Estampes, Paris (Archives ERL)

432. Gustave Courbet. **The Source.** c. 1862. Oil, 120 × 74 cm. The Metropolitan Museum of Art, Bequest of Mrs. H. O. Havemeyer, New York (Museum photo)

433. Gauguin. **Changing Residence.** Woodcut. Bibliothèque Nationale, Cabinet des Estampes, Paris (Archives ERL)

434. Panathenian Procession. From Charles Yriarte, **Les Frises du Parthénon,** with collotype plates by Gustave Arosa. Bibliothèque Nationale, Cabinet des Estampes, Paris (Archives ERL)

435. Edgar Degas. **Mlle. Fiocre in the Ballet "La Source."** 1866–68. Brooklyn Museum, Gift of James H. Post, John T. Underwood, and Augustus A. Healy.

436. Young native on horseback, Tahiti, photograph (Collection O'Reilly)

437. Gauguin. **Study of a Horse.** Pen and ink, 24 × 32 cm. Boymans-van Beuningen Museum, Rotterdam (Museum photo)

438. Gauguin. **The White Horse.** 1898. Oil, 141 × 91 cm. Musée d'Orsay, Paris (Archives ERL)

439. Gauguin. **The Poor Fisherman.** 1896. Oil, 76 × 66 cm. Museu de Arte, São Paulo (Museum photo)

440. Pierre Puvis de Chavannes. **The Poor Fisherman** (detail). 1881. Oil, 155 × 192 cm. Musée du Louvre, Paris (RMN)

441. Fisherman and dugout canoes, Tahiti, c. 1896, photograph. Musée de l'Homme, Collection Dormoy de Laharpe

442. Johan Barthold Jongkind. **Sailboats.** 1861. Part of Arosa auction, 1878. Bibliothèque Nationale, Cabinet des Estampes, Paris (Archives ERL)

443. Sailboat, Tahiti, photograph (Collection O'Reilly)

444. Gauguin. **Tahitian Idyll.** 1901. Oil, 73 ×

94 cm. Collection E. G. Bührle Foundation, Zurich (W. Dräyer)

445. Michelangelo. **Ignudo.** Sistine Chapel, Rome. 1509–10 (Roger-Viollet)

446. Gauguin. **Aha Oe Feii (Are You Jealous?)** 1894. Monotype. Collection Druet (RMN-Vizzavona-Viollet)

447. Gauguin. **Auti Te Pape (Women at the River).** 1891–93. Woodcut. Bibliothèque Nationale, Cabinet des Estampes, Paris (Archives ERL)

448. Gauguin. **And the Gold of Their Bodies.** 1901. Oil, 67 × 76 cm. Musée d'Orsay, Paris (H. Josse)

449. Pierre Puvis de Chavannes. **Hope.** c. 1872. Oil, 71 × 82 cm. Musée du Louvre, Paris (Giraudon)

450. Vincent van Gogh. **Sunflowers.** 1888. Oil, 91 × 72 cm. Neue Pinakothek, Munich (Museum photo)

451. Gauguin. **Sunflowers on a Chair.** 1901. Oil, 72 × 91 cm. The Hermitage Museum, Leningrad

452. Gauguin. **Still Life with "Hope."** 1901. Oil, 65 × 77 cm. Collection Mrs. Joanne Toor Cummings, New York

453. Native hut, Tahiti, c. 1895, photograph. Album Lemasson (Collection O'Reilly)

454. Gauguin. **Noa Noa,** folio 71. Musée du Louvre, Paris (RMN)

455. Gauguin. **Noa Noa,** folio 181. Musée du Louvre, Paris (RMN)

456. Gauguin. **Landscape with Three Figures.** 1901. Oil, 65 × 76 cm. Carnegie Institute, Purchase through the generosity of Mrs. Alan M. Sciafe, Pittsburg (Museum photo)

457. Gauguin. **Young Woman with Fan.** 1902. Oil, 92 × 73 cm. Folkwang-Museum, Essen (Giraudon)

458. Model for **Young Woman with Fan.** Photograph

459. The Atuana valley with the church, bishop's residence, and school for girls (Archives M. Bengt Danielsson)

460. Marquesans, Atuana, 1900. Photograph by Lemasson (Collection O'Reilly)

461. Edouard Petit, Governor of Tahiti from 1901 to 1904, photograph (Collection O'Reilly)

462. Monsignor Joseph Martin, apostolic vicar of the Marquesas Islands. Photograph (Collection O'Reilly)

463. Pastor Paul Vernier, who comforted Gauguin as he neared death. Photograph (Collection O'Reilly)

464. Death certificate filled out by Officer Claverie at Atuana, May 8, 1903 (Archives M. Malingue)

465. The tomb of Paul Gauguin shortly after the artist's death, Hiva Oa (Dominique), Marquesas Islands. Photograph by A. t'Serstevens (Archives Mme Amandine Doré, Paris)

466. Mother and daughter, Tahiti, c. 1895. Album Lemasson (Collection O'Reilly)

467. Gauguin. **Two Marquesan Natives.** c. 1902. Monotype. British Museum, Gift of Cesar M. de Hauke, London (Museum photo)

468. Gauguin. **Mother and Daughter.** 1902. Oil, 73 × 92 cm. Private collection (Droits réservés)

469. Gauguin. **Tahitian Lovers.** 1902. Oil, 73 × 93 cm. Národni Galerie, Prague (Held)

470. Gauguin. Lintel and panel from the door of Gauguin's "House of Pleasure," Hiva Oa (Dominique), Marquesas Islands. Musée du Louvre, Paris (Giraudon)

471. Gauguin. **The Sorcerer of Hiva Oa.** 1902. Oil, 92 × 73 cm. Musée d'Art moderne, Liège (Museum photo)

472. Gauguin. **Tahitian Family.** c. 1902. Monotype, 47 × 28 cm. Musée National des Arts Africains et Océaniens, Paris (RMN)

473. Sorceress, Tahiti. From a set of photographs taken by Colonel Stuart Wortley. Bibliothèque Nationale, Paris (Archives ERL)

474. Gauguin. Woodcut from **Le Sourire** 1899–1900.

475. Gauguin. **Tahitian Family.** 1902. Oil, 92 × 73 cm. Private collection (Archives Smeets)

476. Gauguin. Study for **Contes Barbares**

477. Gauguin. **Meyer de Haan,** from **Noa Noa,** folio 174. Musée du Louvre, Cabinet des Dessins, Paris (RMN)

478–479. Bas-reliefs, Temple of Borobudur, Java. Details of plates from Van Kinsbergen, **Antiquités javanaises,** 1910. Bibliothèque Nationale, Cabinet des Estampes, Paris (Archives ERL)

480. Gauguin. **Contes Barbares.** 1902. Oil, 130 × 89 cm. Folkwang–Museum, Essen (Archives ERL)

481. Gauguin. **Riders on the Beach.** 1902. Oil, 66 × 76 cm. Folkwang–Museum, Essen (Museum photo)

482. Gauguin. **Rider.** Engraving. Bibliothèque Nationale, Cabinet des Estampes, Paris (Archives ERL)

483. Edgar Degas. **Racehorses.** c. 1884. Oil, 45 × 65 cm reproduced in part (Bulloz)

484. Ignacio Merino. **Riders on the Beach.** Formerly Collection Arosa. Bibliothèque Nationale, Cabinet des Estampes, Paris (Archives ERL)

485. Gauguin. **Riders on the Beach.** 1902. Oil, 73 × 92 cm. Collection Stavros Niarchos

486. Rider. From Charles Yriarte, **Les Frises du Parthénon,** with collotype plates by G. Arosa. Bibliothèque Nationale, Cabinet des Estampes, Paris (Archives ERL)

487. Tahitian on horseback, photograph. Musée de l'Homme, Paris (Coll. P. Verger)

488. Gauguin. **Last Self-Portrait (Self-Portrait with Glasses).** 1903. Oil, 42 × 25 cm. Kunstmuseum Basel (Giraudon)

489. Gauguin. **Landscape with Pig and Horse.** 1903. Oil, 75 × 65 cm. Ateneumin Taidemuseo, Antell Collection, Helsinki (Matti Tirri)

INDEX